GW00467581

prizes & awards

This edition first published in the United Kingdom in 2005 by

Dewi Lewis Publishing
8 Broomfield Road
Heaton Moor
Stockport SK4 4ND
0161 442 9450

www.dewilewispublishing.com

All rights reserved

Copyright ©2005 Dewi Lewis Publishing

ISBN: 1-904587-16-X

Design and production: Dewi Lewis Publishing
Print: Biddles Ltd, King's Lynn

*No information included in this publication
may be deemed in any circumstances to be a representation,
undertaking or warranty and the publishers cannot accept any liability
should any information prove to be inaccurate in any way*

prizes & awards

edited by
Caroline Warhurst
and Juliette McAuliffe

DEWI LEWIS

PUBLISHING

introduction

This is the third edition of Prizes and Awards. It is now considerably expanded and we hope that it will continue to prove a useful source of information on the many competitions and award schemes which are open to creative artists and writers from the UK.

Gathering together the detailed information included in the book is a complex and time-consuming task. Over the last few months we have contacted literally hundreds of organisations to try to ensure that everything is as up to date as possible and we would like to thank all of those who have helped us with this. Their input and support is much appreciated.

Undoubtedly there will be omissions but we hope that they are few and far between, and that they will be incorporated in our next edition of the directory. And so we would be delighted to hear from any competition organisers, grant-aiding bodies or charitable trusts that run schemes which could be appropriately included. Equally if you, as an artist, craftsperson, writer or photographer, come across any new schemes we would be grateful to hear from you.

We would also welcome any other comments that you have as to how you would like to see this directory improved. After all it is intended to be of benefit to you.

Dewi Lewis & Caroline Warhurst
March 2005

contents

Using this Directory 6

General 9

Visual Arts 49

Crafts 89

Photography 111

Residencies 159

Literature 185

Special Funds 264

Poetry 267

Translation 289

Arts Funding Agencies 297

Index 313

using this directory

In this new edition of *Prizes & Awards* there are even more entries than ever before. As you will see, the book is divided the book into sections, which reflect the key interests and funding policies of the organisations involved. However, it is worth noting that many of the schemes are extremely broad, and are open to individuals and organisations across a range of artforms. Many are also very complicated in terms of their specific requirements. With this in mind, we have tried to track down email and web site contacts, so that you are able to access the fullest information possible, and keep in touch with any updates, as and when they emerge.

The first section of the book covers more general awards and competitions – those which are effectively cross art-form in their interests. We then look at those for the visual arts and crafts, before moving on to photography, literature and poetry. The final section provides information on Arts Council England, The Arts Council of Northern Ireland, Scottish Arts Council and Arts Council Wales.

Many of you, however, will work in ways which don't quite fit such neat categorisation and we hope that you will check all the possible entries just to make sure that you're not missing that key opportunity.

As far as possible try to do further research about whatever competition you are entering, or award you are applying for. Try to get a sense of what is being sought, the preferred approach and the sort of subjects that appear to be of interest. It is often useful to find out who the previous winners or recipients have been. A key starting point is the organisation's web site, if there is one available.

Do also bear in mind that entry dates, rules, method of application can all change without advance warning and so once you have identified the areas of your potential interest do make sure that you make early contact with the organisers to ensure that you are added to their mailing list.

Presentation is always an important element in the submission of work whether it is an entry to a competition or an application for grant-aid support. Essentially anything and everything that you can do to make it easier to understand your ideas is a great help to judges and other assessors.

If you are making a submission for a bursary or a grant then you will almost always have to prepare a written outline of your project. Try to summarise it in no more than two sides of A4 and keep the description clear and precise. You should include a CV listing your education and training, any exhibitions, previous publications, magazine features etc. Again keep it short and don't put in a mass of things simply to fill out the space. Finally prepare an

introductory letter drawing attention to any of the key points that you have made in the outline or in your CV. As with the other two items keep it short. If you are being asked to include referees then always ask the referee first, before using their names, and make sure that they understand what you are applying for. Their support can be critical in the final decision.

Always ensure that you have copies of everything. Hopefully nothing will get lost, misplaced or damaged but it is always a possibility. With many submissions it makes sense to send them in a reusable box or packaging. Make sure that it is clearly marked with your name and the return address (an address which will be valid for several months) and that you have enclosed stamps to cover the return postage.

Once you've sent your work in you have to realise that it may be quite some time before you see it again. In the case of many competitions and grant applications it can be a matter of a few months before you will hear anything at all. If you are going to need any of your submitted material as a matter of urgency then it is important to check before making your submission as to the likely time-scale involved.

After a few weeks even the most patient person will begin to get anxious about how their work has been received. Hard though it is, you should leave a respectable amount of time before beginning your onslaught on the organiser or the Trust Secretary for their reaction. On the other hand don't sit back for six months waiting for an acknowledgement. If a decision has been taken and your work has been been rejected then it is serving no purpose with them whilst you, on the other hand, may be able to send it off for consideration somewhere else.

A word of warning. Be careful about any competition which appears to be 'vanity publishing' in disguise. If you as a 'winner' of a competition are told that a publisher or an exhibition organiser is very keen to publish or exhibit your work if you contribute to the costs then it is reasonable to suspect that the competition was simply a device to try to exploit your ambition. Having been just told that you are a 'winner' may be just enough encouragement to persuade you to throw caution to the wind!

Finally I can not stress enough the need for spending time and care on the presentation. It is so important. You are asking people for their support and they will want to feel that you are serious about your work and that you are concerned about detail. If your work is strong and you present it so that it is clear and understandable then you are well on the way. Best of luck!

Dewi Lewis

Alt-w

Contact: Susannah Silver, Alt-w Co-ordinator
Phone: 01382 348631
Email: info@alt-w.com
Web: www.alt-w.com

Alt-w is an initiative set up to support and promote creative entrepreneurial talent and innovative digital productions that can be delivered via the web. The fund strongly encourages applicants to explore experimental and interactive creations.

Alt-w consists of a Partnership Board made up of Scottish Screen, Dundee City Council, Scottish Enterprise Tayside, Dundee College, University of Abertay and University of Dundee (School of Television and Imaging).

Under certain circumstances, Alt-w Partner organisations may provide equipment resources for successful applicants. Specialists from these organisations can also offer a limited level of training and mentor support.

Eligibility: Applicants must live in Scotland. The fund aims to support and develop Scotland's new media talent at all levels including:

Individuals (visual artists, designers, film + video makers, audio artists, musicians, games and program developers).

Artists' groups, writer/director/producer teams, games & program development teams.

Artists wanting to creatively explore the new media field. Previous experience in this area is not essential but you will need to demonstrate that you are able to realise the project you are proposing.

Students (provided projects are not part of examination coursework).

Production grants up to a maximum value of £2,500.

Application: Use the Alt-w application form available on the website.

Anglo-Brazilian Society (BAT/Souza Cruz Scholarship)

32 Green Street
London W1K 7AU
Contact: Ellie Dell'Aglio
Phone: 020 7493 8493
Email: info@anglobraziliansociety.org
Web: www.anglobraziliansociety.org

Anglo-Brazilian Society and BAT/Souza Cruz Scholarships, worth £1,000 are intended to further knowledge of Brazil with regard to a particular project, thesis or event. Although the funding application states it is restricted to

postgraduates and undergraduates, the Society is flexible.

Open to: UK Residents. A working knowledge of Portuguese and some knowledge of Brazil is required.

Application: Request application form.
Closing date: Normally in March.

Arts and Science Research Fellowships

Web: www.artscouncil.org.uk/ahrb

In 2005 the Arts & Humanities Research Board (AHRB), Arts Council England and the Scottish Arts Council ran the second Arts and Science Research Fellowships scheme.

The scheme aims to support collaborative research specifically between the fields of the creative and performing arts and science and engineering, as well as providing opportunities for individual researchers in the arts to work alongside those working in a scientific context. It also seeks to explore wider questions about whether, and how, art and science can mutually inform each other.

The Fellowship offers individuals working within the creative and performing arts the opportunity to engage in a process of collaborative research in a UK Higher Education Institution (HEI) for six to twelve months, on a full- or part-time basis, working with colleagues in a scientific or engineering discipline.

The first Arts and Science Research Fellowships programme funded sixteen major research fellowships for artists and scientists working together.

Awards are available up to £38,000. Applicants must provide a breakdown of the costs for which they are seeking support. Guidance on the kinds of costs permissible is provided in the programme guidelines.

For more information and links to application packs and guidelines visit www.artscouncil.org.uk/ahrb

Closing date: February.

The Laura Ashley Foundation

John Dowling, The Administrator
The Laura Ashley Foundation
3 Cromwell Place
London SW7 2JE
Phone: 020 7581 4662
Web: www.laf.uk.net

The Laura Ashley Foundation was set up in 1986, in memory of Laura Ashley, the designer, who died the year before. It is very much a family affair and the Ashley family are actively involved in the day to day running of the Foundation. It has a strong commitment to Art and Design, and to Wales.

The Foundation awards two fellowships per year of around £12,000 to £25,000. They are very competitive and given to individuals aged 30 plus, who have outstanding ideas they need funding to develop. Because of the Ashley

Family interest, they seek applications from Powys, in particular from community & education projects, music, art & design, and rural life.

Application: The Administrator is happy to answer queries about funding criteria and how best to put together an application if you meet the criteria. The office is usually open on Monday, Wednesday and Friday.

Belluard Bollwerk International

CP 214
CH-1701 Fribourg
Switzerland
Phone: +41 26 3212420
Fax: + 41 26 3212421
Email: info@belluard.ch
Web: www.belluard.ch

Belluard Bollwerk International (BBI) is an annual contemporary arts festival held in Fribourg at the beginning of each summer. Founded in 1983 by regional artists and organisers the festival to date has presented the projects of more than 1,000 artists and groups. It supports regional and international artistic projects and organises a contest which is open to all.

The BBI looks for "innovative, relevant, audacious, surprising and committed projects." Any form, method or means are admitted. The contest is open to all.

Each project is to be presented on 2 A4 pages, at most. Describe the concept, goals and the means required to realise the project as well as the space and time needed. Include a detailed budget. Plans, drawings, photos, videos, recordings are recommended.

Each winning project will be awarded, a maximum of 6,000.

Winning projects will be supported by the BBI (organization, distribution, promotion) and presented as part of the festival.

Closing date: January. Results announced: February.

BFWG Charitable Foundation

The Secretary
BFWG
4 Mandeville Courtyard
142 Battersea Park Road
London SW11 4NB
Phone: 020 7498 8037
Web: www.bcfgrants.org.uk

BFWG Charitable Foundation is the wholly owned subsidiary of the British Federation of Women Graduates. The Federation promotes women's opportunities in Education and public life; it works as part of an international organisation to improve the lives of women.

- *Foundation Grants*

The Charitable Foundation offers Foundation Grants to help women graduates with their living expenses (not fees) while registered for study or research at an

approved institution of higher education in Great Britain. The criteria are the proven needs of the applicant and their academic calibre. Grants are not likely to exceed £2,500.

Closing date: May.

- **Emergency Grants**

The Charitable Foundation offers Emergency Grants to graduate women who face an unforeseeable financial crisis whilst engaged in study or research at institutions of higher education in Great Britain. Grants are not likely to exceed £500. Offered three times a year in December, March and June.

- **Theodora Bosanquet Bursary**

This Bursary is offered annually to women graduates whose research in History or English Literature requires a short residence in London in the summer. It provides accommodation in a hall of residence for up to 4 weeks between mid June and mid September.

Closing date: October.

The Foundation does not give grants for Undergraduate Degrees.

BlindArt Competition

PO Box 50113
London SW1X 9EY
Phone: 020 7245 9977
Fax: 020 7245 1228
Email: info@blindart.net
Web: www.blindart.net

BlindArt is an organisation whose aim is to promote audience participation and to create awareness of the visually impaired in the sighted domain of the visual arts, and, in time, to create a permanent collection of accessible work that enhances the ethos of BlindArt. 2004 saw an inaugural competition and exhibition. While details of the second competition are not yet finalised they are likely to be as below.

Artists are invited, in all media, to submit work specifically created for blind and partially sighted people. Artists are asked to adopt their own interpretation of this challenge. BlindArt encourages artists to consent for their work to be touched. Selected works will be shown at the Royal College of Art.

Eligibility: Open to all artists over age 18, born or resident in the UK.

Submission: Two or three dimensional work in any medium including photography, painting, video, sculpture and installation. The work should have been carried out within the last five years. Artists are required to send slides and/or photographs (max 5) or CD-ROMs together with an application form. Submission fee: £10 per work per artist.

Two prizes: a first prize of £5,000 to be selected by the panel of judges, plus a Purchase Prize awarded by BlindArt Trading Ltd which will become part of the BlindArt permanent collection.

Application: Send SAE or download from website. Entry forms in Braille and on audio CD available on request from the competition administrators.

The British Academy

10 Carlton House Terrace
London SW1Y 5AH
Phone: 020 7969 5200
Fax: 020 7969 5300
Email: secretary@britac.ac.uk
Web: www.britac.ac.uk

The British Academy offers grants in the humanities and social sciences. Grants are available to support advanced research at postdoctoral level (or equivalent). Grants are offered for the support of scholars who are normally resident in the UK, except for the programmes for visiting scholars. See the website for details of available grants and general notes of guidance.

British Chamber of Commerce in Germany e.V.

Brückenstr. 2
D-50667 Köln
Germany
Phone.: +49 221 31 44 58
Fax: +49 221 31 53 35
Email: foundation@bccg.de
Web: www.bccg.de

The BCCG Foundation is a charity registered in Germany. Since its formation in 1983 it has provided financial support and partial scholarships to young British and German nationals for study or research in Germany or the United Kingdom respectively. In this way it seeks to promote understanding between the peoples and the furtherance of cultural relations between the two countries.

UK citizens are eligible to apply for awards for study or research in Germany, and German citizens for awards for study or research in the UK. Applicants should be undertaking full time courses at universities leading to degrees, diplomas or equivalent qualifications. Research students are also eligible. Successful candidates receive a BCCG Foundation Scholarship Award in the form of a one-off payment. This is intended to provide supplementary financial support, not to defray the full cost of the proposed course or research. Payment is subject both to acceptance by the institution at which their study is to be undertaken and evidence that the course or research activity has been started.

Application forms for the following academic year can be requested in writing from February onwards.

The application form must be received in Cologne between the 1st May and 30th June. Awards cannot be made to applicants whose 30th birthday occurs on or prior to the 30th June.

Winston Churchill Memorial Trust

15 Queen's Gate Terrace
London SW7 5PR
Phone: 020 7584 9315
Fax: 020 7581 0410
Email: office@wcmt.org.uk
Web: www.wcmt.org.uk

The Winston Churchill Travelling Fellowships offer about 100 awards per year to enable British citizens to undertake travel projects to help them learn about other cultures and to gain knowledge and experience which will enable them to be more effective in their work and community upon their return. Each year scholarships are awarded for various categories. Details are usually published in June on the website.

Applicants do not require formal educational or professional qualifications.

The Trust generally prefers to award Fellowships to people unlikely to obtain funding from other sources. In particular, the Trust is looking for those to whom the opportunity represents the Chance of a Lifetime. Grants will usually cover a stay overseas of between 4 to 8 weeks (longer periods may be considered). Applications for less than 4 weeks will not be considered.

Open to: British citizens who are resident in the UK.

Application: Request application form. The Trust does not expect applicants to have planned their project in detail at this stage but they must demonstrate that their project is feasible and worthwhile, and indicate the benefits to this country after their return. You will be expected to remain in the UK for at least three years. Grants do not cover attending courses or academic studies. If awarded a Fellowship, you will receive a grant to cover all your Fellowship expenses: return air fare, daily living, travel within the countries being visited, essential equipment and, in certain cases, home expenses. You will also be appropriately insured. Grants usually cover a stay overseas of about 4-8 weeks. Fellows will be expected to commence their travels within a year.

Clark Digital Bursary

Watershed Media Centre
1 Canon's Road
Harbourside
Bristol BS1 5TX
Phone: 0117 927 6444
Fax: 0117 921 3958
Email: bursary@watershed.co.uk
Web: www.watershed.co.uk/bursary

The Bursary is supported by J.A. Clark Charitabe Trust, Watershed Media Centre, Arts Council England, Mobile Bristol (Hewlett Packard Labs, University of Bristol and The Appliance Studio) and The University of the West of England. In general the bursary aims:

- To enable artists and multimedia producers to develop their creative practice in digital media, primarily working with mobile technologies.
- To engage audiences with developments in creative technology practice within the social environment of Watershed and its surroundings.
- To explore the integration of interactive exhibition systems into the social experience of a visit to Watershed.
- To foster creative collaborations between artists, technologists and Watershed Media Centre to explore innovative working practices.
- To develop the Mobile Bristol infrastructure through practice based R&D and iterative testing involving users.
- To make new digital work and practice available to audiences in the

South West of England

- Projects which actively engage young people in the creative process.are encouraged.

The Bursary will offer three awards. It is anticipated that there will be one award of £12,000 and two awards of £6,000.

Cockpit Arts Seedbed Award

Cockpit Yard
Northington Street
London WC1N 2NP
Phone: 020 7419 1959
Fax: 020 7916 2455
Contact: Mandy Meaden, Studio Manager
Email: mandy@cockpitarts.com
Web: www.cockpitarts.com

A limited number of Seedbed Awards to designer-makers who are setting up a studio for the first time are available. Priority is given to those who need the greatest amount of financial and business support in the first three years. Applicants who have previously had a studio elsewhere should apply for a Standard Award. The selection committee mets once a month to consider applications.

Collide

Arts Team
Birmingham City Council
Chamberlain Square
Birmingham B3 3DH
Contact: Bob Jowett
Phone: 0121 303 4962
Email: bob_jowett@birmingham.gov.uk
Web: www.collide-arts.co.uk

Collide is an arts commissioning programme that profiles the talent of culturally diverse artists in Birmingham. Mentors from the creative industries work with each of the commissioned lead artists to give creative and professional support, develop skills and enhance the confidence and quality of the artists' showcased work. The term minority ethnic refers to people of African, Caribbean, Asian, Chinese and Refugee origin including people of mixed ethnic origin.

Key elements include: multi-media performances, animation and video, spoken word, dance and music.

Collide is part of a city to city collaboration between Birmingham, Sandwell, Wolverhampton, and Coventry local authorities. To date, Collide has commissioned 33 new projects.

Collide offers awards of up to £5,000 for innovative arts projects. Open to all artforms including film and new media, visual and performing arts.

Application to regional offices – see website for details.

Coventry Arts and Heritage

The Herbert
Jordan Well
Coventry CV1 5QP
Contact: Rachel Heath
Phone: 02476 832310
Email: rachel.heath@coventry.gov.uk
Web: www.coventrymuseum.org.uk

Community-based and individual arts projects can benefit from up to £1,000 as a Small Arts Grant from Coventry City Council. Nearly £20,000 is available in total, open to all Coventry-based artists and groups. New projects and those that broaden the base for the arts as a whole are particularly welcome.

Cultural Co-operation And Touring

CCAT @ Aberystwyth Arts Centre
Penglais
Aberystwyth
Ceredigion SY23 3DE
Contact: Rob Tiernan
Phone: 01970 622897
Fax: 01970 622883
Email: rrt@aber.ac.uk.
Web: http://users.aber.ac.uk/rrt

CCAT is administered by Aberystwyth Arts Centre and Temple Bar, Dublin. Its aim is to encourage professional artistic relationships between venues, companies, or individuals in the INTERREG IIIA Regions of Wales and Ireland. It will develop networks between cultural practitioners and facilitate cross-border touring by giving direct financial assistance.

Eligible Activities

- Touring in the Irish INTERREG Region
- Programme support for venues wishing to stage tours by Irish artists and companies
- Co-productions to be performed in both the Welsh & Irish INTERREG Regions.

Work Supported

- Performing Arts Touring: Drama, dance, music, opera, street-theatre, mime, and literature presentations.
- Inter-Disciplinary Arts Touring: Visual-performance art, multi-media and multi-artform performance.
- Exhibitions Touring: Exhibitions of visual arts in any media.

Grant payments – CCAT will fund up to 60% of total project costs. The applicant will be required to provide a minimum of 40% match funding.

Eligible expenditure – Touring, performance, exhibition fees, and salaries; Travel and accommodation costs; Project management, administration, marketing and publicity costs.

Eligible areas:

In Wales: Carmarthenshire, Ceredigion, Conwy, Denbighshire, Gwynedd, Isle of Anglesey, and Pembrokeshire.

In Ireland: Carlow, Dublin, Kildare, Kilkenny, Meath, South Tipperary, Waterford, Wexford, and Wicklow.

Grant allocation

The following are provided as a guide to possible grant support:

Performance Touring: £5,000 to £20,000
Venue Programme Support: £5,000 to £20,000
Touring Exhibitions: £25,000
Co-productions: £30,000 on both sides.

GO & SEE Grants

CCAT also offers 100% visit grants for those wishing to conduct project research and make useful contacts in Ireland.

Closing date: In 2005: 8th Apr, 24th Jun, and 7th Oct

D&DA

Spring House
9 Graphite Square
Vauxhall Walk
London SE11 5EE
Phone: 020 7840 1111
Fax: 020 7840 0840
Awards helpline: 020 7840 1140
Web: www.dandad.org

D&AD is a UK-based educational charity working on behalf of the international design and advertising communities. The D&AD Awards span 30 different categories encompassing all aspects of creative communications from writing and art direction to architecture, graphic design, music videos and photography.

Numerous awards within the following general categories: Moving Image & Radio / Integrated Communication, Direct Mail & Ambient Media / New Media / Print Advertising / Graphic Design, Branding & Writing / Photography, Illustration & Typography / 3D Design.

See website for details.

DAAD – German Academic Exchange Service

London Branch Office
34 Belgrave Square
London SW1X 8QB
Phone: 020 72 35 17 36
Fax: 020 72 35 96 02
Email: info@daad.org.uk
Web: http://london.daad.de

Scholarships for Artists: Study Scholarships

Objective – These study scholarships aim to provide foreign applicants from

the field of Fine Art, Design, Film, Music and Architecture with an opportunity to complete a course of extension studies, without gaining a formal degree or qualification, at a state institution of higher education in Germany.

Duration – Study scholarships are generally awarded for one academic year. In individual cases and upon application, scholarships may be extended.

The DAAD will pay a monthly scholarship of 715 plus travel and luggage costs and a health insurance allowance. In addition, the DAAD will, where appropriate, pay a rent subsidy and family allowance. Tuition fees cannot be covered by the DAAD.

As a rule, scholarships for attendance of a course of extension studies are awarded to applicants who have exhausted the training possibilities available to them in their home country and have, as far as possible, concluded these studies with an appropriate degree.

The age limit at the time of commencement of the scholarship is 32.

Applicants who will already have been in Germany for more than two years when they begin their scholarship-supported studies cannot be considered.

Study Scholarships for Graduates of All Disciplines

Objective – Study scholarships are awarded to provide foreign graduates of all disciplines with opportunities to complete a postgraduate or Master's degree course at a German higher education institution and to gain a degree in Germany (Master's/Diplom).

Duration – Depending on the length of the chosen degree course or study project, the study scholarship will be awarded for between 10 and 24 months. Initially, scholarships are awarded for one academic year and can be extended for students with good study achievements to cover the full length of the chosen degree course.

The DAAD will pay a monthly award of 715 or , in exceptional cases for applicants holding advanced academic qualifications (e.g. a doctorate/PhD), 975 plus travel and luggage costs and a health insurance allowance. In addition, the DAAD will pay a study and research allowance and, where appropriate, a rent subsidy and family allowance. Tuition fees cannot be paid by the DAAD.

Applications for DAAD study scholarships are open to excellently-qualified graduates who, at the latest when they commence their scholarship-supported studies, hold a first degree (Bachelor's, Diplom or comparable academic degree). Doctoral candidates cannot be considered for this programme. The DAAD "Research Grant" programme is available for such candidates.

Besides previous academic achievements, the most important selection criterion is a convincing presentation of the applicant's academic and personal reasons for the planned study project in Germany.

The Daiwa Anglo-Japanese Foundation

Daiwa Foundation Japan House
13/14 Cornwall Terrace
London NW1 4QP
Phone: 020 7486 4348
Fax: 020 7486 2914

Email: office@dajf.org.uk
Web: www.daiwa-foundation.org.uk

The Foundation seeks to promote links between the UK and Japan through projects of mutual interest and benefit.

Daiwa Foundation Awards support innovative and collaborative projects between British and Japanese organisations. Awards are £10,000 to £25,000.

Awards divide into three categories: Arts & Culture; Education & Society; Science & Technology. Each generally has two sub-themes which change periodically. For Arts and Culture in 2005-06, the sub-themes are:

i) Visual arts – collaboration on joint projects between British and Japanese museums, galleries and other institutions in the visual arts.

ii) Performing arts –- collaboration between British and Japanese groups or companies in the performing arts (theatre, music, dance, etc).

Daiwa Foundation Awards are open to:

- institutions and organisations
- projects that will have tangible outcomes in furthering understanding between the UK and Japan

Guidelines and application forms can be downloaded from the website.
Closing date: May for a decision by 30 September.

Danish Cultural Institute

3 Doune Terrace
Edinburgh EH3 6DY
Phone: 0131 225 7189
Fax: 0131 220 6162
Email: dci@dancult.demon.co.uk
Web: www.dancult.demon.co.uk

Artist-in-residence programme – The Institute can arrange for contacts to a variety of art studios in Denmark, where international artists are welcome to apply for artist-in-residence for shorter or longer periods. For more information contact dci@dancult.demon.co.uk

The Coscan Travel Award Scheme – This gives out minor grants to young British people between 15 and 25 years of age wishing to visit a Scandinavian country. The visit must have an educational purpose.

More information and an application form can be obtained from:
Dr. Brita Green,103 Long Ridge Lane, Nether Poppleton, York YO26 6LW.

Applications should be received by end of March.

Wyndham Deedes Memorial Travel Scholarship

The Anglo-Israel Association
PO Box 4718
London NW11 7WD
Email: info@angloisraelassociation.com
Web: www.angloisraelassociation.com

Awarded for a minumum of 6 weeks to graduates of British Universities and others with special qualifications and interests. Applicants must be of British nationality and intend normally to be resident in the UK. Value up to £2,000.

To study and report on an aspect of life in Israel (sociological, economic, etc) that would be of direct interest to those working in that field in this country.

Closing date for applications: 31st March.
For further information write enclosing a large SAE.

The English-Speaking Union Scholarships

The English-Speaking Union
Dartmouth House
37 Charles Street
London W1J 5ED
Phone: 020 7529 1550
Fax: 020 7495 6108
Email: esu@esu.org
Web: www.esu.org

The ESU Chilton Art History Scholarship

The ESU Chilton Art History Scholarship sponsors a student on a Christie's Education Course. The award is designed to help fund part of the fees for either the one year Christie's Course or for the M Litt Programme (awarded by the University of Glasgow). The options for both courses are either "Early European Art", "Fine and Decorative Arts from the Renaissance to the Present Day" or "Modern and Contemporary Art".

The successful candidate will be chosen by the normal selection procedure at Christie's Education, in conjunction with representatives from the ESU. Applicants must be fluent in both written and spoken English and must be prepared to attend interviews, at their own expense, in either London or New York. Candidates must be 35 or under at the beginning of the course in September.

Chatauqua Institution Scholarships

ESU Chautauqua Scholarships are open to all qualified teachers. The award covers the cost of attendance at the Chatauqua Institution and includes lectures, classes, board, lodging, and entertainment for up to six weeks' stay.

Chautauqua is situated on the west side of the 20-mile long Lake Chautauqua, about 80 miles south of Buffalo in Upper New York State. The Chautauqua Institution generously offers two scholarships for British teachers to study for two to six weeks at the Chautauqua Summer School.

The Summer Session, held by Syracuse University at the Institution, offers a wide variety of courses, usually in the following fields: Art (painting, ceramics and sculpture); Music Education; Literature; International Relations. The emphasis at the Summer School is markedly cultural and is of value to those teachers who have particular interests in music, art, drama or crafts.

Entente Cordiale Scholarships

Service Culturel
Ambassade de France
23 Cromwell Rd
London SW7 2EL
Phone: 020 7073 1306
Fax: 020 7073 1326
Email: entente.cordiale@ambafrance.org.uk
Web: www.francealacarte.org.uk/entente/

The Entente Cordiale Scholarships scheme was set up at the time of the 1995 Franco-British summit by Prime Minister John Major and President Jacques Chirac. The scheme is administered by the Cultural Department of the French Embassy in London and by the British Council in Paris. It is financed entirely by the private sector and by charities.

A scholarship scheme for outstanding British and French postgraduate students in the arts, humanities and sciences, who wish to carry out research for one year on the other side of the channel. It seeks to to promote contacts and increase exchanges between tomorrow's decision-makers in the United Kingdom and France and to confront preconceived ideas with the realities of life in the United Kingdom and France.

Application form available online.
Closing date: March

European Association for Jewish Culture

79 Wimpole Street
London W1G 9RY
Contact: Lena Stanley-Clamp, Director
Phone: 020 7935 8266
Fax: 020 79353252
Email: london@jewishcultureineurope.org
Web: www.jewishcultureineurope.org

The mission of the European Association for Jewish Culture is to enhance Jewish life by fostering and supporting artistic creativity and achievement, assisting scholarly research, and encouraging access to Jewish culture across Europe.

The Association is an independent body established by Alliance Israélite Universelle (AIU) and the Institute for Jewish Policy Research (JPR) to help create the conditions in which Jewish creativity in Europe can thrive.

For the Visual Arts awards are made for the following: exhibitions of painting/sculpture/photography/installations/electronic art/artists-in-residence projects/workshops/design of Jewish artifacts.

For Media and Publishing awards are made in the following areas: periodicals/development of arts websites/documentary films/ development of on-line publishing/translations of essays, short-stories and novels.

See website for guidelines and application forms.

European Cultural Foundation (ECF)

Jan van Goyenkade 5
1075 HN Amsterdam
The Netherlands
Phone: +31 20 573 38 68
Fax: +31 20 675 2231
Email: eurocult@eurocult.org
Web: www.eurocult.org

The ECF is Europe's only independent, non-national and pan-European cultural foundation.

Grant-giving in support of independent cultural projects continues to be a core commitment of the ECF. In an enlarged EU where there is a lack of accessible funding for cross border projects, they remain convinced that grants for small to medium-sized cultural organizations are an essential part of developing collaborative practice and boosting the cultural dimension of a richly diverse Europe. ECF is looking for high professional standards, genuine forms of cross-border cooperation, and European relevance. There is considerable competition, and they are unable to support every eligible project.

Projects must have relevance to one or more of the 'current areas of interest'. Grant guidelines are available on the website.

Areas of current interest include:

- Intercultural competence and collaboration across borders
- Increased participation in the arts and the media
- The cultural dimension of EU enlargement
- Strategies for change within cultural infrastructures

Closing date: 15th September 2005

The S.T.E.P. beyond mobility scheme

S.T.E.P. means 'Supporting Travel for European Projects'. Launched in February 2003, the mobility scheme encourages cross-border cultural cooperation and exchange between all European countries, including those that are not currently members of the European Union. Specifically, it offers grants to people (individuals or those representing an organization) whose travel would contribute to this goal.

Who can apply – Arts professionals, Cultural operators, Cultural journalists, Cultural translators, Cultural researchers

S.T.E.P. will not contribute towards the costs of: Participation in festivals, conferences, summer schools or training session; The showcasing of work or the staging of productions; Student or University exchange, Government officials.

There are no set dates for applications. However, the completed application must be sent eight weeks before the travel date at the latest.

The Ford Foundation

Secretary
Ford Foundation
320 East 43rd. Street
New York NY 10017

United States
Email: office-secretary@fordfound.org
Web: www.fordfound.org

The Ford Foundation works mainly by making grants or loans that build knowledge and strengthen organizations and networks. Within its broad goals, it focuses on a limited number of problem areas and program strategies.

Under the *Knowledge, Creativity and Freedom program* is included *Media, Arts and Culture*

This supports the development of media, information and technology resources to advance social change, human achievement and understanding. Grant making includes both infrastructural and access issues and independent production, with a focus on print, film, radio and Web-based media. In the arena of arts and culture, fosters new artistic talent, strengthens arts institutions, attends to cultural knowledge and resources and encourages contributions of artists and arts and culture organizations to the quality of civic life, assists projects that advance understanding of cultural identity and community.

Before a request is made for a grant or program related investment, a brief letter of inquiry is advisable to determine whether the foundation's present interests and funds permit consideration of the request.

Most grant funds are given to organizations. Although it also makes grants to individuals, they are few in number relative to demand and are limited to research, training and other activities related to its program interests. Most grants to individuals are awarded either through publicly announced competitions or on the basis of nominations from universities and other non-profit institutions. In all cases, recipients are selected on the merits of their proposals and on their potential contribution to advancing the foundation's program objectives.

Applications are considered throughout the year.

Foundation for Sport and the Arts

P.O. Box 20
Liverpool L13 1HB
Phone: 0151 259 5505
Fax: 0151 230 0664
No current website

Set up by the football pools promoters, this body has around £60 million annually to donate to sports and arts organisations. Grants have been given to a wide range of projects. The overarching aim is to assist the creation or to maintain facilities and opportunities for the general community or to assist arts or sports provision that the community can enjoy. Grants are available for a wide variety of arts purposes e.g. museums, arts projects, drama centres, as well as individuals.

Community groups and organisations are eligible. Funding is available for Capital & Revenue projects. Grant up to £75,000. The Foundation is also open to requests for loans over a maximum of five years.

Information, including details of the criteria for the allocation of funds, is available from the address above.

The Gen Foundation

45 Old Bond Street
London W1S 4DN
Tel: 020 7495 5564
Fax: 020 7495 4450
Email: info@genfoundation.org.uk
Web: www.genfoundation.org.uk

The Gen Foundation is a charitable trust providing substantial scholarships and grants to students and scholars from a broad cross-section of fields. The Foundation aims to further academic research in both the humanities and natural science by awarding grants to candidates from a variety of disciplines. In recognition of the importance of cross-cultural exchange in today's global society, it also aims to deepen understanding between Japan and the rest of the world. Candidates from the following disciplines are invited to apply: modern languages, music, art, natural science.

The trustees of the Foundation make a preliminary selection of candidates on the basis of submitted application forms. The trustees then conduct interviews of candidates whose applications have passed this initial screening process.

Scholarships are awarded annually to candidates mainly from the United Kingdom and Japan, although applicants of all nationalities will be considered. At the end of their studies, all successful applicants will be required to submit a report to the Trustees.

Gen Foundation scholarships are one-off, non-renewable grants in the region of approximately £3,000.

Application: Download from website.
Closing date: end of March.

The Getty Foundation

1200 Getty Center Drive, Suite 800
Los Angeles, CA 90049-1685
United States
Phone: Grants: +1 310 440 7320
Fax: Grants: +1 310 440 7703
Web: www.getty.edu

The Getty Foundation provides support to institutions and individuals throughout the world, funding a diverse range of projects that promote the understanding and conservation of the visual arts. The grant-making foundation furthers the work of all Getty Programs.

Through core program areas and special initiatives, grants support a diverse range of projects all over the world that strengthen the understanding and preservation of the visual arts.

Research Grants for Scholars

The Getty provides non-residential grants to support scholars throughout the world, as well as residential fellowships at the Getty Center. Grants support scholarship in the history of the visual arts and related fields, and do not offer support for art production or studio practice.

Research Grants for Institutions

The Getty fund educational and cultural institutions, including museums, libraries, and universities, to develop a variety of basic scholarly resources, as well as publication series.

They are particularly interested in funding model projects that make significant scholarly resources available via electronic means.

Closing date: November.

Internships

The Getty offers graduate internships as well as multicultural undergraduate internships at the Getty Center. In addition, the Getty supports multicultural internships at Los Angeles area museums and visual arts organizations.

Application procedures and deadlines vary by grant category. Detailed information and application materials are available on the website.

Great Britain Sasakawa Foundation

Dilke House
1 Malet Street
London WC1E 7JN
Phone: 020 7436 9042
Email: grants@gbsf.org.uk
Web: www.gbsf.org.uk

The Foundation's aim is to develop good relations between the United Kingdom and Japan by advancing the education of the people of both nations in each other's culture, society and achievements. It seeks to promote mutual understanding and cooperation through financial support for activities in various fields which include Arts & Culture. The Foundation's awards are intended to provide "pump-priming" and not core funding of projects. Because of the high demand for grants in the arts, Trustees look for innovative aspects, high quality and broad impact from any project in this field.

The Foundation grants awards each year to a total value of about £350,000. Because of the level of demand, most awards are quite small, the average being around £1,500. There are no set budgets for any category of activity, but emphasis is placed on projects involving groups of people in both countries (especially young people) rather than individuals.

Applications are not normally accepted from individuals seeking support for personal projects. However, an organisation may apply for a grant in support of the work of an individual which advances the aims of the Foundation, and an application from an individual may be considered if there is clear evidence of organisational support. Only UK and Japanese citizens are eligible.

In assessing applications for awards, the Trustees will take into account any unique or innovative aspects of the project and the extent to which it will have a wide and lasting impact.

Application: There is a strong preference for emailed applications.

Trustees decide awards at meetings in London and Tokyo two or three times a year.

Closing date: Awards Meetings are normally held in London in February, May and October. The closing dates are the end of December, March and August.

Calouste Gulbenkian Foundation

98 Portland Place
London W1B 1ET
Phone: 020 7636 5313
Fax: 020 7908 7580
Email: info@gulbenkian.org.uk
Web: www.gulbenkian.org.uk

The UK branch of the Foundation supports funding programmes in Arts, Social Welfare and Education, and Anglo-Portuguese Cultural Realtions.

The Arts programme is principally for professional arts organisations or individual professional artists working in partnership or groups. Its purpose is to support the development of new art-making in any form.

Research and development. Its fundamental aim is to provide early-stage support for experimemtal research and development activities for realisable professional arts projects. They are particularly interested in fostering unconventional and unusual ideas. Projects in which artists engage with science come within the scope of this programme. Individual projects are likely to attract grants up to £5,000.

Non-professional Arts Projects. Grants are available to groups of non-professional participants outside the formal education and community sectors for the research and development of unusual experimental projects.

Anglo-Portuguese Cultural Relations. This programme aims to help projects that promote contemporary Portuguese culture in the UK and Republic of Ireland. This includes activities in the arts, crafts and education.

Check website for current priorities. Leaflet on 'advice to applicants for grants' can be requested by emailing info@gulbenjian.org.uk or can be downloaded from wcbsite.

Proposals are considered at three Trustee meetings a year, usually held in the first week of March, July and November. Initial proposals need to be submitted at least 10 weeks in advance.

The Gunk Foundation: Grants For Public Art Projects

P.O. Box 333
Gardiner
New York NY 12525
United States
Contact: Nadine Lemmon, Grants Coordinator
Phone: +1 845 255 8252
Email: info@gunk.org
Web: www.gunk.org

The Grants for Public Art Projects intend to challenge the current market-dominated system of art production and to move art out of the market and into the 'public realm'. It is interested in supporting projects that make it out of the museum, gallery, and alternative spaces and into the spaces of daily life. They are looking for non-traditional, thought-provoking public work that is site specific: i.e. the context in which it is seen is essential to its meaning.

Types of Projects Funded

Grants are provided for 'works' of art (not, for example, art festivals, or group

exhibitions). Because of limited funds and the need to stay focused, the committee has decided not to fund art education, art therapy, mural projects, community gardens, restoration projects, architectural design projects, traditional commemorative sculpture/painting, traditional theater projects or documentary film. In addition, it does not fund video, film, or music.

Eligibility: Any one can apply – individuals, groups, or organizations. International projects and artists are encouraged.

See website for further information on selection criteria. Artists and organizations should look at the foundation's guidelines, at the previous works funded, and contact people at the foundation to determine whether it is appropriate to apply.

The Grant Committee is interested in seeking out unestablished artists as well as established artists but the participants need to show competence in their field of expertise.

Each deadline approximately 200 applications are received and on average 6 grants awarded. The average grant is $1,000; the maximum $5,000.

Closing date: 30 April

The Paul Hamlyn Foundation

18 Queen Anne's Gate
London SW1H 9AA
Phone: 020 7227 3500
Fax: 020 7222 0601
Email: information@phf.org.uk
Web: www.phf.org.uk

The Foundation was established in 1987 by Paul Hamlyn, the publisher and philanthropist who died in 2001. His overriding concern was to address issues of inequality and disadvantage, particularly in relation to young people, and this is the focus of the Foundation's grant giving programmes. Support is concentrated on projects in the UK which address these issues through the arts and education.

Increasing Access to the Arts

The Foundation is interested in supporting initiatives in all parts of the UK which address inequality of access and lack of opportunity to experience and enjoy the arts, particularly for young people. Priority is given to exemplary projects concerned with social inclusion and under achievement amongst young people, including those 'at risk', and young offenders.

Arts and Learning. The priorities are:

- Imaginative partnerships between schools, arts organisations and other agencies which aim to develop the arts within formal education.
- Schemes which give teachers access to best practice in the performing and creative arts, thereby enhancing their own professional development and their pupils' or students' learning experience.
- Informal educational experiences for children who are not currently well served.

Awards for Artists

A Foundation Award for individual artists was launched in 1993. The award is

currently for visual artists, with a strong emphasis on experiment, innovation and cross arts collaboration. Each year twenty nominators put forward names of artists who live or work in the UK and five awards are made by a panel of independent judges.

The Foundation does not make grants for the following: Capital projects/ Support for individuals, except where the Foundation has established a special scheme/Performances, production costs, exhibitions, resource packs and publications.

Applications for sums of £5,000 or less are handled by a Small Grants Committee which meets monthly, except August and December. Grants will be made for one year only and applications in consecutive years from the same organisation will not normally be considered. A second Grants Committee, which meets four times a year, deals with applications for sums from £5,000 to £30,000. Applications for sums above £30,000 will be considered at the quarterly Trustees Meetings. These usually take place in February, May, September and November.

Guidance Notes and Project Details Form can be downloaded from the website. The Foundation is happy to receive exploratory phone calls or letters in the first instance before you consider making a formal application.

Japan Foundation

London Office
Russell Square House
10-12 Russell Square
London WC1B 5EH
Phone: 020 7436 6695
Fax: 020 7323 4888
Web: www.jpf.org.uk

The Japan Foundation is Japan's principal agent for cultural relations between Japan and overseas countries and exists to promote a wider knowledge of Japan abroad and to promote mutual understanding between nations.

Local Project Support Programme

The Japan Foundation London office holds a small budget for assistance towards activities and projects that help to promote a greater awareness of Japan, its arts, language and culture in the UK. It is designed to support onshore costs only i.e. hire of venue, honoraria, publicity, domestic transport and accommodation costs, but not costs within Japan or international airfares.

Demand on the budget is high and the amount allocated to each project is normally no more than £1,000.

What kind of project/event is eligible? Non profit-making projects/events that help to promote a greater awareness of Japan, its arts, language and culture in the U.K. They can be in the arts (e.g. exhibition, performing arts), or can be projects in the humanities, social sciences or in Japanese studies (e.g. a lecture, an academic research project), as long as the content is wholly or for the most part related to Japan.

Completed applications need to be submitted to the London office at least two months before the commencement of the project.

Fellowship Programme

The Fellowship Programme gives the opportunity to academics and professionals in Japanese studies to visit Japan to pursue research in their field. As a rule, a named affiliate in Japan is required at the time of application. The Fellowship comprises airfare, stipend to cover living expenses and other allowances. There are three categories within the Programme. See website for further details.

Peter Kirk Travel Scholarships

Email: mail@kirkfund.org.uk
Web: www.kirkfund.org.uk

Ten to twelve Scholarships each worth up to £1,500 are offered annually. Special conditions are attached to two of the scholarships.

The award money is to undertake research into an aspect of modern European life in a European country or countries other than your own. It is not intended to cover all expenses.

The Scholarships are open to British nationals, and those of any other European country, aged 18 – 27 at the time of the project. Participants would normally be expected to visit another country or countries for between 6 weeks and 3 months. A written report is required within four months of return from fieldwork.

Peter Kirk Scholarships are awarded for independent study projects. Scholarships cannot be used to pay for course work which is required as part of an academic qualification but applicants sometimes find it possible to undertake an independent project alongside studies abroad.

Closing date: February.

Frank Knox Memorial Fellowships

3 Birdcage Walk
Westminster
London SW1H 9JJ
Phone: 020 7222 1151
Fax: 020 7222 7189
Web: www.frankknox.harvard.edu

Up to six Frank Knox Memorial Fellowships will be awarded to students from the United Kingdom for graduate study at Harvard University.

Fellowships are open to men and women who:

- are British citizens at the time of application and who are normally resident in the United Kingdom;
- have studied or are studying for a first or higher degree and have spent at least two of the last four years at a U.K. University or University College at the time of application.

Application: Refer to website for guidelines and application details.
Closing date: Last week in October, annually.

Korea Foundation

Intellectual Exchange
10th Foor, Diplomatic Center Building
1376-1, Seocho 2-dong, Seocho-gu
Seoul 137-072
Korea
Phone: +82 23463 5613
Fax: +82 23463 6075
Email: intellectual@kf.or.kr
Web: www.kofo.or.kr

The Korea Foundation is an independent organisation affiliated with the Ministry of Foreign Affairs and supported by public funding and private donations. It was established with the aim of enhancing Korea's image and reputation in the world through the promotion of various academic and cultural exchange programmes.

The Intellectual Exchange Programme – distinguished individuals from social, cultural, and academic circles are invited to visit Korea to broaden their understanding of the country and its people. Guests are given the opportunity to visit relevant organisations and take part in academic and cultural events.

Eligibility: Scholars of international distinction and distinguished individuals from abroad in the areas of politics, economy, and society.

The programme funds round-trip airfare and hotel accommodation.

Application: Application must be made under recommendation by Korean missions abroad and domestic organizations.

The Daniel Langlois Foundation for Art, Science, and Technology

3530 Saint-Laurent Blvd., suite 402
Montréal
Québec H2X 2V1
Canada
Phone: +1 514 987 7177
Fax: +1 514 987 7492
Contact: Angela Plohman, Program Officer
Email: aplohman@fondation-langlois.org
Web: www.fondation-langlois.org

The Foundation is not currently accepting grant applications. A moratorium has been placed on its two main programmes. Check website for updates.

Leverhulme Trust

1 Pemberton Row
London EC4A 3BG
Phone: 020 7822 5220
Fax: 020 7822 5084
Email: see website
Web: www.leverhulme.org.uk

The trust makes awards for the support of research and education. It emphasises individuals and encompasses all subject areas. The Trust's financial support is organised into grants and awards which vary in size, purpose and application procedure. See website for full details where guidelines and application forms can be downloaded.

Academic Collaboration: International Networks

Support is given both to encourage the formation of international networks and to permit the visit of individual scholars to the UK. The Aim is to foster and develop fields of research where the participants can benefit from an international exchange of ideas and of experience between two or more institutions. It is expected that the outcome of a grant will be the creation or development of an effective research network.

Artists in Residence

The scheme is intended to support the residency of an artist of any kind at an institution of higher education or a museum in the UK.

Visual artists, creative writers, poets, and other producers of original creative work are eligible. The intention is that the artist should work within a closely-knit group of people in order to produce measurable and recognisable benefits; therefore a small institution, or a department or distinct centre of a larger institution, would be particularly suitable. The scheme is intended particularly to bring artists into research or study environments where creative or performing arts are not a part of the normal curriculum or activities of the host group. The Trust wishes to promote cross-disciplinary interactions by bringing artists into science environments or vice versa.

The application should be made by the host institution acting in full consultation with the artist.

Early Career Fellowships

To provide career development opportunities for those with a proven record of research who do not hold, or have not held a full-time established academic post in a UK university or comparable institution in the UK. Approximately 30 Fellowships offered in 2005.

Eligible Applicants – should be or have recently been a member of the UK academic community and intend to remain so.

Fellowships can be held at universities or at other higher education institutions in the UK.

Eligible fields – all fields.

Major Research Fellowships in the Humanities and Social Sciences

Up to 25 Major Research Fellowships are offered in UK Universities, designed to enable researchers to devote themselves to a project of outstanding originality and significance.

Eligible Applicants – Candidates holding an established post at a UK university who have held a post in the UK for at least the past five years.

Eligible fields – All fields in the humanities and social sciences.

Research Fellowships

Approximately 100 awards offered in 2005. Aims to support experienced researchers, particularly those who are or have been prevented by routine duties from completing a programme of original research. Awards are not limited to those holding appointments in higher education.

Eligible Applicants – Resident in the UK, should normally be age 30 or over.

Eligible fields – All fields.

Study Abroad Fellowships

Study Abroad Fellowships support a period overseas in a stimulating academic environment. These differ from Research Fellowships in that the awards support a range of activities other than straight-forward research (e.g. the exchange of ideas or the development of new lines of research and collaboration).

Eligible applicants – Must be resident in the UK and be aged 30 or over. Should have held an established full-time post in a UK institution of higher education, or in a museum, art gallery or comparable institution for at least five years.

Eligible fields – All fields.

Study Abroad Studentships

This scheme supports post-graduate-level and post-doctoral-level scholars. Aims to support an extended period of advanced study or research at a centre of learning overseas (except the USA). Approximately 20 awards are offered annually.

Eligible Applicants – should have been resident in the UK for at least 5 years and hold an undergraduate degree from a UK institution; should be aged under 30 or, if older, make a strong and appropriate case for special consideration; should be able to demonstrate why their work requires residence overseas.

Eligible Fields – All fields

Training and Professional Development

Formerly known as Education Grants, awards are made to offer support for education, mainly in the form of bursaries or scholarships and most frequently in the fine and performing arts.

Aim – To permit talented individuals to obtain training or professional development in the performing and fine arts, support is offered in the form of bursaries or scholarships designed to be used for the maintenance of students. Grants are made to institutions, and the award of a bursary is at the discretion of those institutions. All applications must come from the host institution, clearly indicating the envisaged programme of support; applications from individual students are NOT eligible.

Eligible Fields – Most grants offered are in the fine arts or performing arts.

Visiting Fellowships

The Trustees are offering Visiting Fellowships to a number of UK universities to enable them to invite one or two visitors to the UK for the purpose of research and collaboration. Eligible Universities are defined on a rota.

Visiting Professorships

These awards enable UK universities to host an internationally distinguished academic from overseas (chosen and invited by the host institution) in order to enhance the research skills and work of the host institution.

Hilda Martindale Awards

The Secretary
Hilda Martindale Educational Trust
c/o The Registry
Royal Holloway and Bedford New College
University of London
Egham TW20 0EX
Phone: 01784 434455

These annual awards (£250–£1,000) are for women seeking to fund full time vocational courses (of up to a year) where public funds are not available.

Paddy Masefield Award

art+power
St Werburghs Community Centre
Horley Road
Bristol BS2 9TJ
Phone: 0117 9089859
Fax: 0117 9089861
Minicom: 0117 9089860
Email: info@artandpower.com
Web: www.artandpower.com

art+power has joined forces with Equata (regional Disability Arts Forum for the South West of England) to establish the Paddy Masefield Award for visual artists with learning difficulties. The award will celebrate the life and contribution to the arts of Paddy Masefield OBE, playwright, theatre director and Disability Arts activist. Artists from art+power are helping to run the award scheme to support and promote the work of other disabled artists.

The new award will offer a cash prize of £1,000. art+power will assist the winning artist in deciding how to best use the prize money. The award will be made annually for the next 5 to 10 years to Learning Disabled Artists (in the first phase) for 2 dimensional works of art.

Apply for application pack by phone, fax or email.

Francis Mathews Travelling Scholarship

Educational Charity of the Stationers & Newspaper Makers Company
The Old Dairy
Adstockfields
Adstock MK18 2JE
Contact: Mr Paul Thornton, Secretary
Phone: 01296 714886
Fax: 01296 714711
Web: www.stationers.org

In addition to the major awards, the Stationers & Newspaper Makers Company Educational Charity (SNMCEC) administer specific Travelling Awards. These aim to enable winners to travel to gain experience and further their knowledge of the Printing, Bookbinding, Paper Conservation, Stationery, Papermaking, (journalistic) Photography, Publishing, Bookselling or Newspaper Production

industries at home and abroad. Awards are normally for £750.

Open to: Applicants must be aged 18-35, of British Nationality and be either employed in, or are intending to make a career in, these industries.

Application: Send for application form.
Closing date: November

James Milne Memorial Trust

Scottish Trade Union Congress
Middleton House
333 Woodlands Road
Glasgow G3 6NG
Phone: 0141 337 8100
Fax: 0141 337 8101

Open to young Scots aged 26 and under of outstanding talent, based in Scotland and able to extend their skills by a period of study out of the UK.

Priorities under review.

Multi Exposure, British-Israeli-Palestinian Awards

PO Box 2935
London NW1 8LF
Fax: 020 7722 5243
Contact: Caroline Molloy, Administrator
Email: info@multi-exposure.com
Web: www.multi-exposure.com

Multi-Exposure promotes and funds artists from British, Palestinian and Israeli communities. Invited artists are given the opportunity to travel and work in each other's countries and to produce a personal project. Works created are presented to a wide public through publications, exhibitions and on the internet.

Multi-Exposure is an independent non-aligned foundation run by British, Palestinian and Israeli artists interested in promoting artistic exchange.

N.E.S.T.A.

The National Endowment for Science, Technology and the Arts
Fishmongers' Chambers
110 Upper Thames Street
London EC4B 4AQ
Phone: 020 7645 9638
Fax: 020 7646 9501
Email: nesta@nesta.org.uk
Web: www.nesta.org.uk

NESTA runs a range of pioneering programmes, some of which are outlined below. We recommend that you visit their website.

Invention and Innovation Programme

NESTA's Invention and Innovation programme aims to turn ground-breaking ideas into innovative products, services or techniques with commercial or social potential. Through the programme, NESTA is the UK's biggest single source of early-stage seed funding, enabling the development of projects that might otherwise not get off the ground. They also prepare promising projects for further investment elsewhere.

Funding is flexible because different projects have different needs. Support is not just financial and can include access to professional support and expertise from carefully selected mentors. This can make a significant difference in turning a great idea into a successful one. In return for the investment and support, they take a stake in any future commercial success of the invention, and any financial returns made are invested back into new ideas.

The programme is open access and accepts proposals via the NESTA website only. The programme is extremely competitive, receiving more than 1000 proposals a year and investing in around 50 of them. Most projects receive between £30,000 and £85,000. The process involves a preliminary filter via the website which is independently assessed, then an invitation to submit a full proposal. For further information see the guidance notes on website.

Learning Programme

Illuminate. A new scheme which is an award for museums, galleries, science and discovery centres to encourage them to breathe new life into existing collections and exhibitions.

Between autumn 2004 and spring 2006, awards totaling £1 million will be made to support new approaches to existing collections and displays. Funding from £2K up to £80K, or £120K for organisations working in partnership.

Fellowship programme

The Fellowship programme gives creative and innovative individuals who have demonstrated exceptional talent and originality, the time, space, resources and support to develop their ideas, pursue their goals, experiment, and push at the boundaries of knowledge and practice.

Awardees come from all branches of the sciences, arts and technology.
Awards of up to £75,000 and can last up to five years.

Potential awardees are brought to the attention of NESTA through a number of different routes, primarily a UK-wide network of nominators.

Dream Time Fellowships

Open application award which is up to a year in length and to a maximum value of £40,000. Aimed at exceptional achievers with at least ten years experience in their field who wish to take structured time away from their work to pursue ideas and activities which will benefit both themselves and their sector. *Dream Time* is open to individuals working in any area of technology/engineering, science or the arts. NESTA are keen to receive applications from those who are working across disciplines or who wish to make interesting connections between significantly different fields.

Applications are submitted via the website. More details and application pack from http://www.nesta.org.uk/dreamtime.

Ignite!

A new initiative from the Fellowship programme. It aims to stimulate creativity in young people and thereby understand the triggers and barriers to a young person's creativity. See website for further information.

Creative Pioneer Programme

NESTA's Creative Pioneer Programme is a funding initiative designed to encourage the growth of a new generation of creative entrepreneurs.

The programme offers an opportunity for personal and professional development. Individuals who are at the early stages of their career, typically up to three years after graduation, can apply for places at the Academy. At this residential course they receive personal coaching alongside intensive, experiential training in business practice. Teaching takes place in an atmosphere of challenge and enquiry where Pioneers, as the students are known, are encouraged to view establishing a business as a creative project in its own right.

To complete the Academy programme, Pioneers develop a full business proposition, which they can submit for a Pioneer Award in the form of up to £35,000 in start up finance. Long-term support is also provided, in the form of a mentoring programme and an ongoing schedule of professional development activities, which are available to all pioneers.

Creative Pioneers are individuals with outstanding talent and a vision for the future. They are highly self-motivated and possess a willingness to learn and the ability to both spot and seize opportunities. They are people with imagination, who are keen to think laterally about how art and design can enhance quality of life.

To be eligible for the Academy, applicants need to have an original business idea, something genuinely new and innovative. That could be a new product, a new process, or an alternative application for an existing product or service.

Applications for the next session at the Academy will be open from Spring until early Autumn 2005. For full information on the Creative Pioneer Programme, and application materials got to www.nesta.org.uk/theacademy

The Nordic Culture Fund

Nordisk Kulturfond
Store Strandstræde 18
DK-1255 Copenhagen
Denmark
Phone: + 45 33 96 02 00
Email: kulturfonden@norden.org
Web: www.nordiskkulturfond.org

The Nordic Culture Fund is a Nordic body of cooperation whose task is to support cultural cooperation in the broad sense between the Nordic countries.

The Fund awards about 25 million Danish kroner (DKK) every year to cultural projects in the Nordic Region or Nordic projects outside the Nordic Region.

Projects widely reflect the entire cultural life, and includes everything from art, theatre, music and dance to literature, song and new media. Education, research and transsectorial projects are also included, but must have a clear connection with culture.

Projects must include at least three Nordic countries or autonomous areas (the Faroe Islands, Greenland and the Aland Islands).

The fund subsidises:

- one-off projects

- projects that involve profiling the Nordic Region internationally through broad Nordic participation
- non-Nordic initiatives that have Nordic scope and benefit the Nordic Region
- public relations concerning Nordic cultural cooperation and the cultural life of the Nordic countries
- individuals whose projects involve at least three Nordic countries
- only projects that are completed within two calendar years

Alexander S. Onassis Foundation

Foreigners' Fellowship Programme
Secretariat
7 Aeschinou Street
105 58 Plaka, Athens
Greece
Fax: +30 210 3713013
Email: foreigners@onassis.gr
Web: www.onassis.gr.

The Foundation runs an annual programme of research grants and educational scholarships which is addressed to non Greeks, full Members of National Academies, University Professors of all levels (Ph.D. holders), postdoctoral researchers (Ph.D. holders), artists, translators of Greek literature, elementary and secondary school teachers of Greek as a forein language, post-graduate students and Ph.D. candidates.

The Programme covers six fields which include:

- Human Sciences: including Literature and Translation
- Arts: Visual Arts, Music, Dance, Theatre, Photography, Film Studies

Research Grants for University Full Professors
Number of grants: Ten. Duration: One month during the academic year.

Research Grant – University Faculty all levels, Post Doctoral Researchers, Artists-Musicians, Translators.
Number of grants: Fifteen. Duration: From three to six months.

Educational Scholarships. Postgraduate Stuents and Ph.D. candidates.
Number of scholarships: Seventeen. Duration: From five to ten months.

See website for full details
Closing date: 31 January for the following academic year.

The Pearl Awards

EMF House
12 Charlotte Street
Manchester M1 4FL
Phone: 0161 245 3251 / 3252
Fax : 0161 245 3325
Email: enquiries@thepearlfoundation.org.uk
Web: www.thepearlfoundation.org.uk

The Pearl Awards recognise and celebrate Chinese achievements in multi-cultural Britain. The intentions of The Pearl Awards are:

- to recognise the achievements of individuals and organisations of Chinese origins for their work towards raising the profile, creating positive images and awareness of the Chinese community in multi-cultural Britain, and
- to recognise the work and achievements of other individuals and organisations who have unselfishly assisted the Chinese community in all areas of development.

Awards are made in nine categories which include:

Pearl Award for Creative Endeavour – Recognising achievements in the visual and performing arts.

Pearl Award for Media Excellence – Recognising achievements in film, broadcasting, new media and publishing.

Pearl Award for Services to the Community – Recognising projects and/or work by voluntary, non-profit individuals or organisations that have benefited the Chinese community.

Pearl Award for Most Promising Newcomer

The Pearl Awards are made by nomination but individuals may also enter themselves as long as they meet the criteria. See website for futher details.

Prince's Trust

Head Office
18 Park Square East
London NW1 4LH
Phone: 020 7543 1234
Fax: 020 7543 1200
Web: www.princes-trust.org.uk
Details of regional ofices available on website.

Business start up

Eligibility criteria: aged 18-30, UK resident, unemployed, have an idea for a business but can't get the funding you need from other sources. The Trust can provide:

- a low interest loan of up to £4,000 for a sole trader, or up to £5,000 for a partnership (the average loan is between £2,000 and £3,000 but varies regionally)
- a grant of up to £1,500 in special circumstances
- a test marketing grant of up to £250
- ongoing business support and specialist advice such as a free Legal Helpline.
- ongoing advice from a volunteer business mentor
- access to a wide range of products and services, free or at discounts

There is an online enquiry form and applications can be downloaded.

Grants for education, training or work

Grants from £50 to £500 to help gain access to education, training or

employment as well as volunteer support to help set goals, make decisions and find other programmes or support. 14 – 25 year olds.

Royal Overseas League Travel Scholarship

ROSL ARTS
Over-Seas House
Park Place
St James's Street
London SW1A 1LR
Phone: 020 7408 0214 x324
Fax: 07499 6738
Email: culture@rosl.org.uk
Web: www.roslarts.co.uk

ROSL Arts offers five Travel Scholarships each year for artists selected from five different Commonwealth countries (or former Commonwealth countries), one each from Africa, the Americas, Asia, Australasia and Europe. Selected artists receive a travel scholarship to make a study visit to a country other than their country of origin, and participate in the ROSL Annual Exhibition at Over-Seas House, London, and Over-Seas House, Edinburgh. Countries and regions change each year.

ROSL Arts offers one scholarship for the UK.

- £3,000 for an artist from the UK to spend a minimum of four weeks in a Commonwealth country or countries of their choice between July and June the folllowing year.
- Scholarship should cover: return airfares from UK, accommodation and living expenses.
- Eligibility: citizens of the UK up to and including the age of 35 and currently living in the UK
- Media: ROSL Arts will consider work in any medium
- the work resulting from the scholarship will be exhibited in a central London venue alongside work by the overseas scholarship winners.

See website for application details.
Closing date: end of March.

Royal Netherlands Embassy – Postgraduate Scholarships

Royal Netherlands Embassy
38 Hyde Park Gate
London SW7 5DP
Phone: 020 7590 3200
Fax: 020 7581 0053
Web: www.netherlands-embassy.org.uk

Each academic year the Netherlands Ministry of Education and Culture issues scholarships. Candidates must be British and under the age of 36. Those who apply should have obtained their Bachelor's degree no longer than two years prior to the application. Candidates must explain why they have chosen to study in the Netherlands and indicate that the specific study course does not

exist in another country. Scholarships are given for 3-10 months, include a monthly allowance, health insurance, travel expenses and tuition fees.

Application forms available in October each year.
Closing date: February

Society of Wildlife Artists

Society of Wildlife Artists
Federation of British Artists
17 Carlton House Terrace
London SW1Y 5BD
Contact: The Secretary
Web: www.swla.co.uk

The Society of Wildlife Artists offers two bursaries:

Wetlands for Life

An award of up to £500, sponsored by the Wildfowl and Wetlands Trust, will be given to an artist applying to pursue a piece or a body of work that reveals a true understanding of the biodiversity and conservation issues affecting UK or international wetland habitats. The results should also reflect the artist's imagination and ability to express originality and genuine creativity in their work. The work can be in any medium, and be either 2 or 3 dimensional.

The body or piece of work resulting from the bursary must be able to travel to WWT wetland centres across the UK for display and educational purposes for one year following its showing at the annual SWLA exhibition.

One award each year will be made.
Age limit: 20yrs+ (no upper age limit)

SWLA Bursaries

Five awards of up to £500 each for young artists aged 15 to 30 to enable them to develop their skills through mounting a special project, travel or education.

In the last ten years SWLA bursaries have supported projects as varied as a young artist travelling to the rain forests of Colombia to record wildlife as part of a broader university research programme, to a young Japanese artist researching Ukiyou style printing and its use in describing wildlife.

The St. Hugh's Foundation

The Administrator
The St. Hugh's Foundation
Andrew & Co, Solicitors
St. Swithin's Square
Lincoln LN2 1HB
Email: sthughesfoundation@lineone.net
Web: www.interactive.humber.ac.uk/website/st.hughes/frames.htm

The Foundation's policy is to encourage research and development in the arts, through enabling applicants from Lincolnshire and the former Humberside to make their own impact regionally, nationally or internationally through new work in any of the art forms.

A series of award schemes have been offered annually since 1992. To date grants awarded under these schemes have amounted to some £195,000.

These are reviewed from time to time, and a specific Awards Programme is publicised each year.

The St. Hugh's Fellowship

The fellowship has carried an award of up to £10,000. It helps established artists, from any field of the arts, to develop their careers, and to contribute to wider knowledge of arts practice in the region. Applicants must be resident and working in the region, and over the age of 30 years.

The Henrietta Bowder Memorial Bursary

The Memorial Busary is an international travel award for young professional arts workers under the age of 30, from any field of the arts, and the same residence qualifications apply. It is not available for students in full-time education. The Bursary has been £2,000.

Stiftung Kunstlerdorf

Schoppingen Foundation
Feuerstiege 6
48620 Schoppingen
Germany
Phone: +25 55 938 10
Email: kuenstlerdorf@tzs.de
Web: www.kuenstlersorf.tzs.de

The Kunstlerdorf Schoppingen is a foundation that has scholarships for artists and writers for a maximum of 6 months. There are 24 scholarships in total.

Application documents should include the following:
For writers – a CV, 20 pages of an unpublished manuscript.
For artists – a CV, Exhibition list, catalogues (not more than 3), Folder including not more than 25 photos or slides of the objects (no originals).

Closing date: January.

The Sir Richard Stapley Educational Trust

The Administrator
North Street Farmhouse
Sheldwich
Nr. Faversham
Kent ME13 OLN
Email: admin@stapleytrust.org
Website: www.stapleytrust.org

The Trust was established in 1919 and has been a Registered Charity since 1974. Its objectives are to provide financial assistance to graduates with a First or Upper Second class degree, over the age of 24, who register for a higher degree or equivalent academic qualification in any subject at a UK university.

Grants normally £300–£1,000. Awards are competitive and made on the basis of academic merit and financial need. All grants are awarded for a full year of

academic study and for one year only. Applicants for full time postgraduate degree courses may be supported up to a maximum of three years but new applications have to be submitted each year.

Application: Enquire by post initially enclosing SAE.
Closing date: end of February.

Stationers And Newspaper Makers' Educational Charity

The Old Dairy
Adstockfields
Adstock MK18 2JE
Contact: Mr Thornton, Secretary
Phone: 01296 714886
Fax: 01296 714711
Web: www.stationers.org

Awards are offered by The Educational Charity of the Stationers' and Newspaper Makers' Company to young persons engaged in printing and allied trades, bookbinding and paper conservation, stationery, papermaking, publishing, book selling and newspaper production. Previous awards have averaged £2,000.

The Awards are open to UK residents engaged in the occupations associated with the Stationers' and Newspaper Makers' Company's industries as listed above.

The object is to enable young persons to develop their careers by extending their knowledge in the areas of management and technology in a way that would not be possible unless these awards were available.

Open to: UK residents under the age of 25.
Application: Request application form.
Closing date: usually November.

Thouron Awards

The Registrar
Thouron Awards
University of Glasgow
Glasgow G12 8QQ
Contact: Deborah Maddern
Phone: 0141 330 5853
Email: D.Maddern@admin.gla.ac.uk
Web: www.gla.ac.uk/Otherdepts/Court/thouronawards.html

The Thouron-University of Pennsylvania Fund for British-American Student Exchange exists for the promotion of better understanding and closer friendship between the people of the United Kingdom and the United States of America. This academic exchange and experience in international friendship was conceived by and is supported by gifts from Sir John Thouron and the late Esther du Pont, Lady Thouron, of Unionville, Pennsylvania.

The Thouron Award provides support for British recipients to attend any of the graduate and professional schools of the University of Pennsylvania.

Candidates must be British citizens, normally resident in the UK who have followed a regular school education in the UK. They must be qualified to pursue a postgraduate course of study at the University of Pennsylvania. Applications for courses and programmes at the University of Pennsylvania are made separately from applications for Thouron Awards.

A Thouron Award covers tuition fees plus a living allowance/travel stipend. Awards are granted for one or two years depending on the time required to earn a particular degree. The second year of funding is dependent on reports of satisfactory progress after the first year.

Closing date: October annually.

UNESCO-Aschberg Bursaries for Artists Programme

UNESCO
Bourses pour artistes UNESCO-Aschberg
Fonds international pour la promotion de la culture (FIPC)
1, rue Miollis
75732 Paris Cedex 15
France
Email: dir.aschberg@unesco.org
Web: www.unesco.org/culture/aschberg

The UNESCO-Aschberg Bursaries for Artists programme was established in 1994 to open new career prospects to young artists and provide them with the possibility for further training in specialised institutions. Since its creation, hundreds of young artists have benefited. For 2005/06, the programme offers 62 fellowships through 50 partner institutions in 30 countries.

The fellowships are co-financed by the International Fund for the Promotion of Culture (IFPC) and an international network of partner institutions specialised in the training of artists.

Guidelines and application details are available on the website. In general however a letter of application must explain in no more than two pages the reasons why you wish to participate in a chosen residency or training programme. You need to be accurate in describing your objectives, needs and expectations in relation to the residency.

Artistic documentation should be enclosed which will vary according to the discipline and the requirements of each institution. It can consist of :

Visual arts: a sample of photographs, mounted slides or CD-ROM.
Creative writing: copy of a manuscript or published text.
Media Arts: CD-ROM or videotape (VHS).

Institutions at which residencies can take place are listed on the UNESCO website according to discipline.

The selection of candidates will take place at the end of June. Artists can only benefit from the bursary programme once and bursaries are not renewable.

Wales Arts International – International Project Fund

International Project Fund
Wales Arts International
28 Park Place
Cardiff CF10 3QE
Contact: Rhys Edwards
Phone: 029 2038 3037
Fax: 029 2039 8778
Email: rhys.edwards@wai.org.uk
Web: www.wai.org.uk

International Projects Fund

The Fund helps support productions, performances, exhibitions and collaborative projects in countries outside the UK. The Fund is open to professional arts organisations based in Wales and to professional artists who live and work in Wales.

Funding under the *International Projects Fund* will rarely exceed £3,000. A significant element of partner support is required for all projects, it is recognised that this will not necessarily comprise only monetary support.

Factors taken into consideration when assessing applications are:

- the quality of the project, its likely contribution to artform development within Wales and its potential for long-term benefits for the artist / arts organisation involved
- the professional experience of the applicant
- the degree of confirmation of the project, the commitment and professional experience of partners and the security of partner support
- the existence of established links between Wales and the host country and how the project will develop such links
- the project's relevance to Wales Arts International's strategic priorities

Initial approaches should be made to the International Projects Administrator.

Closing date: Should be received a minimum of three months prior to the start of the project. In 2005 – 1 April, 27 May, 29 July, 30 September, 25 November 2006 – 27 January

International Project Research Fund

The *International Project Research Fund* encourages professional practitioners to explore contacts with producers, presenters and promoters in countries outside the UK with a view to future collaborations. Support is available for research visits aspiring to develop international work in Wales and to deliver and promote projects in countries outside the UK that involve Wales based artists / arts organisations.

Eligibility: Open to professional arts organisations based in Wales and to professional artists who live and work in Wales. Support will usually be towards travel costs.

Initial approaches should be made to the International Projects Administrator.

Closing date: complete applications should be received a minimum of eight weeks prior to the start of the project and by the last Friday of every month.

The Wellcome Trust

sciart
The Wellcome Trust
215 Euston Road
London NW1 2BE
Phone: 020 7611 8332
Fax: 020 7611 8545
Email: sciart@wellcome.ac.uk
Web: www.wellcome.ac.uk

sciart offers £500,000 per year to support and encourage innovative arts projects investigating biomedical science and its social contexts.

Collaborations between art and science is a buoyant field of activity. Visual art, music, digital media, film, creative writing and the performing arts provide fresh and exciting ways of interacting with scientific research, intriguing and captivating spectators and engaging a wide range of audiences in scientific issues. In turn, science – with its vivid history, complex contemporary advances and the social, ethical and emotional implications – offers an inexhaustible supply of inspiration for the arts.

Projects should aim to explore new modes of enquiry and stimulate fresh thinking and debate in both disciplines. Innovation and experimentation are crucial. At the same time projects should be accessible to diverse audiences and should attempt to engage the public in the philosophical and ethical issues that surround contemporary biomedical science.

There are two sciart awards available:

Research and Development Awards (up to £15,000)

Research and Development awards aim to support the development of ideas in their formative stages. Artists and scientists can either work in a collaborative partnership or residency, or named scientists can take an advisory role in an arts project. The Research award could have two possible outcomes: either open-ended research, or small-scale productions which could include prototypes, artworks, performances, broadcast proposals or digital media.

The awards are aimed at arts and science practitioners, as well as mediators, academics and health professionals.

Production Awards (from £50,000)

Production awards will be awarded to substantial projects likely to make a significant impact on the public's engagement with science. They are aimed at arts, science and broadcast organisations and can be used to fund major activities such as exhibitions, art projects, programmes for TV and radio, theatre, film, public performance or events programmes.

Individuals will also be eligible to apply provided they are attached to, or associated with, a recognized organization and can demonstrate a clear strategy for public presentation and associated outcomes.

There is no fixed upper limit to the amount of Production funds that can be applied for, however, applicants are advised to contact the sciart office prior to submission if the proposed budget exceeds £100,000.

Who can apply – The nominated project coordinator or organisation should be UK based and the eventual outcome should be first disseminated in the UK.

Application form can be downloaded.
sciart Surgeries are held to discuss proposal ideas in more detail.

Wellcome Trust – People Awards

The Wellcome Trust
215 Euston Road
London NW1 2BE
Contact: Dr Veronica McCabe, Grants Manager, PEDG
Phone: 020 7611 8415
Fax: 020 7611 8254
Email: engagingscience@wellcome.ac.uk
Web: www.wellcome.ac.uk

These awards - up to £30,000 - provide fast-track funding for activities that:

- communicate biomedical science to the public
- stimulate thought and debate about biomedical science
- improve understanding of the powers and limitations of science

All projects must be in the area of biomedical science and span either historical, social, ethical, cultural or contemporary issues. Projects are funded for a maximum of three years and may include:

- workshops, talks, discussions, exhibitions in public venues
- arts projects for a variety of different audiences and age groups
- teaching materials or techniques to encourage wider discussions
- projects that utlilise the collections of the Wellcome Library and the Wellcome Collection at the Science Museum

Applicants must be based in the UK and the activity must take place in the UK. The scheme is open to a wide range of people including: science centre/museum staff, artists.

Applications are accepted from a range of organisations and partnership projects (e.g. between different organisations, scientists and artists or ethicists and educators) are welcomed. Application guidelines available on the website.

Regional pre-application workshops are available to those interested in applying to the Engaging Science grants programme.

Closing date: Applications can be made at any time during the year and will be peer reviewed.

Wellcome Trust – Pulse

Public Engagement Development Group
The Wellcome Trust
215 Euston Road
London NW1 2BE
Phone: 020 7611 8222
Fax: 020 7611 8254
Email: pulse@wellcome.ac.uk
Web: www.wellcome.ac.uk

These awards provide funding for arts projects that:

- engage with biomedical science
- encourage debate about issues raised by scientific developments
- interact imaginatively with young people (up to 22 years old)

All projects must be in the area of biomedical science and the Trust are keen to encourage projects that tackle historical, social, ethical, cultural or contemporary issues arising from science.

Pulse 2 is inviting applications to work in any art form or combination of art forms. This could include dance, drama, live arts, visual arts, music, film, craft, photography, creative writing or new media. The first round of this grants scheme, Pulse 1, focused on the performing arts only.

Pulse 2 projects can run for up to two years and you can apply for funding at two levels:

Up to £10,000 could cover

- research and development of a new idea perhaps showing the results as ' work in progress' to an invited audience
- a series of workshops in a variety of educational contexts with different groups of young people
- a school group working on a project in collaboration with a local artist and scientist

Up to £50,000 could cover

- full production costs for an arts project with a regional audience
- part production costs for a national touring project

Innovative project formats are encouraged.

Applicants must be based in the UK and the activity must take place in the UK. The scheme is open to a wide range of people including: science communicators, scientists and science educators; artists, youth arts workers, performing arts teachers, art & design teachers; education officers, citizenship teachers.

Organisations might include: museums, galleries, science centres, regional theatres, arts centres; schools, colleges, universities, youth clubs, youth theatres; touring arts organisations, arts agencies.

The next closing date is 7 October.

Wingate Scholarships

The Administrator
Wingate Scholarships
2nd Floor, 20-22 Stukeley Street
London WC2B 5LR
Web: www.wingate.org.uk

Wingate Scholarships are awarded to individuals of great potential or proven excellence who need financial support to undertake pioneering or original work of intellectual, scientific, artistic, social or environmental value, and to outstandingly talented musicians for advanced training. The Committee welcomes applications from more mature students and those from non-traditional academic backgrounds. The Scholarships attempt to provide funding for cross-disciplinary projects that might not fall comfortably into any of the conventional funding categories.

They are designed to help with the costs of a specific project which may last

up to 3 years. The average total award is about £6,500 and the maximum in any one year is £10,000. The Scholarship Committee may consider the personal circumstances of a candidate as well as the excellence of a project.

Funding opportunities are offered for: Independent Research Projects in most subjects / Doctoral and Post-Doctoral studies / Field Work associated with Independent Research / Doctoral or Post-Doctoral Projects / Advanced Music Training / Creative Writing / Design and Craft Research Projects.

Funding opportunities are not offered for: Performing Arts with the exception of Music (this includes all Theatre, Dance, Television, Media and Film studies.) / Taught Courses (this includes all Undergraduate and most Masters Degrees) / Courses leading to Professional Qualifications / Courses at Drama, Art or Business Schools / Electives / Fine Art and Fine Art Photography.

Applicants must be 24 or over, living in the British Isles during the period of application, citizens of the United Kingdom or other Commonwealth country, Ireland or Israel or citizens of another EU country (provided that they have been resident in the United Kingdom at least 3 years).

Application: download the application form from website.
Closing date: February.

Wrexham County Borough Council

Art Sponsorship Scheme
Ty Henblas
Queen's Square
Wrexham LL13 8AZ
Tel: 01978 297423
Web: www.wrexham.gov.uk

In order to encourage young people with special talents in the arts Wrexham County Borough Council operates an Arts Sponsorship Scheme.

Applicants should preferably be under 25 years of age and must reside within Wrexham County or have connections with the area. Applicants must be talented artists in the field of visual arts, music, drama, dance or literature.

Application form can be downloaded from the website.

5 Counties Competition

Obsidian Art
Layby Farm
Old Risborough Road
Stoke Mandeville HP22 5XJ
Phone: 01296 612150
Email: trisha@obsidianart.co.uk
Web: www.obsidianart.co.uk

Open to 2D and 3D artists from Bucks, Herts, Beds, Berks and Oxon. Unthemed, unjuried competition in spring of each year at Obsidian Art Gallery.

Art Plus

Arts Council England
14 Great Peter Street
London SW1P 3NQ
Phone: 0845 3006200
Email: pase@artscouncil.org.uk
Web: www.artscouncil.org.uk/artplusawards

Art Plus – Award Scheme for Art in Public Places was launched in 2004 and is once again open for bids. Art Plus, is a competitive award scheme led by Arts Council England, South East and the South East England Development Agency (SEEDA). It seeks to improve our environment, whether streets, schools or other public spaces, by including the creativity of artists in their design. Individual applicants must live in the South East region, and the ideas and development must take place in the region too.

There are two categories of awards:

Individual Artists Awards

Up to 8 development awards and up to 4 final awards will be made to artists who are at an early stage in their career, including undergraduate or postgraduate students.

Organisation Awards

Up to 8 development and up to 4 final awards in the following categories:

Community Award where community engagement and participation must be the core element. Applicants might be community organisations, youth groups, civic societies, residents' associations, or those working with them.

Diversity Award for projects that are led by disabled or ethnic minority individuals or organisations, or which engage with issues relating to disability or ethnicity in the public realm with the participation of people from these communities.

Environmental Award for projects engaging with sustainability, biodiversity, recycling or other environmental issues.

Award for Vision for imaginative, innovative schemes involving artists integrating their work into the public realm. Projects in this category could also engage with one or more of the other Organisation Award categories.

Closing date: for initial suggestions by 3 May 2005.

Up to 16 Development Award Winners will be announced in June 2005, who will receive funding and support to produce materials for public exhibition.

The final winners of the Art Plus Awards will be announced in March 2006.

Art Plus offers financial awards for development of up to £10,000 and final awards can be made up to £50,000 for organisations and £5,000 for individuals.

Artes Mundi Prize

Park Gate (BT), PP P5D
Westgate Street
Cardiff CF10 1NW
Phone: 029 2072 3562
Email: info@artesmundi.org
Web: www.artesmundi.org

The Artes Mundi Prize is an international visual arts prize, established to celebrate visual culture from across the globe. Based in Wales, the first Artes Mundi Prize was awarded in March 2004, launching the event as a biennial opportunity for artists.

The Prize celebrates how visual artists from all corners of the globe interpret the broad theme of human form, human condition and humanity. The theme differentiates it from other visual arts prizes and is intended to promote a greater understanding of humanity in all its different forms.

A prize to the value of £40,000 is awarded.

In addition a purchase fund worth £30,000, established through the generosity of the Derek Williams Trust, enables works of art by the shortlisted artists to be bought for the National Museum & Gallery, Cardiff, building a unique collection of international contemporary visual art in Wales.

Full details for the 2006 exhibition and prize are available on the website.

The Arts in Architecture Award – Saltire Society

9 Fountain Close
22 High Street
Edinburgh EH1 1TF
Phone: 0131 556 1836
Fax: 0131 557 1675
Email: saltire@saltiresociety.org.uk
Web: www.saltiresociety.org.uk/

The Saltire Society exists to promote the art and culture of Scotland. Awards are made for works of art and craft designed to enhance and enrich buildings.

Examples include works of sculpture, painting, tilework, mosaic, tapestry, textile hangings, glass, plaster and metalwork, and enamel.

Artists and craftsmen working in any suitable medium are invited to enter the competition by completing the application form. The Society may arrange for members of the Arts and Crafts in Architecture Panel to inspect selected entries on site. Adjudication will take place as soon as possible after the closing date of entry. Awards or Commendations, each in the form of a certificate, will be made to the artist or craftsman and commissioning body or person.

Further details not available at time of publication. Check website.

Arts Grants Committee (Sweden)

Konstnärsnämnden
PO Box 1610
Stockholm 11186
Sweden
Contact: Nils Johansson, Director
Phone: +46 8 402 3570
Fax: +46 8 402 3590
Email: info@konstnarsnamnden.se
Web: www.konstnarsnamnden.se

The Visual Arts Fund, part of the Arts Grant Committee, runs a programme called AIRIS (Artists in Residence in Sweden). It offers an opportunity for Swedish artists to invite foreign artists, with whom they wish to work/ collaborate, to Sweden to participate in workshops, symposia or to work towards an art exhibition. Grants are issued four times a year and range from £3,500 to £20,000 to cover the costs of travel, accommodation, fees, materials, premises and documentation.

Application: Approach must be made by Swedish artists. Grants are awarded for an invited visit to Sweden.

Artworks: Young Artists of the Year Awards

The Clore Duffield Foundation
Studio 3, Chelsea Manor Studios
Flood Street, London SW3 5SR
Phone: 020 7351 6061
Fax: 020 7351 5308
Email: info@cloreduffield.org.uk
Web: www.cloreduffield.org.uk
Web: www.art-works.org.uk.

The form and future of the Artworks programme and The Young Artists of the Year Awards are being re-assessed. Although the Awards are now 'on hold', it is hoped that they will be re-launched in autumn 05. The programme has been running for 5 years.

The Artworks Awards Scheme

These annual Awards reward high-quality teaching and learning in art and design inspired by contact with works of art and artists (including craft, design

and architecture). All nurseries, schools and sixth form colleges are eligible to apply and projects can be with any age up to 18.

Each year, around 30 schools receive Artworks Awards at a ceremony held at Tate Modern on Children's Art Day. Winning schools receive £2,000 to extend art activities.

Awards are made in three categories:

- *Working with Artists* recognises the value of residences and workshops in which pupils have contact with practising artists.

- *Working with Galleries* acknowledges the value for pupils of encountering art in galleries and museums and, for schools, in building lasting partnerships with venues in which art is displayed.

- *Working with Other Sources* rewards inspiring teaching that makes meaningful links between secondary sources such as art in books or on the Internet and first-hand experiences of, for example, public art and architecture.

The programme is supported by The Clore Duffield Foundation. This was formed in December 2000, from the merger of the Clore Foundation and the Vivien Duffield Foundation. The Foundation's main areas of interest are museum and gallery education; art and design education; education; performing arts education; health, social welfare and disability.

Association of Mouth and Foot Painting Artists

9494 Schaan, Im Rietle 25
FL-9494
Principality of Lichtenstein
Phone: 423 232 11 76
Fax: 423 232 75 41
Web: www.amfpa.com

The Association supports up-and-coming mouth or foot painting artists by granting scholarships: a scholarship may be awarded to any mouth or foot painting artist living anywhere in the world.

Grants may only be awarded to persons who, as a result of their handicap, are not able to paint with their hands but only with their mouth or feet. Other seriously disabled artists are not eligible.

A scholarship is awarded for three years by the Managing Board. The scholarship holder receives a monthly amount from the Association. The level of this scholarship is set at the discretion of the Association's Managing Board and is adjusted to the recipient's artistic development.

The AMFPA's scholarship is not intended for day-to-day living expenses but exclusively for artistic development: attendance at a painting school or lessons with a recognized artist, the purchase of painting utensils, art books, etc.

Application form can be downloaded online.

The Bass Ireland Arts Award

Visual Arts Department
The Arts Council of Northern Ireland
MacNeice House
77 Malone Road
Belfast BT9 6AQ
Phone: 028 90 385200
Fax: 028 90 661715
Web: www.artscouncil-ni.org/award/award8.htm

This Award of up to £5,000 exists to encourage and enrich the cultural scene in Northern Ireland by providing financial assistance to aspiring, creative individuals or groups in all the Arts. There is normally one award each year, but there may be more than one depending on the merit of the applications.

Closing date: August.

Beck's Futures Exhibition and Award

I.C.A.
The Mall
London SW1Y 5AH
Phone: 020 7930 3647
Web: www.ica.org.uk
Web: www.becksfutures.co.uk

This is one of the most most valuable of the Visual Arts prizes with a total of £65,000 prize money awarded. Nominees – professional exhibition curators, museum directors, critics and artists, from throughout Britain and Ireland – suggest three artists each.

BOC Emerging Artist Award

The BOC Emerging Artist Award
International Art Consultants/Art for Offices
The Galleries
15 Dock Street
London E1 8JL
Contact: Laura Young
Email: laura@afo.co.uk
Web: www.boc.com/artist/

The BOC Emerging Artist Award supports promising young artists based in the UK with a grant of £20,000 to the winner, with additional discretionary awards of £1,000 each to runners-up. The winner's award also includes ongoing support from BOC and its art consultant, Art for Offices / International Art Consultants.

Application may be made by any artist working in two-dimensions (2-D) who is based in the UK.

Applicants must be under 30 years of age. They must: a) have completed or be completing a Master's degree in an artistic discipline or; b) have completed a Bachelor's degree in an artistic discipline and have pursued a working artistic

career for at least two years since graduating or; c) in exceptional circumstances, be able to demonstrate commitment to an artistic career and at least five years working experience.

The Award – The BOC Emerging Artist Award has three parts:

- A grant of up to £12,000 for studio rental, essential materials and equipment.
- A travel grant of £3,000 to visit and work in a country or countries of the artist's choice. As BOC operates in more than 50, the Group may be able to provide support in those countries visited.
- A grant of £5,000 for a London exhibition and promotion to be held at the end of the award year.

The award is for one year only and all costs must be incurred during that year.

The winning artist will be expected to mount two exhibitions in the atrium of BOC's headquarters at Windlesham in Surrey. The first will be an exhibition of existing and initial work. Subsequent exhibitions will be of work undertaken during the award period.

BOC will choose one item of work undertaken by the artist during the award year to keep and add to its art collection which is displayed at Windlesham.

BOC will endeavour to promote the winning artist through presentations, on BOC's website, in newsletters and other publicity. To aid promotions of the winning artist and future awards, the artist and BOC will share joint copyright over the work undertaken during the award year.

BP Portrait and Travel Award

BP Portrait Award
National Portrait Gallery
St Martin's Place
London WC2H 0HE
Phone: 0870 1126772 (Exhibitions Department)
Web: www.npg.org.uk/bp

BP Portrait Award

The Portrait Award is now in its twenty-fifth year at the National Portrait Gallery and has been sponsored by BP for the past 15 years. An annual event aimed at encouraging young artists to focus upon and develop the theme of portraiture within their work. Many artists who have had their work on show have gained commissions as a result of the considerable interest in the Portrait Award and the resulting exhibition. The competition is judged from original paintings and an exhibition of works selected from the entries is mounted. The prize winners and exhibition will be selected by a judging panel that will be chaired by the Director of the National Portrait Gallery. £13 registration fee.

Prizes:
1st – £25,000, plus at judges' discretion a commission worth £4,000, to be agreed between the National Portrait Gallery and the artist.
2nd – £6,000, 3rd – £4,000, 4th – £2,000.

The BP Travel Award

All 2005 exhibitors will be invited to submit a proposal for the BP Travel Award. The aim of the Award is to provide the opportunity for an artist to experience working in a different environment, in Britain or abroad, on a

project related to portraiture which will then be shown as part of the BP Portrait Award exhibition and tour the following year.

Closing date: 20 March.
Award: £4,000

British Council

Grants To Artists Scheme
Visual Arts Department
The British Council, 11 Portland Place
London W1N 4EJ
Contact: Katie Boot
Phone: 020 7389 3045
Fax: 020 7389 3101
Web: www.britcoun.org/arts/index.htm

The Grants to Artists Scheme is designed to help promote British art, by assisting professional British artists, who are resident in the UK, to exhibit overseas in public or commercial spaces. Artists who have received a firm invitation to exhibit overseas may apply for a grant to assist them in meeting the costs of the transport, packing and insurance of their work to and from Britain and the country concerned.

Grants only give a contribution towards these costs. Artists may also apply for their own travel costs where their presence is essential. Grants are not given to assist with either the production costs of the work or framing and other preparation costs. Submit a copy of the contract/invitation from the overseas galleries, and a selection of 6 x 35mm slides showing recent work.

Open to: British artists, who are resident in the UK.
Application: Request application form.
Closing date: usually 1st August, 1st November, 1st February.

Caerleon International Sculpture Symposium

Peter Appleton
University of Wales College Newport
School of Art Media and Design
Caerleon Campus
PO Box 179
Newport NP18 3YG
Email: online
Web: www.caerleon-arts.org

2005 is the third Sculpture Symposium to be held in Caerleon. It is open to sculptors who work in wood.

Caerleon Arts are eager to attract as many sculptors from the newly enlarged EU as possible and will pay reasonable travel expenses from within the EU. The theme for 2005 is Romano Celtic vision.

Fee is £1,000 to work publicly for 10 days in July. Free accomodation. Materials supplied – timber (mostly oak), chain saw, fuel and electric power.

To apply send in CV and visual materials on slide or CD.

The George Campbell Memorial Travel Grant

Visual Arts Department
The Arts Council of Northern Ireland
MacNeice House
77 Malone Road
Belfast BT9 6AQ
Phone: 028 90 385200
Fax: 028 90 661715
Web: www.artscouncil-ni.org/award/award8.htm

This annual award was instituted to celebrate the strong cultural contacts which the Irish artist George Campbell developed in Spain. It is funded by the Arts Council of Northern Ireland, the Arts Council/An Chomhairle Ealaíon and the Instituto Cervantes, and is made specifically to allow for a period of work in Spain. One Award is normally made each year. The Award is administered on alternate years by the two Arts Councils. The 2005 Award by the Arts Council of Northern Ireland; the 2006 Award by An Chomhairle Ealaíon.

Commonwealth Arts and Crafts Award

The Commonwealth Foundation
Marlborough House, Pall Mall
London SW1Y 5HY
Contact: Andrew Firmin
Phone: 020 7930 3783
Fax: 020 7839 8157
Web: www.oneworld.net

This biennial enables young artists and craftspeople to learn new techniques or enhance existing skills, to work with more established artists and to mount an exhibition of their work in another region of the Commonwealth. It seeks to encourage the sharing of artistic traditions within the Commonwealth and to promote excellence in arts and crafts in Commonwealth countries.

Each award of £6,000 covers the cost of airfares and living expenses up to nine months, as well as the expenses of mounting an exhibition in the host country. Preference will be given to talented individuals who have shown promise of artistic initiative, merit and achievement in their own countries and who are seeking opportunities for creative work with other artists and craftspeople.

Eligibility: Anyone 22 – 35 who is a citizen of a Commonwealth country.
Application: Request application form.

Discerning Eye

Parker Harris Partnership
PO Box 279
Esher, Surrey KT10 8YZ
Tel: 01372 462190
Fax: 01372 460032
Email: de@parkerharris.co.uk
Web: www.parkerharris.co.uk

The Discerning Eye is an educational charity, established some ten years ago, to encourage a wider understanding and appreciation of the visual arts, and to

stimulate debate about the place and purpose of art in our society, and the contribution each one of us can make to its development.

The Discerning Eye is a show of small works independently selected by six prominent figures – two artists, two collectors and two critics. Work is selected from open submission. These works are put together with works by artists invited by the selectors. Each section is hung separately to give each its own distinctive identity. The impression emerges of six small exhibitions within the whole. It provides an unusual opportunity for works by lesser-known artists to be hung alongside contributions from internationally-recognised names.

The annual prizes awarded at the Discerning Eye Exhibition are:

ING Purchase Prize – £3,000
The Crispin Odey Prize For Three Dimensional Work – £1,000
The Discerning Eye Chairman's Purchase Prize – £1,000
The Humphreys Purchase Prize – £750
Meynell Fenton Prize – £1,000
Up to 8 Outstanding Regional Entry Prizes – £250 each

All works must be handmade. Photographic works are admissible. All works must be for sale. All works must be within the maximum size limit of 20 inches. Each artist may submit up to six works.

A submission fee of is £8 per work is payable. Send SAE for entry form or download from website.
Closing date: November

Dundee Visual Artists Awards Scheme

Dundee Leisure and Arts
Dundee Contemporary Arts
152 Nethergate
Dundee DD1 4DY
Contact: Arts Development Officer
Phone: 01382 432485
Fax: 01382 432471
Email: anna.robertson@dundeecity.gov.uk
Web: www.dvaa.info

The Dundee Visual Artists Awards Scheme is a partnership between the Scottish Arts Council and Dundee City Council. The Scheme was established in 2000 to support the work of outstanding Dundee-based artists by awarding grants towards the costs involved in researching and creating new work.

The Awards are open to Dundee-based artists of all ages, at any stage in their career, working in any visual media. You must be able to demonstrate a commitment to your work and to advancing your skills base and ideas.

You must live within the Dundee City Council boundary or work, maintain a studio space, or be a member of and regularly use a visual arts facility within Dundee. Grants up to a maximum of £500 are available and there are two deadlines for applications each year.

In 2004/05, the Scheme has a total budget of £7,000. The panel reserves the right to make a discretionary award of £1,000 to an outstanding applicant to the Scheme.

Application: Download from website.
Closing dates: last Wednesday in May and November.

East International

Norwich School of Art and Design
St George Street
Norwich NR3 1BB
Phone: 01603 610561
Fax: 01603 615728
Email: nor.gal@nsad.ac.uk
Web: www.norwichgallery.co.uk

This is an exhibition open to visual artists working in any medium. Each year one of the artists is given the EAST award of £5,000. EAST takes place at Norwich Gallery, the Fine Art Studios of Norwich School of Art & Design and the Sainsbury Centre for Visual Art at the University of East Anglia. The emphasis is on choosing artists from work submitted on slide.

EAST is a major international open exhibition held every summer and has been selected by distinguished curators and artists. EAST International has no rules of age, status, place of residence or media to limit those who may enter.

Open to visual artists working in any medium.
For entry form and further information contact the above address or download from the website. Application fee £15.

European Biennial Competition for Graphic Art

Eric Wieme
Sportstraat 57, Box 18
B-8400 Ostende
Belgium
Tel: +32 59 51 00 32
Fax +32 50 31 28 94
Email: eric.wieme@pandora.be
Web: www.graphicartes.be

A biennial competition for graphic art, to be held next in 2007. Open to any resident of an EU member state. The competition is open to all reproducible graphic techniques with the exception of pure photography. Three works may be submitted in formats 13x18 cm and 20x30 cm. Works are judged by an international jury. An exhibition is held in July and August at a gallery in Bruges.

Submission date for 2005 was between Sept 04 and Jan 05.
Dates for 2007 are likely to be Sept 06 to Jan 07. Check for updates.

Prizes: 1st – 2,500, 2nd – 1,000, 3rd – 750

Esmée Fairbairn Foundation

11 Park Place
London SW1A 1LP
Phone: 020 7297 4700
Fax: 020 7297 4701
Email: info@esmeefairbairn.org.uk
Web: www.esmeefairbairn.org.uk

The Esmée Fairbairn Foundation make grants and loans to organisations which aim to improve the quality of life for people and communities in the UK, both now and in the future. They consider work which others may find hard to fund, perhaps because it breaks new ground, appears too risky, requires core funding, or needs a more unusual form of financial help such as a loan. They also take initiatives themselves where new thinking is required or where they believe there are important unexplored opportunities.

Arts & Heritage Programme

From May 2005 the Foundation will be introducing changes to the Arts programme and application procedures – new Application Guidelines will be published. There will be no significant changes to the Heritage programme.

Arts programme

The Arts programme has two main areas of interest: Serving Audiences and Supporting Artists. Proposals are welcomed that fit the aims of both of these, particularly proposals that benefit audiences and artists outside Greater London.

Serving Audiences

The Foundation aims to expand high quality performing and visual arts provision in parts of the UK less well served than others.

Proposals are supported which do one or more of the following:

- sustain and/or create regional touring circuits and/or tour across UK national borders
- create opportunities for showing new work or second runs
- involve artform/s which tend to be less well funded
- reach new audiences.

Supporting Artists

The Foundation aims to support the professional development of talented artists throughout their careers. They do not accept applications from individual artists.

Proposals are supported which do one or more of the following:

- nurture artists at an early stage in their career
- help artists to develop new approaches to their artistic practice later in their careers
- enable the creation of new work
- develop the skills of curators and arts professionals who support the work of artists.

In addition the Foundation wishes to support proposals that do one or more of the following:

- support innovation in terms of artistic practice and delivery
- add value such as levering in other funding
- have the potential to make a wider impact on policy, or have a significant influence on a particular area of the arts.

New Key Focus from May 2005 to April 2008. In the past the Esmée Fairbairn Foundation's Arts programme has been better known within the Performing Arts than the Visual Arts. They believe however that it is Visual

Arts organisations that have greater difficulty in obtaining funding from independent Trusts and Foundations. In the future therefore they have decided:

- To focus the Arts programme, for a three-year period, on the contemporary Visual Arts including architecture, crafts, design, fine art, new media, photography, public art and sculpture.

- To give priority to Visual Arts projects that fit the two main areas of interest detailed in our current application guidelines: Serving Audiences and Supporting Artists.

- Since 2000, they have given priority to organisations based outside Greater London. Applications from Visual Arts organisations working in Greater London will now be accepted.

Federation of British Artists

Mall Galleries
17 Carlton House Terrace
London SW1Y 5BD
Web: www.mallgalleries.org.uk

The FBA's Mall Galleries are one of the few London venues to show the work of well-established artists alongside that of up-and-coming students and unknown artists. The FBA, registered charity and umbrella organisation for nine leading art societies, aims to be the national focal point for contemporary art with timeless values. It aims to inspire, educate, and involve the public in the appreciation and practice of fine art by living artists.

There are nine member art societies in the Federation, eight of which hold their Annual Open Exhibitions in the Mall Galleries. Any artist may submit work for selection. Work for exhibition is selected by a committee consisting of members of the particular society to which the work has been submitted.

It is extremely important that details of the Receiving Day dates, the specific requirements for each Annual Open Exhibition are fully checked before making any submissions. There are Regional Handing-In points in Bristol, Perth, Glasgow, Penrith, Ambleside, Manchester, Newcastle upon Tyne, Doncaster, Norfolk, and the West Midlands. Check web site for full information.

• The Royal Institute of Painters in Water Colours

The Annual Exhibition is established as one of the leading and largest exhibitions of contemporary watercolour painting. It shows a rich panorama of visual imagery in paintings by members and non-members, and demonstrates the whole range of the use of water-soluble media from traditional forms to more testing experimental work. A feature of the exhibition in recent years has been the encouragement of work by young artists alongside that of the best of progressive water colour painters.

Acceptable media: watercolour or any water soluble colour. Any use of acrylic must be treated as watercolour.

Maximum No. of works to be submitted: 6. Maximum No. of works which will be selected: 6. See website for dates.

The following awards are given

- *Winsor & Newton Young Artists Award (aged under 30)*
- *Winsor & Newton/RI Members Group Award*
- *Matt Bruce RI Award*
- *John Blockley Prize*
- *Worshipful Company of Painter Stainers*
 – Stoke Roberts' Bursary Award
- *Lincoln Joyce/Donald Blake Award*
- *Llewellyn Alexander Gallery Award*
- *The Debra Manifold Memorial Award*
- *Kingsmead Publications / Rowland Hilder Award*
- *Frank Herring Awards*
- *St Cuthberts Mill Award*
- *Arts Club Award*

• The Royal Institute of Oil Painters

The ROI has been a leading art society in Britain for over a century, since it was founded in 1882. It is the only major art society showing work exclusively in oils. The Annual Exhibition is work by both members and non members.

Maximum No. of works to be submitted: 6. Maximum No. of works which will be selected: 4.

Acceptable media: oils, acrylic is acceptable if it is framed as an oil, so as not to spoil the general appearance of the exhibition, ie: glazed works with wide mounts are not admissible, non-metallic frames are preferred.

Maximum size: The longest dimensions of each work exhibited, when added together must not total more than 10 feet.

The following awards are given

- *Winsor & Newton Young Artists Awards (under 30 yrs)*
- *Winsor & Newton Awards to Non-member*
- *Alan Gourley Memorial Award of £1,000*
- *Stanley Grimm Prizes*
- *The Dartington Crystal Award*
- *L. Cornelissen & Son Award*
- *The Le Clerc Fowle Medal*
- *The Llewellyn Alexander Gallery Award*
- *C. Robertson & Co. Award*
- *Menena Joy Schwabe Memorial Award*
- *Frank Herring and Sons Easel Award*

• The Pastel Society

www.thepastelsociety.org.uk

The Pastel Society aim to promote the best contemporary work by painters

who use the medium for its vibrant colour, immediacy and vitality. It is also committed to restoring Pastels to the levels of popularity which the medium experienced during the 17th and 18th centuries and during the time of the Impressionists.

The annual exhibition features works by both members and non members.

Maximum No. of works to be submitted: 6. Maximum No. of works which will be selected: 4.

Acceptable media: pastels, including oil pastels, charcoal, pencil, conte, sanguine, or any dry media. All works must be framed. Metal frames are inadmissible

The following awards are given

- *Daler Rowney Art Materials Award, £500*
- *W.H. Patterson Fine Arts Award*
- *Brian Sinfield Fine Arts Award*
- *Annie Longley Award*
- *Cross Gate Gallery Award Kentucky U.S.A.*
- *Willi Hoffmann-Guth Award*
- *Inscribe £200 Pastels Prize*
- *Frank Herring Awards*
- *The Art Club Award*
- *Unison Pastel Materials Award*
- *Linda Blackstone Gallery Award*
- *Alexander Prowse Web Site Award*
- *Stuart Defries Award presented by Buzzacott*

- **Royal Society of Marine Artists**

The Society's Annual Exhibition of members work is also open to non-members who may submit up to six works in any medium.

Subject matter must be essentially marine in character, the main interest must be the sea or tidal waters or some object essentially connected therewith. Sculpture and portraits related to the sea are also considered. An annual award is given to the work judged to be the best submitted by a non-member.

Maximum No. of works to be submitted: 6. Maximum No. of works which will be selected: 4.

Acceptable media: oil, acrylic, watercolour, original prints of any media, drawings, pastels. Sculpture: work must be from a limited edition not exceeding twelve, signed or initialled, and, if more than one piece, the edition indicated on each piece.

The Gallery cannot hang pictures taller than 8ft.

The following awards are given

- *Charles Pears Memorial Award for the best non-members work*
- *The Worshipful Company of Shipwrights' Award*
- *The 'Classic Boat' Award*

- *St Cuthberts Award*
- *Conway 'Age of Sail' Award*

• The Royal Society of Portrait Painters

www.therp.co.uk

The Society is a registered charity which aims to promote, maintain, improve and advance education in the Fine Arts and in particular to encourage the appreciation, study and practice of the art of portraiture. The annual exhibition features new works by members of the Society as well as selected works by non-members.

For some years now the Society has supported the charity Changing Faces, a charity which works for and with people with facial disfigurements, by helping to raise awareness about the charity's work and by offering an opportunity to engage in fundraising activities based around the exhibition.

Maximum No. of works to be submitted: 3. Maximum No. of works which will be selected: 3

Acceptable media: oil, watercolour, acrylic, pastel, pencil, sanguine, conte & any dry medium. Original prints (please give details of edition)

The Gallery cannot hang pictures taller than 8ft.

The following awards are given

- *The Ondaatje Prize for Portraiture: £10,000 plus the Society's Gold Medal awarded for the most distinguished painting in the Society's annual exhibition.*

- *The Carroll Foundation Award for Young Portrait Painters: £3,000 plus the Society's Silver Medal for the most outstanding portrait by an artist less than 35 years of age.*

- *The Prince of Wales's Award for Portrait Drawing: £2,000 and framed certificate for work in a recognised drawing medium.*

- *The Changing Faces Prize: £2,000 for the portrait which is most outstanding in the way it communicates with the viewer.*

- *The De Laszlo Prize: £2,500 plus medal for an outstanding group portrait.*

• Society of Wildlife Artists

www.swla.co.uk

Founded in 1964 the society aims to encourage all forms of visual art based on or representing wildlife. The society also hopes, through art, to encourage the education and concern of the public in the conservation of the environment. It is with this aim in mind that the society has, over the last few years, set about forging links with a number of charities including the Woodland Trust.

The works on display are by both members of the society and non-members who have submitted their works for consideration through the open selection.

Maximum No. of works to be submitted: 6. Maximum No. of works which will be selected: 6.

Acceptable media: oil, acrylic, watercolour, drawings, pastel, original prints (please detail edition), sculpture.

Any work depicting wildlife subjects is admissible. The committee will also consider work that evokes the spirit of the natural world. Botanical subjects and domestic animals are not admissible.

The Gallery cannot hang pictures taller than 8ft.

The following awards are given

- *GMAC Commercial Mortgage Europe. New £5,000 Prize for the most distinctive, exciting and creative work in the show*
- *RSPB Fine Art Award*
- *Artists for Nature Foundation Prize*
- *St Cuthberts Mill Award*
- *PJC Drawing Award*
- *RSPB Young Explorers Wild Art*

- **Royal Society of British Artists**

Works on exhibition include both members and non-members and represent every form of media including fine art prints and sculpture.

Maximum No. of works to be submitted: 6. Maximum No. of works which will be selected: 6

Acceptable media: Work may be any medium including sculpture and original prints.

The Gallery cannot hang works taller than 8ft

The following awards are given

- *The Artist Magazine Award*
- *The Astor College for the Arts Award*
- *The Aylesbury College Award*
- *The David Wolfers Memorial Prize*
- *The Davison Award*
- *The De Laszlo Medal*
- *The Edward Wesson Award*
- *The Elizabeth Frink School of Sculpture Award*
- *The Fabbrica Prize*
- *The Gordon Hulson Memorial Prize*
- *The Italia Award*
- *The Marianne von Werther Memorial Award*
- *The Northbrook College Award*
- *The Scott Goodman Harris Award*
- *The Sir William Ramsay School Prize*
- *The St Cuthberts Mill Award for Works on Paper*
- *Surdival Memorial Award*
- *The Winsor and Newton Painting Award*
- *The Woodhay Gallery Award*

- *The Wykeham Gallery Award*

• New English Art Club

www.newenglishartclub.co.uk

The New English represents the very best of contemporary British figurative painting. Figurative painting includes all painting that is based on nature – on representation of the visual world.

Maximum No. of works to be submitted: 6. Maximum No. of works which will be selected: 6

Acceptable media: paintings, drawings, pastels, original framed prints (please detail edition). Sculpture is not admissible.

The Gallery cannot hang pictures taller than 8ft.

The following awards are given

- *The Llewellyn Alexander Award*
- *Minto Prize*
- *Horan Prize*
- *Bill Patterson Memorial Award*
- *The Worshipful Company of Painter Stainers' Award*
- *The St Cuthberts Mill Award for Works on Paper*
- *The Woodhay Gallery Critic's Choice Prize*
- *Kathleen Tronson Award to Critics' Choice 2nd & 3rd Prizes*
- *The Jans Ondaatje Rolls Award*
- *NEAC Travelling Scholarship sponsored by Manya Igel*
- *Arts Club Dover Street Award*
- *Alresford Gallery Prize*
- *Cedarhouse Gallery Prize for a Non-Member*

• The National Print Exhibition

The National Print Exhibition is organised by the Mall Galleries in conjunction with the Royal Society of Painter Printmakers. It has become one of the largest exhibitions of its kind.

Up to six works can be submitted. All printmaking methods are accepted but no unframed work, although unframed editions may be listed in the catalogue if information is supplied.

The following awards are given

- *Gwen May RE Commemorative Award*
- *St. Cuthbert's Paper Mill Awards*
- *Juliain Trevelyan Hon. RE Memorial Award*
- *Artichoke Print Workshop Awards*
- *Galleries Magazine Award*
- *Fabriano Paper Mill Award, presented by R.K. Burt & Co. Ltd.*

- *T.N. Lawrence Materials Prize*
- *The Whatman International Papers Award*
- *John Purcell Paper Awards*
- *The Joseph Webb ARE Commemorative Fund Award*
- *The Art Review Award*
- *Zenith Gallery Purchase Prize*
- *The Gavin Graham Gallery Award*
- *The Arcturus Award*
- *Printmaking Today Award*

J D Fergusson Arts Awards Trust

c/o Perth Museum and Art Gallery
78 George Street
Perth PH1 5LB
Contact: Robin Rodger
Phone: 01738 632488
Fax: 01738 443505
Web: www.pkc.gov.uk/ah/jdaward.htm

The J D Fergusson Arts Awards Trust was established in 1995 to encourage promising Scottish artists who have otherwise received no major distinction or awards for their art. This annual Award alternates between an Exhibition Award (odd years) and a Travel Award (even years). This must be completed within 8 months of the Award being made. There will be no restriction placed on the place of destination or on the duration of travel subject to the limitation of resources.

Eligibility: Any artist who is Scottish by birth, or who has spent the greater part of their life resident in Scotland (ie. 51% or greater). Open to any form of visual art. The award is not open to students in full-time education, including post-graduate studies.

Application: Request application form.
Closing date: October annually.

Franklin Furnace Fund for Performance Art

80 Arts – The James E. Davis Arts Building
80 Hanson Place, # 301
Brooklyn, NY 11217-1506
United States
Phone: +1 718 398 7255
Fax: +1 718 398 7256
Email: info@franklinfurnace.org
Web: www.franklinfurnace.org

Supported by the Jerome Foundation and the New York State Council on the Arts, Franklin Furnace awards grants of $2,000–$5,000 to emerging artists, allowing them to produce major works anywhere in the State of New York. Franklin Furnace has no curator; each year a new panel of artists reviews all

proposals. The peer panel system is seen as allowing artists from Brooklyn and Bolivia an equal shot at presenting their work to the New York art audience. Every year the definition of 'emerging artist',and even the definition of performance art itself changes, so if at first you don't suceed, you are encouraged to try again.

Eligibility: Artists from the United States and from abroad are invited to apply.

The Garrick/Milne Prize

Parker Harris Partnership
PO Box 279
Esher
Surrey KT10 8YZ
Tel: 01372 462190
Fax: 01372 460032
Email: GarrickMilne@parkerharris.co.uk
Web: www.parkerharris.co.uk

The Garrick/Milne Prize was launched in 2000 in memory of A.A. Milne, a member and benefactor of the Garrick Club. The Garrick Club is home to a unique collection of theatrical portraiture.

Prizes totalling £35,000 are offered for depictions of actors and performers during their rehearsals and performances.

Artists are required to submit up to four paintings that have been carried out within the last three years and not previously exhibited.

Application: Entry forms may be downloaded from the website. The entry fee is £10 per work or £5 per work for students at a recognised school of art.

Closing date: June

Adolph & Esther Gottlieb Foundation Grants

Adolph & Esther Gottlieb Foundation
380 West Broadway
New York, NY 10012
United States
Contact: Sheila Ross, Grants Manager
Phone: +1 212 226 0581
Fax: +1 212 226 0584
Web: www.gottliebfoundation.org

Ten Individual support grants available through an annual, juried competition. Grant amounts are determined each year (typically ten grants of $20,000 each are awarded at the end of March). The Foundation also administers an Emergency Assistance program year-round. This second, separate grants program assists artists suffering from recent catastrophic circumstances such as fire, flood, medical emergency, and who have worked for a minimum of ten years in a mature phase of their art. Grant range from $1,000 to $10,000.

Open to: painters, sculptors, printmakers who have been working for a minimum of 20 years in a mature phase of their art and have financial need.

Application: Application forms are available by mail in early September. Only

written requests for application forms will be honoured. The Foundation will not mail out applications in response to telephone or fax requests.

Graham Foundation

4 W. Burton Place
Chicago
IL 60610
United States
Phone: +1 312 787 407
Web: wwwgrahamfoundation.org

The Graham Foundation offers grants to sculptors producing artwork that is intrinsically involved with architecture. Grants range from $500 – $10,000.

Application: No application form. Submissions should include a resumé, a work plan and schedule, a budget, any support materials applicable, three letters of recommendation, and an SASE for return of support materials. Letters of recommendation must be from people who are familiar with the proposal being submitted and must be mailed by the recommenders directly to the Graham Foundation.

Closing date: Two annual deadlines, 15th January and 15th July.

Elizabeth Greenshields Foundation

1814 Sherbrooke St. West, Suite # 1
Montreal H3H 1E4
Quebec, Canada
Contact: Micheline Leduc, Administrator
Phone: +1 514 937 9225
Fax: +1 514 937 0141
Email: greenshields@bellnet.ca

The Foundation offers grants to artists in the early stages of their careers, working in painting, drawing, printmaking, sculpture. Work must be representational or figurative. Applicants must have started or already completed art school training and/or demonstrate through past work and future plans a commitment to making art a lifetime career.

Award: Canadian $12,500 (tenable anywhere in the world). May be used for any art-related purpose – study, travel, studio rental, purchase of materials etc.

Eligibility: Applicants must have started or already completed art school training and/or demonstrate through past work and future plans a commitment to making art a lifetime career. No age restriction.

Application: Request application form.
Closing date: Ongoing.

Virginia A. Groot Foundation

PO Box 1050
Evanston
IL 60204-1050
United States
Contact: Virginia A. Groot

The Virginia A. Groot Foundation offers a grant of up to $20,000 to an artist who has exceptional talent and demonstrated ability in the areas of ceramic sculpture or sculpture.

Application: Request application form (send SASE).

Herbert Art Gallery and Museum – Coventry Open

Herbert Art Gallery
Jordan Well
Coventry CV1 5QP
Phone: 024 7683 2381
Email: artsandheritage@coventry.gov.uk
Web: www.coventrymuseum.org.uk

The Coventry Open has been held biennially at the Herbert Art Gallery and Museum. Entry open to artists over 18 working in any medium who live in an area with a CV postcode, or have connections with Coventry. Work is selected by a panel of judges who also award a main winning prize of £1,000 and select a piece to purchase.

Currently on hold due to Gallery redevelopment. See website for updates.

HI-Arts Artists' Award Scheme

HI-Arts
4th Floor, Ballantyne House
84 Academy Street
Inverness IV1 1LU
Contact: Maggie Dunlop, Funding & Liaison Manager
Phone: 01463 717091
Fax: 01463 720895
Email: maggie@hi-arts.co.uk
Web: www.hi-arts.co.uk

Scheme established to support visual artists based in the Highlands and Islands of Scotland by helping to meet the costs of a range of activities which can assist the development of an individual artist's practice.

Grants of up to £500 are available to support initiatives which will assist individuals to develop and extend their own personal practice.

This can include, for example:

- Travel and subsistence costs to attend a major conference or symposium or to visit galleries with a view to future exhibitions of your work.
- Training costs related to extending your practice (eg into a new medium)
- Costs of preparing for an exhibition (eg framing, packing, etc)

- Research and development costs for a new project (eg exploring a possible site-specific installation)

Applications for projects costing more than £500 must indicate how the balance of the costs will be funded.

Eligibility: Visual artists who have been resident in the Highlands and Islands for at least 12 months prior to the date of application to the Fund. Also open to visual artists who use film, video or other new media in their practice.

This scheme is now a 'rolling programme' of decisions. Applications can be submitted at any time, but not less than eight weeks before the start of the project or activity for which the funding is sought. Application forms can be downloaded from website.

L. Ron Hubbard's Illustrators of the Future Contest

P.O. Box 3190
Los Angeles, CA 90078
United States
Email: contests@authorservicesinc.com
Web: www.writersofthefuture.com

All themes of science fiction and fantasy illustrations are welcome. The Contest is open to entrants from all nations. No entry fee.

Open to those who have not previously published more than three black-and-white story illustrations, or more than one process-color painting, in media distributed nationally to the general public, such as magazines or books. Only one entry per quarter is permitted.

Entries should consist of three illustrations in a black-and-white medium. Each must represent a different theme. Entries should not be originals, but large black-and-white photocopies. Entries must be submitted unfolded and flat, in an envelope no larger than 9 inches by 12 inches.

There will be three co-winners in each quarter. Each winner will receive an outright cash grant of $500 and a certificate of merit. Such winners also be eligible to compete for the annual Grand Prize of an additional cash grant of $4,000, together with the annual Grand Prize trophy.

The Contest contains four quarters each year, beginning on October 1st, with the year ending on September 30th.

See website for full details.

The Hunting Art Prizes

Hunting Art Prizes
Parker Harris Partnership
PO Box 279
Esher, KT10 8YZ.
Web: www.parkerharris.co.uk

Established in 1980 The Hunting Art Prizes is an open competition welcoming entries that range from traditional figurative to modern abstract. As a result it attracts a wide range of entries, including leading established artists, promising

newcomers and talented amateurs. It has proved particularly important as a vehicle for up and coming artistic talent to achieve recognition and past prize winners have gone on to enjoy significant success.

The blend of figurative and abstract art featured in the annual exhibition at the Royal College of Art makes the event highly attractive to visitors. Hunting has capitalised on this by inviting clients, the financial community and people from other key groups to attend the prize giving ceremony and promoting itself to a wider public. The presentation of the prizes is a prestigious platform which has been occupied by influential figures from politics and the arts.

Prizes

1st Prize – £12,000
2nd Prize – £4,000
Young Artist of the Year Prize (Age limit 25) – £5,000
Runner Up Prize (Age limit 25) – £1,500
Print & Drawing Award – £1,000
Outstanding regional entry – £1,000
Most Popular painting of the Show Prize – £500

Eligibility: Open to all artists resident in the UK, to submit paintings, drawings or prints (excluding photography), there are no age limits. Works in any type of combination media, including original prints, are eligible.

Submission: Send SAE for entry form or download from website.

Works of art submitted must not exceed 183 cm including frame in their largest dimension. Works also must have minimum dimensions of 30 x 25 cm including frame. Entry fee: £10 per work. Artists may submit up to three works.

Closing date: The exhibition usually takes place in early February, with call for entries being advertised in the November of the the preceeding year and hand in of works for selection taking place in early December.

The Jerwood Drawing Prize

The Exhibition Co-ordinator
The Jerwood Drawing Prize
Wimbledon School of Art
Merton Hall Road
London SW19 3QA
Phone: 020 8408 5533
Fax: 020 8408 5050
Email: jerwood@wimbledon.ac.uk
Web: www.wimbledon.ac.uk/jerwood/index.htm

The Jerwood Drawing Prize aims to promote and reward excellence and talent in contemporary drawing practice.

The exhibition is currently open to entry by all artists resident or domiciled in the United Kingdom. Every year, the changing panel of distinguished artists, writers, critics, collectors and curators select the show independently and without knowledge of the artists submitting; they define their own priorities for an exhibition of current drawing practice. This fashions a constantly shifting set of values and concerns, evidenced in the resulting touring exhibitions, in which fundamental questions are asked about what drawing is: its purpose, value, relevance and nature.

The administrative centre for the exhibition is at Wimbledon School of Art. The project is delivered through the working partnership of Wimbledon School of Art, the University of Gloucestershire and The Jerwood Charity.

Entry forms for 2005 will be available in April 2005.

Jerwood Painting Prize

Parker Harris Partnership
PO Box 279
Esher, Surrey KT10 8YZ
Tel: 01372 462190
Fax: 01372 460032
Email: JPP@parkerharris.co.uk
Web: www.parkerharris.co.uk
Web: www.jerwood.org

In 1993 the Jerwood Foundation created the Jerwood Painting Prize. It was, at £30,000, the single largest prize awarded to one artist annually in the United Kingdom.

Major changes in the prize are to be announced and not currently available. See websites for updates.

Jerwood Sculpture Prize

Parker Harris Partnership
PO Box 279
Esher, Surrey KT10 8QS
Phone: 01372 462190
Fax: 01372 460032
Email:jsp@parkerharris.co.uk
Web: www.parkerharris.co.uk
Web: www.jerwood.org

The Prize is open to anyone who is within 15 years of graduation from a recognised school of art, is either a British citizen or a citizen of the Irish Republic, or a sculptor who has lived in the UK for at least the last three years.

The Prize takes the form of a £25,000 commission for a piece of work to be placed at the Jerwood Sculpture Park, Ragley Hall, Warwickshire. It is awarded to the sculptor whose initial proposal, short listed commissioned maquette and detailed schedule, in the opinion of the Judges, demonstrates excellence and originality in the skill of outdoor sculpture. The final commissioned work must be of a size that will be in scale with, and suitable for, a large outdoor park landscape; and of a material which will withstand the elements indefinitely.

From the open submission entry of initial proposals, the judges short list a maximum of eight sculptors who are then commissioned to develop their proposal and to create an 18 inch maquette. The short listed proposals and commissioned maquettes form an exhibition held at the Jerwood Space during which the overall winner will be chosen and the £25,000 commission awarded.

Sculptors should submit an initial proposal detailing their idea for the commissioned sculpture.

For the last round of the prize the following timetable operated:

Closing date for initial proposals: 1 November 2004.
Shortlist announced: 10 November
Deadline for submission of commissioned maquettes and detailed schedule: 25 March 2005
Exhibition of short listed proposals at the Jerwood Space: 6 April 2005
Announcement of Prize Winner, commission awarded: 19 April 2005

The Helen Keller International Award

Sense Scotland
5th Floor, Clydeway Centre
45 Finnieston Street
Glasgow G3 8JU
Tel: 0141 564 2444
Fax: 0141 564 2443
Text: 0141 564 2442
Email: arts@sensescotland.org.uk
Web: www.sensescotland.org.uk

American campaigner Dr Helen Keller established a fund entitled The Helen Keller Award in 1933, on a visit to Scotland. Initially the fund financed an annual essay competition. When Sense Scotland became trustees of the Award in 1989, it was transformed into a multi-media art competition on the subject of deafblindness, open to professional and non-professional artists.

The competition is open to any artist, with the only criterion being that work submitted must be on the subject of deafblindness, interpreted in the widest sense. Submissions may be in any artistic medium. Artists wishing to submit a piece of work to the competition must complete an entry form. An exhibition of the work is provisionally booked for early 2007 at the Collins Gallery, Glasgow.

Prize: £1,000 and a trophy. Two highly commended entries will receive £200 each and a certificate.

Award will be launched in October 2005.
Closing date: likely to be August 2006.

RSA John Kinross Scholarship to Florence

The Secretary
The Royal Scottish Academy
The Mound
Edinburgh EH2 2EL
Email: info@royalscottishacademy.org
Web: www.royalscottishacademy.org

The John Kinross Memorial Fund was established in 1982 by Mr JB Kinross CBE, HRSA in memory of his father, John Kinross RSA, a renowned architect who was greatly influenced by Florence.

The £1,400 scholarship is intended to assist students in Scotland within the disciplines of Painting, Sculpture, Printmaking and Architecture to live and study in Florence for a period of three months. The RSA also arranges a

galleries and museums pass for the students allowing them free access to the city's artistic and historical treasures.

The work programme could probably be in the form of drawings done in various museums, churches and outside environments in Florence, together with historical notes, perhaps made as a result of attending lectures. It is not intended that the 'study tour' should be available to one who simply wishes to follow his/her own inclinations.

Students eligible:
Painting, Sculpture and Printmaking – Students in their final or post-graduate years of study at one of the four Scottish Colleges of Art.
Architecture – Applicants must be senior students at one of the six Scottish Schools of Architecture.

Application forms available from colleges.

Kress Conservation Fellowship

Samuel H Kress Foundation
174 East 80th Street
New York, NY 1002
United States
Contact: Wyman Meers
Phone: +1 212 861 4993
Fax: +1 212 628 3146
Web: www.kressfoundation.org

The Kress Foundation offers ten $30,000 Conservation Fellowships for advanced museum-based internships in fine arts conservation. Funds are allocated as follows; $25,000 as a fellowship stipend, $5,000 towards administrative costs, benefits for the fellow, and other direct costs.

Eligibility: Restricted to individuals who have completed an MA degree in art conservation, and are for a one year internship.

Application: Application must be made by the museum or conservation research facility at which the internship will be based. Applications should include a brief description of the internship, the dates for the internship, the CV of the individual nominated, and 3 letters of recommendation.

Closing date: 1st March.

John Moores Exhibition

The Exhibition Assistant
Walker Art Gallery
William Brown Street
Liverpool L3 8EL
Phone: 0151 478 4199
Fax: 0151 478 4190
Web: www.biennial.org/johnmoores.htm

A biennial exhibition of contemporary painting. The next will be in 2006.

Prize: First (purchase) prize of £25,000 and four prizes of £2,500.

Application: For entry form and further information send SAE to the above address. A handling fee is payable on request of an entry form.

The exhibition is a collaboration between the John Moores Liverpool Exhibition Trust and the National Museums Liverpool.

National Museum of Women in the Arts (NMWA)

Library Fellows Programme
Library and Research Centre
National Museum of Women in the Arts
1250 New York Avenue
N.W.Washington 2000DC
United States
Contact: Leah R Davis, Library Assistant
Phone: +1 202 783 5000
Fax: +1 202 393 3235
Web: www.nmwa.org

The Library Fellows Program encourages and promotes the art of the book. The Program provides funds for the creation of new artist's books by book artists or artists of other media who are interested in creating a book.

Each year, one proposal for a new artist's book is selected and funding is provided for its creation. The artist who is responsible for the overall creation, design and realization of the book must be a woman. Technical assistance or literary collaboration in developing the book edition by both women and men is acceptable. Only new books will be considered. Previously published books or books which are versions of books previously published or planned for publication will not be considered.

Eligibility: Women artists.
Application: Request application form.
Closing date: 31st December annually.

New English Art Club Drawing Scholarship

New English Art Club Drawing School
PO Box 8760
Chelsea SW3 4ZP
Web: www.newenglishartclub.co.uk

The Scholarship comprises free involvement in selected Drawing School activities during the year and a cash prize of £500. At the end of the year's study there is an opportunity for a small personal exhibition in the Mall Galleries to run concurrently with the NEAC Annual Exhibition.

Applications: initially by CV and letter of intent on how the scholarship would be used. Portfolios of work may then be requested.
Closing date: September

The Alexander S. Onassis Public Benefit Foundation

1st International Competition (2006) for the Composition of an Original Painting.

Secretariat of the Onassis International Prizes
7, Eschinou str.
105 58 Athens
Greece
Phone: +30 210 37 13 000
Fax: +30 210 37 13 013
Email: pubrel@onassis.gr (for information only)
Web: www.onassis.gr/english/competition_prizes/paint.html

The Alexander S. Onassis Public Benefit Foundation runs a competition awarding three Onassis Prizes for the composition of an original painting. For full details see website.

Submission of works: Original works are not initially submitted but three 35 x 35 mm framed slides, professionally photographed. Each participating artist must submit the following supporting documents:

- Complete CV with particular emphasis on the artist's activities and the title of the submitted work and/or the identification mark.

- A certificate by an official Association of Visual Artists or other competent public authority, certifying the artist's membership and that one at least of the artist's works has received recognition at a national or international art exhibition. Otherwise that the participant artist is a graduate of a recognized School of Fine Arts.

- A declaration that his/her submitted work is original and has not been exhibited/exposed/published in any way or form and that it will remain so until the end of the competition unless the artist is otherwise notified by the Foundation.

- A declaration by the artist that the artist accepts unconditionally all the rules and regulations of the competition incorporated in the present announcement.

- A declaration that the artist undertakes to send or ship his/her original work within one (1) month from the date he/she will be requested to do so, in order to be exhibited for public viewing in Athens and in venues chosen by the Foundation for a duration of up to six (6) months from the day of the award of the prize.

Type of work: Paintings (only) of any sort for display on a wall, using any material and of a reasonable size, are accepted.

Selection process: All the works are submitted to a First Level Selection Committee, these are then submitted to a Second Level Selection Committee which will, in a joint meeting with the Onassis International Prizes Committee, propose to the Board of Directors of the Foundation up to ten of the works among which the Board of Directors will choose three.

Distinctions: The Foundation may decide to award distinctions accompanied by a monetary prize freely determined by the Foundation, to one or more artists who have participated in the competition and not been awarded a prize.

Prizes: Three monetary prizes are awarded as follows:

1st – 150,000; 2nd – 100,000; 3rd Prize – 75,000

Closing date: 31st March

The Pilar Juncosa & Sotheby's Awards

Fundació Pilar I Joan Miró a Mallorca
Joan de Saridakis 29
07015 Palma
Majorca, Balearics
Spain
Phone: +34 71 70 14 20
Fax: +34 71 70 21 02
Email: premibeques@fpjmiro.org
Web: www.a-palma.es/fpjmiro

Four types of grant are available. Some details vary from year to year so therefore check the website for any updates.

Entry is open to artists of any nationality, place of residence or age.

Closing date: 31st July

Grants announced: October

The Pilar Juncosa and Sotheby's Award

This is open to all fields of creativity. In 2004, the Foundation awarded the prize for works of art or installations created especially for the area of the Museum known as the "Cubic Space". The Jury was concerned with the artistic value of the projects entered, technical skills and any other innovative or experimental aspect that they deem important.

A total of 24,000 was awarded to the winning project: 12,000 for the project itself, and up to 12,000 for the actual creation of the project.

The winning project will be exhibited in the "Cubic Space" during October 2005.

The Pilar Juncosa Research Grant on Miró

The Foundaton awards the Miro Research Grant to further research into, and disemmination of information about, Joan Miro's life and work.

The grant totals 6,000. 3,000 to fund the work and 3000 for its publication.

Proposals submitted must not have been published previously. Research projects related to the Foundation's archives or its Art Collection or those that study Joan Miró's creative work in his Majorca workshops would merit special attention. The actual research work for the selected projects must be carried out during the six months following receipt of the Jury's decision.

The Pilar Juncosa Grant for an educational project

The grant is for the creation of educational projects, including both formal and non-formal education.

In 2004 this was specifically for an experimental educational workshop concerning plastic arts, to be held at the Museum.

The grant totals 6,000. 3,000 for the design and the running of the workshop and 3,000 for the production, costs of materials and the editing of a publication explaining the process of the work completed.

The Pilar Juncosa Grants for training, experimentation and creative work in the Miró's Graphic art Workshops

Amongst the aims of the Fundació Pilar i Joan Miró a Mallorca is the teaching and diffusion of printmaking, a medium much loved by Joan Miró. These

grants seek to offer help and provide the support needed for printing projects, to promote research and experimentation into different techniques and new methods in the field of graphic art, including all kinds of engraving techniques, woodcutting, lithography, silkscreen-printing, the application of new technologies, digital prints, photography etc.

The Foundation offered 10 grants in 2004. Two grants of 4,500 each for creation and experimentation in printmaking: 3,000 for the project itself, which must be completed in the Foundation's Workshops and 1,500 for the creation, purchase of materials and publication of each project.

Seven grants to fund courses run annually by the Miro's Graphic Art Workshops. Each grant consists of free registration for one of the workshops and up to 1,200 for travelling costs and expenses.

One grant for working in other graphic workshops on printing techniques, either national or international, of 3,000. Candidates awarded this grant must agree to submit a complete written account of the project undertaken within one month of finishing the workshop.

The Pollock-Krasner Foundation Inc.

863 Park Avenue
New York, NY 10021
United States
Fax: +1 212 288-2836
Email: grants@pkf.org
Web: www.pkf.org

The Pollock-Krasner Foundation's mission is to aid, internationally, those individuals who have worked as artists over a significant period of time. The Foundation's dual criteria for grants are recognizable artistic merit and financial need, whether professional, personal or both. The Foundation welcomes, throughout the year, applications from visual artists who are painters, sculptors and artists who work on paper, including printmakers. There are no deadlines. The Foundation encourages applications from artists who have genuine financial needs that are not necessarily catastrophic. Grants are intended for a one-year period of time. The Foundation will consider need on the part of an applicant for all legitimate expenditures relating to his or her professional work and personal living, including medical expenses. The size and length of the grant is determined by the artist's individual circumstances.

Application forms and guidelines can be downloaded from the website, or write, fax or e-mail your complete mailing address. Artists are required to submit a cover letter, an application, and slides of current work. Do not send application forms by fax or e-mail.

Reapplication Procedure – Applicants may reapply to the Foundation, whether recipients of grants or those who have been declined. All reapplicants must send slides of work not previously submitted.

Grant Restrictions – Applications not accepted from commercial artists, photographers, video artists, performance artists, filmmakers, crafts-makers or any artist whose work primarily falls into these categories. The Foundation does not make grants to students or fund academic study.

Selection Process – Selection is made by a Committee of Selection comprised of recognized specialists in the fields of the Foundation's concern.

Refocus Now Ltd.

Sixth Floor, 175 Piccadilly
London W1J 9TB
Phone: 020 7232 0168
Email: info@refocus-now.co.uk
Website: www.refocus-now.co.uk

Refocus-now run 4 competitions each year approximately one each quarter. These are:

Calendar Competition
International Open Image (IOI)
Fusion Competition
Originate Competition.

See website for further details.

Rootstein Hopkins Foundation Grants

Rootstein Hopkins Foundation
PO Box 14720
London W3 7ZG
Fax: 020 7381 2557
Web: rhfoundation.org.uk

The Rootstein Hopkins Foundation offers financial support to artists, art students, lecturers and designers in the form of travel grants, support grants, sabbatical awards, mature student grants and exchanges. The trustees will choose candidates they feel will make the best use of the grants to further their careers, and who can present a plan which seems likely to be realised within the grant period.

Types of grant available: Sabbatical Grant/Project Grant/Mature Student Grant/Exchange Student Grant.

Eligibility: Holders of British passports only.
Application: Apply in writing.
Closing date: January annually.

Royal Academy of Arts Summer Exhibition

The Summer Exhibition Office
Royal Academy of Arts
Burlington House
Piccadilly
London W1J 0BD
Phone: 020 7300 5929/5969
Email: summerexhibition@royalacademy.org.uk
Web: royalacademy.org.uk

The Royal Academy's Summer Exhibition draws together a wide range of new work by both established and unknown living artists. Held annually since the Royal Academy's foundation in 1768, it is a unique showcase for art of all styles and media, encompassing paintings, sculpture, prints and architectural

models. Well over 1,000 works are included and, following long Academy tradition, the exhibition is curated by an annually rotating committee whose members are all practising artists.

Any artist may enter work for selection. An artist is entitled to submit a maximum of three works and there is a handling fee of £18 per work.

Prizes: Over £70,000 will be given in prizes to cover work of all categories. This includes the prestigious Wollaston Award of £25,000.

Entry forms can be downloaded from the website.
Closing date: 23rd March for submission of entry forms.

Royal Birmingham Society of Artists

4 Brook Street
St. Paul's
Birmingham B3 1SA
Phone: 0121 236 4353
Fax: 0121 236 4555
Email: secretary@rbsa.org.uk
Web: www.rbsa.org.uk

The RBSA Gallery holds an annual Prize exhibition with a grand prize of £1,000. The show is open to submissions from all. A maximum of three pieces of 2D work may be offered, and six pieces for 3D artists. The exhibition is independently judged. Check the Exhibition Programme for dates of the Open exhibitions. Submission forms can be obtained form the RBSA Administrator.

The Royal Scottish Academy – Friends Bursary

The Royal Scottish Academy
The Mound
Edinburgh EH2 2EL
Contact: Administrator (Bursary)
Phone: 0131 225 3922
Web: www.royalscottishacademy.org/pages/friendsframe.html

This bursary is to enable artists to continue and extend their creative development. £2,000 is awarded to the artist who in the opinion of the judges submits the most meritorious and worth-while project for artistic development. It is intended to support such items as the cost of travel, research, periods of exploration or experimentation etc. and is available to artists qualified and working within the RSA disciplines of painting and drawing, sculpture, architecture and print making.

Eligibility: Artists permanently resident in Scotland. Applicants must have completed full-time education (including post-graduate study) at least three years before the date of application. Strong preference will however be shown for applications from artists over the age of 35 and/or who are able to demonstrate sustained commitment to the development of their art for a period of at least 10 years since qualification.

Closing date: June. Send SAE.

Royal Scottish Society of Painters in Watercolour

Royal Scottish Society of Painters in Watercolour
5 Oswald Street
Glasgow G1 4QR
Contact: Gordon C McAllister, Secretary
Tel: 0141 248 7411
Fax: 0141 221 0417
Email: enquiries@robbferguson.co.uk
Web: www.thersw.org.uk

Each year at the annual Exhibition the RSW offers encouragement to artists of all ages, both young and established, through generous financial awards. These reflect a commitment by the Society to promote and encourage member and non-member artists working in waterbased media. The prizes are awarded at the annual exhibition.

May Marshall Brown Award

This award is named after May Marshall Brown, an accomplished painter in oil, but mainly watercolour and etched landscapes and architectural subjects.

Award: £500.

Sir William Gillies Award

In memory of one of the founder members of the 1922 Group which included artists such as William MacTaggart and George Aright Hall. He visited Paris, studying with Andrew Lhote. He painted still lifes, interiors, and landscapes, in particular the villages of Midlothian and the fishing villages on the east coast. He was Head of Painting and Principal of Edinburgh College of Art.

Award: £500

John Gray Award

In memory of John Gray, whose early works were of fishing boats, harbours and east coast bays, painted in a 'direct style' on rough paper, to 'evoke the windswept atmosphere of the east coast'. He is best known, however, as a flower painter.

Award: £500.

Alexander Graham Munro Travel Awards

Awarded to an artist under 30, and presented in memory of Alexander Graham Munro, the Edinburgh artist best known for his landscapes and outdoor scenes, who travelled extensively throughout France, Western Europe and North Africa.

One award of £3,500 and one of £1,000.

RSW Council Award

This is presented to the most outstanding work at the Exhibition.

Award: £3,000.

Other Awards:

The Scottish Art Club Award
The Glasgow Arts Club Fellowship
Dundee Arts & Heritage Purchase Prize
Hospitalfield Residency in Visual Arts
Winsor& Newton Award – £500 Materials
Betty Davies SFI Award – £250

Royal Society of British Sculptors

108 Old Brompton Road
London SW7 3RA
Contact: Claire Foster (020 7373 5554)
Phone: 020 7373 8615
Web: www.rbs.org.uk
email: info@rbs.org.uk

Royal Society of British Sculptors Bursary

The RBS awards ten membership places for sculptors of outstanding talent in April each year. Open to applications from artists of all nationalities working in all styles and media, including installation, site specific, conceptual and video work.

The 10 winners will participate in a curated exhibition at the RBS Gallery in the autumn and will enjoy all the benefits of RBS membership for two years, becoming an Associate Member at the end of this time.

See website for application and submission details.

Royal Academy Bronze Casting Award

This annual award enables a graduate of the Royal Academy Schools to go into the foundry, Cine Sera in Hampshire, and produce work there to the value of £3,000. Winners of this award are given the opportunity to exhibit the work created in a solo exhibition at the RBS Gallery the following year.

Royal West of Engalnd Academy – Student Bursaries

Student Bursaries
Queen's Road
Clifton
Bristol BS8 1PX
Contact: Fiona Swadling, Marketing Officer
Phone: 0117 973 5129
Email: info@rwa.org.uk
Web: www.rwa.org.uk

The Academy annually invites applications for the RWA bursary. Two bursaries of £1,000 are available to students in final year undergraduate or first year postgraduate courses in painting, printmaking, sculpture and architecture. Application details for the bursary are available from late Autumn, the closing date for applications is the 31st March each year. For further details please contact the Marketing Officer at the RWA.

RSA Design Directions

8 John Adam Street
London WC2N 6EZ
Contact: Janet Hawken
Phone: 020 7451 6852
Email: design@rsa.org.uk
Web: www.rsa-design.net

RSA Design Directions aims to motivate and enthuse young designers to think from a different perspective and explore new contexts for design.

Design can create connections, change attitudes and effect change and designers can visualise and give life to radical ideas and solutions. Through its various projects, RSA Design Directions aims to stimulate the application of design thinking and processes to create inspired and innovative responses to a range of challenges and issues.

RSA Design Directions aims to encourage emerging young designers to engage with the broader social and environmental context in which they will work.

Closing date: December

Alastair Salvesen Art Scholarship

The Alastair Salvesen Scholarship
The Royal Scottish Academy
The Mound
Edinburgh EH2 2EL
Phone: 0131 225 6671
Web: www.royalscottishacademy.org

Sponsored by the Alastair Salvesen Trust in association with the Royal Scottish Academy, the Scholarship is intended to encourage young painters who have made the transition from college to a working environment. The prize should fund travel for three to six months. In addition the winner will be given a solo exhibition in the Royal Scottish Academy.

Applicants are normally aged between 25 and 35 and must be painters who:

- have trained at one of the four Scottish colleges of art.
- are currently living and working in Scotland;
- have worked for a minimum of three years outside a college or student environment; and
- have during 2004 had work accepted for exhibition in the Annual Exhibition organised by one of the following – the Royal Scottish Academy, the Society of Scottish Artists, the Royal Glasgow Institute of Fine Arts, the Aberdeen Artists' Society, Visual Arts Scotland, the Royal Society of Painters in Watercolours or, in a recognised gallery, have held a one-artists exhibition or participated in a group exhibition.

Closing date: usually January.

Sefton Open

Netherton Arts Centre
Glovers Lane
Netherton
Merseyside L30 3TL
Contact: Philip Wroe, Arts Project Officer
Phone: 0151 525 0417
Email: philipwroe@blueyonder.co.uk
Web: www.seftonarts.pwp.blueyonder.co.uk

Open competition aimed at contemporary artists working in any two dimensional medium apart from photography. The Sefton Open is held each autumn at The Atkinson Art Gallery in Southport and seeks to develop the audience for new and challenging art while providing artists from throughout the country and abroad with opportunities to showcase their work.

Prizes: 1st – £1,000. 3 prizes of £250

Dick Young Award of £500 to an artist based in Merseyside.

Closing date: September

Shrewsbury Open Competition

Shrewsbury Museum & Art Gallery
Barker Street
Shrewsbury SY1 1QH
Contact: Barbara Gillian, Competition Organiser
Phone: 07718 530060
Email: openinfo@shrewsbury.gov.uk
Web: www.vanetwork.co.uk

2005 sees the 4th Shrewsbury Open Art Competition. Shrewsbury is the birthplace of Charles Darwin. In 2005 the first Charles Darwin Symposium takes place, and takes the theme Climate Change. The theme of the Open Competition in 2005 is *Future Landscapes*, to link it to the symposium and to overall themes of human intervention and evolution.

Open to UK and international artists. Open to all art forms including new media. Shortlisted works will be exhibited and screened during the Shrewsbury 'This Is Art' Festival. For initial selection process send slides, photographs or for new media CDs, Videos etc.

Entry fee: £12 per piece. Up to two pieces may be submitted.
Closing date: 1st May

First Prize – £3,000.
Local Artist Prize – £1,000.
People's Choice Prize – £500.

Singer & Friedlander /Sunday Times Watercolour Competition

Parker Harris Partnership
PO Box 279
Esher, Surrey KT10 8QS
Phone: 01372 462190
Fax: 01372 460032
Email: SFwatercolour@parkesharris.co.uk
Web: www.parkesharris.co.uk

The competition is limited to paintings in any water based media, including gouache and acrylics.The competition is open to all artists born or resident in the UK. There are no age limits for artists wishing to enter. The paintings entered should have been carried out in the last three years and have not been previously exhibited. The artist must own the copyright of any works entered into the competition and, if selected for exhibition, agree for an image of the

work to be used for any publicity material relevant to the Singer & Friedlander/Sunday Times Exhibition.

Entry fee: £10 per work. Entry is free to full time art students at a recognised school of art. Artists may submit up to three works.

Prizes:1st Prize – £15,000; 2nd – £7,000.
Young Artist Prize (under 25) – £5,000.
3 further prizes of £1,000.

The Mark Tanner Award

Gallery Curator
Standpoint
45 Coronet St
Hoxton
London N1 6HD
Phone/fax: 0207 739 4921
Email: standpoint@btopenworld.com
Web: www.standpointlondon.co.uk

Mark Tanner was a sculptor who trained at St. Martins School of Art (1975-79) under Philip King and Anthony Caro. Working mainly in steel he was one of the first artists to exhibit at Standpoint Gallery. He died in 1998. The award was established in 2001 on the initiative of a private charitable trust to keep alive the passion and enthusiasm Mark had for the making of art.

The award is intended to subsidise the creative work of a suitable recipient over one year. The value of the award is £4.000 to cover the artists expenses, both in terms of time and materials, towards making new works which will be exhibited for the first time at the Standpoint Gallery in the following September/October. All costs of the exhibition, including publicity, advertising, private view and administration costs are covered by Standpoint.

Criteria: The award is for an artist who is a maker of sculptural objects within a fine art tradition who can show a mature body of work, a clear understanding of their practice and an ability to plan, organise and execute work within a professional setting. Financial and practical constraints limit applications from artists whose studio is within the Greater London area.

The selection process will take place during early July with the award announced in early September.
Closing date: end June

V&A Illustration Awards

Victoria & Albert Museum
South Kensington
London SW7 2RL
Web: www.vam.ac.uk (under Activities & Events/Events)
Contact: Annemarie Riding, Assistant Curator
Word & Image Department - Tel: 020 7942 2381

The V&A Illustration Awards are the premier awards for book and editorial illustration in the UK. The awards have been running since 1972 and previous winners include Quentin Blake, Michael Foreman, Ian Pollock, Ralph

Steadman, Posy Simmonds and Sara Fanelli. The V&A Illustration Awards are sponsored by the Enid Linder Foundation.

A panel of judges prominent in the arts, illustration and publishing, choose the winning illustrations from editorial publications, children's books, adult illustrated books and book covers.

Prizes of up to £2,500 can be won.

First (£1,000) and Second (£500) Prizes are chosen for the following award categories:

- Book Illustration
- Book Cover and Jacket Illustration
- Editorial Illustration

An overall winner is selected from the three First Prize winners to receive an additional £1,500, making the top prize £2,500.

- Student Illustrator (new in 2005)

Five commended winners will each receive £300. An overall winner will be chosen to receive an additional £1,000.

Closing date: July. April for Student Illustrator.

The Andy Warhol Foundation for the Visual Arts

Pamela Clapp, Program Director
The Andy Warhol Foundation for the Visual Arts
65 Bleecker Street, 7th Floor
New York, NY 10012
United States
Email: info@warholfoundation.org.
Web: www.warholfoundation.org

The Foundation's grant program is primarily focused on supporting institutions within the United States. However, in rare cases, they will make grants outside the United States and will accept letters of inquiry from arts institutions abroad. Include a brief description of the organization and of the project for which funding is sought. In limited cases, the foundation will then request a full proposal. Letters of inquiry may be sent to the address above.

Whitney Museum of American Art

Independent Study Program
100, Lafayette Street
New York, NY 10013
United States.
Contact: Ron Clark, Director
Phone: +1 212 431 1737
Fax: +1 212 431 1783

The Independent Study Programme (ISP) consists of three interrelated parts: the Studio Program, Curatorial Program and Critical Studies Programme. The ISP provides a setting within which students pursuing art practice, curatorial

work, art historical scholarship and critical writing engage in on-going discussions and debates that examine the historical, social and intellectual conditions of artistic production. The programme encourages critical study and theoretical inquiry into the practices, institutions and discourses that constitute the field of culture.

Studio Program

The twenty students participating in the Studio Programme each year are engaged in a variety of art practices including painting, sculpture, film and video making, photography, performance and various forms of inter-disciplinary work. They are provided with studio space in the programme's loft in downtown Manhattan. The majority are enrolled at universities and art schools and receive academic credit for their participation, while others have recently completed their formal studies.

Curatorial Program

The four Curatorial Fellows collaborate to produce an exhibition. Working closely with the program's faculty and curators at the Whitney Museum, the students develop proposals for the exhibition. Once a proposal has been approved by the Museum's curators, the students proceed to select art work, arrange loans and design and oversee the installation. They write essays for and participate in the production of an extended brochure that accompanies their exhibition.

Critical Studies Program

The six Critical Studies Fellows engage in individual scholarly research and critical writing projects. These projects take the form of a tutorial with a professional art historian, critic, or cultural theorist. The program's faculty arranges tutorials and provides additional advice and guidance. A symposium is held at the Whitney Museum each spring at which the Critical Studies students present their work to a larger community of artists, scholars and students.

The ten students participating in the Curatorial and Critical Studies Programs each year are designated as Helena Rubinstein Fellows in recognition of substantial support provided by the Helena Rubinstein Foundation.

The program's regular and visiting faculty members are available to meet individually with all members of the program to discuss their work or more general practical, theoretical or historical questions. Each week during the year a professional artist, critic or historian is invited to conduct a seminar at the programme. Members of the Studio, Curatorial and Critical Studies programs participate in these seminars which focus on the work of the seminar leader. In addition, all members of the programme participate in a weekly reading seminar in cultural theory and criticism led by the program's faculty. This seminar provides an occassion for the group to collectively study and discuss contemporary critical theory. There is a particular emphasis on alternative methodologies committed to the critical examination of the social and psychological factors that condition cultural production and reception. The programme runs mid-September to end of May.

Tuition for the program is $1,800 per year. Financial assistance in the form of reduced tuition is available on the basis of need. Participants must arrange for their own housing and supply their own materials. Each Curatorial Studies Fellow receives a stipend of $3,500 for the year in three installments. Stipends are not available for participants in the Studio and Critical Studies Programs.

Eligibility: Graduate students, candidates for advanced post graduate degrees,

and undergraduates with a demonstrated capacity for advanced scholarship or those who have recently completed formal academic study.

Application: In writing.
Closing date: 1st April annually.

The Woo Charitable Foundation Arts Bursaries

The Administrator, Arts Bursaries
The Woo Charitable Foundation
277 Green Lanes
London N13 4XS

The Foundation offers Arts Bursaries for artists who have completed their education at least 10 years previously. Approximately 5 Bursaries of £10,000 are awarded to artists working in the visual arts sector, both fine and applied. In this context visual arts includes fine arts and crafts, photography and mixed media.

Aberdeen Art Gallery & Museums Craft Commission

Aberdeen Art Gallery
Schoolhill
Aberdeen AB10 1FQ
Contact: Christine Rew
Phone: 01224 523
Fax: 01224 632133
Email: chrisr@aberdeencity.gov.uk
Web: www.aberdeencity.gov.uk (search - commision)

The National Collecting Scheme for Scotland (NCSS) is operated by the Contemporary Art Society with Funds from the National Lottery through the Scottish Arts Council. The Scheme is an innovative and proactive approach to collecting challenging works of applied and visual contemporary art for museum collections. Aberdeen Art Gallery & Museums is acquiring new works of applied and visual art through the scheme.

The Commission offers individual artists or those working collaboratively the opportunity to design and create a substantial piece of metalwork for Aberdeen Art Gallery & Museums Collections.

Artists, designers, crafts people and makers of all ages can apply. Applicants must either live or have been trained in Scotland. Collaborative applications are eligible; at least one of the collaborative partners must be living and/or trained in Scotland. Priority will be given to artists who demonstrate a commitment to metalwork and a desire to develop their current practice.

The Commission Fee is £15,000 to design and make a new piece of work. The work should be completed by end of July.

Deadline date for applications: 31 March
Short list announced: 28 April
Short listed applicants will be invited to submit a full proposal by: 30 June

Bombay Sapphire

The Bombay Sapphire Foundation
58 Queen Anne Street
London W1G 8HW
Phone: 020 7224 0994
Web: www.bombaysapphire.com

The Bombay Sapphire Designer Glass Competition is held annually to recognise excellence among emerging design talent. The aim is to design a functional martini glass inspired by the Bombay Sapphire brand.

The competition takes place each April in Milan during Salone del Mobile. One winning glass from each participating country is professionally

manufactured to be displayed and judged on site in Milan.

An original martini glass design must be submitted in jpeg form. The winner will be awarded with the physical creation of their martini glass, a trip to Milan and the opportunity to compete in the international finals.

Application: Via website.

The Archie Bray Foundation for the Ceramic Arts

2915 Country Club Avenue
Helena MT 59602
United States
Phone: +1 406-443-3502
Fax: +1 406-443-0934
Email: archiebray@archiebray.org
Web: www.archiebray.org

Fellowships

The Bray will award three fellowships in 2005: the *Taunt Fellowship*, the *Lilian Fellowship*, and the *Lincoln Fellowship*.

Each fellowship awards $5,000 and a one-year residency to a ceramic artist who demonstrates exceptional merit and promise. The Fellows are expected to embrace the Bray experience of community and creative exchange, and will have the opportunity to focus their attention to produce and exhibit a significant body of work during their residencies. Although non-renewable, artists may elect to extend their residency for up to a second year.

There are no prerequisite degrees for application/selection, and only one application is necessary to be considered for any of the three fellowships.

Submision details on website and application form can be downloaded.

Closing date: February. Winners notiffied by March 1. The residencies can then begin within the year.

Scholarships

Scholarships will be awarded to two of the ceramic artists coming to the Bray for summer residencies. *The Bill and Stirling Sage Scholarship* provides an $800 scholarship to a ceramic artist between the ages of 18-35, and *The Eric Myhre Scholarship* provides a $750 scholarship to an artist of any age who demonstrates exceptional merit and promise.

Those wanting to be considered for one or both of the scholarships need to submit a residency application and express an interest in receiving one of the scholarships in their letter of intent.

British Glass Biennale

The International Festival of Glass
Ruskin Glass Centre
Wollaston Road, Amblecote
Stourbridge
West Midlands DY8 4HF
Phone: 01384 399444.

Fax: 01384 399469
Email: information@ifg.org.uk
Web: www.ifg.org.uk

2004 saw the inauguration of a major new international glass festival. At least 100 major new glass works from British artists were shown, making it a significant statement of national glass talent. As part of the festival, a selling exhibition, 'British Glass Biennale' was held. The emphasis at the exhibition was on new works, made in the previous 24 months, which were available for purchase. All works submitted were placed before the jury panel anonymously and each piece judged on merit and not the reputation of the artist.

Open to: Craftspeople, artists and designers working in all areas of contemporary glass practice. Applicants must have been living and working in the United Kingdom for the last four consecutive years, for 2006 it will be from March 2002.

Submission: Submission fee is £20. Forms available from the address on the website. Images of up the three works can be submitted by slide or CD. Each piece must be predominantly glass, but can incorporate other materials.

Closing date: For 2006 likely to be the end of March.
Prize: £5,000 awarded to 'best in show' as judged by the Festival Committee.

David Canter Memorial Fund

c/o Devon Guild of Craftsmen
Riverside Mill
Bovey Tracey
Devon TQ13 9AF
Contact: Nina Fox, Secretary
Phone: 01626 832223
Fax: 01626 834220
Email: Nina@crafts.org.uk
Web: www.crafts.org.uk

The David Canter Memorial Fund provides financial assistance to those working in the Crafts; for special projects, travel for specific research and for educational work. Grants usually range between £500 and £1,000. The awards are usually made in the autumn, and the selection process falls into two stages: i) preliminary application using the application form, for short-listing; ii) short-listed applicants will be asked to send further information about their current work, together with 6 slides of recent pieces for final selection. At each round a different Craft discipline is the focus for the awards.

Biennial – next to be awarded in 2006.

Open to: Artists who have finished formal training, working full or part-time.
Application: Request application form.
Closing date: end of June for preliminary applications.

Inches Carr Trust Decorative Arts Bursaries

Robin Blair, Trustee
The Inches Carr Trust
2 Greenhill Park
Edinburgh EH10 4DW
Phone: 0131 447 4847
Fax: 0131 446 9520
Web: www.inchescarr.org.uk

Awarded for a period of study in the field of the Decorative Arts to professionals working in Scotland. Proposals for international study will also be considered. Each bursary will be for a sum of £4,000 and will be paid over a three month period. The purpose is to enable the recipient to develop a particular aspect of his/her work. The recipient is expected to demonstrate that a practical result will be achieved through the award. The award is designed to help established artists to develop their skills, applicants must have an established career history of not less than two years practice in the current craft. Bursaries are not awarded to students.

Closing date: May – annually. No set application form.

4th Cheongju International Craft Competition, Korea

Competition Dept.
The Organizing Committee of the Cheongju International Craft Biennale
755 Sajik 1-dong, Heungdeok-gu
Cheongju City
Chungcheongbuk-do
361-828 Republic of Korea
Phone: +82 43 277 2603
Fax: +82 43 277 2610
Email: competition@cheongjubiennale.or.kr
Web: www.okcj.org

The Cheongju International Craft Biennale 2005 takes place between 30 September and 23 October 2005. Both first-time entrants and well-established artists are invited to submit craftworks and artworks that creatively reflect the theme of "Hide and Reveal".

Categories: Metal/ Ceramics/ Wood and lacquer work/ Textiles/ Others (glass, paper, leather, bamboo, and stone craft, etc.)

Participation is open. Independent and joint presentations are both possible. One participant (or up to three for a joint work) may submit up to two works.

The prospectus, entry form, and the form for description of the artwork can be downloaded from the website.

Application Process
1st screening: July 1 – July 10. Results announced 18 July.
2nd screening: August 8 – August 19. Results announced 26 August.
Award Ceremony – September 29.
Exhibition: September 30 to October 23

Awards and prizes:
Grand Prize (One) $20,000 (includes purchase of artwork; trophy and citation)
Gold Prize (Four) $10,000 (including purchase of artwork; trophy and citation)

Silver Prize (One for each category) $2,500 (trophy and citation)
Bronze Prize (One for each category) $1,000 (trophy and citation)
Special Citation (Several for each category) Trophy and citation
Honorable Mention (Many) Citation

The Clerkenwell Award

Clerkenwell Green Association
Pennybank Chambers
33-35 St Johns Square
London EC1M 4DS
Phone: 020 7251 0276
Email: info@cga.org.uk
Web: www.cga.org.uk

The Clerkenwell Award aims to help craftspeople set up in business in their own workshop. It subsidises the cost of a workshop during the first 18 months of setting up and provides an ongoing package of business advice and support. A wide range of craft and design disciplines are supported with particular emphasis on jewellery, textiles, glass ceramics and illustration.

The workshop must be in one of the four city fringe boroughs – Islington, Hakney, Tower Hamlets or Camden.

Applicants must have completed a recognised course within the last five years and be planning a first business venture.

Application: Must be made on the Clerkenwell Award application form and accompanied by a business plan, a curriculum vitae and slides/photographs of work. You must be a member of the Clerkenwell Designers Network to apply.

Applications are considered on an ongoing basis with interviews usually being held about four times per year. Up to 12 Awards are allocated each year.

Coburg Glass Prize

Kunstsammlungen Der Veste Coburg
Veste Coburg
D-96450 Coburg
Germany
Phone: +49 9561 8790
Fax: +49 9561 87966
Email: glaspreis@kunstammlungen-coburg.de
Web: www.kunstsammlungen-coburg.de

The Kunstsammlungen der Veste Coburg is organising its third international competition for contemporary European art glass. The competition is open to glass artists resident in Europe.

Main Criteria: participants must have pursued a professional career as a glass artist for at least five years (including their training period) and have a workshop in Europe. There is no age limit. All the works entered for the competition must have been produced in the year before the entry deadline. The works should not have been entered for any other competitions. Flat glass/stained glass is excluded.

The closing date for submission of photographs to the preliminary selection panel is 30 June 2005. Preliminary selection made September, final selection made December, presentation of prizes April 2006.

Entry forms available for downloading from the Kunstsammlungen's website.

Prizes: 1st prize – 15,000, 2nd – 10,000, 3rd – 5,000. The jury can also divide the prize money differently, should it wish to.

A special prize for glass engraving worth 2,000 will be donated by the Kurt Merker company, Kehlheim. Other prizes will be sponsored by public and private bodies.

Commonwealth Arts and Crafts Awards

Commonwealth Foundation
Marlborough House
Pall Mall
London SW1Y 5HY
Tel: 0207 930 3783
Fax: 0207 839 8157
Email: geninfo@commonwealth.int
Web: www.commonwealthfoundation.com

The Commonwealth Arts and Crafts Award is an award scheme for young artists and craftspeople, sponsored by the Commonwealth Foundation. Every two years, up to ten awards are made to craftspeople and artists, aged between 20 and 35, who show promise and initiative in their own country but who have had little opportunity of working in another country.

The award, which will range between £3,000 and £6,000 (depending on the country being visited and the length of the visit), is intended to help winning artists explore their art in another Commonwealth country by working alongside other artists or within an arts institution for a period of between three and six months. Normally the payment covers airfares, fees, living expenses and the cost of mounting an exhibition.

Closing date: 31 March.
Entry forms can be downloaded from website.

The Ernest Cook Trust

Fairford
Gloucestershire GL7 4JH
Phone: 01285 713273
Fax: 01285 711692
Email: grants@ernestcooktrust.org.uk
Web: www.ernestcooktrust.org.uk

The Trustees are particularly interested in applications which provide opportunities for young people; these may either encourage the latter to gain qualifications to further their employment prospects, or they may assist training in crafts which are in danger of dieing out. The Trustees are keen to support applications which educate people about the rural environment and the countryside. However, grants are also awarded for projects which educate young people in the arts, particularly if such work is linked to schools and the

National Curriculum. Grants range from £100 to £3,000 in the small grants category, of which modest amounts for educational resources for small groups form a large part. There are also grants in excess of £3,000.

Application: see website for details.

The Craft Pottery Charitable Trust: Annual Awards

c/o Liz Gale
Trustee and Secretary to the Trust
Taplands Farm Cottage
Webbs Green, Soberton
Southampton SO32 3PY

The trust makes annual awards in line with the following criteria:

- Awards are made to persons in ceramics
- The benefit should apply as widely as possible
- For the preparation of books, travel, film, conference attendance and organisation and other ceramic projects

The trustees will not support grants towards formal education, student exhibitions or subsistence and living expenses.

The trustees have only limited funds available for allocation, therefore the maximum sum awarded is £1,000, however applicants are encouraged to apply for lesser sums.

Closing date: 15th December each year.

Applications: Send SAE for guidelines and application form.

Crafts Council Development Award

Crafts Council
44a Pentonville Road
London N1 9BY
Phone: 020 7278 7700
Fax: 020 7837 6891
Web: www.craftscouncil.org.uk

The Crafts Council Development Award (previously the Setting Up Scheme) helps craftspeople to set up a creative practice. The Award provides financial and business support for those at the start of their creative career, over the course of one year. The scheme has no limits to the number of awards, which are granted and no specific number per discipline.

The Development Award is a one year scheme offering the following support:-

- A maintenance grant of £2,500 that is divided into four payments over one year, and is intended to assist with the costs of funding the practice and general subsistence.
- Equipment grant which can be up to £5,000 of which the Crafts Council contributes 50% of all eligible purchases. 33.3% can be used towards purchasing marketing equipment such as cameras or computers
- One-to-one support from a Professional Development Officer.

- Access to a creative mentor.
- A residential course in business training, aimed specifically at the small creative practices targeting areas where creative practices need the most support, e.g. Marketing, Press, Intellectual Property, and Financial Management.
- The provision, free of charge, of 1,000 postcards.
- Two studio visits by a designated Professional Development Officer who will assess their equipment needs, workshop's suitability and offers advice about the work, direction and sales opportunities.
- Inclusion on the Crafts Council's Photostoreâ, which is a selected visual database available to everyone who wishes to source suitable makers, including architects and the press. Photostoreâ is housed at the Crafts Council and can also be accessed through 13 venues across England.

Eligibility: Applicants must have completed their studies, although applicants require no formal education to apply for the Award and the Crafts Council welcomes applications form second careerists. There is no minimum or maximum age limit.

Applicants need to be about to or have practised as a craftsperson for no more than three years, and must live and work in England and be resident for tax purposes. The Scheme is open to non UK nationals as long as they fulfil this condition upon application.

Applicants cannot apply solely with work that has been produced whilst training for an academic qualification.

Applicants must plan to spend the majority of their time in the workshop. For full details see website.

The Crafts Council supports makers working with ceramics, glass, metal, wood, textiles, leather & plastic. Those working in other materials may be eligible.

The annual deadlines for the Crafts Council Development Award are: March 1st, June 1st, September 1st, and December 1st.

Crafts Council 100% Design Bursary

100% Design
Oriel House
26 The Quadrant
Richmond TW9 1DL
Phone: 020 8910 7724
Fax: 020 8910 7985
Email: janine.keal@reedexpo.co.uk
Web: www.100percentdesign.co.uk

The Crafts Council/100% Design Bursary Scheme was established in 1997 to make it easier for smaller companies to exhibit at 100% Design, and since then has helped more than 70 designers-makers.

It is the only show of its kind where the country's most talented young designers show alongside world-renowned manufacturers in a commercial environment.

Open to: UK-based designer-maker (excl. Northern Ireland) producing furniture, lighting, wall/floor coverings, textiles or accessories for the contemporary interior, and have not previously exhibited on your own stand at 100% Design, you may be eligible for one of 100% Design/Crafts Council bursaries.

In 2004 there were 5 Crafts Council Bursaries. Each winner received 50% discount against the cost of their stand space at 100% Design 2004 – the equivalent to £900 discount on a 6m² stand.

Successful winners also received a further 25% discount off their stand costs for the next 3 years.

Criteria: You must be based in the UK (excluding Northern Ireland).
You should not have exhibited independently at a previous 100% Design (but can have shown as a sharer or on a group stand).
Your designs must demonstrate an appropriate marriage of craft and design skills, an awareness of materials and the ability to produce commercially viable products.

Products must be appropriate to the event, new and non-derivative. 100% Design is a show for high quality contemporary interiors products that are suitable for contract or domestic applications – the primary content of the show is furniture, lighting, fabrics, kitchens and bathrooms, wall and floor coverings, architectural hardware and fittings and interior accessories.

Application: Download from website.

Design and Decoration Awards

National House
121-123 High Street
Epping CM16 4BD
Phone: 01992 570030
Fax: 01992 570031
Email: info@designanddecorationawards.co.uk
Web: www.designanddecorationawards.co.uk

The Design & Decoration Awards celebrate the best in interior, garden and product design, whatever the style.

The awards are open to:

Projects – Interior architects, interior designers and decorators, landscape architects, garden designers and end users/clients.

Products – Designers, manufacturers, distributors, importers and end users.

Entries must have been launched or completed between 1 January 2004 and 18 March 2005.

Entry fee payable. Entry form can be downloaded. See website for full details.

Embroiderers' Guild Scholarship

Embroiderers' Guild
Apt 41, Hampton Court Palace
Surrey KT8 9AU
Phone: 020 8943 1229
Fax: 020 8977 9882
Email: administrator@embroiderersguild.com
Web: www.embroiderersguild.com

The Embroiderers' Guild Scholar award of £1,000 each are awarded annually to embroiderers to develop the practice of embroidery. One scholarship is for embroiderers in the age category 18–30 years, and one for embroiderers over 30 years of age.

The Guild promotes embroidery as being all work stitched or derived from stitch. Applicants should have studied the practice of embroidery or stitched textiles through formal or informal learning. Scholarships are to support embroiderers to undertake projects which further their own practice.

Working with the Embroiderers' Guild during the Scholarship year provides each Scholar with opportunities to be introduced to the Guild's network of members, branches and practicing professionals. The Guild holds additional funding to enable them to participate in Guild activities (e.g. The Knitting and Stitching Shows).

Application: Send a SAE.

Embroiderers' Guild – art of the STITCH

Embroiderers' Guild
Apt 41, Hampton Court Palace
Surrey KT8 9AU
Phone: 020 8943 1229
Fax: 020 8977 9882
Web: www.embroiderersguild.com

International Open Biennial Exhibition.

Open to all artists, this major exhibition, presented by the Embroiderers' Guild in association with Coats Crafts UK, aims to represent the diversity of contemporary embroidery. Works may be in any medium or on any theme stitched or derived from stitch.

Eligibility:

- Work must demonstrate one or more of the following: incorporation of/use of/reference to/inspiration from stitch.
- Work must not exceed 3 metres in height.
- Work framed with glass will not be accepted (work framed with perspex or acrylic will however be accepted).
- Only work commenced after August 2004 will be eligible and must not have been previously exhibited in an open-submission exhibition.
- There are no rules regarding who may apply except that applicants must be aged 18 or over. There are no other limitations on eligibility.

Submission: Applications only accepted by post on the official entry form, which can be downloaded from the website. Applicants may enter up to 3 works, each accompanied by its own entry form. If an entry is multi-part, it must have been conceived and created as a single entity. Each work should be represented by 2 x 35mm slides only. One slide must show the entire work as it would be displayed, including frame or other presentational setting. The other slide should be a detail which will help the selectors understand the method of technique and/or construction. Time-based media (VHS pal tape only) will only be accepted to represent time-based work, and is limited to 5 mins.

Selection: While reference may be made to supporting information, the selection panel's decisions are based on the slides (or video representing time-based media) submitted. Therefore their quality is very important.

Entry fee: £12.00 per entry (£10.00 for Embroiderers' Guild Members)

Closing date: 25 Nov 2005. Selected works announced early Feb 2006.

Prizes: Anchor Awards presented by Coats Crafts UK
The Anchor Award, £1,000. Most outstanding exhibit.
Anchor International Award, £500. Most outstanding exhibit by an artist not primarily resident in the UK.
Anchor Innovation Award, £500. Most outstanding exhibit developed through innovative use of stitch.
Anchor Student Award, £500. Most outstanding exhibit by an artist who has completed an accredited further or higher education art or craft course since January 2001.

European Ceramic Work Centre

EKWC
Zuid Willemsvaart 215
5211 SG's- Hertogenbosch
The Netherlands
Phone: +31 73 612 4500
Fax: +31 73 612 45 68
Web: www.ekwc.nl

ekwc is a workshop where participants and staff members explore the artistic and technical possibilities of ceramics as a medium. Experiments are being conducted to find new ways of presenting ceramics. About 44 participants a year, artists, ceramists and designers, get the opportunity to work for a continuous or phased period of three months. Participants enter in three different ways: through worldwide public application (20 vacancies), through a competition for recently graduated art students (4 vacancies) and through invitation (20 vacancies).

There are 2 ways to apply:

Individual work period

Intended for professional artists, designers and architects who would like to learn more about ceramics as a medium or to acquire more in-depth knowledge of ceramics. Only candidates with an academic education and who have worked as independent professionals for at least two years will be considered. An international selection committee will assess the applications that come in through the annual public application round. The selection will be based on documentation of the last five years work and an activity plan.

Work period with a stipend for young applicants

Candidates under the age of thirty can apply for an individual work period for young participants. This work period is intended for candidates who graduated less than two years ago from an academy of art and/or design. At the ekwc, they can learn about ceramics as a medium or increase the knowledge they already have. A three-month work period at the ekwc often provides a good impulse for building up a professional career. The ekwc provides young participants with a grant and a budget for materials. An internal selection committee assesses the applications, based on documentation of the last few years' work (including the final project), an activity plan and references from teachers and/or supervisors.

The next round of applications will be 1 May 2006 for a work period in 2007.

Charles Henry Foyle Trust Award for Stitched Textiles

Forge Mill Needle Museum
Needle Mill Lane
Riverside
Redditch B97 6RR
Phone: 01527 62509
Contact: Jo-Ann Gloger

Annually Redditch Borough Council and the Charles Henry Foyle Trust jointly organise an award for Stitched Textiles. The first prize of £2,000 is to enable the recipient to further their artistic development by funding either educational travel or advanced study in the field of textiles. In addition, two further awards of £500 will be made for technical excellence.

The intention is to promote the work of new and promising textile artists. Students who are interested in taking part will be asked to submit up to 5 slides of their current work with one slide showing details of stitching.

Closing date: November.

The Glass Sellers' Prize & Student Award

London Glassblowing Workshop
7 The Leather Market
Weston Street
London SE1 3ER
Phone: 0207 403 2800
Fax: 0207 403 7778
Email: info@londonglassblowing.co.uk
Web: www.londonglassblowing.co.uk

Two awards are made by the Worshipful Company of Glass Sellers: The Glass Sellers' Prize and The Glass Sellers' Student Award.

The awards recognise originality and talent in the use of glass as a medium of artistic expression. They are presented for the artistic and technical excellence of submissions predominantly in glass but specifically excluding stained glass windows. Entrants should submit one work, although this may include components forming a single work. Pieces submitted must have been produced during 2004/5, and must not exceed 1.5 metres in the largest dimension.

Entrants for the Student Award may submit up to three pieces and they must currently be studying or be within three years of graduating. Student finalists will receive travel expenses up to a maximum of £75.

Prizes:
The Glass Sellers' Prize – £4,000
The Glass Sellers' Student Award – £1,000
Runners up prizes may also be awarded at the discretion of the judging panel.
Closing date: 31 May 2005.

HI-Arts Makers Awards Scheme

HI-Arts
4th Floor, Ballantyne House
84 Academy Street
Inverness IV1 1LU
Contact: Maggie Dunlop, Funding & Liaison Manager
Phone: 01463 717091
Fax: 01463 720895.
Email: maggie@hi-arts.co.uk
Web: www.hi-arts.co.uk

Scheme established to support craft workers and makers based in the Highlands and Islands of Scotland by helping to meet the costs of a range of activities which can assist the development of an individual artist's practice.

Grants of up to £500 are available to support initiatives which will assist individuals to develop and extend their own personal practice. This can include, for example:

- Travel and subsistence costs to attend a major conference or symposium or to visit galleries with a view to future exhibitions of your work.
- Training costs related to extending your practice (eg into a new medium)
- Costs of preparing for an exhibition (eg framing, packing, etc).
- Research and development costs for a new project.

Applications for projects costing more than £500 must indicate how the balance of the costs will be funded.

Eligibility: Makers who have been resident in the Highlands and Islands for at least 12 months prior to the date of application to the Fund.

This scheme is a 'rolling programme' of decisions. Applications can be submitted at any time, but not less than eight weeks before the start of the project or activity for which the funding is sought. Application forms can be downloaded from website.

The Jerwood Applied Arts Prize

Crafts Council
44a Pentonville Road
London N1 9BY
Phone: 020 7278 7700
Fax: 020 7837 6891
Web: www.craftscouncil.org.uk

The Jerwood Prize celebrates design and innovation in contemporary craftwork made by individuals in the United Kingdom and encourages its appreciation, understanding and collection.

The Prize showcases work from different disciplines in a 6 year cycle: Metal, Jewellery, Ceramics, Textiles, Glass, Furniture. 2005 was Metal and the next prize in 2006 will be Jewellery. The prize is awarded by the Jerwood Charity to the individual who, in the opinion of the independent judging panel, has made the most significant contribution to contemporary craftwork, demonstrating commitment, excellence and innovation over the past six years.

There is no age limit, however students are not eligible. Applicants must have lived and worked in the United Kingdom for not less than the last three

consecutive years. Application fee of £15.00.

Closing date: January.
Prize: £30,000.

Theo Moorman Charitable Trust

14a Oakfield Road
Clifton
Bristol BS8 2AW
Contact: Lisa Harms
Phone: 029 20 530125
Fax: 029 20 530125
Email: lisa@theom.freeserve.co.uk

The Theo Moorman Trust was set up in 1985. Its aim is to enable weavers to enjoy artistic freedom in order to contribute to the development of the craft and the education of future craftsmen.

Bursaries are awarded to enable weavers: to purchase special equipment to pursue their craft in a creative manner; to enjoy a sabbatical period to reassess the creative nature of their work; to take a specific project or projects in furtherance of their craft which might not be ordinarily possible; to develop the craft in any other way which is approved by the trustees. Grants may be given for travel overseas as part of a project. Grants vary between £500 and £5,000.

Application: Request application form.
Closing date: March 2006 (biennial).

The Queen Elizabeth Scholarship Trust

The Secretary
No 1 Buckingham Place
London SW1E 6HR
Email: qwest@rwha.co.uk
Web: www.qest.org.uk

The Queen Elizabeth Scholarship Trust makes annual craft awards to fund further study, training and practical experience for men and women who want to improve their craft or trade skills. Scholarships are not awarded for buying or leasing equipment or premises or for funding courses in general further education. Grants of between £2,000 and £15,000 are offered. The amount of each award depends on how much funding is needed for a project. Scholarship winners also receive an emblazoned certificate and an engraved sterling silver medal.

The Trust are looking for well thought out proposals which will contribute to the excellence of modern and traditional British crafts. Applicants need to explain clearly why the proposed training experience will improve their skills, and what they expect to achieve as a result. A careful estimate of the full cost of the training also needs to be provided.

Open to: A huge range of modern and traditional crafts are covered. Scholarship winners have included; an antiques restorer, a ceramic artist, calligraphers, a digital photographer, farriers, glassmakers, upholsterers etc..

There is no age limit. Applicants need to be able to demonstrate that they have already developed a high level of skill, and show that they are firmly committed to their craft or trade. Applicants must live and work in the UK.

Application: Forms can be downloaded from the Trust's website or send an A4 self-addressed envelope.
Closing date: Scholarships are awarded twice a year – in spring and autumn.

Scottish Arts Council

12 Manor Place
Edinburgh EH3 7DD
Phone: 0131 226 6051
Fax: 0131 225 9833
Web: www.scottisharts.org.uk
Help Desk: 0845 603 6000 (local rate within the UK).

The Crafts Strategy states that all crafts, including Scottish indigenous crafts, should make a dynamic contribution to contemporary culture and the economy.

For individuals

Support is given to:

- Professional development. Short-term or one off training courses, conference fees, mentoring, research etc. Minimum £75 – maximum £2,000

- Start Up – To encourage new makers with a high level of creativity and skill, who have a viable development plan, to establish themselves as practitioners in Scotland. Funding is available to assist with maintenance and the cost of equipment for production.
 Minimum £3,000 – maximum £8,000

- Creative Development – To encourage established makers to create new work. Funding is available to buy time and/or additional equipment to develop work in new directions and promote the results.
 Minimum £5,000 – maximum £8,000

For organisations

Support is given to:

- Projects which ultimately improve the quality and quantity of crafts exhibitions.

- Related educational programmes, shown, initiated and circulated in Scotland.

Evelyn Shapiro Foundation Fellowship

The Clay Studio
139 North 2nd Street
Philadelphia PA 19106
United States
Contact: Artistic Director, Jeff Guido
(215.925.3453 x18 or email jeff@theclaystudio.org)
Phone: +1 215 925 3453

Fax: +1 215 925 7774
Email: info@theclaystudio.org
Web: www.theclaystudio.org

The Clay Studio offers the Evelyn Shapiro Foundation Fellowship, a one-year artist residency. The Fellowship provides a 180 square foot studio space, a monthly stipend of $500, a materials and firing allowance, access to gas and electric kilns, access to glaze materials, the opportunity to teach for pay in the Studio's school and to exhibit work in the Studio's gallery and shop. There will also be a solo exhibition for the recipient in the fall of 2006 with a small catalogue. The residency runs from September 1, through August 31.

The focus of the work of the Fellowship recipient will alternate annually between functional work/vessel oriented work (even years) and sculpture/ installation oriented work (odd years).

The incoming fellow will become part of a community of 11 other Resident Artists. He/she is expected to participate in the program fully, sharing the same duties as those of other Resident Artists including the maintenance of the studio spaces and a small amount of volunteered time to The Clay Studio.

Applicants will be judged by an independent three-member jury and will be notified by the third week of April. All applicants are strongly encouraged to visit The Clay Studio prior to submitting an application.

Application must include; a completed application form, a resume, artist statement, a personal statement, and ten slides of recent work. There is no application fee.

Closing date: 31st March.

Tasara, Centre for Creative Weaving, India

Phone: +91 495 414 233
Web: www.tasaraindia.com

Tasara is an institution dedicated to creative weaving situated in Beypore, on the west coast of Kerala. Established in 1989, Tasara (Weaver's shuttle in Sanskrit) is an extension of the family's long standing tradition in weaving. Tasara attracts artists and weavers from all over the world. They provide a basis for research workshops and ongoing training programmes on weaving and allied techniques. The Tasara technique practised is unique to the centre and has given a whole new dimension to contemporary tapestry weaving. Applying dyes directly onto the warp allows for active spatial arrangements and surface layering of colours providing a far greater potential for artistic expression. Individual looms with experienced weaving assistance will be provided during the tenure. Participants will acquaint themselves with the unique Tasara weaving techniques and a number of other weaving practices. Tasara is open to explore individual interests in creative and natural dyeing, printed and woven furnishings and fashion fabrics developed as fine art.

Duration is one to three months. The monthly fee for the artist in residence is $750. This includes all expenses such as raw materials for weaving, food and accommodation.

Application: In writing. Please apply by sending photographs of your work, CV and time of your preferred period.

Textile Industry Awards

Textile Institute
1st Floor, St James's Buildings
Oxford Street
Manchester M1 6FQ
Phone: 0161 237 1188
Fax: 0161 236 1991
Email: tiihq@textileinst.org.uk

The purpose of these awards is to honour and encourage young people of outstanding talent and proven ability employed by companies within the weaving sector of the UK textile industry.

Young Weaver of the Year

Applicants for this award must be employed as weavers, technicians or operators concerned with weaving machinery, the preparation of yarn or other processes directly related to weaving. They should be able to demonstrate their commitment to become better qualified and the particular contribution they are making to their companies, at whatever level.

Young Designer of the Year

This award is open to designers who have a textile design qualification and minimum two years' work experience. Applicants must be able to show that they are making a significant or particular contribution to their companies' ranges and business development.

Young Manager of the Year

Applications are invited from people with appropriate qualifications and at least two years' experience in a managerial position within the textile industry, who can demonstrate their contribution to the development of their employer's business.

All applications must have the endorsement of the applicant's employer.

Candidates must be British subjects who are less than 29 years on the closing date for applications and employed in the weaving sector of the United Kingdom textile industry.

Self-employed designer/weavers may also apply. Previous title-winners are not eligible to re-apply for the same award, but winners of a Commendation or other subsidiary award may do so.

Application forms can be downloaded from website.
Closing date: 30th September.
Prize: £1,000 for each award.

Vetrate Artistiche Toscane – Apprenticeship in Tuscany

Vetrate Artistiche Toscane Snc.
Via della Galluzza 5
53100 Siena
Italy
Contact: Gianni Bracciali
Email: info@glassisland.com
Web: www.glassisland.com

Vetrate Artistiche Toscane is based in Siena and specialises in the creation of

stained, painted and fused glass. The Studio handles both original commissions and restoration work and is equally skilful in religious or secular/commercial objects as well as modern designs with an emphasis on fused glass.

Three-month apprenticeships for those working in fused and stained glass start each January, April, July and October in Italy. English is the studio's working language. The apprenticeship is held in Sienna, Italy.

Application: Apply in writing.

Women's Studio Workshop

P.O. Box 489
Rosendale, NY 12472
United States
Phone: +1 845.658.9133
Fax: +1 845.658.9031
Email: info@wsworkshop.org
Web: www.wsworkshop.org

The Women's Studio Workshop's mission is to operate and maintain an artists' workspace that encourages the voice and vision of women artists. They provide professional opportunities and employment for artists at various stages in their careers, and promote programs designed to stimulate public involvement, awareness and support for the visual arts.

Studio Residency

The Women's Studio Workshop is currently offering a six week residency for an artist working in printmaking, papermaking, photography, book arts, or ceramics. This grant includes a $2,000 artist's stipend, a $500 materials budget, a travel stipend, housing, and unlimited studio use. This residency is to support the creation of new work in one of WSW's studio disciplines.

The Women's Studio Workshop welcomes applications from artists in all stages of their career. International applicants are encouraged to apply.
Closing date: 1 April.

This grant is pending funding from the National Endowment for the Arts. While not guaranteed, WSW has received support for this program for the last several years.

Independent Work

WSW Fellowship Grants are designed to provide concentrated work time for artists to explore new ideas in a dynamic and supportive community of women artists. WSW welcomes applications from emerging artists.

The facilities feature complete studios in intaglio, silkscreen, hand papermaking, photography, letterpress, and clay. Two to six week sessions are available each year from September through June.

Fellowships are awarded through a jury process. The cost to Fellowship recipients is $200 per week plus materials, approximately one fifth the cost of the actual residency. The award includes on-site housing and unlimited access to the studios. Artists are given a studio orientation but should be able to work independently. Technical assistance is available for an additional fee.

Closing date: 15 March & 1 November.

Special Ceramics Fellowships

WSW's Ceramics Program is now entering its seventh year. Our fellowships in ceramics are available to artists seeking a block of uninterrupted work time in our clay studio within a supportive environment. Two- to six-week sessions are available each year from September through June.

WSW offers a limited number of special fellowships to potters who make bowls for the annual WSW Chili Bowl Fiesta fund raiser. Potters who will make fifty glazed bowls or 100 bisqued bowls will receive a half-cost fellowship, so the pots plus $200 will cover a two-week residency. Please be sure to indicate on your application that you are interested in this opportunity.

Fellowships are awarded through a jury process. The award includes on-site housing and unlimited access to the studio. Artists are given a studio orientation but should be able to work independently.

International applicants are encouraged to apply.
Closing date: 15 March & 1 November

Artists' Book Residency Grants

These awards enable artists to produce a limited edition book work at WSW. Working intensively in our studios for six weeks, artists print and bind their own book works. WSW provides technical guidance and advice and, when possible, help with editioning. WSW will teach appropriate skills when necessary.

The grant includes a stipend of $2,000 for six weeks, materials up to $450, access to all studios, and housing. International applicants are encouraged.

Artists' Book Production Grants.

These awards are for artists working off site. They are designed to assist artists working in their own studios with the publication of smaller scale projects. Funds cover production costs up to $1,000. They are not intended for re-issuing already published material. If used as partial funding for a larger project, proof of the additional funds will be required.

Closing date: 15 November

Worshipful Company of Glaziers

The Glaziers Company
9 Montague Close
London Bridge
London SE1 9DD
Phone: 0207 403 3300 or 0207 403 6652 (also fax)
Email: info@worshipfulglaziers.com
Web: www.worshipfulglaziers.com

The Company offers a number of awards which cater for a wide spectrum of postgraduate training and experience.

The Stevens Competition

A competition for Architectural Glass Design. Each year, a different subject for the competition is stipulated on the website. In 2005 the competition was to design a backlit panel for the reception and waiting area of the radiotherpay department of the new UCL Hospital, London.

Entrant must be resident or employed in the United Kingdom and fall within one of the following categories:

- A student at a recognised Art School or College
- A student of a Private Artist
- An Artist employed by a commercial firm, aged 30 or under
- Self-employed in the Craft, aged 30 or under.

First Prize is the *Brian Thomas Memorial Prize* of £1,000. The Second Prize is £500 and the Third £350. In addition the *John Corkill Memorial Prize* of £250 is awarded to the entry which in the opinion of the judges is the best presentation and layout of a design, and the *George and Evelyn Gee Prize* for Craftsmanship of £250. Commendations and additional monetary awards may be given to other entrants who, in the opinion of the judges, merit recognition.

Eligibility details are on the website. Entrants must be resident or employed in the United Kingdom.

The Award for Excellence

A forty-week enhanced work experience programme for a graduate from a stained glass course, open also to applicants from courses in further education. Runs from September to June. The programme is tailored to the needs and interests of the award winner, and offers the opportunity for further training in a variety of studios, under the guidance of experienced professional designer/makers. The award emphasises the development of practical skills in a working environment. Placements can be arranged with conservation studios and those working with new design in stained and architectural glass. Short placements can also be agreed with individual artists and designers. A three week placement with a European studio is usually possible.

A monthly allowance of £720 is provided to assist with subsistence, rent and travel costs for the duration of the award. In addition the Company will pay the award winner's subscription to the British Society of Master Glass Painters for one year. Award winners are encouraged to attend lectures organised by the BSMGP and the Glaziers Company.

The Ashton Hill Award

Biennial award providing a ten-week placement, with financial support, in an accredited Conservation Studio. It is open to a recent graduate or promising trainee interested in broadening his or her experience in stained glass conservation or glass painting, with a view to making a career in this field. Candidates must be resident or employed in the United Kingdom. Although good basic hand skills and background knowledge are essential, glass conservation experience is not considered as important as an active interest and commitment to the subject, and a willingness to learn.

Two awards of £1,500 are offered to assist in meeting the cost of subsistence, travel and rent during the placement.
Closing date: March.

The Arthur and Helen Davis Travelling Scholarship

An award of £1,500, offered in alternate years. It provides the winner the opportunity to develop the study and knowledge of glass through travel. It is aimed primarily at graduates between the ages of 22 and 30 but mature students and those who have not yet graduated may also apply.

Closing date: March.

Neville Burston Memorial Award

A commission is given every third year to a selected graduate.

The Worshipful Company of Turners: Bursary Awards

The Clerk
The Worshipful Company of Turners
182 Temple Chambers
Temple Avenue
London EC4Y OHP
Phone: 020 7353 9595
Email: clerk@turnersco.com
Web: www.woodturners.co.uk

One or more bursaries worth up to a total of £8,000 are available to assist talented turners to achieve their professional aspirations and enhance their future career opportunities. Open to UK resident turners of high ability whose work is well regarded. Special consideration given to candidates judged to be most capable of advancing the boundaries of the craft. The Bursary may be used for research, training, equipment, materials, travel for study, to demonstrate or display work, to produce an invention of turning-related equipment, to set up a turning-related business, or for any other purpose approved by the Committee that will assist the candidate in achieving recognition as an exceptional turner.

Applicants shall normally be aged under 35. However, consideration will be given to more mature applicants.
Application: Send for application form or download from the website
Closing date: usually November.

Zelli Porcelain Award

30a Dover Street
London W1S 4NB
Tel: 020 7493 0203
Fax: 0)20 7493 0580
Email: info@zelli.co.uk
Web: www.zelli.co.uk

The Zelli Award for Porcelain Artists is presently offered every 18 months. The theme for the third award in 2005 was Nursery Rhymes. Selected entries are exhibited for sale at Zelli Gallery.

Prize: £3,000.

The Ansel Adams Research Fellowship

Research Fellowship Committee
Center for Creative Photography
The University of Arizona
P.O. Box 210103
1030 N. Olive
Tucson, AZ 85721-0103
United States
Web: www.dizzy.library.arizona.edu/branches/ccp/education/internships.html

Through a generous endowment provided by the Polaroid Corporation in honour of Ansel Adams, the Center for Creative Photography at the University of Arizona offers an annual Research Fellowship. The program is intended to provide research time for scholars needing to use the archives, photograph collection, and/or library of the Center for Creative Photography. The research topic may be anything appropriate to the Center's holdings. A complete list of past recipients of the Fellowship is available on request.

Fellows are expected to have projects that will require approximately two weeks research at the Center. Access to the library, archives, and fine print collection will be available during the Center's regular public hours and will be facilitated by knowledgeable staff. During the residency, each Fellow should be prepared to make an informal presentation of his or her research.

Eligibility: The fellowships are open to scholars from any discipline, as well as museum professionals, independent researchers, artists, and candidates for advanced degrees. U.S. citizenship is not required.

The Award: One $2,500 fellowship will be awarded.

Application: Send cover letter with four (4) copies each of curriculum vitae and detailed description of research project (500-2,000 words). Within this description, please include the expected outcome(s) of your project; i.e., exhibition, publication, lecture, etc.

Closing date: October. Announcement made at the end of December

AgfaPhoto GmbH

www.agfanet.com

The International Agfanet Photo Award is in its 14th year (2005). Each year the competition is on different theme. In 2005 this was *Close-up*s – 'close-ups are often puzzling and surprising, showing completely new aspects of things we think we know well'. Agfa reserves the right to publish the photos in

connection with the AGFAnet Photo Award in any form and reserves the right to purchase prize-winning photos for its own use. All submissions must be uploaded on the website.

Closing date: March 28th. Jury meets April 18th.

Prizes: 1st – Olympus Camedia E1 digital single lens reflex camera, 2nd – Canon EOS 300 D digital single lens reflex camera.

Details of the other prizes and the rules of the competition can be found at www.agfanet.com. The 40 best entries will also be on view here.

The Alexia Foundation

Professional division
S.I. Newhouse School of Communications
215 University Place
Syracuse NY 13244-2100
United States
Contact: David Sutherland
Phone: +1 315 443 2304
Email: dcsuther@syr.edu.
Web: www.alexiafoundation.org

Professional Alexia Grant

The Alexia Foundation offers the professional grant to enable a photographer to have the financial ability to produce a substantial picture story that furthers the foundation's goals of promoting world peace and cultural understanding. The professional Alexia Grant recipient will receive $15,000 for the production of the proposed project.

Eligibility: Any photographer may apply. Proposals that have received grants or awards exceeding $1,000 in the previous calendar year are not eligible. This award is for an individual photographer. Collaborative applications are not accepted.

The Alexia Competition was not created with the single purpose of rewarding the best picture takers – this is not a portfolio competition. The award will go to a photojournalist who can further cultural understanding and world peace by conceiving and writing a concise, focused, and meaningful story proposal. The story proposal is the most important part of the application. When evaluating your portfolio, the judges consider your technical ability, your ability to work with your subjects and your style. The strongest entries are those that provide strong story proposals with portfolios that exhibit the photographic ability to execute a story at a high level.

Application: Applications must be submitted online.

Closing date: January

Alexia Annual Photography Contest – Students

The Alexia Foundation offers helps to provide the financial ability for students to improve their knowledge and skills of photojournalism and to increase their own knowledge and understanding of other cultures by providing scholarships to study photojournalism at Syracuse University in London, England. The Foundation also provides cash grants to enable student photographers to undertake the foundation's goals.

The awards go to students who can further cultural understanding by

conceiving concise, focused, and meaningful story proposals. The story proposal is the most important part of the application.

You are encouraged to consider stories that explore cultural understanding in or near your local community. While we do not discourage proposals on foreign topics, the judges give no extra weight to foreign topics, and indeed, think that you are more likely to complete a story near home than one abroad.

When evaluating your portfolio, the judges consider your technical ability, your ability to work with your subjects and your style. The winning entries will be those that provide strong story proposals with portfolios that exhibit the photographic ability to execute a story at a high level.

Student Awards

First Place: A $9,000 scholarship toward tuition, fees and living expenses to study photojournalism in London in the fall semester through the Syracuse University Division of International Programs Abroad; A grant of $1,000 for completing the proposed picture story. An additional $500 will be awarded to the sponsoring academic department.

Second Place: A $6,000 scholarship toward tuition, fees and living expenses to study photojournalism in London during Fall through the Syracuse University Div. of International Programs Abroad; A grant of $500 for completing the proposed picture story.

Awards of Special Recognition: Three scholarships of $1,600 toward tuition, fees and living expenses to study photojournalism in London during Fall through the Syracuse University Division of International Programs Abroad, and three grants of $500 for completing the proposed picture stories. If, for any reason, either the 1st or 2nd place winners cannot accept any portion of their awards, these awards may be offered to winners of the Awards of Special Recognition at the discretion of the competition judges & administrators. Alexia Scholars are responsible for the balance of tuition and fees for the semester in London. All scholarships are contingent upon admission to the Syracuse University DIPA London Program.

Eligibility: Applicants must be duly enrolled full-time students in an accredited college or university in the U.S. or abroad in a degree program at the time of application. Graduate and undergraduate students are eligible. No student who has completed more than three internships or a year of full time professional experience is eligible.

Application: See website for submission procedure

Closing date: February.

Arcimboldo Award for Digital Creation

Prix Arcimboldo
c/o Publiprovence - 1er étage cour
37, Rue d'Amsterdam
75008 Paris
France
Web: www.arcimboldo-award.com

Each year the Fondation d'entreprise HP France awards a prize of 10,000 to a digital artist. The award, sponsored jointly by the Fondation d'Entreprise HP France and the association Gens d'Images, was established in 1999. It is

organized in partnership with the Maison Européenne de la Photographie, which displays the work of each year's prizewinner, and Laboratoires Dupon, which produces the prints for the exhibition.

The contest entry portfolio should include: a maximum of 10 works dealing with one or more themes of the candidate's choosing. Material from various sources must be digitized so that paper prints can be produced in a format ranging from 18x24 cm to 50x60 cm maximum.

No other medium (on-line, CDROM, floppy disk, etc.) will be accepted.

The candidate must certify that he or she is the author of the contest entry portfolio and has full moral and legal ownership of the works it contains.

There is no on-line registration.

Above all, the portfolio must be representative of the candidate's achievements to date, his or her personal tastes and the techniques used, and indicate the directions which he or she wishes to pursue for future work. Candidates may enter the Archimboldo contest several times in different years.

Closing date: February.

Arles Photography Book Prize

Rencontres d'Arles
10 Rond-point des Arenes
13200 Arles
France
web: www.rip-arles.org

Reinstated in 2000 this prize is awarded to the best photography book published in the previous year (July to June). The Prize is 30,000FF shared between the publisher and the photographer, and awarded at the Recontres Internationales de la Photographie which takes place in Arles in July each year.

Closing date: June

The Association of Photographers

The Association of Photographers
81 Leonard Street
London EC2A 4QS
Phone: 020 7739 6669
Fax: 020 7739 8707
Email: general enquiries - general@aophoto.co.uk
Email: award enquiries - awards@aophoto.co.uk
Web: www.the-aop.org

The AOP runs various different Awards throughout the year for all types of Photographer – and membership of the AOP is not always necessary.

The AOP Photographers' Awards (members)

These were launched in 1983. Over 3,500 images are submitted annually by AOP members and the work is judged purely as photographs by a panel of highly respected professionals, including photographers and commissioners from advertising agencies, design groups and magazines.

Gold, Silver and Bronze awards.

Document (members and non members)

In 2005 a new section has been added to the AOP Photographers' Awards to recognise the importance of documentary photography to the industry. As with the main sections of the Photographers' Awards, Gold, Silver and Bronze will be awarded by the judges and all the selected work will appear in the Photography Awards Book and Exhibition.

AOP Document is open to both AOP members and non-member photographers. Document is part of the AOP's commitment to developing the Photography Awards to cover all photographic genres.

A 'Best in Document' prize of £2,500 will also be awarded.

Assistants Awards (Assistant members)

The AOP Assistants' Awards were introduced in 1993 to recognise the excellent standard of photography produced by assistant photographer members of the AOP. Over the years, many of the aspiring young photographers who have achieved acclaim through these awards have gone on to become successful photographers in their own right.

As well as receiving acknowledgement for the high standard of their work, six winners will be awarded a complimentary page in the AOP members' yearbook and a cheque for £400. Additional merit awards are allocated to work which the judges feel deserves special mention and will receive a cheque for £200.

Zeitgeist (open)

Zeitgeist was introduced in 2004 to provide an overview of trends and fashions in published photography, acknowledge a broader range of photographic practice and to appeal to a wider public by providing a context for the Photography Awards.

The aim is to reflect the 'spirit of the age'. Open to submissions from any photographer, art director, designer, picture editor or any other individual working within the creative industries. Photographs will be judged in the context in which they appeared (ie including graphics, copy lines, text and layout) and should be submitted as such. Zeitgeist appears in the Awards Exhibition and the Awards Book.

AOP Bursary (members)

The AOP Bursary is an initiative introduced by The Association in 2004 to award a substantial financial prize of £15,000 to one AOP member each year. The objective of the Bursary is to give an individual the opportunity to explore a photographic idea or new photographic area, which they would otherwise be unable to realise and which will make a significant impact on their future career as a photographer.

The judges will be looking in particular for a project they feel will challenge or stretch the applicant, and the AOP will work with the Bursary winner, if required, to form a sympathetic mentoring group. The Bursary winner will be expected to complete their chosen project and provide the AOP with a portfolio of at least 12 images within a 12 month period.

The AOP Open

For further information on the AOP Open please contact Anna Roberts at the AOP.
Phone: 020 7739 6669
Email: gallery@aophoto.co.uk
Web: www.aop-open.com

The AOP Open is one of the few major photographic competitions accessible to everyone. Professional, amateur, occasional snapper – all are welcome. The aim of the show is to celebrate the diversity of photography, and to promote its role as an artistic medium. Membership of the AOP is not necessary, and there are no set themes or categories.

A panel of respected people from the photographic, editorial and publishing industries judge the entries and select a total of 100 images which form the Annual Open Exhibition at the AOP Gallery. Prizes will be awarded for the judges *Best in Show* selection, which is announced at the opening.

Prizes: In 2005 the AOP in association with Adobe, EPSON and Nikon, is offering a full professional digital photographer's kit as a first prize worth over £2,500. The Best in Show winner will receive a Nikon D70 Digital camera, Adobe's Creative Suite Premium software, and an EPSON Stylus 2100 printer.

AOP Student Photographer of the Year

Eligibility: Open to full-time UK photography students. A significant majority of the final images must be photographically generated. Work submitted must not have previously been entered into any AOP awards scheme in any form.

Categories: Entrants must submit a minimum of 4, and maximum of 8 pieces of work in any of the following categories:

- Lifestyle & Portraiture (Single & Series)
- Fashion & Beauty (Single & Series)
- Landscape, Interiors & Exteriors (Single & Series)
- Still Life (Single & Series)

AOP Student Photographer of the Year will receive

- A double-page spread in the 2006 Photography Awards book
- A special profile in the Student Awards issue of IMAGE magazine
- An Epson Stylus Photo 2100 printer
- A day's work experience with a high-profile AOP member
- Their winning images used to promote the Student Awards 2006

All work selected for the AOP Student Awards will feature in a special exhibition at the AOP Gallery in London and will also feature in the Student Awards issue of IMAGE magazine.

Closing date: 8th April. Judging will take place during April and notification will be posted to all entrants by the end of April.

The Chrisi Bailey Award

Visual Arts Department
Arts Council England
14 Great Peter Street
London SW1P 3NQ
Phone: 020 7973 6552
Fax: 020 7973 6581
Email: vivienne.reiss@artscouncil.org.uk
Web: www.thechrisibaileyaward.org.uk

The Chrisi Bailey Award: The National Award for Media Arts by Under 10s promotes media arts projects by children which explore photography, digital art, animation and video as creative visual media. It highlights the educational potential of these media. Chrisi Bailey was an explorer of photographic

education with primary aged children, her work is commemorated with this annual Award.

Winning entries also receive copies of Hyperstudio multimedia software, Kidspiration visual planning software and Site Central website authoring tool. All of the above products have been designed specifically for education and are suitable for under 10s.

Projects should be with children under the age of 10 using media arts. The project must have been completed in the last year; a proposed project will not be accepted. The project should explore media arts as a visual medium, demonstrating creative and experimental uses of the media, not just a means of recording events. The project should provide a model for other people.

The Award will be made by a panel including representatives from the Bailey family, Arts Council England, Clore Duffield Foundation, Times Educational Supplement, the media arts sector and TAG Learning.

Application: Application can be made as an individual or group, or nominate other individuals or groups. Submission details available on website.

Prizes:

1st Prize – £1,000, VideoBlender Presentation & Video Editing Tool, Clay Animation Kit, plus a camera kindly donated by Annabel Jankel and Rocky Norton, friends of Chrisi.
2nd Prize – £500, KidPix Deluxe 3 Painting, Drawing & Multimedia Tool
3rd Prize – ImageBlender Image Editing Tool

Closing date: March

The Oskar Barnack Prize

Leica Camera AG
Oskar-Barnack-Straße 11
D-35606 Solms
Germany
Phone: +49 (0)6442-208-0
Fax: +49 (0)6442-208-333
Email: info@leica-camera.com
Web: www.leica-camera.com

Established in 1979 to mark Oskar Barnack's 100th birthday. The prize is worth 5,000 or a Leica camera of the same value. The international jury gives the *Leica Oskar Barnack Award* to the photographer whose powers of observation most vividly express man's relationship to his environment in a photo series consisting of up to 12 pictures.

Either duplicates of 35 mm slides or enlargements may be submitted (min. 7 x 9 inches, max. 8 x 11 inches).

Entry is open to all series taken in the year of the award or for long-term projects with at least a few photographs taken in the year of the award.

The prize is awarded in cooperation with the Rencontres Internationales de la Photographie in Arles, France.

Closing date: 31st January.

Entry forms can be ordered at the national Leica agency or directly at the Leica Camera AG, Solms, Germany. They are also available on the website.

Beneath The Sea

495 New Rochelle Road
Suite 2A,
Bronxville, NY 10708
United States
Contest Hotline: +1 718 409-0240
Email: Photo@BeneathTheSea.org or DigitalPhoto@BeneathTheSea.org
Web: www.beneaththesea.org

The Beneath The Sea Photography Competition is open to all amateur photographers and/or videographers. A professional is considered to be any individual who earns more than 40% of their income from the sale, production or publication of their photographs, videos or motion pictures or who have been paid for publication of more than six photos during the year. Photos that have been published (or accepted for publication) are not eligible.

All entries must be exposed underwater (no aquarium, pool or surface shots). Photos cannot show any disrespect for the environment.

Judging will be by a panel of professional photographers and other professionals in the underwater community. Decisions will be based on composition, technique, exposure and general interest.

Prizes for 2005:

Best-In-Show Prize (Video): The Stan Waterman Award for Excellence in Underwater Videography, and a trip to Cocos Island on the Undersea Hunter.

Best-In-Show Prize (Photo): The David Doubilet Award for Excellence in Underwater Photography, and one week Live-Aboard dive trip of the winner's choice on The Nimrod.

Explorer (diving the Great Barrier Reef in Australia), the Caribbean Explorer (diving Statia, Saba and St Kitts) or the Turks & Caicos Explorer.

Best In Show Prize (Creative): The Jim Church Award for Excellence in Underwater Creative Photography and a one week trip aboard Peter Hughes' Windancer in Tobago.

Black River Publishing

P.O. Box 10091 - Dept. ONET
Marina del Rey, CA 90295
United States
Phone: +1 310 694-0060
Fax: +1 310 694-0080
Web: www.brpub.com
Email: contest@brpub.com

An annual photography competition where the winning entries will be published in a calendar (Outdoor Grandeur) for the following year on a non-exclusive basis. Capture an image that reflects the great outdoors: be it a waterfall, snow covered mountains, a scenic beach, or a forest of changing leaves. The photographs will be judged on their photographic quality and subject material. The pictures can be from any season of the year. All entries should be of outdoor themes, both landscape and close-up shots are acceptable. Horizontal pictures are preferred to vertical (portrait).

No limit to the number of images that can be submitted. Multiple images should be submitted with a single entry form and entry fee. Entry fee $5.00

Prizes: 1st – $1,000, 2nd – $250, Ten Runners Up – $50
Closing date: end of July.

The British Deer Society

The British Deer Society
Fordingbridge
Hampshire. SP6 1EF.
Phone: 01425 655434
Fax: 01425 655433
Email: h.q@bds.org.uk
Web: www.bds.org.uk

Since the foundation in 1963 of the British Deer Society, photography has always been an area of great importance both as an activity in its own right, and also as a key element in many of the Society's functions, i.e. Conservation, Training, Education, and Publications. The Society has a long history of photographic competitions and this continues to the present with annual competitions run at branch, inter-branch and national level.

Center for Documentary Studies/Honickman First Book Prize in Photography

CDS / Honickman First Book Prize
Center for Documentary Studies
1317 W. Pettigrew Street
Durham, NC 27705
United States
Web: cds.aas.duke.edu/grants/index.html

The Center for Documentary Studies (CDS) at Duke University and The Honickman Foundation (THF), based in Philadelphia, co-sponsor this prestigious biennial prize for American photographers. The only prize of its kind, the CDS / Honickman First Book Prize competition is open to American photographers of any age who have never published a book-length work and who use their cameras for creative exploration, whether it be of places, people, or communities; of the natural or social world; of beauty at large or the lack of it; of objective or subjective realities. The prize will honour work that is visually compelling, that bears witness, and that has integrity of purpose.

The winning photographer receives a grant of $3,000, publication of a book of photography, and inclusion in a travelling exhibition. The judge also writes the introduction for the book, which will be published by Duke University Press in association with Lyndhurst Books of the Center for Documentary Studies.

Next prize 2006. Submission dates June to September.

The Howard Chapnick Grant

W. Eugene Smith Fund, Inc.
c/o International Center of Photography
1133 Avenue of the Americas
New York, NY 10036
United States
Web: www.smithfund.org

The Howard Chapnick Grant encourages and supports leadership in fields ancillary to photojournalism, such as editing research, education and management. The Grant was established to honour the memory of Howard Chapnick, and acknowledge his enormous contribution to photography.

The annual $5,000 grant may be used to finance any of a range of qualified undertakings, which might include a programme of further education, research, a special long-term sabbatical project, or an internship to work with a noteworthy group or individual. According to the Fund's Board of Trustees, special consideration will be given to projects that promote social change and/or serve significant concerns of photojournalism. The grant is not intended to be used for the production of photographs, which will continue to be funded by the main grant of the Smith Fund.

Recipients of the Howard Chapnick Grant will be selected by the Board of Trustees of the W. Eugene Smith Memorial Fund in Humanistic Photography.

Application form can be downloaded or applied for in writing.
Closing date: July.

Commonwealth Photographic Awards

Commonwealth Press Union
17 Fleet Street
London EC4Y 1AA
Phone: 020 7583 7733
Fax: 020 7583 6868
Email: cpu@cpu.org.uk
Web: www.cpu.org.uk

Established in 1999, the Commonwealth Photographic Awards are organised by the Commonwealth Press Union in collaboration with the Commonwealth Broadcasting Association.

This is an open competition for all Commonwealth residents whatever their profession. Each year there is a different theme and the entrants are asked to write a short caption explaining why they think their photos are significant. Theme in 2004 was Youth.

A film about the winning images and the Awards will be commissioned and made available for broadcast in most Commonwealth countries. An exhibition of the winning pictures will take place in London.

Prizes: 1st – £2,000 with cash prizes for regional winners.

The Awards are sponsored by The Commonwealth Foundation with additional support from the Commonwealth Telecommunications Organisation and the Royal Commonwealth Society.

The Dan Eldon Prize

A special category created in 2004 for children aged between 12 and 18. The Prize (£250) will be awarded to a young photographer, whose work is used for social or humanitarian purposes. Dan Eldon, a photojournalist, was born in London and raised in Kenya. He worked as a photographer for Reuters in Africa. He was killed on a street in Mogadishu in 1993, aged 22.

The Creative Visions Foundation which is sponsoring this prize was set up to assist and encourage young photographers, artists and film makers to create work which will help to stimulate positive change in the world.

Deutsche Börse Photography Prize

The Photographers' Gallery
5 & 8 Great Newport Street
London WC2H 7HY
Phone: 020 7831 1772
Fax: 020 7836 9704
Web: www.photonet.org.uk

The Deutsche Börse Photography Prize replaces of the Citigroup Photography Prize as the annual photography prize at the Photographers' Gallery.

The Deutsche Börse Photography Prize aims to reward a living photographer, of any nationality, who has made the most significant contribution to the medium of photography during the past year. Photographers will be nominated for a significant exhibition or publication that takes place in Europe between 1 November – 31 October in any year. These nominations will be made by an Academy, a diverse group of people invited by The Photographers' Gallery from photography institutions throughout Europe. From the nominations, four shortlisted photographers will be selected by a Jury and will be invited to present their work in an exhibition at The Photographers' Gallery. The winner of the Deutsche Börse Photography Prize will receive £30,000 and the three runners-up will each receive £3,000.

Deutsche Gesellschaft für Photographie e.V.

Geschäftsstelle DGPh
Ulrike Friedrichs
Rheingasse 8-12
50676 Köln
Germany
Phone: +49 (0)221 923 2069
Fax: +49 (0)221 923 2070
Email: dgph@dgph.de
Web: www.dgph.de

The Deutsche Gesellschaft für Photographie (DGPh) is as an organization whose activities predominantly concern the cultural interests of photography and related imaging media. These activities include both the conventional process of photography and its many different fields of application in art, science, education, journalism, industry and politics, as well as the non-conventional methods and new forms of imaging media.

Cultural Award – Annual, no public application, awarded to those who have rendered particular service to photography in artistic, scientific or promotional field. The award comprises a certificate as well as a gold-mounted lens and is presented as the highest distinction of the DGPh. The award winners include internationally renowned scientists, inventors, writers, publishers, editors, lecturers, art directors and, in particular, top photographers from Germany and abroad.

Dr.-Erich-Salomon Award – Annual, no public application, honours media and photographers for outstanding applications of photography to publicity works. It celebrates the memory of the great photographer of the Weimar Republic, Dr. Erich Salomon, whom many regard as the principal founder of modern photojournalism. The award comprises a certificate and a Leica M Camera, engraved with the name of the recipient. It is presented every year as the highest distinction of the DGPh.

Herbert-Schober-Prize – Every two years, public application for grant, for medical and scientific photography; Last endowment 1,000.

Otto-Steinert-Prize – Every two years, public application for grant and prize, to promote deserving projects in pure and applied photography, German residence; Last endowment 5,000.

Erich-Stenger-Prize – Every two years, public application for grant and prize, for photohistorical work; Last endowment 3,000.

Robert-Luther-Prize – Every two years, public application for grant, for services to photographic science and technology, work has to be realized at a German university/ college/ academy or at a German laboratory of research Last endowment 1,500.

The Annual Alfred Eisenstaedt Awards for Magazine Photography

Web: www.lifemag.com/Life/eisies/index.html

Administered by the Columbia University Graduate School of Journalism, under a grant from LIFE. The prizes were established to honour excellence in magazine photography – and the memory and spirit of Alfred Eisenstaedt, a pioneer of photojournalism. The awards recognize the work of photographers, in a number of categories, for images published in American magazines during the year. The rules, guidelines, qualifications, definitions and categories for the awards are determined by the Columbia University Graduate School of Journalism in cooperation with the editors of LIFE.

European Publishers Award for Photography

Dewi Lewis Publishing (UK Contact)
8, Broomfield Road
Heaton Moor
Stockport SK4 4ND
Phone: 0161 442 9450
Fax: 0161 442 9450
Email: mail@dewilewispublishing.com
Web: www.dewilewispublishing.com

This annual award offers publication of the winning work by six European publishers (UK, Germany, France, Spain, Italy, Grrece) in six editions in six languages.

The total value of the award is dependent on the initial print run of the winning book but the minimum award is valued at 12,000. In addition the sponsors, LEICA, present the winning photographer with a specially engraved camera. The Award is hosted each year by one of the publishers in their own country but submissions can be made to any of the publishers.

The work must be a completed and unpublished photographic project suitable for publication in book form. Submission is fully open and there is an entry fee of £25.00 to cover return delivery. Check website for details.

Previous winners include: Dario Mitidieri; Shanta Rao; Bruce Gilden; Dean Chapman; Jeff Mermelstein; Alfons Alt; David Farrell; Simon Norfolk.

FiftyCrows

International Fund for Documentary Photography
5214-F Diamond Heights Blvd. #615
San Francisco, CA 94131-2118
United States
Phone: +1 415 647 1100
Web: www.fiftycrows.org

As the core program of FiftyCrows, the Photo Fund supports emerging documentary photographers whose outstanding ability in visual storytelling leads us to a better understanding of our common humanity.

Funding for the grants program comes from sales of Fine Prints donated by well-established photographers such as Bruce Davidson, Paul Fusco, Eve Arnold and Hansel Mieth.

FiftyCrows has evolved the Photo Fund Program to include broader distribution of the winning essays to a worldwide audience of millions in order to bring about awareness leading to action and positive social change. To date, the Photo Fund has awarded over $500,000 in grants to 78 photographers from over 30 countries around the world.

Each year a jury of respected members from the international photography and journalism communities are selected.

Four winners are selected for this competition. There are two winners from each of the two categories:

Each winner receives the following:

- a monetary grant of $5,000
- a FiftyCrows Media television short created with your images and voice-over
- a mini-website featured for two weeks on the home page of FiftyCrows.org and permanently archived within FiftyCrows.org including your entire photo essay, bio, written essay and associated information
- ongoing support and mentorship from FiftyCrows in the areas of marketing, publishing, exhibiting, building your successful career
- sales opportunities through FiftyCrows Fine Print program

- free lifetime Membership to FiftyCrows
- international press coverage
- one year of free service using Digital Railroad's suite of web-based applications for professional photographers
- free Adobe software

Fujifilm Distinction Awards

Fuji Photo Film (U.K.) Ltd.
Fujifilm House, 125 Finchley Road
London NW3 6HY
Phone: 020 7586 5900
Fax: 020 7722 5630
Email: admin@fujifilmdistinctions.co.uk
Web: www.fujifilmdistinctions.co.uk

Fujifilm Distinction Awards work on two levels: Merits are awarded on a quarterly basis in response to work submitted via the website for online judging and Distinctions are awarded at the end of the four-quarterly judging period. All Merit award winners will be asked to submit hard-copy prints for the final judging. Photographs must be taken on Fujifilm materials or captured on digital media. Winners must output their image on Fujifilm materials. Number of entries unlimited. All entries to be submitted online. The Awards are split into three categories: Social, Commercial and Assistants.

All merit winners receive a certificate and a £50 Fujifilm product voucher. One or more distinctions is awarded in each category at the end of the four-quarterly judging period. Each Distinction winner receives £1,000 plus a trophy and certificate. As an added bonus, if a Distinction is awarded to an Envisage member, Fujifilm give an extra £500 of Fujifilm product vouchers.

The winner of the Assistant's category will receive £1,000, a trophy, a certificate and the title, *Fujifilm Assistant Photographer of the Year.*

Fujifilm Student Awards

Contact: Jeanette Beattie, Marketing Manager (jbeattie@fuji.co.uk)
Phone: 020 7586 5900
Fax: 020 7722 5630
Web: www.fujifilmstudentawards.co.uk

In 2005 the awards featured three main categories all with an open brief:

Social / Editorial, (any image created as a portrait for the general public, or an image which would be suitable for use in a newspaper or magazine to illustrate a story)

Advertising / Commercial (an image used to *sell* a product, or any other image which could be commissioned by a commercial client)

Fine Art / Pictorial (include landscapes, still life, etc.)

Entry is open to all students undertaking full or part-time professional photographic training, or full or part-time graphic design training of which photography is a major part at a UK based college or university. Photographs

must be taken on Fujifilm material or captured on digital media. Merit winners must output their image on Fujifilm materials. The number of entries is unlimited. All entries will be received online.

Closing date: end of Janury

Prizes:

The winner of each category receives a cash prize of £1,000.

The overall winner receives an additional £1,000 and the title of *Fujifilm Student Photographer of the Year.*

Up to 20 Merit prizes will be awarded in each category and each Merit winner will receive £50 in Fujifilm Professional product vouchers.

Each winner's college will receive £500 in Fujifilm Professional product vouchers. Additionally, the college that submits the most Merit winning entries will also receive £500 in Fujifilm Professional product vouchers.

Fujifilm/PPLA Colour Printer Awards

Phone: 020 7465 5793
Fax: 020 7722 4259
Email: printerawards@fuji.co.uk
Web: www.fujifilmprolabs.co.uk

The Awards continue to reward the skills of pro-lab hand printers and digital retouchers. Hand-printers working in a professional laboratory are invited to demonstrate their skills on a 12" x 16" hand print which is judged against a straight, un-retouched machine print from the same original. Digital retouchers, with a laboratory or freelance, have three separate digital briefs that are set for the competition. Three Handprinting catagories are specified and three digital categories

In both hand printing and digital retouching the following prizes are awarded

Overall hand printer, and digital retoucher, of the Year – £700

1st prize (in each category) – £300, 2nd – £200, 3rd – £100.

In addition, the overall winners' labs will win £700 of Fujifilm product and each category winners' labs will receive £300 of Fujifilm product.

Registration form available online.
Closing date : End of February.

Glenfiddich Food and Drink Awards

See entry in Literature section

The Leopold Godowsky, Jr. Colour Photography Awards

Photographic Resource Centre at Boston University
Email: prc@bu.edu.
Web: www.bu.edu/prc/godowsky.htm

The Leopold Godowsky, Jr. Colour Photography Awards are sponsored by the PRC. The Awards honour the co-inventor of Kodachrome film, a man whose contributions have had a major and lasting impact on the field of photography. Made possible through the generosity of the Godowsky family, the awards rotate throughout different regions of the world, recognizing artists who have achieved excellence in colour photography.

Artists for the Godowsky Awards are selected by invitation only.

The Guardian Student Media Awards

See entry in Literature section

The Hasselblad Foundation

Erna och Victor Hasselblads Stiftelse
Ekmansgatan 8
412 56 Göteborg
Sweden
Phone: + 031 778 1990
Fax: + 031 778 4640
Web: www.hasselbladfoundation.org

The Hasselblad Foundation International Award in Photography

The Hasselblad award is an annual international photography award, made for the first time in 1980.

The Hasselblad award is granted to "a photographer recognized for major achievements". This may be an individual who has made a pioneering achievement in photography, who has had a decisive impact on one or more younger generations of photographers, or who has implemented one or more internationally significant photographic projects. Today the award comprises the sum of SEK 500,000, a gold medal and a diploma.

Nomination only.

Stipends and Grants in Photography

In accordance with the intentions expressed by Victor Hasselblad, the Foundation strives to maintain a worldwide orientation. Internationally, the Foundation is best known for its activities in the field of photography. The Foundation also promotes photography by means of research grants, donations and stipends. One such activity takes the form of a large annual allocation to the Hasselblad Center. The Foundation also provides developmental support to individual photographers, both in the form of one-year stipends for postgraduate education in photography – The Victor Stipend – and as two annual stipends to spend time in Grez-sur-Loing, France or at the Villa San Michele in Capri, Italy.

The Victor Fellowship

Since 2004, the Foundation has annually awarded the Victor Fellowship, for a one-year tailor made postgraduate program in the discipline of photography. The aim is to encourage continuing professional and artistic development at an institution of higher education outside Sweden, recognised for its high standards in the field of photography. The winner is selected on the basis of a

competition, in which five nominated finalists participate in an exhibition at the Hasselblad Center.

The fellowship sum is SEK 150,000 (approx. 16,300) and is to be used for tuition fees, travel costs and living expenses.

Application is open to individuals holding at least an undergraduate degree in photography or fine arts with focus on photography. In 2005 individuals must have studied at specified institutions (see website). Application forms and guidelines available on the website.

Closing date: February.

The Grez-sur-Loing Stipend

Since 1994, the Hasselblad Foundation has awarded an annual stipend to a Swedish photographer, enabling him or her to to work on a project in an international environment by spending September and October at Hôtel Chevillon in Grez-sur-Loing near Fontainebleau, France.

The stipend amounts to SEK 30,000 plus the rental cost of the accommodation.

The Grez-sur-Loing stipend may only be applied for by photographers working and living in Sweden and by Swedish citizens residing abroad. Application forms and guidelines available on the website.

Closing date: March

The San Michele Stipend

Since 2001, the Foundation has awarded a stipend to a Swedish photographer, enabling him or her to work on a project in an international environment by spending September at Axel Munthe's Villa San Michele on the Italian island of Capri.

The stipend amounts to SEK 20,000 plus the rental cost of the accommodation.

The San Michele stipend may only be applied for by photographers working and living in Sweden and by Swedish citizens residing abroad. Application forms and guidelines available on the website.

Closing date: March

Humanity Photo Awards (HPA)

China Folklore Photographic Association
P.O.BOX 8006
Beijing 100088
China
Phone: +86 10 6225 0403
Fax: +86 10 6225 2175
Email: hpa@china-fpa.org
Web: www.china-fpa.org

Humanity Photo Award (HPA) is a biennial international photographic contest. The aim of HPA is to record, explore and study folk culture and traditions that are disappearing today. The last award set nine categories for the contest, which included: personage & adornment, residential architecture, life-style & production activities, festivities, food & drinking cultures, religions, rite & traditional customs, recreation & sports and others. Open to both professional and amateur.The awards ceremony was held at the end of December and an exhibition opened in Bejing and toured major cities. UNESCO jointly

sponsored the contest with CFPA .

HPA 2006 will run from September 2005. Closing date: 31st March 2006. Entry forms will be available on the website from the end of August.

International Photography Awards

Main office:
844 S. Robertson Blvd.
Los Angeles, CA 90035
United States
Phone: +1 310 659 0122
Fax: +1 310 652 7114
Email:
General Information
info@photoawards.com
Information regarding the Competition
competition@photoawards.com
Web: http://photoawards.com/

The IPA Mission is to salute the achievements of the world's finest photographers, to discover new and emerging talent, and to promote the appreciation of photography.

The International Photography Awards conducts two parallel competitions each year – one for professional photographers, who earn the majority of their livelihood from their craft and a second for non-professional or amateurs – open to photographers from every country of the world.

Certificates of excellence will be awarded in all sub-categories to both groups: professionals and non-professionals competing in separate pools. Professional and amateur winners will then compete within their respective pools for top prizes in major categories:

- Advertising Photographer of the Year
- Architectural Photographer of the Year
- Editorial Photographer of the Year
- Photography Book of the Year (professional only)
- Fine Art Photographer of the Year
- Nature Photographer of the Year
- People Photographer of the Year
- Photographer of the Year in Special category

The New Discovery Award will be made to one of the seven category awards in the amateur section. Prize: $2,000.

International Photographer of the Year will be awarded to the overall winner from both professional and nonprofessional category winners. Prize: $10,000.

The work of all the winners will be published in the annual International Photography Awards Book and displayed in a prestigious gallery in Los Angeles. In addition, the fifteen finalist (eight professionals and seven non-professionals) will also receive two tickets each to the Lucie Awards ceremony.

Closing date: May 31, 2005.

Submissions can be sent directly to the U.S. office or any regional office
(UK – ATOSA Photographic, 14 Temple Fortune Parade, London NW11 QS)

Isle of Man Tourism Photo Competition

Department of Tourism and Leisure
Sea Terminal
Douglas, IM1 2RG
http://www.gov.im/tourism/events/photocomp/Welcome.xml

The Isle of Man Tourism Photo Competition is organised by the Isle of Man Department of Tourism and Leisure. The Competition is open to resident and visiting photographers, amateur or professional.

Photographers can enter up to two images in each of the following seven categories:-

- Scenic Landscapes
- Scenic Coastal
- Trains and Trams
- Manx Birds
- TT and Motorsport
- Harbours
- Manx Glens

A minimum of one image and a maximum of 14 images per person may be entered into the Competition. Images must have been taken in the Isle of Man.

Prizes: £1,000 to the overall winner; seven £500 prizes to each category winner; and £100 to each runner-up. Entrants can win more than one prize for different images.

Closing date: Submissions received between 1 June and 1 July.

Jerwood Photography Awards

Portfolio
The Catalogue of Contemporary Photography in Britain
43 Candlemaker Road
Edinburgh
EH1 2QB
Phone: 0131 220 1911
Fax: 0131 226 4287
Email: info@portfoliocatalogue.com
Web: www.portfoliocatalogue.com

Edinburgh based Portfolio Magazine organise and manage the Awards which are open to artists based in the UK who work with photography and who have graduated from visual art degree courses in the UK within the last three years. There is no age limit. The Jerwood Charity is dedicated to excellence and supporting talented artists in the opening stages of their careers.

There are 5 awards, each winner receiving £2,000. They also have their work published in the December issue of Portfolio Magazine and presented in a group exhibition at the Jerwood Space, London, followed by a tour.

Guidelines and application forms for the 2005 Jerwood Photography Awards will be available on 1 May 2005 on Portfolio Magazine's website. Submission is initially by registration. Registration: August. Closing date for entries: September. Winners announced: December

Entry fee: £20 (applicants receive a year's subscription to Portfolio Magazine)

John Kobal Book Award

John Kobal Foundation
Mount Pleasant Studios
51-53 Mount Pleasant
London WC1X 0AE
Tel: 020 7278 8482
Web: www.johnkobal.org
Email: admin@johnkobal.org

John Kobal was a renowned authority on cinema and on Hollywood portrait photography. He was the founder of The Kobal Collection, one of the world's leading collections of film photos and photography related books.

Before his death in 1991, John Kobal established The John Kobal Foundation, a registered charity, to which he donated his personal archive of Hollywood negatives and fine art prints. Funds raised from the exploitation and sale of these items are used to encourage aspiring portrait photographers and to help advance the general appreciation of portrait photography.

The Foundation over the last 10 years has been pursuing this aim primarily through the annual John Kobal Photographic Portrait Award which ended in 2002. It has just launched the John Kobal Book Award in association with the Royal Photographic Society.

This award has been created to encourage new photographic publication in the UK. It recognises the best first published monograph by a living photographer who is either a British national published in any country worldwide or of any nationality but originally published by a publishing house based in the UK.

Prize: £1,000

Kodak Portrait & Wedding Awards

Kodak House (A8M)
Station Road
Hemel Hempstead
Hertfordshire HP1 IJU
Web: www.kodak.co.uk

In 2004 Kodak launched their new-look Kodak Portrait & Wedding Awards Programme.

There are four categories:

- Wedding – This category is for all photographs taken on a working Wedding Day pertaining to brides or to the wedding.
- Family – This category is for photographs of a Family or a group containing three or more subject's shot in the studio or on location.
- Children (12 and under) - The Child category is for photographs of a child or children under the age of 12 shot in the studio or on location.
- Creative Portrait - The Creative Portrait category is for photographers to push creative portrait boundaries. The images don't necessarily have to show the subject predominately, but needs to be shot in a studio or on location.

Portraits which have been taken between 1st November and 13th September by

professional photographers are eligible for entry into the Awards in any of the categories. The photographer can enter as many portraits in as many categories as they wish to.

Entries must be professionally taken, unmounted, colour or black-and-white photographs taken on Kodak Professional film and printed on Kodak Professional paper. Minimum size 12.7 x 17.8cm and maximum 25.4 x 25.4cm and copyright therein must be vested in the entrant or the professional photographer signing the entry form. Digitally captured images are acceptable.

Closing date: September

Photographer prizes – In the September judging each finalist will receive a certificate and trophy. All of the September winners will go forward to a national final in November. There will be a total of 40 finalists, from which four category winners will be chosen. The national final will take place in November. The Kodak Wedding Photographer, Family, Child and Creative Portrait Photographer of the Year will be selected from the September category winners and will each receive £1,500 worth of Calumet Photographic Vouchers, a trophy, a press release and £500 towards the cost of a exhibition or display at a local venue of choice.

Customer Prizes – The customer of the Kodak Wedding Photographer, Family, Child and Creative Portrait Photographer of the Year, will each receive £1,500 worth of vouchers. Entry is open to residents of the UK except Kodak Limited employees and their families, their advertising agents, professional photographers' families, or anyone directly connected with the competition.

Kraszna-Krausz Book Awards

See Literature section

Kraszna-Krausz Foundation Grants

Andrea Livingstone
Kraszna-Krausz Foundation
122 Fawnbrake Avenue
London SE24 0BZ
Phone: 020 7738 6701
Fax: 020 7738 6701
Email: grants@k-k.org.uk.
Web: www.editor.net/k-k

The Kraszna-Krausz Foundation offers grants to assist in the development and completion of new or unfinished projects, work or literature in the fields of photography and the moving image. Small grants are available, usually between £1,000 and £3,000 with a maximum of £5,000. Projects must be based in Great Britain.

Guidelines on Grants

1. Grants are given to assist in the completion of new or unfinished projects, work or literature where the subject relates to the art, history, practice or technology of photography or the moving image. Projects must aim to make a significant contribution to the understanding, appreciation or application of these media or their derivatives. The moving image is defined as cinema, film,

television, video and related screen media. The word 'literature' is defined as applying not only to print but also to audio-visual media – e.g., a CD-ROM.

2. In giving a grant, the Trustees must be satisfied that the work which they are supporting could not be finished or published without the grant and that, with the grant, it will be completed.

3. Applications will be considered for grants broadly in support of research, development, writing, editing or publication. Support for publication will normally only be in the form of an initial grant – for start-up expenses for a journal, for example; grants for research will require that the results of the work will be made known and accessible through appropriate means; in the case of literature, projects must have a real prospect of publication. Applicants must demonstrate that their work will have a clear expectation of making a significant and beneficial contribution to the literature, knowledge or application of audio-visual media. In assessing applications, the Trustees will give consideration to the social, cultural, scientific or professional value of the proposed project.

4. Applicants are required to satisfy the Trustees on the soundness of their projects, identify grants from other trusts and foundations (if any), and give the reasons why the commercial support is not available.

5. The Trustees will not make commitments to support recurring annual funding (e.g. for a journal), nor make grants to cover the fees or maintenance of students undertaking courses. Film and video productions will not be supported unless they further the aims as described in clause 1. In the case where funds are not granted by the Foundation because certain criteria has not been met, applicants may re-apply at a future date.

6. Projects must be based in the UK.

7. Completed work must acknowledge the financial support of the Kraszna-Krausz Foundation, where appropriate.

How to Apply
Applicants must complete an application form provided by the Foundation. Applicants are asked to set out the nature of the project in not more than 500 words. Supporting documentation may be enclosed. Details of experience or qualifications of person(s) or organisation making the application should be included. Applications should be accompanied by a budget clearly identifying the sum being requested for a grant and the purposes for which it will be used.

Applications are considered twice a year. Applications for consideration in July should reach the Foundation by 1 May and those for consideration in December by 1 October.

Submissions must be accompanied by an application form, obtainable by email from grants@k-k.org.uk.

Dorothea Lange–Paul Taylor Prize

Dorothea Lange–Paul Taylor Prize Committee
Center for Documentary Studies
1317 W. Pettigrew Street
Duke University
Durham, NC 27705
United States
Web: cds.aas.duke.edu/grants/index.html

2005 marks the 50th anniversary of the Dorothea Lange–Paul Taylor documentary prize, a $10,000 award given annually by the Center for Documentary Studies. It was created to encourage collaboration between documentary writers and photographers in the tradition of the acclaimed photographer Dorothea Lange and writer and social scientist Paul Taylor.

The Lange–Taylor Prize is offered to a writer and a photographer in the early stages of a documentary project. By encouraging such collaborative efforts, the Center for Documentary Studies supports the documentary process in which writers and photographers work together to record the human story.

Eligibility: Collaboration is essential to the nature of the work this award supports; therefore, individual submissions will not be considered. More than two people may apply as long as one of the collaborators is a writer and one is a photographer working with black-and-white or colour still photography.

Application forms on-line must be printed and submitted. It is not possible to submit applications electronically. Submissions on any subject are welcome.

The amount of the award is $10,000.

Leica Medal of Excellence

Leica Camera AG
Oskar-Barnack-Straße 11
D-35606 Solms
Germany
Telephone +49 (0)6442-208-0
Telefax +49 (0)6442-208-333
Email: info@leica-camera.com
Web: www.leica-camera.com

The 'Leica Medal of Excellence' is presented by the international Leica Galleries (New York, Tokyo, Prague, Vienna and Solms), based on the nominations of the jury members. It is not open for entries.

London Photographic Awards

Kevin O'Connor, Director
Tel: 020 8392 8557
Email online
Web: www.london-photographic-awards.com

The London Photographic Awards started life as an annual international competition for professional, fine art, and keen amateur photographers. Founded in 1997, LPA, was designed to address the breadth of photography's creative potential and the abundance of developments in the medium worldwide. While the award's title bears the name of its host city, the LPA strongly encouraged entries from all countries, backgrounds, and disciplines. The LPA received thousands of entries each year, attracting submissions from Europe to North America, India, South East Asia, and Australia. From these entries, a panel of judges selected the finalists and ultimately the prize winner.

The LPA has a rolling programme of competitions. All these are internet based. Entries are only accepted via email. Entrants must be at least 18 years of age.

See website for up to date information. Recent or current competitions include:

Adsight (commissioned avertising)

Adsight 2004 was the first international award competition showcasing the best commissioned creative advertising photography of the year. Entries are invited for photographs created to meet a specific commercial brief for ads, outdoor or sales literature. Photographs are judged on their composition, executional detail, relevance and impact – but above all the ability to answer the brief creatively and convincingly, within the given guidelines.

The Award is divided into two categories, one for advertising (posters, press ads etc) and the other for design and promotion (brochures, direct mail, point-of-sale etc). Winners are awarded LPA folios which are kept in the 'Winners folios' accessed from the front page of the website. Entry fees payable.

Work must have been produced January to December the previous year..
Closing date: 1st March.

Photoart Competition (All along the Watchtower)

In 2004/05 the brief was the Bob Dylan song "All Along The Watchtower". A unique visual response to the track is required. There are no constraints on how a theme is interpreted and no preconceived ideas in the minds of the Judges. Entries can either be a single image or a series of up to six related images.

Entry fees payable.
Closing date: 8th April.

Let's Face It – portraiture competition

For both established and up-coming talent who have a love of 'the portrait', images can be of both people and animals. The top three chosen photographers from each category will be given an LPA portfolio that is fully editable and kept in the 'winners portfolio gallery'. An overall winner may be chosen at the discretion of the judges. Captions of up to 100 words can be added to images.

Entry fees payable.
Closing date: 1st April.

The London Salon of Photography

P.O. Box 12382
Solihull B92 9AL
Email: secretary@londonsalon.org
Web: www.londonsalon.org

The London Salon of Photography is a unique body of photographers, from world wide membership, whose sole aim is to exhibit, annually, the very best of pictorial photographic imagery.

All photographers may send up to four prints made by any photographic process, including digital.

Entry fee: £8 per person.
Closing date: 30th April.

The Maine Photographic Workshops

PO Box 200
2 Central St.
Rockport, ME 04856
United States
Phone: +1 207 236 8581
Fax: +1 207 236 2558
Email: info@theworkshops.com
Web: www.theworkshops.com

The R.I.P.E. Benefactor Scholarship Fund

Partial tuition scholarships and additional financial support is available to deserving applicants through donations by corporations and individual benefactors to the Rockport Institute for Photographic Education Scholarship Fund. Funds are intended to support the educational process of today's most talented filmmakers and artists. Application is by portfolio, evidence of financial need and letters of recommendation. Application forms and information are available by calling the Registrar or e-mail at: registration@theworkshops.com

Karen Van Allsburg Memorial Scholarship

Maine Media Women, an organization of Maine writers, photographers, editors, and other media-related professionals, award a tuition scholarship to a qualified woman, an emerging artist who would like to further her skills with a course in still photography (preferably documentary, landscape, or portraiture). The scholarship, which provides tuition for a one-week course, is need-based but requires a statement of intent, references, and submission of a portfolio.

Scholarship application deadline: for summer courses the end of April.

3rd Annual Yarka Vendrinska Memorial Photojournalism Scholarship

Scholarships now available to Emerging Photojournalists

Through the generous donation of the family of Mark and Tanya Bohr, who established the Yarka Vendrinska Photojournalism Memorial Fund for their daughter, Yarka, we are pleased to announce that we will be offering the third annual scholarship to emerging photojournalists who demonstrate financial need to continue their careers. The award will be used to attend any of the Photojournalism workshops at The Maine Photographic Workshops. The award will be made officially on April 25th, the anniversary of Yarka's birth.

The $2,000 award is offered in the memory of Yarka, who was a passionate photographer, drawn to photograph people often ignored by society – the homeless, the aged and the ill. She found great humanity in her subjects, and attempted to show this through her imagery. To read more about the Foundation, please visit www.yarkasfund.org

Application Process: The ideal applicant will not only be interested in photojournalism, but will have a propensity toward social awareness in the spirit of Yarka's work. While the award will be based upon demonstrated need, the applicant must provide a portfolio of recent work as well. All portfolios and proof of need for financial assistance must be submitted in digital format, as the awarding committee is not centrally located. Scholarship application deadline: March 1.

Applications can be downloaded online.

The Maine Photographic Workshops – The Golden Light Awards

Awards & Grants
The Workshops
2 Central Street
P. O. Box 200
Rockport, ME 04856
United States
Phone: +1 207 236 8581
Fax: +1 207 236 2558
Email: info@theworkshops.com
Web: www.theworkshops.com

An international competition which recognizes the work of the world's emerging photographers. Its aim is to support exceptional personal vision and encourage photographers to continue their exploration of the world. The Award includes a variety of opportunities for professional and semi-professional photographers, students, educators and amateurs to receive recognition and prizes, as well as tuition grants for Master Classes at The Workshops. The work selected by the Jury is chosen on the basis of exceptional personal vision, high level of craft and a demonstrated passion for imagemaking.

The Photographic Project Award Program

Projects may include traditional photojournalism, documentaries, photographic essays, picture stories, book projects, exhibitions or research, as well as projects which experiment with new and old photographic processes.

Criteria for selection is based on the quality of each photographer's vision, the craftsmanship of their images, as well as the relevance of their written proposal. Colour and/or Black & White prints, portfolios, as well as digital, traditional and non-silver photography are accepted in all categories.

In 2004 there were 7 Project Categories:

- Documentary & Photojournalism
- Advertising & Commercial
- Personal & Fine Art
- Environment & Landscape
- Travel
- Digital
- Portraiture

Eligibility – The Awards seek to discover, encourage and support emerging photographers, full-time and semi-professionals, as well as amateurs who have not received national or international recognition. Photographers who have received a major award or have already published a monograph are ineligible.

Entry fee: $45 per project or portfolio.

Prizes: An award of $1,700 grant in tuition and fees to attend a Master Class at The Workshops for each category winner. Additional awards also.

The Photographic Print Competition

Entries may be a single print or an entire body of work, and may include B&W, colour, alternative processes or digital prints. Prints from slides may be laser-generated, but quality of reproduction will play a part in the judging. Colour and B&W slides are also accepted. The Judges will select a winner in each category, others may be considered in the Top 100 listing. Selection of winners is based on the imagination of the photographer, the quality of the print, and the interpretation of the artist.

Print Categories:

- The Land & Landscapes
- Portraits and People
- Still Life
- Humour
- Architecture & Interiors
- Families and Life Style
- Personal Documentary
- Photojournalism Story
- Holga and Plastic Camera

Entry Fee: $30 for up to eight images.

Prizes: The winner of each category will receive a $500 tuition grant towards a Master Class at The Workshops plus additional Awards. First place winners will have their winning images published in the Annual Awards Web Site, and exhibited at the Photo Plus Trade Show in New York City.

The Top 100 Photographers

The Jury will select 100 photographers. This list appears on the Awards Web Site and will also be on display at the New York City Photo Plus Trade Show.

The Photographic Book of The Year Awards

Each year, The Workshops recognizes the world's best photography books, their authors, publishers and printers. The Book of The Year Award is presented to the authors and editors of a single book of photographs which represents the highest achievement in the medium.

Photographers, as well as publishers and authors, are encouraged to submit books for consideration for this award. There is no entry fee required.

First place winners are selected in various categories, including monographs, anthologies, collections, text books, technical books, works on criticism and history, biographies, essays and writings which deal with photography and the photographic process. Small edition hand-made books are eligible, however portfolios are not.

Awards Web Site – Winners in each Award category will have a selection of their work published on the Awards web site. The Top One Hundred Photographers list will also be included. The web site will contain examples of written project proposals, and a gallery of all winning work.

New York City Exhibition – A selection of work from the winners, with descriptions of winning projects, and a list of the Top One Hundred Photographers feature in an exhibition at PhotoPlus Trade Show, New York.

Entry form available on web site, or request one via mail, email or fax.
Closing date: early October

Nikon Photo Contest International

Nikon UK Limited
Nikon House
380 Richmond Road
Kingston upon Thames
Surrey KT2 5PR
Phone: 020 8541 4584
Web: www.nikon-image.com/eng/npci

Since 1969, the Nikon Photo Contest International has been held by Nikon Corporation to provide an opportunity for photographers around the world to communicate and to enrich photographic culture for professionals and amateurs alike. The contest has so far attracted more than 1,190,000 photographs from a total of 280,000 photographers, with the last contest receiving entries from as many as 102 different countries.

Below are details for the 2004/05 contest. Information is not yet available for 2005/06. Check the website – (http://nikonimaging.com/global/activity/npci/)

There were two categories of entry: Documentary and Art.

Entries: Any photographer, professional or amateur, from any part of the world.

Submission Procedures: Entries can be submitted in print by conventional mail, as JPEG images via the Internet or as a combination of both.

Details on entries submitted in print by conventional mail : One person can submit up to 10 entries: 5 for each category. Entries accepted in print are colour or black-and-white photographs taken with 35mm film cameras, Advanced Photo System (APS) film cameras and digital still cameras (not including digital camera backs). Photographs that have been digitally edited with software are also accepted.

Details on JPEG images submitted via the Internet: One person can submit up to two entries: 1 for each category. Accepted JPEG images are graphic files taken with digital still cameras (not including digital camera backs) and scanned data of photographs taken with 35mm film cameras or Advanced Photo System (APS) film cameras. Images that have been digitally edited with software are also accepted. Colour and black-and-white images are accepted.

Awards and Prizes

The Grand Prize winner will be given Nikon imaging products to the value of $10,000. A total of 53 winners will be given Nikon imaging products as prizes. Additionally, the Grand Prize winner and 20 winners and runners-up for the Emerging Talent Award will be given the chance to exhibit work other than their winning photographs on the Nikon Photo Contest International.

Grand Prize: One (selected from both categories) Nikon imaging products ($10,000 equivalent) and exhibition of photograph on the contest website.
1st: Two (1 per category) Nikon imaging products ($5,000 equivalent)
2nd: Ten (5 per category) Nikon imaging products ($2,000 equivalent)
3rd: Twenty (10 per category) Nikon imaging products ($1,000 equivalent)
Emerging Talent Award: Four (selected from both categories) Nikon imaging products ($500 equivalent) and exhibition on the contest website
Runners-up: Emerging Talent Award: Sixteen (selected from both categories) Nikon imaging products ($300 equivalent) and exhibition on contest website

The Observer Hodge Photographic Award

Web: www.observer.co.uk/hodgeaward

The Award aims to give creative and dynamic young photographers the opportunity to bring their work to a wider audience and to introduce the next generation of photojournalists. The award was set up in 1986 in memory of photojournalist David Hodge who died, aged 29, in the course of his work.

Photographs are accepted on the understanding that they are not the result of a

commission by a UK publication and have not been published as such.

Five cash awards with a total value of £7,000. All prizewinners receive an Olympus E-1 digital camera system, and the opportunity to exhibit their entries at The Newsroom–The Guardian and Observer's archive and visitor's centre. The winner also receives an expenses paid assignment for the Observer.

Open to: Student, amateur and professional photojournalists aged 30 or under based in the UK, working in all areas of photographic reportage including photojournalism, documentary photography and portraiture

The next competition will be open for entries in April 2005.

Ian Parry Award for Photographers

The Ian Parry Memorial Scholarship
c/o The Sunday Times Picture Desk
1 Pennington Street
London E98 1ST
Contact: Rebecca McClelland
Phone: 020 7782 7391

The photographer Ian Parry was killed while on assignment for the Sunday Times in Bucharest during the Romanian revolution in 1989. In his honour, his family, friends and colleagues formed a special scholarship award offering photographers the opportunity to cover a foreign assignment of their choice.

Unlike other competitions, the Ian Parry Award is contested on the basis of both words and pictures. Entrants are required to submit an existing body of work as evidence of their ability to pursue a story, as well as a proposal of the project that would be undertaken if they won the Award.

PDN Contests

Photo District News
770 Broadway
New York, NY 10003
United states
Phone: +1 646 654 5792
Email: jgimenez@pdnonline.com
Web: www.pdnonline.com/contests/

For more than 20 years, PDN's contests have celebrated the best work in the professional community. The contests allow photographers to be recognized for excellence, to applaud colleagues for their achievements, and to continue to be inspired all year.

Listed below are the contests for 2004/5. Details of forthcoming prizes were not available at the time of writing but check website for updates.

PDN Photo Annual

The PDN Photo Annual features an extensive portfolio of award-winning pieces and an editorial recap of the most important stories of the year. The editors re-examine current visual trends, profile movers and shakers in the industry and analyze the impact of specific technologies in the field. The annual is an essential guide for creatives looking for talent and trends, and

serves as a lasting record of our industry's achievements over the past year.

Sponsored by – Canon, Epson, Fujifilm, Nikon and Olympus

Categories:

1. Advertising
2. Magazine / Editorial
3. Photo Books
4. Photojournalism / Sports / Documentary published / unpublished
5. Corporate Design / Photo Products / annual reports / brochures / catalogs / greeting cards / calendars / posters/ book covers / cd covers / packaging
6. Personal Work
7. Stock Photography
8. Web Sites
9. Student Work

This competition is open to work produced or published during the caledar year. Entries must be submitted as proofs, tearsheets, finished printed pieces, CD-ROM, zip disk, photo CD, or transparency and you must include a hard copy or printed version (category 7 excluded). Hard copies are judged, digital files are for reproduction purposes only. See category requirements for specifics. Entry fees applicable.

Closing date: January

The Marty Forscher Fellowship recognizes students and young professionals with a talent for humanistic photography. The fund will award two grants in 2005. Photographers are eligible by entering humanistic documentary images to the PDN Photo Annual. The Fellowship is sponsored by Parsons and Photo District News. Additional prizes, scholarships, judges and sponsors to be announced.

TOP KNOTS: The New School of Wedding Photography Contest

The contest celebrates distinctive, unique, and creative approaches to high-end wedding photography. The contest is judged in 5 categories: ceremony, party, portraits, details, spontaneous.

> Prize for the Best of Category winners:
> A Fujifilm finepix S20 Pro Digital Camera
> 20 Pack Fujifilm Professional Colour Negative Film
> $200 Discount coupon to an Authorized Participating Studio Master Pro Lab
> PhotoServe Portfolio
> Tamrac's Rolling Photo Briefcase

> Grand Prize Winner : – The New Fujifilm Finepix S3 Pro Digital Camera

PDN/Nikon Self-Promotion Awards

The PDN/Nikon Self-Promotion Awards have acknowledged photographers' outstanding self-promotion pieces for the last 20 years.

Categories:

1. Best Ongoing Campaign – Established Talent

Any photographer working as a professional for more than 3 years. A concerted self-promotion effort of 3 or more related pieces distributed over a period of 6 to 12 months (beginning within the last 12 months). The elements of the campaign must be unified by a consistent theme or concept.

2. Best Ongoing Campaign – New Talent

Any photographer working as a professional for more than 3 years. A concerted self-promotion effort of 3 or more related pieces distributed over a

period of 6 to 12 months (beginning within the last 12 months). The elements of the campaign must be unified by a consistent theme or concept.

3. Direct Mail – Cards, Mailers and other printed pieces

Any single self-promotion mailing, flat size smaller than 11" x 14".

4. Direct Mail – Posters

Any single self-promotion poster, flat size 11" x 14" or larger.

5. Print Placement – Creative Directory, Annual or Magazine

Self-promotion ads appearing in publications such as The Black Book, Communications Arts, Le Book, or Workbook, etc. within the last 12 months.

6. Extraordinary Promotions

Included in this category are objects d'art, holiday cards and created promotions distributed over the last 12 months.

7. Best Overall Design

Entries from Graphic Designers, Creative Directors and Art Directors who have designed any photographer's self promotion pieces distributed over the last 12 months.

8. Digital Media / Electronic Promotion

Self-promotions produced on CD ROMs, disks and websites or other digital media are eligible for this category.

Prizes :
First, second and third place in each category will be in PDN's October issue, on PDN Online and featured at the Awards Ceremony during PhotoPlus Expo.
First Place: Winners receive Nikon equipment and portfolio on PhotoServe
Grand Prize: Nikon professional digital camera and portfolio on PhotoServe.com.

Phodar Biennial

P.O.Box 55
1510 Sofia
Bulgaria
Email: antoanbo@yahoo.com; antoanbo@mail.bg
Web: www.fodar.dir.bg/

The Phodar Foundation runs a biennial competition open to photographers internationally. 2005 is the fourth Phodar Biennial and is entitled 'Your World'.

Black and white and colour works are accepted. Works which have previously been submitted are not eligible. The Biennial accepts media products – installations based mainly upon a photographic image as an information bearer. Details available on the website.

Categories:
• Portfolio of 5 to 12 photographs
• Individual works
• 'Photoschool' for students

Photographers can submit one portfolio and up to five individual works – the same applies to students.

Prizes: 1st – 500. Category 1 – 300. Category 2 – 200. Category 3 – 150.

Additional prizes are also awarded.
Closing date: February. Next competition 2007.

Photo Review Annual International Photography Competition

The Photo Review
140 East Richardson Avenue, Suite 301
Langhorne, PA 19047
United States
Phone: +1 215 891 0214
Web: www.photoreview.org

Accepted work will be reproduced in the 2005 competition issue of The Photo Review, a critical journal of photography with an international scope and readership. Prize winners will be exhibited at the photography gallery at The University of the Arts, Philadelphia.

All photographs, black and white, colour, non-silver, computer-manipulated, etc., are eligible. (Reproductions will be in black and white with original process noted.)

Entry fee: $25 for up to three images, plus $5 for each additional image up to a maximum of five entries. All entrants will receive one complimentary copy of the exhibition catalogue. The Photo Review reserves the right to reproduce accepted work in the contest catalogue and for contest promotion in both printed and electronic forms.

Awards: Microtek ScanMaker 6100 Pro scanner with ColoRescue™ system for automatic one-touch photo restoration and 4"x5" transparency adapter, $350 gift certificate from Calumet, and $500 in cash prizes.

Closing date: Submissions to be received between 1st and 15th May.

The Picture Editors' Awards

Email: info@pictureawards.net
Web: www.pictureawards.net

The Picture Editors' Awards were founded twelve years ago to recognise and reward the very best of photographic journalism, and to support and encourage students intending to follow a career in press photography.

The Awards are open to photographic journalists living in the UK or Ireland, and British and Irish photographers wherever they reside.

Newspaper Awards:

- *Newspaper of the Year*
- *Regional Newspaper of the Year*
- *Newspaper Magazine of the Year*

Portfolio Awards:

- *Photographer of the Year: £4,000*
- *Regional Photographer of the Year: £2,000*
- *Magazine Photographer of the Year: £2,000*
- *Photographer of the Year – Local Newspapers: £2,000*

- *Photo Essay Award: £2,000*
- *Sports Photographer of the Year: £2,000*
- *Young Photographer of the Year: £2,000*

Student Award: £2,000. Nominees in the Student category will also be offered work experience opportunities, and receive vouchers for equipment, materials and processing.

Single Image Awards:

- *Celebrity Photographer of the Year: £1,000*
- *Best Black and White Picture: £1,000*
- *News Photographer of the Year: £1,000*
- *Royal Photographer of the Year: £1,000*
- *Sports Picture of the Year: £1,000*

Portfolios consist of not less than eight nor more than ten images. Photographers may enter one portfolio in each of the portfolio categories for which they qualify. Images may be part of more than one portfolio entry – for example a picture in the Sports category might also feature in the Photographer of the Year category.

The Regional Photographer of the Year category is open to photographers who mainly contribute to daily, evening or Sunday newspapers which are published and circulate in a regional city or town. Photographers eligible for this award may also enter the Photographer of the Year category.

The Photographer of the Year – Local Newspapers category is open to photographers who mainly contribute to local weekly and bi-weekly titles. Photographers eligible for this award may also enter the Photographer of the Year category. Photographers working for newspaper groups which include regional and local titles to which they contribute, may enter both categories.

The Young Photographer of the Year category is open to photographers aged under 25 years. Photographers eligible for this award may also enter the Photographer of the Year category.

The Student Award is open to those enrolled in, or graduating from, a recognised higher education course in photography in the UK or Ireland who intend to follow a career in photographic journalism.

Photographers may enter up to three images in each of the single picture categories. No image may be entered in more than one single picture category.

Only email entries can be accepted. Images must be submitted electronically, using the Picture Editors' Awards website at http://www.pictureawards.net. No prints, transparencies, computer disks, or other media will be accepted.

Pictures of the Year International

The Missouri School of Journalism
109 Lee Hills Hall
Columbia, MO 65211
United States
Email: info@poyi.org
Web: www.poyi.org

POYi is one of the world's oldest, largest and most highly respected photo-journalism contests. There are a considerable number of categories within which work can be entered and an entry fee is charged. For full details and

entry guidelines check the website.

The contest is made possible through the continued support of the Missouri School of Journalism. To enhance this support, POYi and the Missouri School of Journalism have established a Pictures of the Year International Endowment to ensure the contest continues to keep pace with changes in the profession while meeting its educational mission and which will eventually make POYi completely self-supporting, and enable it to drop entry fees.

Awards and Prizes

- *Newspaper and Magazine Photographers of the Year* each receive a trophy, a $1000 cash award and $500 worth of film. The runners-up will receive a plaque, a $500 cash award and $500 worth of film. Third-place winners receive a plaque, a $250 cash award and $250 worth of film.

- The newspaper winning the *Angus McDougall Overall Excellence in Editing Award* will receive a sterling silver traveling trophy, a plaque and tuition to the Missouri Photo Workshop.

- *The Best Book Award* winner will receive a plaque and $1,000.

- *The World Understanding Award* winner will receive a trophy and $1,000 and $1,000 worth of film. Essays judged worthy of special recognition receive a plaque and $250.

- Winner of the *Community Awareness Award* will receive $1,000 and a trophy and $500 worth of film. Entries judged worthy of special recognition receive a plaque and $250.

- Winning photographer of the *Public's Best Picture of the Year* will receive $1,000 and a plaque.

- First place winners in individual categories will receive plaques. All other places in individual categories will receive certificates.

Polaroid Corporation

Corporate Headquarters
1265 Main Street - Bldg. W3
Waltham, MA 02451
United States
Phone: +1 781-386-2000
www.polaroid.com

The Polaroid International Photo Awards

2004 was the fifth year of the Awards. Professional photographers around the world have been using Polaroid instant film for more than 50 years for fine art, advertising and self expression. This contest provides the opportunity to recognize and acknowledge their inspirational work.

Artist Support Program:

The Artist Support Program is designed for the mutual benefit of all parties: artists receive support and exposure, the viewing public gains access to a richly creative body of work, and the Corporation gains feedback, publicity, and sales for its products. Photographers are given small film and equipment grants and asked to provide Polaroid with one image per grant for the Collection. Exhibitions are created periodically from the Collection and toured throughout the international museum circuit, publicity is generated, portfolios

are printed in the media, and books are published. Since 1973, more than 40 exhibitions have been exhibited, including, Aigner's Paris, From My Window (André Kertész), Lucas Samaras: Polaroid Photographs, 1969-1983, and Legacy of Light. In addition to generating positive publicity for the corporation, exhibitions like these illustrate the quality and creative potential of Polaroid films to a wide audience.

Rhubarb-Rhubarb Bursaries

Rhubarb-Rhubarb
212 The Custard Factory
Gibb Street
Birmingham B9 4AA
Contact: Lorna Mary Webb
Email: info@rhubarb-rhubarb.net
Web: www.rhubarb-rhubarb.net

Rhubarb is the UK's International Festival of the Image. Arts Council England West Midlands are supporting 8 one day bursaries for photographers to attend the Rhubarb-Rhubarb festival. Photographers must live or work in the West Midlands region and have some experience of working to commission, being published or exhibited.

Each bursary place will consist of:

- Advice on folio presentation
- Profiling yourself and your work
- 6 x 20 minute sessions with international reviewers
- Floating reviewer opportunities

Preference will be given to those who have not previously received an Arts Council West Midlands Bursary or UK Trade and Investment Bursary to attend the Rhubarb Festival.

Closing date: 1st March.

Royal Horticultural Society Photographic Competition

Phone: 01805 624067
Email: photocomp@rhs.org.uk
Web: www.rhs.org.uk/news/photocomp2005.asp

Competition categories:

- *Plant Portrait Photograph of the Year:* A single or grouping of the same plant or flower.
- *Plant Combination Photograph of the Year:* A combination of two or more different plants. Flower arrangements are excluded.
- *Close-Up Photograph of the Year:* Detail of a plant or flower.
- *Tree or Shrub Photograph of the Year:* Any tree or shrub, not necessarily in a garden setting.
- *Garden View Photograph of the Year:* A garden (public or private) taken from within the garden or looking into the garden. The photograph should clearly identify 'the garden'.
- *Wildlife in the Garden Photograph of the Year:* Any animal life in a

garden. Includes birds, mammals, insects etc, but not domestic animals.
- *People in the Garden Photograph of the Year:* The main subject should represent a person or persons in a garden or horticultural environment.

The competition is open to all amateur and professional photographers, entries will not be judged separately. There is no restriction on the number of entries, but each photograph may be entered for one category only. A photograph that has won a prize in another major photographic competition (or the RHS Photographic Competition in previous years) is not eligible. Only prints may be submitted. Black and white and colour images are accepted. Digital images may be submitted but must not be supplied on disk. The RHS claims the right to use any award-winning entries in publicity material, exhibitions and publications, including the RHS greetings card collection, to promote the RHS Photographic Competition.

Entry fee: £4 (RHS members), £5 (non-members) per print entered.

Winning entries will be displayed at the RHS London Flower Show and/or at RHS or Sponsor's establishments throughout the year.

Prizes:
- Top prize of £1,000 awarded to the **RHS Photographer of the Year.**
- First prize in each category – £300.
- Second prize in each category – £200.
- Third prize in each category – £100.

Closing date: End of July.

Samaritans – Photographic & Digital Image Competition

Photographic & Digital Image Competition
The Upper Mill
Kingston Road
Ewell
Surrey KT17 2AF
Tel: 020 8394 8300
Fax: 020 8394 8301
Email: admin@samaritans.org
Web: www.samaritans.org/know/competitions.shtm

The Samaritans have run a photography competition and exhibition for a number of years. In 2004 the theme was: Connected. Photographers and digital image artists were invited to capture, or create, images that visualise a moment of human connection and positive human interaction through communication.

Prizes were donated by Pentax UK Ltd.

Santa Fe Center for Photography

P.O. Box 2483
Santa Fe, New Mexico 87504
United States
Phone: +1 505-984-8353
Web: www.photoprojects.org

The Santa Fe Center for Photography (SFCP) is a nonprofit organization that

honors, supports and provides opportunity for gifted and committed photographers. The programs offered by SFCP bring exposure to worthy photographic projects and series, and create fellowship among photographers and influential members of the photographic community. These programs include annual awards and competitions; Review Santa Fe, an annual conference for photographers and picture professionals; and intensive retreats on relevant issues in photography.

Annual Competitions:

Project Competition
The Singular Image
Excellence in Photographic Teaching Award
Santa Fe Prize for Photography

Project Competition

The annual Project Competition honors committed photographers working on long-term documentary projects and fine-art series.

Work derived from all photographic processes, both traditional and digital, is accepted, as well as photo-based mixed media work. Both fine art and documentary photography, and all combinations thereof, are invited. Work that has been published as a monograph is not eligible. Previous winners of the Project Competition may not enter again with the same body of work.

International submissions are welcome.

First Prize: $5,000 cash award; a full-tuition scholarship to the Santa Fe Workshops (restrictions apply), includes campus housing and lunches; complimentary participation in Review Santa Fe, and publication of the winning work.

Juror's Choice Awards (3): $500 cash award; Web publication; complimentary participation in Review Santa Fe.

Entry guidelines available on website. Handling fee of $35.
Closing date: February

The Singular Image

The Singular Image (formerly Assignment Earth) recognizes outstanding individual photographs in colour and black and white.

Work derived from all photographic processes, both traditional and digital, is accepted, as well as photo-based mixed media work. Both fine art and documentary photography, and all combinations thereof, are invited. Work that has been published as a monograph is not eligible. Previous winners of the Project Competition may not enter again with the same body of work.

International submissions are welcome.

Prizes: Black & White

- First: Hasselblad XPan II Kit; includes a camera body, 45mm lens, strap, spirit level, tripod quick coupler, XPan leather case and batteries
- Second: Calumet travelite 375 monolight with sync cord and flash tube cover
- Third: $300 gift certificate from Light Impressions
- Honorable Mention (3): $50 gift certificate from photo-eye Books & Prints

Prizes: Colour

- First: Full-tuition scholarship for a week-long workshop of your choice at the Santa Fe Workshops, including on-campus housing and lunches

(travel expenses not included); some restrictions apply.
- Second: Epson Stylus printer
- Third: $300 Singer Editions gift certificate for fine-art digital printing
- Honorable Mention (3): $50 gift certificate from Twin Palms

Closing date: February

Excellence in Photographic Teaching Award

The Excellence in Photographic Teaching Award rewards high school, college or post graduate level educators for their dedication and passion for photographic teaching. Educators in all areas of photographic teaching are eligible, including fine art, documentary, history and criticism.

Nomination by student or colleague. Deadline for nominations: January

Independent submission. Educators need not be nominated to apply; they may enter by fulfilling the entry guidelines. Deadline for submissions: February.

Prizes:

Teacher of the Year: $2,500 award; Adobe Creative Suite (Adobe Photoshop® CS, Adobe Illustrator®, Adobe InDesign®, Adobe GoLive®, and Adobe Acrobat® Professional)

Honorable mention (2): Adobe Photoshop® CS

Santa Fe Prize for Photography

The Santa Fe Prize for Photography recognizes and rewards a gifted and committed photographer who has completed, or is near completion of, a meaningful body of work. This prize was initiated to bring new work to light, and photographers internationally are eligible. The award process is by nomination only; photographers may not apply independently. The award includes $5,000 and participation in Review Santa Fe; the cash award must be used to complete a body of work or to introduce a completed project to a larger audience.

Schweppes Photographic Portrait Prize

National Portrait Gallery
St Martin's Place
London WC2H OHE.
Phone: 020 7306 0055
Email: jrowbotham@npg.org.uk
Web: wwww.npg.org.uk/schweppesprize

2004 was the second year of the Schweppes Photographic Portrait Prize – a high-profile showcase for new talent in portrait photography. The Prize provides an important platform to celebrate the work of portrait photographers from around the world including students, talented amateurs and professionals aged eighteen and over.

In 2004 entries were received from 2,661 photographers. Judges selected 61 portraits for the exhibition from the 7,906 submitted images.

Prize: £15,000

See website for further information

Aaron Siskind Foundation

c/o School of Visual Arts, MFA Photography
209 East 23rd Street
New York, NY 10010
United States
Email: info@aaronsiskind.org.
Web: www.aaronsiskind.org/grant.html

Individual Photographer's Fellowship

Siskind directed that his estate become a resource that would support contemporary photography and reward and encourage excellence in its practitioners. Since his death in 1991, the Foundation has been one of the few American organizations providing cash grants to individual photographic artists on a annual basis. The Individual Photographer's Fellowship review panel examines the work of upwards of 700 applicants each year, awarding a varying number of grants in amounts of up to $5,000.

Eligible work must be based on the idea of the lens-based still image, but grant recipients work in forms as diverse as digital imagery, video, installations, documentary projects and photo-generated print media. Whether they are established achievers or emerging talents, the Foundation recognizes each recipient's potential to contribute to the medium in its largest sense.

There are no restrictions on the subject matter or processes of past or projected work. However, applicants must be citizens or permanent residents of the United States. Also ineligible are institutions, artists working in non-photographic media, and students who will be enrolled at any time during the calendar year. Past grant recipients may reapply the second year following their previous award.

Closing date: October

Site Gallery

1 Brown Street
Sheffield S1 2BS
Contact: Albert Willaims, albert@sitegallery.org
Phone: 0114 281 2077
Fax: 0114 281 2078
Email: info@sitegallery.org
Web: www.sitegallery.org

Site Gallery runs an ongoing commissions programme. These currently form part of the Immediate project which was first established in 1999 and has run every other year as an exhibition, commissioning and publishing programme. The commissions programme is aimed at showcasing innovative and experimental practice across the broad definition of lens-based media, which includes film, video, chemical and digital photography, interactive and on-line media. Proposals for either new projects or the completion of works in progress are welcome.

The work will be shown on the gallery's projection window that is back projected and is sited on the second floor of the building with visibility from the surrounding Cultural Industries Quarter area. The size of the projection window is 5 x 4 metres.

The commissions are offered to artists who have recently established and are a minimum of 2 years from graduating or setting up a first studio but no more that five years, or are in the final year/just completed an MA or other post-graduate study. The definition of the North of England includes Derbyshire, Leicestershire, Nottinghamshire, West Midlands, the North West, Staffordshire, Yorkshire, Humberside, Cumbria, Northumbria, Lancashire, Cheshire, Lincolnshire, Merseyside, Lincolnshire.

A commissioning fee of £1,000 will be offered plus a production budget.

W. Eugene Smith Memorial Fund

c/o the International Center of Photography
1133 Avenue of the Americas
New York, NY 10036
United States.
Web: www.smithfund.org

The W. Eugene Smith Grant in Humanistic Photography is presented annually to a photographer whose past work and proposed project, follows the tradition of W. Eugene Smith's compassionate dedication exhibited during his 45 year career as a photographic essayist. For 2005, the grant will be $30,000, with an additional $5,000 in fellowship money to be awarded at the discretion of the jury. The grant program is independently administered by the W. Eugene Smith Memorial Fund and generously funded by Nikon Inc.

Applications can be downloaded online or obtained by writing to the fund. In addition to a résumé of educational and professional qualifications, applicants are asked to provide evidence of photographic ability in the form of workprints (8"x10"prints preferred, and no more than 40), and/or photocopies, duplicate transparencies, contact sheets and clippings of published stories. There are no entry fees.

Applications must include a written proposal, which is cogent, concise, journ-alistically realizable, visually translatable and humanistically driven. A three person jury is appointed each year by the Fund. After reviewing applications and proposals, the jury selects the finalists, each of whom is asked to submit a comprehensive photographic portfolio and write a more detailed and focused proposal in addition to answering specific questions about his or her project. At the second meeting, the jury reviews all new material and selects the grant recipient. The grant is announced at ceremonies usually held in October at the International Center of Photography in New York. The recipient must warrant that the project in progress is ongoing, and agree to provide the Fund with a set of photographs when the project is completed. The photographs will be housed as part of the permanent W. Eugene Smith Legacy collection at the ICP.

Closing date: July.

Spider Awards

Black and White Spider Awards
2 Aubrey Close
Marlborough
Wiltshire SN8 1TS
www.spiderawards.co.uk

Black and White Spider Awards is an international awards competition recognizing excellence in black and white photography. The 2004 Awards attracted photographers from twenty nine countries with industry leaders from twelve countries nominating and selecting the winning images.

Eligibility: Open to professional and amateur photographers shooting in all forms of black and white photography using traditional or digital methods. The aim is to showcase the power of black and white photography. All entries will be judged on the basis of: artistic merit, originality, subject and style.

Categories
Professional categories: Abstract, Advertising, Architectural, Fashion, Fine Art, Nature, Nude, People, Photojournalism, Sport, Silhouette, Still Life, Vintage (25+ years)
Amateur categories: Abstract, Architectural, Fine Art, Nature, Nude, People, Photojournalism, Silhouette, Still Life, Vintage (25+ years)

There is no limit to the number of images you can enter.

Entry fees: Professional – £25 per entry; Amateur – £20 per entry.
Collection special: Professional: 5 images for £70; Amateur: 5 images for £60

Closing dates: The Spider Awards has 3 deadlines throughout the year: March 31, August 31, October 31, 2005. All entries must be received before final deadline to be eligible for the 2005 Awards.

Winners in all categories announced in November.

TCB-Cafe Publishing – Photography Competition

PO Box 471706
San Francisco, CA 94147
United States
Phone: +1 415 263 6800
Fax: +1 208 692 0250
Web: http://cafeandre.com/

An international photography contest organized by TCB-Cafe Publishing of San Francisco. It aims to develop and raise the visibility of photographic and creative talent, in the form of a competition and the resulting book publication and exhibition. The culmination will be a cloth-bound photographic book, showcasing the competition winners.The 2005 competition has two separate book themes:

i) Orchid Chic: Passion, Fashion & Orchids

ii) Sand: The Human Form in a Formless Medium

All submitted images must represent one of the themes, and can be in colour or black & white. Open to all. All submissions should be in digital format, submitted either online via email or mailed on CD-ROM. Slides and prints are ineligible, unless requested by the organizers. Submitted work must have been created within the last four years. Entry fee: $25 for the first image, and $10 for each subsequent image. Each Entrant can submit up to three images.

Prizes: Selected images will be published in the books 'Sand' or 'Orchid Chic' by TCB-Cafe Publishing. Selected images will also appear in a TCB-Cafe Publishing exhibit on the contest's theme. A total of 40 First and Second Place Finalists will be selected per theme.

Closing date: March.

The Times / Tabasco® Young Photographer of the Year

c/o Bob Kirwin
Times House
1 Virginia Street
London E98 1GE
Web: www.thetimes.co.uk/youngphotographer

The organisers are looking for young photographers aged between 19 and 25 who have the flair, imagination and determination to succeed on a national newspaper. The Prize is a six-month fully paid contract for a job on The Times. The winner will have the opportunity to work on the main news picture desk as well as on features, arts and sport. There will be the unparalleled opportunity to work and learn alongside some of the leading photographers in national newspapers.

Entries must consist of three different prints or images in contrasting styles, each of which must fall into one of the following categories: action, food and entertainment, portraiture.

Entry can be made online or by post.

Travel Photographer of the Year

PO Box 2716
Maidenhead
Berkshire SL6 7ZN
Email: info@tpoty.com
Web: www.tpoty.com

Travel Photographer of the Year (TPOTY) is an international photographic competition designed to find the very best in travel photography. Open to anyone, amateur or professional. There are no age restrictions.

The competition has four portfolio categories. Entrants should submit a group of four shots in each of the portfolio categories they choose to enter. Those who enter two or more different categories become eligible for the overall title of Travel Photographer of the Year.

2005 themes: *Go Beyond, Human Spirit, Traveller's Tales* and *Natural World.*

There is one single image category: *Moment of Freedom.*

Young Photographer of the Year – 17 years and younger. Entrants should submit a group of four images on the theme *World Through My Lens* which shows what travel means to them.

Entry fee: £5 for one portfolio category or four images in the single image category. £15 to enter every category. Discounts for students and those over 65, and children under 16 enter for free.

Prizes:

Travel Photographer of the Year

- Two economy class round-the-world air tickets on Star Alliance network
- Adobe CS premium and Video Collections software
- Plastic sandwich leather portfolio book

Young Travel Photographer of the Year
- Light & Light trip to Lake District for winner and accompanying adult
- Hewlett packard top spec Photosmart PC with digital camera, scanner and printer
- Adobe CS Premium Collection software

There are prizes for category winners, runners-up and highly commended entries in every category and all the travel prizes are for two people so you can take someone with you if you win. See website for full details.

Closing date: September.

Trierenberg Super Circuit

Chris. Hinterobermaier
Postfach 364
A-4010 Linz
Austria
Fax: +43 732 604030 13
Email: austriansupercircuit@netway.at
Web: www.supercircuit.at

A maximum of 4 monochrome and 4 colour prints may be entered in each section. Any recognized photographic or digital process is eligible, provided the original negative or slide was exposed by the entrant. Entry fees applicable.

General section: Any subject, theme or technique is eligible.
Nature section: restricted to the use of the photographic process to depict observations from all branches of natural history, except anthropology and archeology

Closing date: May 2nd.
Grand Prize: Hasselblad Camera.

The United Nations Environment Programme – International Photography Competition

Web: www.unep-photo.com/

The United Nations Environment Programme (UNEP), with the sponsorship of Canon Inc., held its fourth International Photographic Competition on the Environment under the title 'Focus on Your World'. 'Focus on Your World' will create a visual journal depicting the challenges facing Earth's rich environmental diversity.

The winning photographs feature in travelling exhibitions to increase awareness of the environmental issues world-wide. The 'Focus on Your World' photo collection is a unique and ongoing visual record of this critical period in the history of our planet.

Eligibility: The competition, which is the largest of its kind in the world, invites entries from people of all nationalities and ages and is open to both amateur and professional photographers.

Check the website for entry dates for the next competition.

General : Aged 25 years or older.
Youth : Aged 15 to 24 years.
Children: Aged 14 or younger.

Prize: General Category

Gold Prize (one) $20,000 and plaque
Silver Prize (one) $10,000 and plaque
Bronze Prize (three) $5,000 and plaque
Honorary Mention (forty) plaque

Prize: Youth Category

Gold Prize (one) $5,000 and plaque
Silver Prize (one) $2,000 and plaque
Bronze Prize (three) $1,000 and plaque
Honorary Mention (forty) plaque

Prize: Children's Category

Gold Prize (one) $2,000 and plaque
Silver Prize (one) $1,000 and plaque
Bronze Prize (three) $500 and plaque
Honorary Mention (forty) plaque

Other categories include:

The UNEP Executive Director's Special Prize
The Canon Special Prize

Closing date: Usually October.
Visit the website for application details and guidelines.

Voies Off

26 ter rue Raspail
13200 Arles
France
Phone & fax: +33 4 90 96 93 82
Email : photographie@voiesoff.com
Web: www.voiesoff.com

The Festival is open, without regard to age or nationality, for the general programme selection of work by professionals or amateur photographers, artists using photography, communities, organizations, galleries, agencies or schools. .

The selection committee will be looking for portfolios containing personal, original bodies of work marked by a unity of thought, vision or theme. The main selective criteria remains the expression of an original artistic vision.

Application is in two stages.

Stage 1. Firstly send a preselection application: slides, traditional prints, photocopies, laser prints, digital prints are accepted. CD-Roms are excluded.

Stage 2. Artists must be able to quickly provide digital files of good quality, in accordance with technical conditions.

A Jury of professionals and members of Voies Off will select the prizewinner from a shortlist. The Festival management reserves the right to use any selected work in order to promote the Festival.

Results by email only. Prizewinner announcement in July.
Closing date: May.

Prize: 1525 grant (approx. $1,340)

Tom Webster Photographic Award

Impact Photos
18 - 20 St. John Street
London EC1M 4NX
Web: www.twphotoaward.org

Tom Webster was a freelance journalist who died in 1994 aged 24. In Tom's memory his family, in conjunction with Impact Photos, sponsor an award to give a young photojournalist the opportunity to begin, or continue, an in-depth documentary photography project of their choice. The winner will receive £1,000 towards the cost of their project plus an introduction to, and professional advice from, Impact Photos.

The award is open to any full-time photographer under the age of 29, or anyone under 29 attending a full-time recognised photography course. Entrants must submit not more than 12 photographs from their current portfolio, either a photo-essay and /or a collection of images, black and white and/or colour.

Entries must also include a proposal (of not more than 400 words) for the project that would be undertaken should you win the award, together with a brief budget breakdown.

Closing date: May.

Wildlife Photographer of the Year

The Natural History Museum
Cromwell Road
London SW7 5BD
Contact:Sarah Kavanagh, Competition Manager
Phone: 020 7942 5015
Fax: 020 7942 5084
Email: wildphoto@nhm.ac.uk
Web: www.nhm.ac.uk/wildphoto

The competition is organised by BBC Wildlife Magazine and the Natural History Museum.

Categories

Wildlife Photographer of the Year – Given to the photographer whose individual image is judged the most striking and memorable. Prize: £2,000.

Innovation Award – This award exists to encourage innovative ways of looking at nature. For the photograph that best illustrates originality of both composition and execution. Prize: £1,000.

Eric Hosking Award – This award aims to encourage young and aspiring wildlife photographers to develop their skills and give them the opportunity to

showcase their work. It was introduced in 1991 in memory of Eric Hosking, Britain's most famous bird photographer, and goes to the best portfolio of six images taken by a photographer aged 26 or under. Prize: £1,000

Gerald Durrell Award for Endangered Wildlife – Commemorates the late Gerald Durrell's work with endangered species and his long-standing involvement with the competition. It features species that are critically endangered, endangered, vulnerable or at risk (as officially listed in the IUCN Red List of Threatened Species). Up to three transparencies may be entered. Prize: £1,000.

Adult categories:

Up to three colour transparencies or digital jpeg images on a CD in each of the following categories. Each category has a first prize of £500 and a second prize of £250.

Animals in Their Environment – Photographs must show the habitat as important a part of the picture as the plants or animals being shown. They must convey a sense of the relationship between the plant or animal and its habitat.

Animal Behaviour: Birds – The pictures in this category can't just be record shots or beautiful images, they must have interest value and action as well as aesthetic appeal.

Animal Behaviour: Mammals – These photographs, too, are selected for their interest value as well as their aesthetic appeal, showing familiar as well as seldom-seen active behaviour.

Animal Behaviour: All Other Animals – This category offers plenty of scope for interesting pictures, as animals other than mammals and birds comprise the majority and have behaviour that is often little known.

Animal Portraits – This category invites entries that are true portraits, showing an animal in full or centre-frame, which convey the spirit of the subject.

Composition and Form – Here, realism takes a back seat, and the focus is totally on the aesthetic appeal of the pictures, which must illustrate natural subjects in abstract ways.

From Dusk to Dawn – The criterion for this category is strict: the wildlife must be photographed between sunset and sunrise, and the sun may be on but not above the horizon.

In Praise of Plants – This category aims to showcase the beauty and importance of flowering and non-flowering plants whether by featuring them in close-up or as an essential part of their habitat.

The Underwater World – These photographs can show marine or freshwater animals or plants. The most important criteria are aesthetic ones, but interest value is also taken into account.

The World in Our Hands – These pictures illustrate symbolically or graphically, our dependence on the natural world or our capability for damaging it.

Wild Places – This is a category for landscape photographs, but ones that must convey a true feeling of wildness and create a sense of awe and wonder.

Young Wildlife Photographer of the Year 2004 – This part of the competition is open to anyone aged 17 years or under on the closing date. Entry to the junior competition is free. Pictures must show wild animals or plants, or wild landscapes. The organisers look for good ideas for memorable pictures (a common plant or animal framed by an unusual background might, for example, make a better picture than a rare species in a boring setting).

Concentrate on framing your subject in the best possible way, it's the shots with the best composition that usually win.

The overall title will be given to the young photographer whose individual image is judged to be the most striking and memorable.

Prize: £500, and a day out with a well-known wildlife photographer.

The Young Wildlife Photographer of the Year competition has three age categories. (10 and under, 11-14 years, 15-17 years) The winner of each category receives a prize of £250 and a runner-up prize of £100 is given. You may enter up to six images. Entries may be colour prints, slides or digital images taken within the five years immediately prior to the closing date.

The annual competition is open to anyone except those involved in its organisation and employees of BBC Worldwide and the Natural History Museum.

Application forms available online. Entry fee of £20 for all adult entries.

Closing date: April

World Press Photo Contest

World Press Photo Foundation
Jacob Obrechtstraat 26
Amsterdam 1071 KM
The Netherlands
Phone: +31 20 6766 096
Fax: +31 20 6764 471
Email: office:worldpressphoto.nl
Web: www.worldpressphoto.nl

The Board of the World Press Photo Foundation invites press photographers and photojournalists throughout the world to participate in the annual World Press Photo Contest. This competition accepts press photographs taken during the year of the award and intended for publication. The prize-winning pictures and a number of runners-up selected by the international jury will appear in the yearbook and will be exhibited under the auspices of the Foundation.

Single pictures and picture stories/portfolios may be entered in the following categories:

Spot News – Pictures or stories/portfolios of unscheduled events for which no advance planning was possible.

General News – Pictures or stories/portfolios of planned or organized events.

People in the News – Pictures or stories/portfolios of people or groups of people featuring in the news.

Sports Action – Single sports action pictures or sports action stories/portfolios.

Sports Features – Single sports feature pictures or sports feature stories.

Contemporary Issues – Feature picturesor stories/ portfolios exploring contemporary social issues, environmental and health issues, etc.

Daily Life – Pictures or stories/portfolios illustrating the richness and diversity of everyday life.

Portraits – Pictures or stories/portfolios portraying people (groups and individuals), including public figures and celebrities.

Arts and Entertainment – Editorial reporting in single pictures or stories/portfolios of visual and performing arts, rituals, festivals, etc.

Nature – Pictures or stories/portfolios about the natural world, flora and fauna, landscapes, etc.

The jury may decide to judge submissions in a different category from the one in which it was entered.

Open to: Only work by professional photographers will be accepted for this contest. Full details available on the website.

Application: Download application form. Entries must be accompanied by a completed entry form.
Closing date: January. Winners announced: February.

Academy Schloss Solitude

Stiftung des Offentlichen Rechts
Solitude 3
Stuttgart 70197
Germany
Contact: Ilse Babel
Phone: +49 711 99 619-0
Fax: +49 71199 619-50
Email: iw@akademie-solitude.de
Web: www.akademie-solitude.de

This is a residence fellowship. Fellows are expected to spend at least two-thirds of their residency at Akademie Schloss Solitude.

The fellowship includes the following:

A combined apartment/studio, furnished with electricity, water and heat free of charge.

A stipend amounting to 1,000 monthly (plus one-time expenses incurred by the fellowship holder travelling to and from Stuttgart from his or her primary place of residence).

The Akademie may also offer additional financial supplements, a supplement for so-called double housekeeping (subsidy for apartment or studio costs); freight cost subsidy for the transport of materials, tools and instruments to and from Stuttgart; a project promotion subsidy and a one-time materials subsidy; in the case of non-German guests (from non EU-countries), assumption of part of their health insurance expenses.

The use of the workshops owned by Akademie Schloss Solitude under the supervision of the technical director, is free of charge for fellowship holders.

The combined apartment/studios are generally only suitable for one person. In special cases the Akademie will consider allocating two studios for families. All artists invited are obliged to establish residence in Stuttgart for the duration of the grant (compulsory registration).

The following artistic disciplines are represented: Architecture, Visual arts, Performing arts, Design, Literature, Music/sound, Video/film/new media. Not only artists can apply, but also scholars and theoreticians in their respective disciplines.

Fellowships are awarded to artists who finished their basic studies not more than five years before applying or who are not older than 35. University or college students will not be considered for selection. Several fellowships are also awarded regardless of the applicant's age. 50 to 60 fellowships are allocated every 24 months. The Akademie has 45 studios at its disposal.

Fellowships are granted for either six or twelve months. Extensions are possible in individual cases.

Applicants not selected in the current selection process can reapply a maximum of two more times.

Balmoral Scholarship for Fine Arts

Künstlerhaus Schloß Balmoral
Villenpromenade 11
Bad Ems 56130
Germany
Contact: Dr Sabine Jung
Phone: +49 26 03 94190
Fax: +49 26 03 941916
Email: info@balmoral.de
Web: www.balmoral.de

The Künstlerhaus Schloß Balmoral is an international institution for the fine arts. It allocates grants to qualified artists of all ages in the fields of painting, drawing, sculpture, installation, graphics and design, photography as well as art theory. It is not an art college but a meeting place where gifted artists can widen their horizons by meeting colleagues from various art sectors and from different parts of the world. The Künstlerhaus grants residential scholarships to artists, offers accommodation to international guests, and to short-term guests dealing with a certain project only. It also assists guests (arranging artists' meetings, seminars, conferences and exhibitions). Eight apartments and eight studios are available. A monthly grant of 1,240 is given for an 11 month residency. Extensions are possible in individual, justified cases.

Eligibility: Artists of all ages in the fields of painting, drawing, sculpture, installation, graphics, design, photography and art theory. Applicants should have relevant training/study or degree followed by at least three years experience.

Application: Request application form.

Bellagio Study & Conference Centre

The Rockerfeller Foundation
420 Fifth Avenue
New York, NY 10018-2702
United States
Email: bellagio@rockfound.org
Web: www.rockfound.org

The Bellagio Study and Conference Center in northern Italy provides a contemplative environment for residencies in which scholars, scientists, artists, writers, policymakers and practitioners from all over the world may pursue their creative and scholarly work.

From February to mid-December, the Center offers one-month stays for 15 residents at a time in any discipline or field and coming from any country who expect a publication, exhibition, performance or other concrete product to result. Applicants are accepted not just for individual excellence or for the

potential of their proposed projects, but also for geographical diversity of their homelands and for their capacity to contribute to the intellectual mix of life at the Center.

The Center also offers interdisciplinary, intercultural networking through the convening of small working groups (from three to 25 participants) of policymakers, practitioners, scholars, scientists, artists and others. Priority is accorded to proposals that address significant issues and problems within or across given fields, are innovative in their design, and promise concrete outcomes beyond the drafting of a statement or recommendations.

Applications are reviewed by an interdisciplinary group of Rockefeller Foundation staff and by outside specialists. Decisions are based upon the quality of the project proposed, the importance of the proposed work in its field and discipline, the qualifications of the applicant(s), and the suitability of the Center for the proposed activity.

The Foundation provides room and board without charge for all residents and workshop/team participants. Some travel assistance is available for those from developing countries who qualify.

Details and application forms can be downloaded from the website.

Bolwick Arts

Bolwick Hall
Marsham
Norfolk NR10 5PU
Contact: Caroline Fisher, Curator and Residency Organiser
Phone: 01263 732 131
Email: gandcfisher@supanet.com
Web: www.bolwick.com

BolwickArts is an annual residency programme for artists who make site specific work. The location is Bolwick Hall, a Georgian Country House set in 52 acres, close to the market town of Aylsham, Norfolk.

Four artists are either invited or selected from an open submission, and are provided with a place to stay and studio space for three weeks. Artists are paid a fee and an amount for materials and travel through the support of Arts Council England, East, and Norfolk County Council.

The artists are given the freedom to research aspects of the Hall and its grounds and at the end of the three week residency period the work produced is on show as an exhibition.

The aim is to give the artists involved the opportunity to experiment, to explore their working practices, and to co-operate with the other artists and curator to make a cohesive final exhibition. The programme also brings contemporary art relating to its environment to a local and regional audience.

Braziers International Artists' Workshop

Studio 1.1, LAF
Towcaster Road
London E3 3ND
Email: info@braziersworkshop.org
Web: www.braziersworkshop.org

Braziers International Artists' Workshop is an annual sixteen-day residency in Oxfordshire. It takes place at Braziers Park: fifty acres of fields, gardens, barns, woodland, stables and outhouses. The park surrounds a seventeenth century hall occupied by a small community set up in 1950. Braziers is a non-profit making initiative that brings together an international selection of about fifteen artists from a range of practices, cultures and experiences.

Application: Apply in Writing. Download application form from website.

The British School at Rome (BSR)

at The British Academy
10 Carlton House Terrace
London SW1Y 5AH
Phone: 020 7969 5202
Fax: 020 7969 5401
Email: bsr@britac.ac.uk
Web: www.bsr.ac.uk

The British School at Rome is an interdisciplinary research centre for the humanities, visual art and architecture. Its fine neoclassical building was designed by Sir Edwin Luytens and is situated close to the Borghese Gardens in a quiet residential area of Rome, with easy access to the centre of the city. It provides living and working accomodation for around 35 scholars and other residents in study bedrooms, studios and offices laid out around a central courtyard and surrounded on three sides by private open space including a garden and tennis court. Each year the BSR offers a range of awards in its principal fields of interest.

The British School at Rome (BSR)
Abbey Scholarship in Painting, Abbey Fellowship in Painting

Abbey Awards
43 Carson Road
London SE21 8HT
Contact: Jane Reid
Phone: 020 8761 7980
Email: admin@abbey.org.uk
Web: www.abbey.org.uk; www.bsr.ac.uk

The Abbey Council offers an annual Scholarship and Fellowships in painting at the British School at Rome.

The nine-month Scholarship is usually given to an exceptionally promising emergent painter, while the three-month Fellowships are awarded to mid-career painters with an established record of achievement.

The Scholarship and Fellowships offer all-expenses-paid residencies at the

British School, with a stipend of up to £500 a month for the Scholar and £700 for Fellows.

Abbey Awards are open to people of UK and US nationality, and to citizens of other countries provided that they have lived in the UK or the US for at least 5 years. There is no age limit.

Application forms (which are the same for both the Scholarship and the Fellowships) may be downloaded from the Abbey website or obtained by post. Applications are accepted from October 1st.

Closing date: January.

The British School at Rome (BSR)
The E.A.Abbey Memorial Trust Fund for Mural Painting in Great Britain
The E.Vincent Harris Fund for Mural Decoration

Abbey Awards
43 Carson Road
London SE21 8HT
Contact: Jane Reid
Phone: 020 8761 7980
Email: admin@abbey.org.uk
Web: www.abbey.org.uk; www.bsr.ac.uk

These two funds are vested in the Royal Academy of Arts and since 1970 have been administered by the Incorporated Edwin Austin Abbey Memorial Scholarships (Abbey Awards). Some £6,000 is normally available annually, distributed between two or more projects.

The awards are made to artists who have been commissioned to create murals for public places or charitable institutions; artists' requests for funds must be backed by an authority from the institution in question. Alternatively, the commissioning institute may apply to the Fund on behalf of the muralist.

There are no restrictions of age or nationality. Requests may be made throughout the year, and decisions are made at the twice-yearly meetings (usually May and November) of the Abbey Harris Mural Fund Committee.

Those interested should contact the Administrator of Abbey Awards.

The British School at Rome (BSR)
Arts Council of Northern Ireland Fellowship

The Arts Council of Northern Ireland
MacNeice House
77 Malone Road
Belfast BT9 6AQ
Web: www.artscouncil-ni.org; www.bsr.ac.uk

Biennial nine month residency at the British School at Rome. Next Fellowship tenable 2005-2006. Open to visual artists resident in Northern Ireland. A research grant of approximately £650 per month.

Closing date: 7th April 2005 for 2005–2006 applications.

The British School at Rome (BSR)
Derek Hill Foundation Scholarship

c/o BSR, London Office
Email: bsr@britac.ac.uk
Web: www.bsr.ac.uk

Open to artists whose work demonstrates proficiency in drawing and who have a commitment to portrait and landscape painting. Derek Hill had a love of Italy and was Adviser to the practising artists at the British School at Rome in 1953–4 and 1957–8: this Scholarship is founded in his memory.

Six month residency. The Scholarship offers a grant of approximately £950 per month and full board and lodging in a studio at the British School at Rome.

Applicants must be of British or Irish nationality, aged 24 or over. The selection panel favour applicants who have not previously received a similar scholarship or bursary.

The British School at Rome (BSR)
Sainsbury Scholarship in Painting and Sculpture

c/o BSR, London Office
Email: bsr@britac.ac.uk
Web: www.bsr.ac.uk

Funded by the Linbury Trust, this scholarship is open to painters and sculptors who can clearly demonstrate a commitment to drawing within their artistic practice and who can present a well argued case for the continuation of their studies in Italy and in particular Rome. It is a 12 month residency with, at the discretion of the committee, an opportunity for a further 9 months in the following academic year. The Scholarship offers a grant of approximately £750 per month, full board and lodging in a residential studio. Applicants must be of British nationality or have been working professionally or studying at postgraduate level for at least the last three years in the UK, be under 28, and normally have, or be in the final year of, an MA (or equivalent) in Fine Art.

The British School at Rome (BSR)
Wingate Rome Scholarship in the Fine Arts

c/o BSR, London Office
Email: bsr@britac.ac.uk
Web: www.bsr.ac.uk

Supported by the Harold Hyam Wingate Foundation, this scholarship is open to painters, sculptors and mixed media artists who can demonstate that they are establishing a significant position in their chosen field. The Scholarship offers a grant equvalent of £500 per month and full board and lodging in a studio at the British School at Rome for 5 months.

Applicants must be able to satisfy the selection panel that they need financial support to undertake the work projected and be aged 24 or older. They must be living in the British Isles during the period of application and must be citizens of the UK or other Commonwealth country, Ireland or Israel; or citizens of another European Union country provided that they are, and have been for at least three years, resident in the United Kingdom.

Caldera Residencies

224 NW 13th Avenue, Suite 304
Portland OR 97209
United States
Phone: +1 503.937.7594
Fax: +1 503.937.8594
Email: marna.stalcup@wk.com
Web: www.calderaarts.org

Caldera is a multidisciplinary arts organization committed to fostering creativity, provoking experimentation and stimulating a deeper appreciation for the environment.

Caldera is located at an altitude of 3,500 feet on the shore of Blue Lake, a collapsed volcanic cone, or caldera, which has filled with spring water and is one of the deepest lakes in Oregon.

Caldera provides professional writers and artists of various disciplines the time and space to concentrate on their work. Applications are welcome from those working in traditional mediums as well as those working in new or inter-disciplinary genres. They are particularly interested in applications from artists interested in environmental or site-specific projects. Artists are scheduled for two to four week periods of time from December through March.

Caldera has a competitive admission process. All applications are reviewed on a case-by-case basis by a peer review panel of distinguished arts professionals. In addition, Caldera works with guest curators to extend special invitations to artists. Awards are also offered in conjunction with The Oregon Literary Fellowships, a program of Literary Arts.

Closing date: 1st June annually.

The Camargo Foundation

U.S. Secretariat
400 Sibley Street, Suite 125
St. Paul MN 55101-1928
United States
Phone: +1 651 238-8805
Web: www.camargofoundation.org

The Camargo Foundation maintains a study centre in Cassis, France, for the benefit of fellows who wish to pursue projects in the humanities and social sciences related to French and Francophone cultures, as well as creative projects by visual artists, photographers, video artists, filmmakers, media artists, composers, and writers. Creative projects do not need to have a specific French connection.

The Foundation offers thirteen furnished apartments as well as a reference library, a darkroom, an artist's studio, and a music composition studio. The residential fellowship is accompanied by a $3,500 stipend, which is awarded automatically to each recipient of the grant.

Applicants may include:

- Members of university and college faculties, including professors emeriti, who wish to pursue special studies while on leave from their institutions;

- Independent scholars working on specific projects;
- Teachers in secondary schools, public or private, benefiting from a leave of absence in order to work on some pedagogical or scholarly project;
- Graduate students whose academic residence and general requirements have been met and for whom a stay in France would be beneficial in completing the dissertation required for their degree;
- Writers, visual artists, photographers, video artists, filmmakers, media artists, and composers with specific projects to complete.

For application process see website.

The Foundation has four selection committees: 1) academic, 2) visual arts/photography/video arts/film/media arts, 3) creative writing, and 4) music composition.

The selection of fellows is based only on an evaluation of the projects proposed and on each applicant's professional qualifications. However, final awards will necessarily be made according to the availability of space. Candidacy is open to qualified persons of all nationalities and on a non-discriminatory basis. First-time applicants are normally given preference over previous Camargo fellows. Repeat applications are not considered sooner than three years after the previous residence.

Can Serrat International Art Centre

Masia Can Serrat
08294 El Bruc
Barcelona
Spain
Phone: +34 937 710 037
Email: info@canserrat.org
Web: www.canserrat.org

Can Serrat was founded in 1988 by a group of 12 Norwegian artists. Their primary purpose was to create an exciting working and living space for themselves and others. Since 2003, Can Serrat has run a programme of stipends. Application is open to all regardless of age, sex, nationality or genre. The available categories are:

- Visual Artists Full Stipend
- Writers Full Stipend
- Visual Artists Support Stipend
- Writers Support Stipend

Visual Artists Full Stipend – annually provides two selected artists with a private room and ample workspace in a shared studio with all meals included for a 30 day period.

Visual Artist Support Stipend – a limited number where each artist-in-residence receives a stipend covering 40% of the total cost (food, lodging and workspace) of stays lasting 30 days or longer.

Writers Full Stipend – annually provides two writers with a private room (all meals included) for a 30 day period.

Writers Support Stipend – a limited number where each writer-in-residence receives a stipend covering 40% of the total cost (food, lodging and workspace) of stays lasting 30 days or longer.

The artists-in-residence/writers are responsible for all extra personal living expenses, travel costs, supplies, telephone charges and any other expenses related to the production costs during their stay. Travel and shipping expenses to and from Can Serrat are also the responsibility of the artists. Each recipient may choose a 30 day time slot for any period of the year up to 12 months dating from original notification assuming space is available at that time.

There is no official application form.

Closing date: Applications will be accepted from 1-30 April and 1-31 October. Results of the Full Stipends are announced first weeks of June and December.

Helen Chadwick Fellowship

The British School at Rome
The Laboratory at the Ruskin School of Drawing and Fine Art
74 High Street
Oxford OX1 4BG
Contact: The Registrar
Web: www.britac.ac.uk/institutes/rome

Open to visual artists who have established their practice in the years following graduation and who have identified a project which could be made possible or enhanced by spending periods of time attached to both The British School at Rome and The Laboratory at the Ruskin School of Drawing and Fine Art, University of Oxford. Six month residency (2 months in Oxford and 4 months in Rome). Research grant: £600 per month and £600 travel allowance and £600 materials allowance.

Open to: British nationals and residents.
Application: Request application form.

Ruth Davidson Memorial Scholarship

RDMA – Elphinstone Institute
Taylor Building
University of Aberdeen
Regent Walk, Aberdeen AB24 3UB
Contact: Director
Phone: 01224 272996
Email: elphinstone@abdn.ac.uk

The Ruth Davidson Memorial Scholarship offers the successful applicant 3 months rent-free accommodation in the Languedoc Roussillon region of the South of France to allow him/her the opportunity to develop/express new ideas in their work. The scholarship offers a sum of £3,000 to cover all costs associated with the residency, including return travel to France, travel in the local area (driving licence essential), materials and living expenses. Key criteria used in selecting the successful artist are the quality of work, as shown in a selection of slides, and the nature of the proposal for the residency period.

Eligibility: A painter currently living and working in Scotland of at least 4 years experience since graduation or since beginning to exhibit. Students are not eligible.

Djerassi Resident Artists Program

2325 Bear Gulch Road
Woodside, CA 94062
United States
Phone: +1 650 747-1250
Fax: +1 650 747-0105
Email: drap@djerassi.org
Web: www.djerassi.org

The Djerassi Program is located in a spectacular rural setting in the Santa Cruz Mountains over-looking the Pacific Ocean, and is within easy driving distance of San Francisco and the rest of the Bay Area.

Residencies are awarded competitively, at no cost, to national and international artists in the disciplines of choreography, literature, music composition, visual arts, and media arts/new genres. Applications are sought from emerging and mid-career artists, for whom appointments as resident artists may make a significant difference to their careers, as well as from established artists with national and/or international reputations. Applicants are evaluated by panels of arts professionals in each category. Those selected are offered living and studio space for four to five week sessions during the season which runs from mid-March through mid-November.

Residents work and are housed in two buildings on the ranch according to artistic discipline and creative project. Living quarters and studio space consist of a four-bedroom house and a unique, remodeled twelve-sided barn.

The rooms in the Artists' House are set up to accommodate writers, each with a large desk, work space, and outdoor deck. The Artists' Barn contains three visual art studios, a large dance studio, a darkroom, and a music composition studio with a baby grand and electric piano.

Application forms can be downloaded from the website
Closing date: February 15th, each year, for a residency in the following year.

Fine Arts Work Center

Visual Arts Fellowship/Writing Fellowship
24 Pearl Street
Provincetown, MA 02657
United States
Phone: +1 508.487.9960
Fax: +1 508.487.8873
Email: general@fawc.org
Web: www.fawc.org

The Fine Arts Work Center offers a unique residency program for writers and visual artists in the crucial early stages of their careers. Located in Provincetown, an area with a long history as an arts colony, the Center provides seven-month fellowships to twenty fellows each year in the form of living/work space and a modest monthly stipend. Residencies run from October 1st to May 1st. Fellows have the opportunity to pursue their work independently in a diverse and supportive community. An historic fishing port, Provincetown is situated at the tip of Cape Cod in an area of spectacular natural beauty, surrounded by miles of dunes and National Seashore beaches.

Program: Fellows are expected to live and work in Provincetown during the

fellowship year. Optional group activities are organized both formally and informally and provide Fellows with the opportunity to meet program committee members, trustees and local artists and writers. The Stanley Kunitz Common Room is the site of frequent presentations by visiting artists and writers as well as readings by Writing Fellows. Visual Arts Fellows mount shows in the Center's Hudson D. Walker Gallery. Visiting artists and writers engage in dialogue with the Fellows throughout the year. Shankpainter, a collection of prose and poetry, has been edited by the Writing Fellows since 1970. The Center also seeks to identify local and national venues for both Fellows and Former Fellows to share their work.

Facilities: Visual Arts Fellows are provided with apartments and separate working studios of approximately 400 square feet of floor space. Additional facilities include a basic woodshop, a print shop with etching press, and a darkroom with basic equipment. Writing Fellows are housed in two- to three-room apartments. The Stanley Kunitz Common Room is handicapped accessible, as are two living spaces and several working studios.

Eligibility: Open to writers and visual artists in the emerging stages of their careers. Juries of professionals make the admissions decisions. Writers may apply in fiction and poetry. In the visual arts, painters, sculptors, installation artists, printmakers and photographers are considered. The Fine Arts Work Center actively seeks applicants from diverse cultural backgrounds.

How to Apply: Visual Arts Application and Writing Application forms may be downloaded from the website. They may also be obtained by mailing a self-addressed, stamped envelope indicating whether you are applying for a writing or visual arts fellowship. Applications must be mailed in print form. Electronic applications are not accepted.

Fellows are provided living accommodations and a monthly stipend of at least $500. The exact amount varies from year to year due to funding. Visual Fellows are provided with a separate studio space.

A $35 non-refundable processing fee must accompany any application.
Session runs from October 1st to May 1st.

Florence Trust Residencies

St Saviour's
Aberdeen Park
Highbury
London N5 2AR
Phone: 020 7354 4771
Email: info@florencetrust.org
Web: www.florencetrust.org

The Trust, established in 1988, provides residencies that offer artists professional development support including business planning, marketing, interview and presentation skills and applying to other trusts and foundations for funding. It also provides an intense period for creative production. Housed in a Grade 1 listed Victorian church, the Trust aims to offer an exceptional experience through its resources, development, support and reputation.

Closing date: June for Annual Studios Programme.

Glassell School of Art

The Core Program – Visual Artist Residency /Critical Studies Residency

Glassell School of Art
Museum of Fine Arts, Houston
PO Box 6826
Houston TX 77265-6826
United States
Phone: +1 713-639-7700
Email: hcolvin@mfah.org
Web: www.mfah.org

The Core Program awards one- and two-year residencies to highly motivated, exceptional visual artists and art scholars who have completed their undergraduate or graduate training but have not yet fully developed a professional career. Established in 1982 within the Glassell School of Art, the teaching wing of Houston's Museum of Fine Arts, the Core Program encourages intensive and innovative studio practice as well as the elaboration of an intellectual framework through which to understand that practice. Residents engage in ongoing dialogue with each other and with leading figures in art and criticism who are brought in as visitors.

Each artist-resident is given approximately 450 square feet of private studio space, 24-hour access to school facilities and equipment, and a $9,000 annual stipend (recently increased from $7,500). In 1998, the program added critical studies residencies. These residencies also include a $9,000 annual stipend and access to facilities, including borrowing privileges at the museum's Hirsch Library and the Fondren Library at nearby Rice University. The program runs on an academic calendar, from September through May. Toward the end of each year, the artist residents mount a group show in the school's main gallery, and the critical studies residents prepare essays summarizing aspects of their independent research. These essays, as well as documentation of the resident artists' work, are gathered in a published catalogue.

There is no application form. See website for detailed information.
Closing date: Ist April for submissions of each year.

Global Arts Village Residencies

Mehrauli-Gurgaon Road
Utsav Mandir, Gitorni
New Delhi, 110030
India
Email: info@globalartsvillage.org
Web: www.globalartsvillage.org

The Global Arts Village is a three-acre property that includes gardens, ceramics, sculpture and 2D studios, a meditation hall, a common building, dance studio, performance spaces and accommodations.

The Village offers residency programs to emerging, mid-career and established artists. The Village offers an artist in residence program with no selection process as well as several competitive fellowship programs. Residents choose from standard or duplex accommodation and are provided with three meals per day, laundry service and studio space. Artists are asked to donate one work of art unconditionally to the Village and give seven hours of communal work per week. Visual arts residencies are offered for all major creative disciplines. This

includes studio ceramics, sculpture, photography, Ikebana, digital arts, land art, fiber arts, installation art and public art.

Literary arts residencies are offered for novel writing, playwriting, creative writing, poetry, haiku, script writing, journalism and multimedia works.

Artist in Residence

Artists in residents are provided with accommodation (standard or duplex), laundry service, three meals per day and studio space. The program fee is $30 per day for a standard room and $40 for a duplex room with private studio. The rates are decreased for extended residencies.

Fellowships

The Global Arts Village offers full and partial fellowships for each artistic category as well as several specific fellowship opportunities. All fellowships include accommodation, laundry service, three meals per day, studio or workspace and other benefits dependent on the fellowship program.

Full Artist Fellowship

The 90-day residency has no program fee and includes initial presentation to local artists, concluding exhibition and materials allowance of $100.

Partial Artist Fellowship

Awarded to individuals with exceptionally high energy and creativity. The 90 day residency includes a reduced program fee, initial presentation to local artists, concluding exhibition.

Emerging Artist Fellowship

Awarded to individuals (under 25 years) who have recently finished their studies. The 90 day residency includes shared accommodation, a reduced program fee, initial presentation to local artists, concluding exhibition.

Professional Development Fellowship

Five fellowships; Visual Arts Coordinator, Grant-writer in Residence, Performing Arts Coordinator, Culinary Artist in Residence, Organic Farmer in Residence. Fellowships can be anywhere from 30 days to 90 days in length.

Site Specific Sculpture Fellowship

Awarded to three dimensional artists who will design and produce a permanent sculpture for the Village property. The 60 day residency includes a concluding exhibition and materials allowance of $200–500 depending on project proposal.

Juliet Gomperts and Janet Konstam Memorial Scholarships

Artists' Residencies in Tuscany
48 Hungerford Road
London N7 9LP
Email: n.gomperts@virgin.net
Web: www.geocities.com/bgomperts/Artists_in_Tuscany.html

The Trust funds artists residencies at The Centro d'Arte Verrocchio (at Casolé d'Elsa, near to Siena, Italy) which it has supported since 1990 in association with Nigel Konstam. It also offers research funding to artists to develop bodies of work exploring given themes.

The fund provides studio facilities, board and lodging, some materials and local visits for 4 weeks in the Summer/Autumn at the Verrocchio Arts Centre in Casolé d'Elsa, a medieval hill village near to Sienna. The value is approximately £2,000. The awards are available to artists over 23 and under 45. The outlook of the school is traditional, focussing mainly on landscape and figurative work (including sculpture). The artists will work alongside tutored holiday groups and present seminars on their practice. The Trust wishes to encourage artists whose work stems from drawing and observation, and those with a particular interest in Italy. Successful applicants have included artists whose approach is essentially traditional as well as those who work across media, fusing observation and conceptual practice.

Additionally short listed candidates may apply for the Janet Konstam Travel Fellowship which provides £500 for travel and research and offers full fares to and from Italy. This will be awarded to an outstanding applicant on the basis of the best plan and discussion at interview with the panel of judges.

Applicants must be resident in the UK.
See website for application details.

Tyrone Guthrie Centre

Annaghmakerrig
Newbliss
County Monaghan
Ireland
Phone: +353 (0) 47 54003
Email: thetgc@indigo.ie/info@tyroneguthrie
Web: www.tyroneguthrie.ie

Residencies are available to established professional artists from both parts of Ireland and abroad in all main artistic disciplines including writing, painting, dance, music, photography, sculpture and multimedia.

Bursaries are available for those born or resident in Ireland.

Borough councils and local authorities in Northern Ireland and the Republic of Ireland offer special bursary awards to artists born or domiciled in their areas to enable them to spend two weeks in the Tyrone Guthrie Centre at Annaghmakerrig. Each bursary covers all accommodation and meals plus the use of a studio if necessary. The bursaries are administered by each individual local authority. Interested artists should apply directly to their local Arts Office for further information.

A new series of special bursaries and prizes was initiated by the Tyrone Guthrie Centre in May 2004 with the announcement of two major awards to support writers' residencies at Annaghmakerrig.

The Ireland Chair of Poetry Award

This will be awarded every year for the next five years with the winner being chosen by the previous holder of the Ireland Chair of Poetry.

The Annie Deeny Memorial Prize

Launched by distinguished poet Fleur Adcock. Mrs Annie Deeny was a teacher and mother of six children who, although she wrote, never sought to have her work published. This perpetual prize is in her memory to encourage someone in a similar situation to write and to publish. It provides a two-week residency

in the Tyrone Guthrie Centre at Annaghmakerrig plus 250 to cover extra costs. It will be awarded each year to a woman, preferably a mother, who is developing her career as a writer and whose promise will be nurtured by a period of residency at Annaghmakerrig.

IASPIS

International Artists Studio Programme in Sweden
Box 1610
SE-111 86 Stockholm
Sweden
Tel: +46 8 402 35 77
Web: www.iaspis.com

Primarily, it is an artist-in-residence program based in Stockholm and a government funded institution supporting Swedish artists exhibiting abroad. The main purpose of IASPIS is to facilitate creative dialogues and collaborations between artists from Sweden and from other countries. Both recently graduated and more established Swedish artists can apply for specific projects to be realized in the studios of the Royal Academy of Fine Art in Stockholm. Artists from abroad are invited by IASPIS for periods of two to six months, sometimes in connection with exhibitions or other projects in Sweden. The program is based around ten studios in Stockholm, but there are also studios in the cities of Gothenburg, Malmö, and Umeå.

The residency program is by invitation only, it is not possible to apply.

Kala Artist Fellowship Programme

Kala Institute
1060 Heinz Avenue
Berkeley
California 94710
United States
Email: kala@kala.org
Web: www.kala.org

Kala Institute offers Fellowships to artists who have demonstrated innovative work in traditional and/or contemporary electronic printmaking media and are interested in expanding their technical repertoire through access to the Kala Institute workshop and facilities. Artists with experience in computer graphics in combination with printmaking techniques are encouraged to enter.

Eight Fellowship recipients will each receive a $2,000 or more stipend and a six month Residency at Kala Institute (free of charge) for six months. The fellowship allows 24-hour access to Kala's extensively equipped 8,500 square foot printmaking facilities. Kala also provides qualified fellowship recipients with access to its electronic media center, letterpress shop, and photographic darkrooms.

At the completion of the residency, each fellowship recipient's work will be featured in an exhibition in the Kala Institute Gallery. Exhibitions usually include the work of three or four artists.

Closing date: May 1st.

John Michael Kohler Arts Center

Arts/Industry Artist-in-Residency
Kim Cridler, Arts/Industry Coordinator
John Michael Kohler Arts Center
608 New York Avenue
P.O. Box 489
Sheboygan WI 53082-0489
United States
Phone: +1 920 458 6144
Email: kcridler@jmkac.org
Web: www.jmkac.org

The John Michael Kohler Arts Center Arts/Industry artist-in-residence program provides artists worldwide with access to the plumbingware firm, Kohler Co., through two to six-month residencies. Artists-in-residence are provided with studio space in the factory which is accessible to them 24 hours a day, seven days a week. In addition, they receive free materials, use of equipment, technical assistance, photographic services, housing, round-trip transportation within the continental United States from their home to the site, and weekly honoraria. Available media: vitreous china, iron, enamel, and brass. The John Michael Kohler Arts Center invites emerging and established artists working in any discipline to apply for Arts/Industry residencies.

Closing date: August for residencies the following year.
Application: Send SAE/IRC for application form or visit the website.

Künstlerinnenhof Die Höge

Högenhausen 2
D – 27211 Bassum
Germany
Phone: +49 4249 93 03 0
Fax: +49 4249 93 03 44
Email: info@hoege.org
Web: www.hoege.org

Women scholars as well as women artists from all areas of the arts are invited to work experimentally, innovatively and multimedially. Without pressure to produce, the resident artists have the opportunity to experiment in their respective fields and take part in the current discourse on art.

Recipients live and work at the Höge and are obliged to reside at the colony for at least two thirds of the grant period. They are not required to present any concrete work results at the conclusion of their stay.

Three apartments and studios provide accommodation. Technical facilities are of the highest standard and include a photo lab, graphics workplace, sound studio, Avid video editing desk, Internet connections and a large dance theatre and music room (120 sqm) with a sound system and grand piano. Resident artists are actively supported in networking with the national and international culture scene.

A Jury of three to four members chooses the a.i.r participants, who receive grants to reside at the Höge for between one and nine months.

The Liguria Study Centre for the Arts & Humanities

Web: www.liguriastudycenter.org

Located on the Italian Riviera in the small town of Bogliasco, the Liguria Study Centre offers residential fellowships for artists and scholars in the Arts and Humanities

Bogliasco Fellowships are awarded, without regard to nationality, to qualified persons doing advanced creative work or scholarly research in a number of disciplines which include: Literature and Visual Arts. In the Arts, the Study Center welcomes persons doing both creative and scholarly work (such as Art History, Musicology, Film Criticism, and so on).

Applicants are expected to demonstrate significant achievement in their disciplines, commensurate with their age and experience. An approved project is presumed to lead to completion of an artistic, literary, or scholarly work, followed by publication, performance, exhibition, or other public presentation.

Approximately 50 Fellowships are awarded each year. They are scheduled during the two semesters of the academic year. Fellowships usually have a duration of one month (31-32 days) or, in some cases, a half semester (48 days). In special circumstances residencies of other lengths may be approved.

Fellows may be accompanied by spouses (or spouse-equivalent companions). Spouses or companions who intend to pursue a project, and who wish to be designated as Bogliasco Fellows, must submit separate and complete applications. The Foundation encourages such joint applications.

Applications for Fellowships are reviewed twice a year.

From time to time, the Foundation may offer Special Fellowships. Most often, these are funded through the generosity of individuals or institutions committed to the Arts and Humanities but not directly associated with the Foundation. Some Special Fellowships are dedicated to specific disciplines; others are reserved for persons coming from certain countries or geographic areas. In some cases they may provide funds to assist Fellows who otherwise might not be able to afford the cost of travel to and from Genoa.

All persons who are awarded Fellowships are eligible for Special Fellowship status. No additional application materials are required or accepted.

See website for application procedure.

MEXT (Japanese Government) Scholarships for Postgraduate Research Studies

JICC
Embassy of Japan
101-104 Piccadilly
London W1J 7JT
Education: 020 7465 6583
Email: susan.meehan@jpembassy.org.uk
Web: www.uk.emb-japan.go.jp

The scholarships are offered on an annual basis to those with a bachelor's degree, under the age of 35, who wish to continue their study at graduate level in Japan. The scholarship is primarily a non-degree award, but it can be converted into a Master's degree, depending upon the proficiency of the

student. Japanese language ability is not prerequisite.

There are few restrictions governing the areas of research. It can be difficult, however, to place students who may wish to study visual and performing arts. Candidates are encouraged to establish contacts with Japanese academics in their field when applying for the scholarship. University preferences are taken into account as far as possible.

Applications begin annually in April and the scholarship is tenable from April or October the following year. Those leaving in April will hold their award for two years, whilst those departing in October will hold theirs for 18 months. The Japanese Government will provide return air fare, school fees and a monthly stipend (¥175,000).

Application forms for the 2006-2008 postgraduate scholarship, can be obtained from the Japanese Embassy in London from April 2005 onwards.

The Montana Artists Refuge Residency Program

Box 8, Basin
MT 59631
United States
Phone: +1 406 225 3500
Fax: +1 406 225 9225
Email: mar@mt.net
Web: www.montanaartistsrefuge.org

Montana Artists Refuge, an artist-run residency programme located in a small gold-mining town near the Continental Divide, accepts applications from visual artists in arts and crafts, book art, ceramics, clay/pottery, drawing, fibre/textile, film/videomaking, folk art, installation, jewellery, mixed media, painting, paper art, photography, and sculpture; fiction writers, journalists, literary non-fiction writers, playwrights, poets, screenwriters, and translators; choreographers, composers, dancers, musicians, performance artists, and storytellers; architects, clothing designers, graphic designers, and set designers; general scholars; collaborative teams, conceptual artists, environmental artists, interdisciplinary artists, multimedia artists, and new genre artists.

Founded in 1993 by 4 local artists and area residents for the purpose of providing living and work space to artists in all mediums. The mission is to further the creative work of artists, to create residencies for artists, and provide arts programs and art education for both artists and community members.

Residencies last between 3 months and one year. There are 3 studio/living spaces and the community is in the planning stages of making facilities accessible to disabled residents. Artists purchase their own food and make their own meals. The artist pays for travel, food, personal needs, materials; $450 – $550/month residency fee (some grants are available, up to 50% to help pay fee), utilities cost varies by season.

The Refuge provides some fully funded residencies each year. We offer partial financial aid for other residencies, to the extent of our ability to do so. Artists needing financial aid may apply for aid as part of their residency application.

Application: Download from website.
Closing date: January 15 for summer residencies, May 15 for fall residencies and 15 August for winter residencies.

Henry Moore Sculpture Fellowship

The British School at Rome
Via Gramsci 61
Rome 00197
Italy
Contact: The Registrar
Phone: +39 06 3264 939
Fax: +39 06 322 1201
Email: bsr@britac.ac.uk
Web: www.bsr.ac.uk

The Henry Moore Fellowship at the British School at Rome is funded by the Henry Moore Foundation. The award is made annually to well-established sculptors to enable them to spend 3 months in Rome. The Fellowship offers a spacious studio with en suite facilities, board and accommodation at the School and a grant of £2,000 per month. Accommodation will, when possible, be provided for the Fellow's partner; children cannot be accommodated.

Eligibility: Commonwealth and UK Citizens.
Application: Request application form.

New York Public Library's Center for Scholars and Writers

Fellowship Competition
The New York Public Library
Fifth Avenue and 42nd Street
New York, NY 10018-2788
United States
Email: csw@nypl.org
Web: www.nypl.org/research/chss/scholars/index.html

The Dorothy and Lewis B. Cullman Center for Scholars and Writers is an international fellowship program open to people whose work will benefit directly from access to the collections at the Humanities and Social Sciences Library – including academics, independent scholars, and creative writers (novelists, playwrights, poets). The Center appoints 15 Fellows a year for a nine-month term at the Library, from September through May. In addition to working on their own projects, the Fellows engage in an ongoing exchange of ideas within the Center and in public forums throughout the Library.

Nordic Institute for Contemporary Art (NIFCA)

Suomenlinna B 28
Helsinki
FIN-00190
Finland
Phone: +358 9 68643 105
Fax: +358 9 668 594
Email: residencies@nifca.org
Web: www.nifca.org

NIFCA invites curators, journalists and researchers to its centre on the island of Suomenlinna, near the port of Helsinki. The research residencies are open to

visitors interested in the Nordic art scene who wish to:

- contribute to debate in the Nordic region
- research the Nordic contemporary art scene
- work on projects and themes that situate Nordic art in a global context
- take part in Helsinki's art life
- meet artists, curators and researchers at NIFCA

Four guest apartments are available throughout the year for residencies of 1-2 months. Visitors have free access to workspace and library at NIFCA's office. Residencies include a monthly allowance of 840.

Letters of application with project descriptions are welcomed throughout the year. Applications are considered three times a year. Advisable to apply, at least, six months in advance of the intended residency.

Closing date: 15th January, 15th May, 15th September.

North Lands Creative Glass

Quatre Bras, Lybster
Caithness KW3 6BN
Phone: 01593 721 229
Email: northlands@freeuk.com
Web: www.northlandsglass.com

North Lands Creative Glass is situated in Lybster, a small fishing village on the North East Coast of Scotland. North Lands is open both to glass artists and to painters, sculptors, architects and designers wishing to explore the technical and artistic potential of glass either on its own or in combination with other materials.

In 2005 North Lands offered a six week residency to four talented glass artists in mid career. Future programme to be decided – check website for updates.

Pepinières Européennes Pour Jeunes Artistes

Programme Co-ordinator, International Artists Fellowships
Arts Council England
14 Great Peter Street
London SW1P 3NQ
Direct line: 0207 973 6436
Fax: 0207 973 6581
Email: natasha.messenger@artscouncil.org.uk
Web: www.artscouncil.org.uk/internationalfellowships

The Pépinières Européennes Pour Jeunes Artistes is a non-profit organisation that promotes young professional European artists, providing a diverse range of residency programmes. This year there are 66 residency awards available in 25 countries for artists working in the fields of multimedia, architecture, visual arts, new media, performing arts, dance, theatre, literature, choreography, design, circus, video, music and sculpture. To apply you must be 20 to 35 years old and resident in one of the countries in the programme. The successful artists will develop work during a residency period of 3 - 9 months. Accommodation, workspace, expenses and materials are provided.

For full information and an application form visit the website: www.art4eu.net.

This programme is supported by Arts Council England as part of the International Artists Fellowships Programme.

Closing date: March

The Charles Pick Fellowship

School of Literature and Creative Writing
University of East Anglia
Norwich NR4 7TJ
Web: www.uea.ac.uk/eas/fellowships

The Charles Pick Fellowship is dedicated to the memory of the distinguished publisher and literary agent, Charles Pick. He encouraged young writers at the start of their careers with introductions to other writers and practical and financial help. The Fellowship seeks to continue this spirit of encouragement by giving support to the work of a new and, as yet, unpublished writer of fictional or non-fictional prose. Its purpose is to give promising writers time to devote to the development of his/her talents.

No teaching duties are attached, but the Fellow will be able to consult informally with faculty and students in the School of Literature and Creative Writing. The Fellowship will be for six months, starting on 1 August. The award is £10,000. The Fellowship is residential and free accommodation will be provided on campus.

Terms and Conditions

Applicants must be writers of fictional or non-fictional prose in English who have not yet published a book. Applicants can be writers of any age and any nationality. The successful candidate will be selected by a distinguished panel of writers. There will be no interviews, and candidates will be judged on the quality and promise of their writing and the project they describe, and the strength of their referee's report.

The Fellow will be a member of the School of Literature and Creative Writing at the University of East Anglia for the period of the Fellowship and will have access to shared office space and computing facilities. The Fellow will, during the residential period, be required to satisfy, from time to time, the Head of the School that reasonable progress is being made on the Fellowship writing project being undertaken.

Application procedure – see website
Closing date: January

PS1 Fellowship

Visual Arts Department
The Arts Council of Northern Ireland
MacNeice House
77 Malone Road
Belfast BT9 6AQ
Phone: 028 90 385200
Fax: 028 90 661715
Web: www.artscouncil-ni.org

In association with the Irish American Cultural Institute, the Council offers one annual fellowship which provides a year's studio space at the Institute for Art and Urban Resources at PS1, New York. The award includes provision for accommodation, and a monthly stipend of $1,500. Final selection is made by a PS1 jury in New York on the basis of a shortlist provided by The Arts Council. Application form is available on request.

The Royal Scottish Society of Painters in Watercolours (RSW)

Residency for visual artists at Hospitalfield House, Arbroath

Royal Scottish Society of Painters in Watercolour (RSW)
5 Oswald Street
Glasgow G1 4QR
Contact: Gordon C McAllister, Secretary
Tel: 0141 248 7411
Fax: 0141 221 0417
Email: enquiries@robbferguson.co.uk
Web: www.thersw.org.uk

The Residency's aim is to provide professional artists with the opportunity to explore new directions in their work during a concentrated period of personal development.

Hospitalfield House is an important architectural and cultural landmark situated in its own 30 acre estate overlooking the North Sea.

The award provides for a three month residency or two awards of six weeks, which can be taken at a time convenient to both the successful applicant and Hospitalfield. For Residents with particular interest in printmaking or photography the Trust maintains close relations with Duncan of Jordanstone College of Art (Dundee University) and the Printmakers Workshop at Dundee Contemporary Art where arrangements may be made to use their facilities.

Those eligible must be professional visual artists who have established credible commitment to their work, who are Scottish or have studied in Scotland and permanently based in Scotland or are working in Scotland.

Each artist will be provided with a personal studio space, accommodation and either meals or an allowances for food

Closing date: January

Scottish Sculpture Workshop

1 Main Street
Lumsden
Aberdeenshire AB54 4JN
Phone: 01464 861372
Fax: 01464 861550
Email: office@ssw.org.uk
Web: www.ssw.org.uk

SSW is an international residency centre based in rural North East Scotland which is currently undergoing a process of creative and organisational

development. Encompassing the broadest spectrum of contemporary visual art, it enables research, debate, collaboration, and practice through a programme of curated and open residencies and projects. Check website for updates.

UEA Writing Fellowship

Val Striker, Dean's Office
School of English & American Studies
University of East Anglia
Norwich NR4 7TJ
Phone: 01603 592810
Fax: 01603 507728
Email: v.striker@uea.ac.uk

The Fellowship is open to writers in all genres, but the Fellow is expected to have some expertise in the area of fiction and/or poetry. The Fellow is expected to reside in the University. A flat on campus overlooking parkland and a lake is provided free of charge.

The Fellow is expected to offer a workshop in Creative Writing at undergraduate level during the Spring Semester. The Fellow will also be involved in off-campus activities with assistance from the Eastern Arts Board and the Norfolk County Literature Officer. The fee is £7,500 plus travelling expenses for the off-campus visits. The Fellowship is advertised in September/October each year and an appointment made in December. The Fellow normally takes up residence towards the end of January.

Women's Studio Workshop Fellowship Grants

PO Box 489
Rosendale 12472
New York
United States
Phone: +1 914 658 9133
Fax: +1 914 658 9031
Email: wsw@ulster.net
Web: www.wsworkshop.org

WSW Fellowship Grants are designed to provide concentrated work time for artists to explore new ideas in a dynamic and supportive community of women artists. The facilities feature complete studios in intaglio, silkscreen, hand papermaking, photography, letterpress, and clay (a new addition to the WSW Fellowship program). Two to six week sessions are available each year from September to June.

Fellowships are awarded through a jury process. The cost to Fellowship recipients is $200 per week plus materials, approximately one fifth the cost of the actual residency. The award includes on-site housing and unlimited access to the studios. Artists are given a studio orientation but should be able to work independently. Technical assistance is available for an additional fee.

Eligibility: Women artists.

Closing date: Fall (Sept – Feb): May 15, Spring (Mar – June): November 1.

The David T.K. Wong Fellowship

School of English and American Studies
University of East Anglia
Norwich NR4 7TJ
Contact: Ms Val Striker
Phone: 01603 592810
Fax: 01603 507728
Email: v.striker@uea.ac.uk
Web: www.uea.ac.uk

The David T.K. Wong Fellowship is a unique and generous annual award – £25,000 to enable a fiction writer who wants to write in English about the Far East to spend a year in the UK, at the University of East Anglia in Norwich. The Fellowship is named for its sponsor Mr. David Wong, a retired Hong Kong businessman, who has also been a teacher, journalist and senior civil servant, and is a writer of short stories himself.

Open to anyone, no age limit, and no means test of any kind.

Application: Candidates should send an original piece of fiction (not more than 5,000 words in length) with their applications, and an administration fee of £5. Shortlisted candidates will be asked to submit in addition an outline of the writing project they intend to pursue during the year of the Fellowship. Candidates will be judged entirely on the quality and promise of their writing, and of the project they describe.

Download application form from website.

Closing Date: November. Fellowship starts the following Spring.

Wrexham Arts Centre – International Print Biennale Residency

Wrexham Arts Centre
Rhosddu Road
Wrexham LL11 1AU
Contact: Victoria Reynolds
Phone: 01978 292093
Fax: 01978 292611
Email: arts.centre@wrexham.gov.uk

Artist-in-Residence Project

The following details are based on the residency for 2005. It is anticipated that similar conditions will apply for 2007.

An artist will be selected from submissions to the Wrexham Print International Exhibition to undertake a 6-week residency in Wrexham. The project will run throughout the exhibition from January to March. The artist will be based in the Regional Print Centre and will be able to develop their own work as well as giving lectures and courses for the public, for students of Yale College and the North East Wales Institute art department, and some local schools.

There will be an artist's fee of £2,500, a materials budget of £750 and additional budgets for travel and photography.

Applications in writing
Closing date; Likely to be November 2006.

Yaddo

P.O. Box 395 - Union Avenue
Saratoga Springs
New York 12866-0395
United States
Phone: +1 518 584-0746
Fax: +1 518 584-1312
Web: www.yaddo.org

Yaddo is an artists' community located on a 400-acre estate in Saratoga Springs, New York. Its mission is to nurture the creative process by providing an opportunity for artists to work without interruption in a supportive environment.

Yaddo offers residencies to professional creative artists from all nations and backgrounds working in one or more of the following media: choreography, film, literature, musical composition, painting, performance art, photography, printmaking, sculpture, and video. Artists may apply individually or as members of collaborative teams of two or three persons. They are selected by panels of other professional artists without regard to financial means. Residencies last from two weeks to two months and include room, board, and studio.

Closing date: January and August
Application: Send SAE/IRC for application for or download from website.

The Academy of Children's Writers

Write a Story for Children Competition
PO Box 95
Huntingdon PE28 5RL
Phone: 01487 832752
Email: per_ardua@lycos.co.uk

Awarded to an unpublished writer of children's fiction for a short story of up to 1,500 words.

Prizes:1st – £1,000; 2nd – £200; 3rd – £100.

JR Ackerley Prize for Autobiography

English Centre of International PEN
6-8 Amwell Street
London EC1R 1UQ
Phone: 020 7713 0023
Fax: 020 7837 7838
Email: enquiries@englishpen.org
Web: www.englishpen.org

This annual award is made to an outstanding autobiography written in English by a living author of British nationality or long-term residence. Entries not required. Nominations are made by the Trustees of the Ackerley bequest only. Work must be first published in the UK in the calendar year preceeding the year in which the award is presented.

Winner announced: PEN Writers Day.
Prize: £1,000 plus a sterling silver pen.

Hans Christian Andersen Awards

Nonnenweg 12,
Postfach, CH-4003 Basel
Switzerland
Phone: +41 61 272 2917
Fax: +41 61 272 2757
Email: ibby@ibby.org
Web: www.ibby.org

Every other year IBBY (International Board on Books for Young People) presents the Hans Christian Andersen Awards to a living author and illustrator whose complete works have made a lasting contribution to children's literature.

Often called the "Little Nobel Prize", the Hans Christian Andersen Award is the highest international recognition given to an author and an illustrator of children's books. Her Majesty Queen Margrethe II of Denmark is the Patron of the Andersen Awards.

Nominations are made by the National Sections of IBBY and the recipients are selected by a distinguished international jury of children's literature specialists.

The Author's Award has been given since 1956 and the Illustrator's Award since 1966. The Award consists of a gold medal and a diploma, presented at a festive ceremony during the biennial IBBY Congress. A special Andersen Awards issue of IBBY's journal Bookbird presents all the nominees, and documents the selection process. The Awards programme is supported by Nissan Motor Co.

Angus Book Award

Educational Resources Service
Angus Council
Leisure Services
Bruce House, Wellgate
Arbroath DD11 3TL
Contact: Moyra Hood, Educational Resources Librarian
Phone: 01241 435008
Email: hoodm@angus.gov.uk
Web: www.angus.gov.uk/bookaward/information.htm

Launched in 1996 as an Angus Council initiative to encourage pupils to read and enjoy quality teenage fiction. It is based on pupils not only voting for the winner, but actively participating in all aspects of the award from the selection of the shortlist to the award ceremony. The award was the first of its kind in Scotland and its reputation amongst authors and publishers continues to grow. The shortlist is selected by teachers, librarians and pupils from books appropriate for the 13/15 year old age group, written by authors living in the UK and published in paperback between July and June of the preceding year. Titles are chosen which reflect the range of themes which interest teenagers whilst challenging and interesting both committed and less enthusiastic readers.

The books are read and discussed in detail between January and May by participating classes and some reading groups within the libraries before the pupils vote in a secret ballot for their winner.

Shortlisted authors receive £50 and the winner £250.

The Asham Award

Lewes Town Hall
High Street
Lewes BN7 2QS
Contact: Carole Buchan
Phone: 01273 483159
Email: info@ashamaward.com
Web: www.ashamaward.com

Sponsored by the Asham Literary Endowment Trust and the Arts Council of England. The Award is open to women writers who have not yet had a novel or a collection of short stories published. Stories must not exceed 4,000 words in length and can be on any subject. The winners stories will be published in a collection by Bloomsbury. Entry fee: £10 (£7.50 concessions)

Closing date: January. Winners announced: May.
Twelve winning writers will share over £3,000 in prize money.
Prizes: 1st – £1,000, 2nd – £500, 3rd – £300.
Nine runners-up will receive £200 each.

Authors' Club Best First Novel Award

Secretary
Authors' Club
40 Dover Street
London W1S 4NP
Phone: 020 7499 8581
Fax: 020 7409 0913
Email: authorsclub@hotmail.com

Awarded to the most promising first novel of the year, written by a British author and published in the UK during the calendar year preceding the year in which the award is presented.

Submission by publisher only.
Closing date: October. Winner announced: March.
Prize: £1,000.

Supported by Marsh Christian Trust

Ayr Writers Club

Ayr Writers Club
The AWC800 Competition
c/o 5 Craigholm Road
Ayr KA7 3LJ
Email: awc@rowenamlove.co.uk
Web: www.ayrwritersclub.co.uk

This is a one-off competition to celebrate the 800th anniversary of the Ayr town charter.

The maximum length for the Short Story is 2,000 words. Poems must be no longer than 40 lines. Entries must be entirely the work of the entrant and must never have been published. Worldwide copyright of each entry remains with the author, but the Ayr Writers Club will have the unrestricted right to publish the winning poems and stories (including runners up), on our website and in any subsequent anthology. Neither the Short Story nor the Poetry Competition is open to members of Ayr Writers Club. For full rules and to download an application form see website. Entry fee: £3 per poem or £5 per short story.

Closing date: 31st May.
Short Story Prizes: 1st – £250; 2nd – £100; 3rd – £50.
Poetry Prizes: 1st – £250; 2nd – £10; 3rd – £50.

BA/Nielsen Book Data Author of the Year Award

The Booksellers Association
Minister House
272 Vauxhall Bridge Road
London SW1V 1BA
Contact: Nicola Tarling
Phone: 020 7802 0802
Fax: 020 7802 0803
Email: nicola.tarling@booksellers.org.uk
Web: www.booksellers.org.uk

Each year since 1993, BA members have been invited to vote for the author who had made the biggest impact on their business each year. This impact is not necessarily to be based on sales or on promotional budget, but is to represent a personal preference for a favourite British or Irish author. The winning author is announced during the BA's Gala Dinner held at the Annual Conference in the spring, where they receive £1,000 and a trophy, sponsored by Nielsen Book Data Ltd.

Shortlist announced: February.
Winner announced: April/May (at the BA's Gala Dinner).
Prize: £1,000 and a trophy.

Bad Sex Prize

Phone: 020 7437 9392
Fax: 020 7734 1844
Email: badsex@litrev.demon.co.uk

Sponsored by the Literary Review Magazine this is awarded annually to an exceptionally bad passage describing sex in a work of fiction. Entries are not required.

Winner announced: December

BBC Talent Awards

Web: www.bbc.co.uk/talent

The BBC run a number of competitions for writers. Check website for details as these are ongoing and subject to change.

David Berry Prize

The Secretary
The Royal Historical Society
University College London
Gower Street
London WC1E 6BT
Email: rhsinfo@rhs.ac.uk
Web: www.rhs.ac.uk/berrycomp.htm

An annual award for an essay of not more than 10,000 words on Scottish history. Essays published in the year of the prize or accepted for future publication are eligible for submission. The essay should be between 6,000 and 10,000 words in length.

Closing date: 31st October.
Prize: £250.

Birmingham Short Story Competition

Town Clerk
Westport Town Council
Westport Civic Offices
Altamount Street
Westport, Co. Mayo
Ireland
Phone: +353 98 50400
Email: kmartin@dna.ie
Web: www.shortstoryinfo.netfirms.com

This competition is open to all writers. Script should be at least 1,500 words and not exceed 3,000. There is no limit to the number of entries per person but each entry must be accompanied by an entry fee of 5.00. Entries must be the original work of the entrant. The story must remain unpublished until after 31st March, 2005. See website for full details.

Closing date: 31st March.
Prizes: 1st – 500; 2nd – 300: 3rd – 200.

Biscuit Publishing

International Short Story Prize
PO Box 123
Washington
Newcastle upon Tyne NE37 2YW
Email: info@biscuitpublishing.com
Web: www.biscuitpublishing.com

Biscuit Publishing are introducing a new system of entry for the 2005 Biscuit Short Fiction competition – "Biscuit's Portfolio System." They will publish (in addition to the Top Ten winners' anthology) the outright winner's own collection of short stories or novella and therefore wish to see evidence that the winner can sustain a larger collection of quality writing; i.e. is not just a one-good-story writer. Each entrant is required to submit a 'portfolio' of three titles. This should consist of one complete short story and two beginnings of short stories. The main, complete story should be a maximum of 3,000 words, and the two beginnings between 250 and 350 words. The whole portfolio will be judged. (The winner's book/CD will contain up to ten stories or novella).

Stories may be on any subject. All entries to be in English. All entries must be unpublished and be the original work of the entrant. All ten winning stories must be available for the anthology.

Entry fee: £12 per portfolio. You may submit as many portfolios as you wish. Entries may be submitted by post or by email – see website for details.

Closing date: 31st May 2005. Short list announced on or before 7th July 2005. Final results announced 31st July 2005.

Prizes: 1st – £1,000; 2nd – £250; 3rd – £100.
The Top Ten will receive three copies each of the Anthology + CD in which their work appears. There are two publications: The Outright Winner's Collection – Book and CD and The Top Ten Winners' Anthology – Book and CD.

The Bisto Book Awards

Children's Books Ireland
17 Lower Camden Street
Dublin 2
Ireland
Phone: + 353-1-4750445
Fax: +353-1-4750445
Contact: Liz Marshall, Bisto Administrator
Email: info@childrensbooksireland.com
Email: bistoawards@childrensbooksireland.com
Web: www.childrensbooksireland.com

Annual awards sponsored since their inception by Bisto (RHM Foods).

Each book entered must fulfil the following criteria:

The author/illustrator must have been born in Ireland or be resident in Ireland. The book must be an original work. Books can be in English or Irish. Books can be fiction, non-fiction or poetry. It is possible to submit a book for text or illustration only, if only half the partnership is eligible under the criteria of Irish birth or residence – in which case the book will be judged only on the basis of the Irish part of the collaboration. The following are not eligible: Academic text books, Translations, Anthologies, Re-issues/new editions

Books must be submitted between August and January.
Shortlist announced: May. Awards announced: June for books published in the previous year.

There are a total of five awards:

The Bisto Book of the Year Award
Prize: 3,000 prize and a perpetual trophy and framed certifi cate.

Bisto Merit Awards
Prize: Three Merit Awards share a prize fund of 2,400 and each prizewinner receives a framed certificate.

The Eilís Dillon Award
Prize: 1,000 prize, and a trophy and framed certificate.

James Tait Black Memorial Prize

University of Edinburgh
Department of English Literature
David Hume Tower
George Square
Edinburgh EH8 9JX
Phone: 0131 650 3620

Fax: 0131 650 6898
Email: english.literature@ed.ac.uk
Web: www.englit.ed.ac.uk

The James Tait Black Memorial Prizes are Scotland's most prestigious and the U.K.'s oldest literary awards. The prizes have achieved an international reputation for their recognition of literary excellence in biography and fiction.

Awarded since 1919, previous Fiction prizewinners include D.H. Lawrence, E.M. Forster, Graham Greene, George Mackay Brown, James Kelman and William Boyd. Among past recipients of the Biography prize are Lytton Strachey, John Buchan, Lady Antonia Fraser, and Quentin Bell.

In accordance with the wishes of the founder, eligible works of fiction and biographies are those written in English, and first published or co-published in the United Kingdom in the 12-month period prior to the submission date (September). The nationality of the writer is irrelevant. Both prizes may go to the same author, but neither to the same author a second time.

The two prizes, each of £ 3,000, are awarded annually.

Submission by publisher only.
Closing date: September. Winner announced: January.
Prize: £3,000 (for each category winner).

The Boardman Tasker Award

The Boardman Tasker Charitable Trust
Pound House
Llangennith
Swansea SA3 1JQ
Contact: Miss Maggie Body, Secretary
Phone/fax: 01792 386 215
Email: margaretbody@lineone.net
Web: www.boardmantasker.com

Books with a mountain, not necessarily mountaineering, theme whether fiction, non-fiction, drama or poetry, written in the English language (initially or in translation) will be eligible. The entry must be in book format, and not in the format of a magazine or other periodical or anthology.

The work must be published or distributed in the United Kingdom for the first time between November and October. Books should be submitted as soon as they are available, but by 1 August at the latest. No restriction is made on the number of entries each publisher may make. Entries for consideration may have been written by authors of any nationality but the work must be published or distributed in the United Kingdom. The work must be written or have been translated into the English language.

Submission by publisher only.
Closing date: August. Winner announced: November.
Prize: £2,000.

The Booktrust Early Years Awards

(formerly Sainsbury's Baby Book Award)
Booktrust
Book House
45 East Hill
London SW18 2QZ
Phone: 020 8516 2977
Fax: 020 8516 2978
Email:info@booktrust.org.uk
Web: www.booktrust.org.uk

The Booktrust Early Years Awards were first awarded in 2004. They aim to celebrate, publicise and reward the exciting range of books being published today for babies, toddlers and pre-school children and to promote and make these books accessible to as wide an audience as possible.

Categories of award:

The best book for babies under one year old
The best book for pre-school children, up to five years of age
An award for the best new illustrator

The Booktrust Early Years Awards are supported by the National Bookstart Programme and their sponsors and The Unwin Charitable Trust.

Award: £2,000 plus a crystal award.

Booktrust Teenage Prize

Booktrust
45 East Hill
London SW18 2QZ
Contact: Hannah Rutland
Phone: 020 8516 2986
Fax: 020 8516 2978
Email: hannah@booktrust.org.uk
Web: www.bookheads.org.uk

The prize is open to works of fiction for young adults, between the ages of 13-16, written in English by a citizen of the UK, or an author resident in the UK. Eligible books must have been first published in the year prior to the prize.

Winner announced: November.
Prize: £1,500.

Boston Review Short-Story Contest

E53-407 MIT
Cambridge, MA 02139
United States
Phone: +1 617 258-0805
Email: review@mit.edu
Web: www.bostonreview.net

Stories should not exceed 4,000 words and must be previously unpublished.

A $20 processing fee ($30 for international submissions), must accompany each story entered. Entrants will receive a one-year print subscription to the Review. Email submissions are not accepted. The winning author will receive $1,000 and have his or her work published in the April/May issue of *Boston Review*.

Closing date: October.
First Prize: $1,000.

Harry Bowling Prize

Contact: Dana Arnott
Phone: 020 7387 2076
Web: www.mbalit.demon.co.uk
Web: www.harrybowlingprize.net (under construction)

The next biennial prize will run in 2006. Check new website for details. The prize has been established in honour of Harry Bowling 'the King of Cockney sagas', author of eighteen bestselling novels of London life, who died in 1999. It is intended to encourage new, unpublished fiction and is open to anyone who has not had an adult novel published in any genre, including under a pseudonym. However, entrants may have published short stories, scripts for TV and radio, non-fiction and childrens fiction and non-fiction.

Each entry must be set in London but not confined to any particular fictional genre, past or present. Entrants should submit the synopsis of novel (of not more than 500 words) and a sample from the novel of not more than 5,000 words. There is no commitment to publish the winning or shortlisted entries.

The 2006 competition is administered by Storytracks (www.storytracks.net) in conjunction with MBA, Literary Agents, and Headline publishers.

Prize: £1,000; 5 runners-up prizes of £100 each.

Branford Boase Award

Lois Beeson
18 Grosvenor Road
Portswood
Southampton SO17 1RT
Phone: 023 8055 5057
Web: www.henriettabranford.co.uk

The Branford Boase Award celebrates the most promising new children's writer of the previous year, and highlights the importance of the editor in identifying and nurturing new talent. The Award is made to the most promising book for seven year-olds and upwards by a first novelist in a single calendar year. The author may have published other books in another genre. The book should be first published on a children's list in the UK and the author should live and work in the UK.

Submission by publisher only.

The Henrietta Branford Writing Competition

Young Writer
Glebe House
Weobley
Herefordshire HR4 8SD
Phone: 01544 318901
Email: youngwriter@enterprise.net
Web: www.mystworld.com/youngwriter/

For young writers aged 18 and under. Runs in parallel with the Branford Boase Award. The competition is run in association with *Young Writer Magazine*. The challenge is to write a short fantasy story of no more than 3,000 words which follows on from one of two paragraphs selected from specified books. The writers of the six best stories will be invited to the Branford Boase Award party.

Closing date: May.

The Bridport Prize

International Creative Writing Competition
Bridport Arts Centre
South Street
Bridport
Dorset, DT6 3NR
Phone: 01308 459444
Email: frances@poorton.demon.co.uk
Web: www.bridportprize.org.uk

An annual prize for stories of no more than 5,000 words. Entries must be entirely the work of the entrant and must not have been previously published. Entries must be in English. Worldwide copyright of each entry remains with the author, but the Bridport Prize will have the unrestricted right to publish the winning poems and stories, (including runners up), in the annual anthology. No competitor may win more than one prize in each category. Prize winners will be notified in writing by beginning of November 2005. Prizes will be awarded on 26th November 2005. The entry fee is £6 per story.

The top 26 stories and poems will be published in the Bridport Prize 2005 anthology.

Closing date: June 2005
Prizes: 1st – £3000; 2nd – £1000; 3rd – £500.
There are also 10 supplementary prizes.

Katharine Briggs Folklore Award

The Folklore Society
c/o The Warburg Institute
Woburn Square
London WC1H 0AB
Contact: The Convenor
Phone: 020 7862 8564
Fax: 020 7862 8565
Web: www.folklore-society.com

This annual award is made to a book which is judged to have made the most distinguished contribution to folklore studies. Folklore studies will be interpreted broadly. Open to all books in English on folklore having their first, original and initial publication in the UK and Republic of Ireland. Books must be published between 1st June and following 31st May, for award in the subsequent November.

Submission by publisher or author.
Closing date: 31st May. Winner announced: November.
Prize: £50 and an engraved goblet.

British Academy Book Prize

British Academy
10 Carlton House Terrace
London SW1Y 5AH
Phone: 020 7969 5238
Web: www.britac.ac.uk

The Academy Book Prize established in 2001 celebrates accessible scholarly writing. The judges look for a book built on excellent up-to-date scholarship, about a sufficiently large and interesting humanities or social sciences subject to entice the general reader, treated in as accessible a fashion as a serious treatment of the subject would allow.

Submission by publisher only.
Prize: £2,500.

British Book Awards

Merric Davidson
PO Box 60
Cranbrook, Kent TN17 2ZR
Phone: 01580 212041
Fax: 01580 212041
Email: bba@mdla.co.uk
Web: publishingnews.co.uk

The "Oscars" of the book trade. Nominations are made by members of the book trade. Winners are announced at an annual trade awards ceremony.

British Czech and Slovak Association

BCSA Prize Administrator
24 Ferndale
Tunbridge Wells TN2 3NS
Phone: 01892 543206
Email: prize@bcsa.co.uk
Web: www.bcsa.co.uk

An annual prize for the best piece of original writing in English on the links

between Britain and the Czech and Slovak Republics, or describing society in transition in those republics since the revolution in 1989. Fiction or non-fiction, up to 2,000 words.

Closing date: 30 June.
Prizes: 1st – £300 plus publication in *British Czech & Slovak Review;* 2nd – £100.

British Fantasy Society Awards

The British Fantasy Society
201 Reddish Road
South Reddish
Stockport SK5 7HR
Email: info@britishfantasysociety.org.uk
Web: www.britishfantasysociety.org.uk

Nominations and voting are made by Members of the British Fantasy Society. Further details on website.

Annual awards awarded in the following categories:

Best Novel (The August Derleth Fantasy Award) / Best Short Fiction / Best Anthology / Best Collection / Best Artist / Best Small Press / Special Award (Karl Edward Wagner Award).

British Science Fiction Association Awards

BSFA Awards Administrator
The Bungalow
27 Lower Evingar Road
Whitchurch RG28 7EY
Contact: Claire Brialey, Awards Administrator
Email: awards@fishlifter.demon.co.uk
Web: www.bsfa.co.uk

The awards are voted on by members the of BSFA. Three categories of award are made:

The Best Novel Award open to any novel-length work of science fiction or fantasy.

The Best Short Fiction Award is open to any shorter work of science fiction or fantasy, up to and including novellas.

The Best Artwork Award is open to any single image of science fiction or fantasy artwork.

The award for non-fiction was suspended in 2004, see website for updated announcement.

Closing date for nominations: January.

The Caine Prize for African Writing

48 Edwardes Square
London W8 6HH
Contact: Nick Elam or Jan Hart
Phone: 020 7376 0440
Fax: 020 7603 3274
Email: info@caineprize.com
Web: www.caineprize.com

Awarded for a short story by an African writer published in English, whether in Africa or elsewhere. (Indicative length, between 3,000 and 10,000 words).

'An African writer' is taken to mean someone who was born in Africa, or who is a national of an African country, or whose parents are African, and whose work has reflected African sensibilities.

For practical reasons, unpublished work and work in other languages is not eligible. Works translated into English from other languages are not excluded, provided they have been published in translation, and should such a work win, a proportion of the prize would be awarded to the translator.

The short-list is selected from work originally published in the 5 years preceding the submissions deadline and not previously considered for a Caine Prize. Every effort is made to publicise the work of the short-listed authors. Winning and short-listed authors will be invited to participate in writers' workshops in Africa, London and elsewhere as resources permit.

Submission by publisher only. There is no application form. The award is made in July each year, the deadline for submissions being 31st January.

Prize: $15,000 for the winning author and a travel award for each of the short-listed candidates (up to five in all).

Carnegie Medal

CILIP
7 Ridgmount Street
London WC1E 7AE
Phone: 020 7255 0650
Fax: 020 7255 0651
Email: ckg@cilip.org.uk
Web: www.carnegiegreenaway.org.uk

The Carnegie Medal, was set up by the Library Association in 1935 in honour of Andrew Carnegie. It is awarded by children's librarians for an outstanding book for children and young people. Awarded annually by CILIP: the Chartered Institute of Library and Information Professionals. The winner is announced in July each year.

Sid Chaplin Short Story Competition

Shildon Town Council
Council Offices
Civic Hall Square
Shildon DL1 1AH

Phone: 01388 772563
Fax: 01388 775227
Web: www.shildon.gov/uk

Annual short story competition with a changing theme each year. Adult and Junior categories. Maximum length 3,000 words. Work must not have been previously published, broadcast or performed. Entry fee: £2.00.

Application forms available from September.
Prizes: 1st – £300; 2nd – £150; 3rd – £75.

Children's Writers' & Artists' Story Competition

Writers' and Artists' Year Book
37 Soho Square
London W1D 3QZ
Phone: 020 7758 0200
Fax: 020 7758 0222 / 0333
Email: wayb@acblack.com (Writers' and Artists')
Web: www.acblack.com

For a children's story of no more than 2,000 words on the theme of 'families', The competition is open to all ages, professions and nationalities — see website for full details.

Closing date: 31st March 2005. Winner announced in April.
Prizes: Cash prize of £500, or £1000 of A&C Black books. Lunch with a top children's fiction editor. Publication of your entry on the A&C Black and Bloomsbury Publishing websites.

Arthur C Clarke Award

60 Bournemouth Road
Folkestone
Kent CT19 5AZ
Contact: Paul Kincaid, Administrator
Phone: 01303 252939
Email: arthurcclarkeaward@yahoo.co.uk
Web: www.appomattox.demon.co.uk

The Arthur C. Clarke Award is awarded every year to the best science fiction novel which received its first British publication during the previous calendar year. The Award is chosen by jury. The Award was established with a generous grant from Arthur C. Clarke to encourage science fiction in Britain. The Award was set up in 1986.

The Award consists of an inscribed plaque in the form of a bookend, and a cheque. The value of the prize matches the year. In 2005, it will be £2005.

Submission by publisher only.
Closing date: December. Shortlist announced: January. Winner: May.

David Cohen Prize for Literature

Arts Council England
14 Great Peter Street
London SW1P 3NQ
Phone: 0845 300 6200
Web: www.artscouncil.org.uk

Privately funded by the John S Cohen Foundation, with a contribution from Arts Council England, the David Cohen Literature Prize is widely regarded as one of the most prestigious literary awards. Previous recipients of the prize include V.S. Naipaul, Harold Pinter, Muriel Spark, Doris Lessing, William Trevor, Beryl Bainbridge and Thom Gunn.

Writers living in the Republic of Ireland are now also eligible and so the prize known previously as the 'British Literature Prize' has been renamed the David Cohen Prize for Literature.

The prize money has been increased to £52,500. £40,000 is provided by the John S Cohen Foundation, and £12,500 contributed by Arts Council England, to be given to an individual or organisation, chosen by the winner, to encourage reading or writing among young people.

Commonwealth Short Story Competition

Commonwealth Broadcasting Association
17 Fleet Street
London EC4Y 1AA
Phone: 020 7583 5550
Fax: 020 7583 5549
Email: story@cba.org.uk
Web: www.cba.org.uk

The aim is to promote the Commonwealth through broadcasting high quality short stories submitted by Commonwealth writers. The competition is administered by the Commonwealth Broadcasting Association with funding from the Commonwealth Foundation.

All Commonwealth citizens will be eligible to participate in the Competition. There is no age limit and authors may be either amateurs or professionals. The stories may have any theme or subject, but should be 4'30" when read aloud (approximately 600 words). The stories must be original and not previously published anywhere. All entries must be in English.

Maximum of three entries per writer.

If you are a winner, you assign the broadcasting rights (including audio on demand) for ten years to the Commonwealth Broadcasting Association but you retain the copyright. You also assign publication rights for ten years to the CBA and Commonwealth Foundation, and the rights for the story to be sold on any audio medium by the CBA. Both these rights are non-exclusive.

The names of the winners will be published in "Commonwealth Broadcaster", on the CBA website and in the press and broadcast media of Commonwealth countries.

Closing date: 1st May 2005.
There is no entry fee and no entry form.
Prize: £2,000.

Commonwealth Writers' Prize

Administrator
Book Trust
Book House
45 East Hill
London SW18 2QZ
Contact: Tarryn McKay
Phone: 020 8516 2971
Fax: 020 8516 2978
Email: tarryn@booktrust.org.uk
Web: www.commonwealthwriters.com

The Commonwealth Foundation established the Commonwealth Writers Prize in 1987 to encourage and reward the upsurge of new Commonwealth fiction and ensure that works of merit reach a wider audience outside their country of origin. Awarded annually, the Prize for fiction is fully international in its character and administration. Entries are first assessed by four regional panels of judges and the selection of the overall winner is made by a distinguished pan-Commonwealth panel. Each year the award ceremony is held in a different Commonwealth country. This resource celebrates the outstanding literary talent which exists in many parts of the Commonwealth and its contribution to contemporary writing in English. Any work of prose or fiction is eligible, i.e. a novel or collection of short stories. Drama and poetry and works written for children alone are ineligible. The work must have been written by a citizen of the Commonwealth, must be of a reasonable length and be in English. To be eligible for the 'best first published book' category the entry must be the first work of fiction which the author has published.

Submission by publisher only.
Closing date: November.
Regional winners announced: February. Overall Winners announced: April.

Prizes: £10,000 for the best book: £3,000 for the best first published book. In each of the four regions of the Commonwealth two prizes of £1,000 will be awarded: one for the best book and one for the best first published book.

Thomas Cook Travel Book Award

Contact: Joan Lee, Administrator
Phone: 01482 610707
Email: joantba2004@hotmail.com
Web: www.thetravelbookaward.com

The Travel Book Award originated as an initiative of The Thomas Cook Group in 1980, with the aim of encouraging and rewarding the art of literary travel writing.

Books submitted must fulfil the following criteria:

Travel narrative books only (that is, not guidebooks). Books must be published in English, or translated into English. Minimum length of 150 pages. Published between 01 January and 31 December of the previous year.

Submission by publisher only. Books may only be entered once.
Prizes: £10,000. The winner and shortlisted authors are presented with a reproduction picture from the Thomas Cook company archives.

Duff Cooper Prize

Artemis Cooper
54 Saint Maur Road
London SW6 4DP
Phone: 020 7736 3729
Fax: 020 7731 7638

Named after a politician and diplomat, who at one point in his career was the British ambassador to France. The award is made to a literary work in the field of history, biography, politics or poetry, published in English or French during the last 12 months.

Submission by publisher only.
Closing date: November. Winner announced: February.
Prize: £3,000 and a presentation copy of Duff Cooper's autobiography *Old Men Forget*.

Rose Mary Crawshay Prize

The British Academy
10 Carlton House Terrace
London SW1Y 5AH
Phone: 020 7969 5200
Fax: 020 7969 5300
Email: secretary@britac.ac.uk
Web: www.britac.ac.uk

In 1888 Mrs Rose Mary Crawshay established 'The Byron, Shelley, Keats In Memoriam Yearly Prize Fund'. In 1914, some years after her death, the Charity Commissioners transferred administration of the prize fund to the Academy. Two prizes are normally awarded each year. Each goes 'to a woman of any nationality who, in the judgement of the Council of the British Academy, has written or published within three years next preceding the year of the award an historical or critical work of sufficient value on any subject connected with English Literature, preference being given to a work regarding one of the poets Byron, Shelley and Keats'.

Submission by publisher only.
Winner announced: July.
Prize: £500 each.

Crime Writers Association Awards

PO Box 63
Wakefield WF2 0YW
Email: info@thecwa.co.uk
Web: www.thecwa.co.uk

The CWA offers a number of awards. The titles of the awards vary from year to years dependent on sponsorship. The following are annually awarded. For further details see the website.

CWA Gold and Silver Daggers awarded for the top crime novel of the year. £3,000 and £2,000 prize money respectively.

CWA Gold Dagger for Non-Fiction. Prize of £2,000.

The CWA Ian Fleming Steel Dagger. The best adventure/thriller novel in the vein of James Bond. Prize: £2,000. This Dagger is sponsored by Ian Fleming Publications Ltd.

CWA John Creasey Memorial Dagger. For first books by unpublished writers. Prize: £1,000.

CWA Ellis Peters Historical Dagger. Prize of £3,000 is sponsored by the Estate of Ellis Peters and her publishers, Headline, and the Time Warner Book Group.

CWA Short Story Dagger. Prize: £1,500.

CWA Debut Dagger. Awarded to unpublished authors of fiction. Prize: £250.

CWA Dagger in the Library. This prize, nominated and judged by librarians, is awarded for a body of work, not just a single title. Prize: £1,500.

The CWA Cartier Diamond Dagger. The Diamond Dagger, sponsored by Cartier, has been awarded annually for nineteen years to mark a lifetime's achievement in crime writing.

Dark Tales Short Story Competition

11 Lower Chestnut Street
Worcester WR1 1PB
Email competition@darktales.co.uk
Web: www.darktales.co.uk

Each entry must be no longer than 2,500 words, and the original, unpublished work of the author. UK residents can enter either by post or online. Residents from outside the UK can enter the competition online. Entry fee is £3.00 per story for non-subscribers and £1.50 per story for subscribers.

Closing date: 31st May 2005.
Prizes: 1st – £100; 2nd – £30; 3rd – £20; other shortlisted entrants – £5.
All winning and shortlisted entries published in the magazine.

The Rhys Davies Short Story Competition

Academi
Mount Stuart House
Mount Stuart Square
Cardiff CF10 5FQ
Contact: Chief Executive Peter Finch
Phone: 029 2047 2266
Fax: 029 2049 2930
Web: www.academi.org

For the 2005 Rhys Davies Short Story Competition entries must be writen on the theme of Urban Writing.

Each submission must be no more than 3,000 words in length. Entrants may submit an unlimited number of stories. Each story must be accompanied by a £5.00 entry fee. Entries must be in English, must not have been published or broadcast and not be translations of another author's work.

Eligibility: The competition is open to all those born in Wales or currently living in Wales.

Closing date: 30th April 2005.

Prize: £1,000; plus ten prizes of £100.

The Rhys Davies Short Story Competition is organised by Academi and sponsored by the Rhys Davies Trust. The Rhys Davies Trust is a charity which has as its aim the fostering of Welsh Writing in English.

Diagram Group Prize

The Bookseller Magazine
Endeavour House
189 Shaftesbury Avenue
London WC2H 8TJ
Phone: 020 7420 6006
Web: www.thebookseller.com

Awarded to the oddest title of the year as nominated by readers of *The Bookseller* magazine. Entries are not required, although nominations are encouraged.

Closing date for nominations: October. Winner announced: November.

Prize: Bottle of vintage champagne.

The Tony Doyle Bursary For New Writing

BBC NI Drama Department
Broadcasting House
Ormeau Avenue
Belfast BT2 8HQ
Northern Ireland
Phone: 028 9033 8997
Email: tvdrama.ni@bbc.co.uk
Web: www.bbc.co.uk/ni/drama

The Tony Doyle New Writers Bursary Award is now a biennial event. The next Bursary will be launched in autumn 2005 with a closing date early in 2006.

The aim of the bursary is to encourage television drama about Ireland by writers new to the medium. This may include writers experienced in other forms of fiction as well as new writers.

The winner receives a £2,000 cash prize and will join three other finalists on a residential seminar run by the BBC Northern Ireland Drama Department.

Daphne Du Maurier Festival Short Story Competitions

Restormel Borough Council
Daphne du Maurier Festival Office
39 Penwinnick Road
St Austell PL25 5DR

Phone: 01726 223310
Email: dumaurierinfo@restormel.gov.uk
Web: www.restormel.gov.uk/daphne

The Festival is an annual event in May but the short story competition is biennial (subject to sponsorship), the next one being 2006. Stories should be no more than 3,000 words.

Adult and Young Writers Competition. Stories were themed in 2004. Entrants to Young Writers Award must live in Cornwall, the adult competition is open.

Prize: Adult competition: 1st – £2,000; 2nd – £750; 3rd – £250.
Prize: Young Writers competition: £300 (11-14); £450 (15-18).

Dundee Book Prize

City of Discovery Campaign
Dundee City Council
3 City Square
Dundee DD1 3BA
Email: deborah.kennedy@dundeecity.gov.uk
Web: www.dundeecity.gov.uk/bookprize

The Dundee Book Prize is a joint venture between the City of Discovery Campaign, the University of Dundee and Birlinn Ltd, publishers of the Polygon imprint. Now in its fourth biennial year, it is for an unpublished novel on any theme and in any genre.

The entry must be a novel and an original work of fiction. It must be unpublished. It may be set in the past, present or the future. No limits are set on length (normal length for a novel might be around 80,000 words). Each entry must be submitted with a synopsis of no more than 500 words. Only one entry per person. Manuscripts must not have been entered into the Dundee Book Prize competition on any previous occasion.

Entrants must be willing to have their script published, subject to reasonable financial arrangements with Polygon. No guarantee can be given that the winning novel will be published, however there is every expectation that publication will follow. Scripts should not be under consideration by other publishers during the judging process. Scripts that do not win the prize may also be considered for publication.

Closing date for postal entries: 31st March 2006.
Closing date for email entries: 1st February 2006.
Prize: £6,000.

The S.T. Dupont Golden Pen Award

The English Centre of International PEN
Lancaster House
33 Islington High Street
London N1 9LH
Phone: 020 7713 0023
Fax: 020 7713 0005
Email:enquiries@englishpen.org
Web: www.englishpen.org

This award is presented each year to an author whose work has given both readers and writers pleasure and inspiration throughout his or her career. The winner receives a specially engraved trophy and a golden pen donated by S. T. Dupont.

Encore Award

Awards Secretary
The Society of Authors
84 Drayton Gardens
London SW10 9SB
Phone: 020 7373 6642
Fax: 020 7373 5768
Email: info@societyofauthors.org
Web: www.societyofauthors.org

The work must be a novel by one author who has had one (and only one) novel published previously. The work must be in the English language, first published in the UK in the previous year, and not a work for children.

Either the author must be a British or a Commonwealth citizen or the book must have been first published in the UK. A work that is published on its own is regarded as a novel unless the word 'novella' appears on the cover.

Submission by publisher only.
Closing date: November. Winner announced: Spring.
Prize: £10,000 (sometimes shared between winners).

Christopher Ewart-Biggs Memorial Prize

The Secretary to the Judges Committee
Flat 3, 149 Hamilton Terrace
London NW8 9QS

This biennial award is made in memory of the British Ambassador to Ireland who was assassinated in Dublin in 1976. Established in 1977 it aims to create greater understanding between the peoples of Britain and Ireland, or co-operation between the partners of the European Community. The prize is awarded to a book, a play or a piece of journalism that best fulfils this aim.

Closing date: December. Winner announced: Following spring.
Prize: £5,000. Next award 2006.

Geoffrey Faber Memorial Prize

Faber and Faber Ltd
3 Queen Square
London WC1N 3AU
Phone: 020 7465 0045
Fax: 020 7465 0043
Email: belinda.matthews@faber.co.uk

An annual prize awarded, in alternate years, for a volume of verse and for a volume of prose fiction. The work must be first published in the UK during the two years preceeding the year in which the award is given. The writer must be under 40 at the time of publication and a citizen of the United Kingdom and Colonies, of any other Commonwealth state, of the Republic of Ireland or of the Republic of South Africa. The winner is chosen by nomination – entries are not required.

Winner announced: April / May.
Prize: £1,000.

Eleanor Farjeon Award

The Children's Book Circle
c/o Rachel Wade
Hodder Children's Books
338 Euston Road
London NW1 3BH
contact@childrensbookcircle.org.uk

The Children's Book Circle hosts the annual Eleanor Farjeon Award, which recognises an outstanding contribution to the world of children's books – either by an individual or an organisation. Authors, illustrators, booksellers, publishers, teachers, reviewers etc are all eligible for nomination. The CBC's members nominate and then vote for the award. The award was established in 1965 in memory of Eleanor Farjeon, who died that year.

Fidler Award

Scottish Book Trust
Sandeman House
Trunk's Close
55 High Street
Edinburgh EH1 1SR
Tel: 0131 524 0160
Fax: 0131 524 0161
Email: info@scottishbooktrust.com
Web: www.scottishbooktrust.com

This prize is currently on hold and submissions are NOT invited.

(Awarded to a previously unpublished and unagented author for a novel aimed at eight to twelve year-olds.)

firstwriter.com – Short Story Contest

Web: www.firstwriter.com

Stories can be on any subject and in any style, but must be no more than 3,000 words in length. Entries must be entirely the work of the entrant and must never have been published in a book or anthology, though they may have been previously published in a magazine/journal/periodical.

Stories may be simultaneously submitted to this and other competitions, or for consideration in a magazine, but not for consideration for a book or anthology.

The entry fee is £5.00/$7.50 per story, £8.00/$12.00 for two, £10.00/$15.00 for three, or £13.50/$20.00 for five. Any number of entries can be made online, but no postal entries are accepted.

The prize-money for first place is £200 (approx. $300). Ten special commendations will also be awarded and all the winners will be published in firstwriter.magazine and receive a free year's subscription to the site.

Closing date: 1st April 2005.

Fish Publishing

Durras, Bantry
Co. Cork
Ireland
Phone: +353 (0)27 55645
Email: info@fishpublishing.com
Web: www.fishpublishing.com

One Page Story Prize

Requires stories of 250 words max on any subject. The Prize is open to writers of any nationality writing in English. There is no restriction on theme or style. The winning stories must be available for the anthology and, therefore, must not have been published previously.

Closing date: March.
Prizes: 1,000 First Prize + 100 each to nine runners up. Top 10 published in Fish Anthology. All winning authors will be invited to the launch of the Fish Short Story Prize Anthology. This will take place during the West Cork Literary Festival at Bantry House.

The Historical Short-fiction Prize

Fish Publishing is running this new competition in conjunction with the UK's Historical Novel Society.

The competition is intended to encourage the development of the Short History genre and to enable the publication of new writers of historical fiction in the short-story format. Open to writers of any nationality writing in English. There is no restriction on period or style but the theme must be historical. Maximum 6,000 words. The winning stories must be available for the anthology and, therefore, must not have been published previously.

Closing date: April.
First Prize is £1,000. All other authors whose stories feature in the 2005 Anthology will receive an award of £250. The top 10 stories will appear in the *Short Histories Anthology*, out September 2005.

Fish International Short Story Prize

The Prize is open to writers of any nationality writing in English. There is no restriction on theme or style. Maximum 5,000 words. The winning stories must be available for the anthology and, therefore, must not have been published previously.

First Prize of 10,000 to the winner plus publication as the title story for the annual Anthology. Second Prize – a week's residence at Anam Cara Writers'

Retreat with up to 250 travelling expenses + publication in the Anthology. Third Prize – 250 + publication in theAnthology . Twelve runners up will also be selected to appear in the Anthology and will each receive an award of 100 plus five complimentary copies of the Anthology.

The Fish Unpublished Novel Award

In 2004 Fish ran a very succesful new competition 'The Unfinished Novel Prize'. They will be running a similar competition in 2005 but the details are not yet finalised. See website for details.

Sir Banister Fletcher Award (Authors' Club)

Authors' Club
40 Dover Street
London W1S 4NP
Phone: 020 7499 8581
Fax: 020 7409 0913
Email: authorsclub@hotmail.com

This award was created by Sir Banister Fletcher, who was president of the Authors' Club for many years and is awarded to the best book of the year on architecture. (Books on the fine arts are also considered.) The author must be British or resident in Britain.

Open submission – selection committee will then approach publishers.
Prize: £1,000.

The Tom-Gallon Trust Award and The Olive Cook Prize

The Society of Authors
84 Drayton Gardens
London SW10 9SB
Phone: 020 7373 6642
Fax: 020 7373 5768
Email: info@societyofauthors.org
Web: www.societyofauthors.org

For a short story

These awards are financed by bequests made by Miss Nellie Tom-Gallon in memory of her brother, and by Olive Cook. The awards are made to a writer of fiction who has had at least one short story accepted for publication, and who has serious writing ambitions. The submitted story should be traditional, rather than experimental, in character, and the financial circumstances of the writer will be taken into account. One short story (maximum length 5,000 words), published, or unpublished can be entered. The author must be a citizen of the UK, Commonwealth or the Republic of Ireland. The story submitted must be in English, not a translation, and published or unpublished.

The awards are both biennial, and are awarded in alternate years. Submissions for the Tom-Gallon Trust Award 2006 accepted from 1 July 2005.
Closing dates: 31 October 2005.
Prize: £1,000.

Gladstone History Book Prize

The Royal Historical Society
University College London
Gower Street
London WC1E 7HU
Phone: 020 7387 7532
Fax: 020 7387 7532
Email: rhsinfo@rhs.ac.uk
Web: www.rhs.ac.uk

This annual award is made to an original work on any historical subject which is not primarily related to British history. It must be its author's first solely written history book and must have been published in English, during the calendar year, by a scholar normally resident in the United Kingdom.

Submission by publisher only.
Closing date: December. Winner announced: July.
Prize: £1,000.

Glenfiddich Food and Drink Awards

Wild Card, 299 Oxford Street
London WC1C 2DZ
Phone: 020 7355 0655
Fax: 020 7631 0602
Email: lindsay.stewart@wildcard.co.uk
Web: http://uk.glenfiddich.com/

The Awards recognise excellence in writing, publishing and broadcasting on the subjects of food and drink. An independent panel of judges selects the winners from work published or broadcast during the previous year.

Categories: Food Book, Drink Book, Food Writer, Cookery Writer, Drink/Bar Writer, Wine Writer, Restaurant Critic, Regional Writer, Broadcast, Photography.

Independent Spirit Award – Awarded at the judges' discretion in recognition of a piece of work which falls within no other category, or a progressive individual (newcomer or otherwise), or campaign thought to have made an outstanding contribution towards widening the understanding and appreciation of food and drink in Britain.

Prizes: The winner in each category receives an award, of £1,000 and a special bottling of Glenfiddich Single Malt Scotch Whisky. From among the category winners the judges select one outstanding candidate to receive The Glenfiddich Trophy to be held for one year, and a further £3,000.

Closing date: end January

Sir Israel Gollancz Prize

The British Academy
10 Carlton House Terrace
London SW1Y 5AH
Phone: 020 7969 5200
Fax: 020 7969 5300

Email: secretary@britac.ac.uk
Web: www.britac.ac.uk

This biennial prize in English studies, together with a biennial lecture, was established by Mrs Frida Mond in 1924. It was her intention to associate both prize and lecture with Sir Israel Gollancz, the first Secretary of the British Academy, 'in token of a highly valued old friendship and his effort to further these studies'. The prize is awarded either for published work of sufficient value on subjects connected with Anglo-Saxon, Early English Language and Literature, English Philology, or the History of English Language; or for original investigations connected with the history of English Literature or the works of English writers, with preference for the earlier period.

Phillip Good Memorial Prize

QWF Magazine
P O Box 1768
Rugby CV21 4ZA
Phone: 01788 334302
Email: jo@qwfmagazine.co.uk
Web: www.qwfmagazine.co.uk
Submissions should be sent to:
Sally Zigmond, Assistant Editor
18 Warwick Crescent
Harrogate HG2 8JA
Email: sally_zigmond@yahoo.co.uk

Run by QWF Magazine, an award for short stories of less than 5,000 words in any style or genre except children's. Entries should be the original, unpublished work of the author (including unpaid publication), and should not have won a prize in any previous competitions. Entry fee: £5 for each story up to 5,000 words.

Closing date: 21st August.
Prize: 1st – £300; 2nd – £150; 3rd – £75; runners up – subscriptions to QWF.

The Doris Gooderson Short Story Competition

The Competition Secretary
8 Ragleth Road
Church Stretton SY6 7BN
Web: www.wrekinwriters.co.uk

Entries must not exceed 1,200 words, be in the form of a Short Story and written in English. Open to anyone, of any age, from anywhere in the world.

Entry fee: £3 for each entry or £10 for 4 entries.
Deadline: 15th May 2005. Winners will be notified by 31st July 2005.
Prizes: 1st – £80; 2nd – £40; 3rd – £20. Further prizes may be awarded at the discretion of the judge.

Kate Greenaway Medal

CILIP
7 Ridgmount Street
London WC1E 7AE
Tel: 020 7255 0650
Fax: 020 7255 0651
Email: ckg@cilip.org.uk
Web: www.carnegiegreenaway.org.uk

The Kate Greenaway Medal was established by The Library Association in 1955, for distinguished illustration in a book for children. It is named after the popular nineteenth century artist known for her fine children's illustrations and designs.

It was first awarded to Edward Ardizzone for *Tim All Alone*. The medal is now awarded by CILIP: the Chartered Institute of Library and Information Professionals.

The winner receives a golden medal and £500 worth of books to donate to a library of their choice.

Since 2000, the winner of the Kate Greenaway Medal has also been awarded the £5,000 Colin Mears Award. Colin Mears, a Worthing based accountant and children's book collector, left a bequest to The Library Association providing every Greenaway winner with a cash award as well as the coveted Medal.

The Guardian Children's Fiction Award

The Guardian
119 Farringdon Road
London EC1R 3ER
Phone: 020 7239 9694
Web: www.booksunlimited.co.uk

The award is made to an outstanding work of fiction for children written by a British or Commonwealth author. Entrants are judged by their peers, the winner being chosen by a panel of authors and the review editor for *The Guardian's* children's books section.

Submission by publisher only.
Closing date: July. Shortlist: September. Winner announced: October.
Prize: £1,500.

The Guardian First Book Award

Claire Armitstead
Literary Editor
The Guardian First Book Award
119 Farringdon Road
London EC1R 3ER
Phone: 020 7278 2332
Web: www.booksunlimited.co.uk

The Guardian First Book Award was established in 1999 to reward the finest

new literary talent with a £10,000 prize for an author's first book. The award is open to writing across all genres. Debut works of fiction are judged alongside those of non-fiction. First book means the first printed production in book form of any type or genre, including academic books. The following are not eligible: academic, reference, guide books, children's educational, manuals, reprints, and television, radio and film tie-ins.

Submission by publisher only.
Closing date: July. Shortlist announced: October. Winner: December.
Prize: £10,000 and £1,000 of books for a UK school of the winners choice.

The Guardian Student Media Awards

PO Box 415
St Albans AL4 OJY
Phone: 01727 865395
Web:http://media.guardian.co.uk/studentmediaawards

The Guardian Student Media Awards recognise and reward the very best in student journalism and have launched the careers of many of the country's leading writers and broadcasters.

The details below are for 2004 – those for 2005 not yet available at time of publication. See website for updated information.

Categories:

Student Newspaper of the Year

Looking for originality, quality, diversity and for a paper that isn't afraid to take risks.

First prize: £1,000, three pairs of return flights to any EasyJet destination and a week's work experience at the Guardian for the winning editor. Runner-up: £500.

Student Magazine of the Year

Looking for intelligent mix; accurate targeting of the student and local readership; strong ideas; high-quality writing; thoughtful packaging of articles; clear and confident presentation, design, and "selling" of contents.

First prize: £1,000, three pairs of return flights to any EasyJet destination and a week's work experience at the Guardian for the winning editor. Runner-up: £500.

Student Reporter of the Year

Looking for an ability to dig out original information and present it with verve and style to student readers. First prize: £500, two return flights to any easyJet destination and a week's work experience at the Guardian, plus a six-week placement at Sky News with expenses (travel, accommodation and lunch) for the winning reporter. Runner-up: £250.

Student Feature Writer of the Year

Looking for a fluent and compelling style, which describes vividly, and remains factually accurate and consistently entertaining.

First prize: £500, two return flights to any EasyJet destination and a week's work experience at the Guardian for the winning writer. Runner-up: £250.

Student Photographer of the Year

Looking for the best photograph. The one that sums up your talent as a photographer and makes the judges wish they had taken it themselves. Your work should either have been published in the student press OR be the work of a full-time photography student, in which case the work can be unpublished, but of publishable quality.

First prize: £500, two return flights to any EasyJet destination and a week's work experience at the Guardian for the winning photographer.
Runner-up: £250.

Student Publication Design of the Year

Looking for a publication designer or design team with an instinctive flair for layout and design that displays originality, professionalism, relevancy and accessibility.

First prize: £500, two return flights to any EasyJet destination and a week's work experience at the Guardian for the winning chief designer.
Runner-up: £250.

Student Website of the Year

Looking for innovative web content that exploits the strength of the medium, and displays a clear identity and understanding of the audience.

First prize: £500, two return flights to any EasyJet destination and a week's work experience at Guardian Unlimited for the winning editor.
Runner-up: £250.

Student Critic of the Year

Looking for entertaining, stylish, authoritative criticism that avoids clichés and offers a fresh, illuminating view of a performance/film/television programme etc.

First prize: £500, two return flights to any easyJet destination and a week's work experience at the Guardian for the winning critic. Runner-up: £250.

Small Budget Publication of the Year

Looking for creative triumph over financial adversity – a publication that makes up for in originality and ideas what it lacks in budget. Looking for publications that have a total income, including ad revenue, of £10,000 a year or less.

First prize: £1000, three pairs of return flights to any EasyJet destination and a week's work experience at the Guardian for the winning editor.
Runner-up: £500.

Student Sports Writer of the Year

Looking for original, insightful and accessible sports writing that encapsulates the atmosphere and excitement of a sporting event.

First prize: £500, two return flights to any EasyJet destination and a week's work experience at the Guardian for the winning writer. Runner-up: £250.

Student Diversity Writer of the Year

Looking for writing with a difference about differences. Insightful, fresh, sharp articles about race, religion, gender, sexuality or disability that paint a picture of Britain today.

First prize: £500, two return flights to any EasyJet destination and a week's work experience at the Guardian for the winning writer. Runner-up: £250.

Student Travel Writer of the Year

Looking for informative, entertaining travel writing that encapsulates the atmosphere and diversity of a destination.

First prize: £500, two return flights to any EasyJet destination and a week's work experience at the Guardian for the winning writer. Runner-up: £250.

Student Columnist of the Year

Looking for spirited, innovative comment that brings alive the personality of the publication.

First prize: £500, two return flights to any Easyjet destination and a week's work experience at the Guardian for the winning columnist. Runner-up: £250.

All work entered must have been published in the student media during the academic year. The competition is not open to publications run partly or wholly by non-students. The competition is not open to students who have worked previously as professional journalists, photographers or designers.

Entries should not be sent to the Guardian but the address on the entry form.

Closing date: July, but check website.
Shortlist usually published at the end of September.
The winners usually announced in November.

The Guardian/Piccadilly Press Writing Competition for Teenagers

5 Castle Road
London NW1 8PR
Phone: 020 7267 4492
Fax: 020 7267 4493
Email: books@piccadillypress.co.uk
Web: www.piccadillypress.co.uk.

Annual competition. Stories for 2005 on the theme of *The Perfect Lie?*, to be published the following year.

Entries must be no longer than 3,000 words (and can be shorter). Only one entry per person. The competition is open to all residents of the UK and Ireland in year 8 through year 13 inclusive on September 30th 2005, except previous winners and employees of The Guardian, Piccadilly Press and their relatives. Entry grants to Piccadilly Press Ltd the exclusive rights to publish an entrant's story in all formats throughout the world for the full legal term of copyright.

Closing date: September.

Guild of Food Writers Awards

Christina Thomas
48 Crabtree Lane
London SW6 6LW
Phone: 020 7610 1180
Fax: 020 7610 0299
Web: www.gfw.co.uk

Established in 1996, and presented annually in recognition of outstanding achievement in all areas in which food writers work and have influence.

The Derek Cooper Award for Investigative or Campaigning Food Writing

This award, launched in 2002, honours the Guild's first president, the writer and broadcaster Derek Cooper. It highlights the ever-increasing importance of the work of the food writer in the area of food policy. It is a multi-media category open to specific projects such as a book or television programme, an investigative report or article, as well as individuals or organisations who have undertaken a series of projects in this area.

The Michael Smith Award

Established in 1989 in memory of Michael Smith, a great supporter of British food and produce, this award is for the writer or broadcaster who has contributed most to the promotion of all that is great in British food; the subject of the winning book, magazine article or broadcast programme must be British food and it may be text-led or recipe-led.

The Jeremy Round Award

This award recognises the most promising first-time author of a cookery book or book on a food-related subject. It can be given to either a novice or veteran writer.

Food Book of the Year

This award is given to the author of the best book on a food-related subject published during the previous calendar year. It could be biographical, historical, topographical; a guidebook, an encyclopaedia, a compendium, or even a technical handbook.

Cookery Book of the Year

This award goes to the author of the best cookery book where recipes form the bulk of the text. Its subject may be any cuisine, historical period, specific ingredient or diet.

Food Journalist of the Year

This award is for the writer of the best food-related articles published in a magazine, newspaper or newspaper supplement. The articles must be commissioned and not self published. The articles may contain recipes but they should not form the bulk of the text.

Cookery Journalist of the Year

This award is for the writer of the best recipe columns or pages published in a magazine, newspaper or newspaper supplement. Contributors to websites may enter, providing that the author has been commissioned and paid for the work and is not self-publishing.

Open to: Anyone. Further information is available on the website.
Closing date: February. Winners announced: June.
Prize: £1,000 (for each category winner).

Guildford Book Festival

Tourist Information Centre
14 Tunsgate
Guildford GU1 3QT
Phone: 01483 225388

Email: director@guildfordbookfestival.co.uk
Email: assistant@guildfordbookfestival.co.uk
Web: www.guildfordbookfestival.co.uk

The following 2 prizes were awarded during the 2004. Check website for updated information. The Competition is part of the Guildford Book Festival held during October.

First Novel Award

The best first novel by an author living anywhere in London and the South of England. Known to date as the Pendleton May First Novel Award (sponsored by Pendleton May Insurance Brokers & Financial Advisors and Guildford Arts).

Prize: £2,500.

Short Story Competition
(Sponsored by Allianz Cornhill Insurance).

Any subject – maximum length 2,000 words.
Entry fee: £3 per story.

Prizes: 1st – £250; 2nd – £150; 3rd – £100.
Prizes are presented at the Festival.

Neil M Gunn Writing Competition

Web site: www.neilgunn.org.uk

The competition has been run successfully by Highland Council, in conjunction with other organisations and sponsors.

In 2004 the focus of the Adult competition was both national and international and included writers of all nationalities, races and ethnic groups, aged 16 or over, residing, studying or working anywhere in Scotland at any time during the competition.

Prizes total approximately £1,600 for all sections of the competition. See website for current details.

Hawthornden Prize

Hawthornden Trust
42a Hays Mews
Berkeley Square
London W1X 7RU

The Hawthornden Prize was founded in 1919 by Miss Alice Warrender. It is awarded annually to an English writer for the best work of imaginative literature. It is especially designed to encourage young authors and the word 'imaginative' is given a broad interpretation. Biographies are not necessarily excluded. Books do not have to be submitted. It is awarded without competition. A panel of Judges decides upon the winner.

Prize: £10,000.

The W.H. Heinemann Award

Royal Society of Literature
Somerset House
Strand
London WC2R 1LA
Phone: 020 7845 4676
Fax: 020 7845 4679
Email: info@rslit.org
Web: www.rslit.org

This prize is not being run in 2005, and its future is currently under review.

Heywood Hill Literary Prize

John Saumarez Smith
Heywood Hill Ltd
10 Curzon Street
London W1J7FJ
Phone: 020 7629 0647
Fax: 020 7408 0286

Awarded to a writer, publisher, reviewer, collector or editor for a lifetime's contribution to the enjoyment of books. The award is sponsored by The Duke of Devonshire. Entries are not required.

Winner announced: June.
Prize: £15,000.

William Hill Sports Book of the Year

William Hill Organization
50 Station Road
London N22 7TP
Contact: Press Officer
Phone: 020 8918 3858
Fax: 020 8918 3728
Email: pressoffice@williamhill.co.uk
Web: www.williamhillmedia.com

Annual award for the best sports book published in the year preceding the year in which the prize is awarded.

Prize : £15,000 for the author. The winner will also receive a free £1,500 bet, a specially commissioned hand bound copy of the winning title and a day at the races. All shortlisted authors will receive a leather bound copy of their book, £1,500 cash and a free £1,000 bet.

There is also a cover design award of £750, a free £250 bet, and a framed copy of the work to be awarded to the person nominated by the publishing house of the winning book.

Submission by publisher only.
Closing date: October. Winner announced: November.

L. Ron Hubbard's Writers of the Future Contest

P.O. Box 1630
Los Angeles, CA 90078
United States
Email: contests@authorservicesinc.com
Web: www.writersofthefuture.com

The L. Ron Hubbard's Writers of the Future Contest is an ongoing competition designed to discover new and amateur writers of science fiction and fantasy.

All entries must be original works, in English. To be eligible, entries must be works of prose, up to 17,000 words in length. Does not accept poetry, or works intended for children.

Only those who have not had professionally published a novel or short novel, or more than one novelette, or more than three short stories, in any medium may apply.

The Contest has four quarters, beginning on October 1, January 1, April 1 and July 1. The year will end on September 30. Each entrant may submit only one manuscript per quarter.

There are three cash prizes in each quarter:

1st – $1,000; 2nd – $750; – $500; in U.S. dollars or in the recipient's locally equivalent amount.

In addition, at the end of the year the four First Place winners will have their entries rejudged, and a Grand Prize winner will receive an additional $4,000. All winners will also receive trophies or certificates.

International IMPAC Dublin Literary Award

Ms. Clare Hogan
The International IMPAC Dublin Literary Award
Dublin City Library & Archive
138 -144 Pearse Street
Dublin 2
Ireland
Phone: +353 1 674 4802
Fax: +353 1 674 4879
Email: literaryaward@dublincity.ie
Web: www.impacdublinaward.ie

The International IMPAC Dublin Literary Award is the largest and most international prize of its kind. It involves libraries from all corners of the globe, and is open to books written in any language. The Award, an initiative of Dublin City Council, is a partnership between Dublin City Council, the Municipal Government of Dublin City, and IMPAC, a productivity improvement company which operates in over 50 countries. The Award is administered by Dublin City Public Libraries.

Prize: 100,000.

ISG (CILIP) / Nielsen BookData Reference Awards

CILIP (Chartered Institute of Library and Information Professionals)
7 Ridgmount Street
London WC1E 7AE
Phone: 020 7255 0500
Fax: 020 7255 0501
Email: info@cilip.org.uk
Web: www.cilip.org.uk

Since 1970, the Reference Awards have been recognising excellence; promoting awareness of outstanding reference books and products; encouraging quality; and setting industry standards.

The Awards are administered by CILIP's Information Services Group and sponsored by Nielsen BookData.

The Reference Awards consist of:

Besterman/McColvin Medals. Two medals for outstanding works of reference published in the UK – one for print and one for electronic formats.

The judges will assess the authority, scope and coverage, arrangement, and currency of the information, quality of indexing, adequacy of references, physical presentation, originality and value for money.

Prize: £500 and a prestigious golden medal.

Walford Award. The award is presented to an individual who has made a sustained and continual contribution to the science and art of bibliography in the UK. The nominee need not be resident in the UK.

Prize: £500 and a certificate.

The BBC Four Samuel Johnson Prize for Non-Fiction

Colman Getty PR
Middlesex House
34-42 Cleveland St
London W1T 4JE
Phone: 020 7631 2666
Fax: 020 7631 2699
Email: pr@colmangettypr.co.uk
Web: www.colmangettypr.co.uk/

The Samuel Johnson Prize was set up in 1998 as a major award for non-fiction. It was initially funded for a three year period by an anonymous benefactor. BBC Four will now sponsor the prize for the next three years.

The prize aims to reward the best of non-fiction, from biography, travel and popular science to the arts and current affairs. Authors of all non-fiction books published in the UK are allowed to enter, regardless of nationality.

Submission by publisher only.
Shortlist announced: May. Winner announced: June.
Prize: Winner receives £30,000; each of the shortlisted authors £1,000.

Mary Vaughan Jones Award

Welsh Books Council
Castell Brychan
Aberystwyth
Ceredigion SY23 2JB
Phone: 01970 62415
Fax: 01970 625385
Web: www.cllc.org.uk

This triennial award was established as a tribute to Mary Vaughan Jones, one of the main benefactors of children's literature in Wales. It is presented once every three years to a person who has made an outstanding contribution to children's books in Wales over a considerable period of time. The next award will be made in October 2006.

Prize: Silver trophy depicting characters from Mary Vaughan Jones's books.

Kelpies Prize

Floris Books
15 Harrison Gardens
Edinburgh EH11 1SH
Tel: 0131 337 2372
Fax: 0131 347 9919
Web: www.florisbooks.co.uk/

The Kelpies Prize has been set up to encourage and reward new contemporary Scottish writing for children. The Kelpies imprint has been in existence since the 1970s when it established a reputation as an outlet for Scottish writing and authors.

Manuscripts must be 40,000–60,000 words in length and not previously published (although the author may have been previously published). The story must be set in contemporary Scotland and should be suitable for both boys and girls aged 9-12. Authors do not need to live in Scotland to qualify. Open to all ages, professions and nationalities.

Closing date: February. Winner announced at Edinburgh International Book Fair in August.
Prize: £2,000.

Kiriyama Prize

Jeannine Cuevas, Prize Manager
650 Delancey Street, Suite 101
San Francisco CA 94107-2082
United States
Tel. +1 415 777 1628
Fax +1 415 777 1646
Email: info@kiriyamaprize.org
Web: www.kiriyamaprize.org

Rules and deadlines will vary slightly from year to year.

The purpose of the Kiriyama Prize is to promote outstanding books that will contribute to greater understanding of and among the peoples and nations of the Pacific Rim and South Asia. To be eligible, a book of fiction or non-fiction must relate in some significant way to the Pacific Rim or South Asia, to a particular culture or part(s) of these regions, or to people from these regions. Books submitted must be published in English. They may be works originally written in English or translations from any other language into English. Self-published books are not eligible. Full-length books of poetry by a single author are eligible and will be judged as fiction by the judges on the fiction panel. Authors may be citizens of any country and may reside anywhere but must be living at the time of closing date for entries. There are two separate panels of judges, one for fiction and one for non-fiction. Each panel consists of five judges.

Closing date: Entry forms must be received in October.
Winner announced: March.

The Kiriyama Prize is worth $30,000. It is divided equally between the winning author(s) in the fiction category and the winning author(s) in the non-fiction category.

The Prize is co-sponsored and administered by the Kiriyama Pacific Rim Institute (KPRI) within the Pacific Rim Voices series of projects.

Koret Jewish Book Awards

Koret Foundation
33 New Montgomery Street, Suite 1090
San Francisco, CA 94105
United States
Phone: +1 415 882 7740 x3
Fax: +1 415 882 7775
Web: www.koretfoundation.org

Koret Jewish Book Awards

The Koret Jewish Book Awards were established in 1998 by the Koret Foundation, in cooperation with the National Foundation for Jewish Culture, to help readers identity the most distinguished Jewish books published each year in the English language. There are five categories: biography, autobiography, and literary studies; children's literature; fiction; history; and philosophy and thought.

Books submitted for consideration to the children's literature category must be picture books. All forms of picture books — fiction, non-fiction, and poetry — are acceptable provided they are designed for young readers as the primary audience. Books will be judged on the basis of literary quality, illustration, and Jewish content. Author and illustrator will share the $10,000 equally, with $5,000 awarded to each.

Koret Jewish Book Awards are not restricted to authors who are citizens or residents of the United States.

Closing date: October. Finalists selected and notified: February. Winners selected and notified: March. Awards ceremony: April.

Prizes: $10,000 awarded to authors in each of the five categories.

Koret Young Writer on Jewish Themes Award

Established in 2001, this annually awards one emerging writer. Writers must be aged 40 and younger as of the application due date. Applicants cannot have more than one book published. Work submitted must be in the English language only; translations are eligible. Poetry, non-fiction, and fiction are eligible; scholarly work is not.

This award is not restricted to authors who are citizens or residents of the United States.

Closing date: November. Finalists selected and notified; December. Winner selected and notified: February. Awards ceremony: April.

Prize: $25,000 and the opportunity to spend a quarter as writer-in-residence at Stanford University. The residency allows time for writing, participating in and/or leading workshops on campus and within the Bay Area community; and the option of designing and teaching a course at Stanford.

The Kraszna-Krausz Book Awards

Andrea Livingstone
122 Fawnbrake Avenue
London SE24 OBZ
Phone: 020 7738 6701
Fax: 020 7738 6701
Email: k-k@dial.pipex.com
Web: www.editor.net/k-k

The KK Awards are made annually, with prizes for books on still photography alternating with those for books on the moving image (film, television, video). Entries in each year cover books published in the previous two years. The winning books are those which make original and lasting educational, professional, historical, technical, scientific, social, literary or cultural contributions to the field.

Submission by publisher only.
The next Book Awards for photography are in 2006.
Closing date: July. Winners announced: January.
Prize: £5,000 (for each category winner) and £1,000 special commendations.

The Lady Short Story Competition

The Lady
39-40 Bedford Street
London WC2E 9ER
Phone: 020 7379 4717
Emaiul: editors@lady.co.uk
Web: www.lady.co.uk

Details of the competition are published in the magazine. Usually announced in February but may vary.

Prize: £1,000.

Lakeland Book of the Year Awards

Cumbria Tourist Board
Ashleigh, Holly Road
Windermere
Cumbria LA23 2AQ
Contact: Sheila Lindsay
Phone: 015394 40416
Fax: 015394 44041

Several prizes are awarded but these vary from year to year. *The Hunter Davies Prize* is awarded to the overall winner, which is named Lakeland Book of the Year.

Closing date: March for books published previous year.
Winners announced: June.
Prize: £100 for each of the winning books, together with a certificate.

Lancashire County Library and Information Service

Children's Book of the Year Award
County Library Headquarters
PO Box 61
County Hall
Preston PR1 8RJ
Contact: Jake Hope (jacob.hope@lcl.lancscc.gov.uk)
Phone: 01772 534751
Fax: 01772 534880
Email: jacob.hope@lcl.lancscc.gov.uk
Web: www.cboy.lancashire.gov.uk

The Lancashire Children's Book of the Year Award is for a work of fiction for 12 -14 year olds, first published in the United Kingdom between September and the following August. Publishers nominate books and then pupils from across Lancashire read, evaluate and nominate a short list. The final judging panel is made up of representatives from each participating school. The young people for whom the books are written are the only judges for this award.

Shortlist announced: March. Winner announced: June.
Prize: £1000 and an engraved decanter.

Sponsored by The University of Central Lancashire.

Le Prince Maurice Award

Contact: Tim Lott, President
Email: tim@lott.freeserve.co.uk

The award is for literary love stories, and is alternately awarded to a French- and an English-speaking writer. The aim of the competition is to strengthen the cultural links between Mauritius and the outside world, mainly France and Great Britain, since Mauritius has a rich history influenced by both cultures.

2006 is France, and 2007 will be Great Britain.
Winner announced: May.

Prize: A two week writer's retreat at Le Prince Maurice in Mauritius for two with Air Mauritius flights.

Sponsor: Le Prince Maurice (Mauritius), Air Mauritius and others.

Legend Writing Award

Hastings Writers' Group
39 Emmanuel Road
Hastings TN34 3LB

The national Legend Writing Award was launched in 2001. It is organised by Hastings Writers' Group, founded in 1947, and one of the longest-running writers' groups in the country. This competition is for short stories and particularly aims to encourage new writers.

Entry is open to anyone resident in the United Kingdom who has not had a novel or book of short stories published. Entries must be the original work of the entrant and must not have been commercially published or broadcast, have won any previous national award or be entered for any other current competition. The award is for an open-theme short story, maximum 2,000 words. (Children's stories are excluded.) Entry Fee: £5.00.

Closing Date: 31st August
Prizes: 1 st – £500; 2nd – £250; 3rd – £100; three runners-up of £50.

Lettre Ulysses Award for the Art of Reportage

Frank Berberich, Esther Gallodoro
Elisabethhof Portal 3 b
Erkelenzdamm 59/61
D-10999 Berlin
Germany
Tel.: +49 30 30 87 04 52 / 61
Fax: +49 30 283 31 28
Email: lettre@lettre.de
Web: www.lettre-ulysses-award.org
Web: www.aventis-foundation.org

An annual award established in 2003. It was initiated by the cultural magazine *Lettre International* in cooperation with the Aventis Foundation. The Goethe-Institut is a project partner.

The aim of this first world prize for reportage literature is to draw international attention to the outstanding achievements of reportage literature worldwide, and to provide financial, moral and symbolic support to its authors.

It is awarded annually for the best pieces of literary reportage in the world, which were published within the preceding two years.

Prizes:

The Lettre Ulysses Award gives three cash prizes of: 50,000, 30,000, and 20,000. Additionally, the winner receives a Lettre Ulysses Trophy created by the artist Jakob Mattner.

Further Prizes:

The Goethe-Institut gives four Berlin sojourns to the other finalists.
The clock manufacturer Nomos/ Glashütte gives four hand-made clocks to the other finalists
Every short-listed candidate receives a translation of their texts into English to support their access to international media and publishing houses.

LIBBON Premier Competition

4 Nightingale Walk
Billingshurst RH14 9TY
Email: enquiries@libbon.co.uk
Web: www.libbon.co.uk

Libbon is a short story magazine publishing stories on a wide range of subjects – drama, humour, crime, science fiction, horror, fantasy, or even that story that defies categorisation.

UK residents can enter the competition either by post or online. Residents from outside the UK can enter the competition online. Each entry must be no longer than 2500 words and must be the original, unpublished work of the stated author. Entry fee: £3.00 per story.

Closing date: April 30th 2005.
Prizes: 1st – £100; 2nd – £50; 3rd – £25.
Winning story will be published in Libon in June 2005. All published entrants will receive one free copy of Libbon magazine.

Lichfield and District Writers Short Story Competition

L&DW Short Story Competition
133, Park Road
Barton-under-Needwood
Burton-on-Trent DE13 8DD

Entries must be in English, original, unpublished and no longer than 2,000 words. Any number of entries may be submitted.

Entry fee: £3 per first entry, £2 for each subsequent entry.
Closing Date: November. Winners announced: March.
Prizes: 1st – £125; 2nd – £75; 3rd – £25.

Lichfield Prize

Alison Bessey
Information Centre
Donegal House
Bore Street
Lichfield WS13 6NE
Phone: 01543 308169.
Email: alison.bessey@lichfielddc.gov.uk
Web: www.lichfield-tourist.co.uk

This biennial award is made to the best new novel set in the Lichfield District, Staffordshire. It is the only competition of its kind to be promoted by a local authority on a national basis. The Prize is supported locally by booksellers James Redshaw Ltd.

Open submission.
Closing date: April. Winner announced: July at Lichfield Arts Festival.
Prize: £5,000.

John Llewellyn Rhys Prize

Booktrust
Book House
45 East Hill
London SW18 2QZ
Phone: 020 8516 2977
Fax: 020 8516 2978
Web: www.booktrust.org.uk

The John Llewellyn Rhys Prize is Britain's second oldest and most prestigious literary awards. Entries may be any work of literature written by a British or Commonwealth writer under the age of 35 at the time of publication. Books must be written in English, and published in the UK during the year of the prize.

Submission by publisher only.
Closing date for entries: contact administrator.
Prize: £5000 to the winner and £500 to each of the shortlisted authors

Elizabeth Longford Prize for Historical Biography

The Awards Secretary
The Society of Authors
84 Drayton Gardens
London SW10 9SB
Phone: 020 7373 6642
Fax: 020 7373 5768
Email: info@societyofauthors.org
Web: www.societyofauthors.org

The Elizabeth Longford Prize for Historical Biography was established in 2003 in affectionate memory of Elizabeth Longford, the acclaimed biographer, and is sponsored by Flora Fraser and Peter Soros.

It is awarded annually for a historical biography published in the year preceding the prize.

No unsolicited submissions are accepted.
Prize: £3,000.

Longman History Today Awards

History Today
20 Old Compton Street
London W1D 4TW
Phone: 020 7534 8000
Fax: 020 7534 8008
Web: www.historytoday.com

The Longman-History Today Awards are made jointly by the publishers Longman and History Today magazine to mark links between the two organisations and to foster a wider understanding of, and enthusiasm for, history. Awards are made in the following categories:

Book of the Year

A prize of £1,000 is given for an author's first or second book, written in English, on any aspect of history. The winning books must contribute significantly to making its subject accessible and rewarding to the general reader of history, and display innovative research and interpretation in its field.

New Generation Book of the Year

A prize of £750 is given to the author of the book most likely to stimulate imaginative involvement in, and enthusiasm for, history in young people of secondary school age. Books must be written in English and can be on any aspect of history.

Historical Picture Researcher of the Year

A prize of £500 is given to a picture researcher whose work on a historical subject demonstrates originality, creativity, imagination, resourcefulness and involves a wide range of sources, working from a minimal suggestion list or directly from the text.

Macmillan Writer's Prize for Africa

Macmillan Oxford
Between Towns Road
Oxford OX4 3PP
Phone: 01865 405700
Fax: 01865 405701
Email: writersprize@macmillan.co.uk
Web: www.write4africa.com

The Macmillan Writer's Prize for Africa is a biennial competition devoted to previously unpublished works of fiction by African writers, and aims to promote and celebrate story writing from all over the continent.

The prize is sponsored by Macmillan Education and focuses on the reading interests of children and young people. There are two awards for children's literature and teenage fiction and an additional award for the best new children's writer.

Entrants may select freely from themes that they consider to be of interest and value to their intended readership but all stories should have a strong African flavour. The judges will assess each entry on the depth and originality of the work, the quality of the writing and the story's appeal to its audience. All entries must be original, unpublished works in English. Plays and poems are

not eligible. Entrants are not expected to illustrate their stories unless they wish to do so. This will not affect the assessment.

The competition is open to all nationals or naturalized citizens of countries throughout Africa and to those born in those countries.

Closing date: 30 June 2005.

The Macmillan Writer's Prize for Africa consists of the following awards:

Children's Illustrator Award

This is made in recognition of the importance of pictures in children's books. The winning entry, and runners up, will be displayed as part of the writer's award ceremonies in 2006. Macmillan will enter into separate discussions with the winning illustrator regarding further assignments in children's book illustration for Africa.

Entries will be assessed on quality of draughtsmanship, composition and consistency, as well as evidence of imagination and appeal to children. Entrants will be expected to illustrate in full colour a specified text (see website for details). The competition is open to those aged 18 and over who are naturalised citizens of any of the countries which make up the continent of Africa and to those who were born as citizens in those countries but now reside abroad.

Junior Award

For an unpublished story in English for children between the ages of 8 and 12. Length: Up to 8,000 words.

Senior Award

For an unpublished story in English for teenagers between the ages of 13 and 17. Length: 14,000 to 20,000 words.

New Children's Writer Award

In addition to the above, the prize provides for a Special Award for the most promising new children's writer. This will be awarded to a previously unpublished writer in either of the above categories.

Prizes: *Children's Illustrator Award*: $1,000; *Junior Award*: $5,000; *Senior Award*: $5,000; *New Children's Writer Award*: $3,000

Man Booker Prize for Fiction

Colman Getty PR
Middlesex House
34-42 Cleveland Street
London W1T 4JE
Phone: 020 7631 2666
Fax: 020 7631 2699
Email: sophie@colmangettypr.co.uk
Web: www.bookerprize.co.uk

The Man Booker Prize for Fiction is one of the world's most prestigious awards, and one of incomparable influence. The prize aims to reward the best novel of the year written by a citizen of the Commonwealth or the Republic of Ireland. The book must be a unified and substantial work. Neither a book of short stories nor a novella is eligible. No English translation of a book written originally in any other language is eligible; nor is a self-published book. All

entries must be published in the United Kingdom between the required dates but previous publication of a book outside the UK does not disqualify it.

The panel of judges is chosen by the Prize Advisory Committee, appointed by The Booker Prize Foundation. The Prize is administered by Colman Getty PR.

United Kingdom publishers may enter up to two full-length novels, with scheduled publication dates between October and September. In addition, any title by an author who has previously won the Booker or Man Booker Prize and any title by an author who has been shortlisted in the last ten years may be submitted.

The winner of the Man Booker Prize receives £50,000. Each shortlisted author will receive £2,500 in addition to a leather bound copy of his or her own book.

Closing dates: Entry forms: April, Books: July.

Marsh Biography Award

Katie Brock, Cultural Affairs Officer
The English-Speaking Union
Dartmouth House
37 Charles Street
London W1J 5ED
Phone: 020 7529 1550
Fax: 020 7495 6108
Email: katie_brock@esu.org
Web: www.esu.org

This biennial award is given for the best biography published during the two years preceding the award written by a British author and first published in the UK. Eligible biographies have to record valuable human achievement, be well researched and representative of the highest standards of written English.

Submission by publisher only.
Closing date: April. Winner announced: October.
Prize: £4,000 plus a silver trophy.

Kurt Maschler Award

Book Trust
Book House
45 East Hill
London SW18 2QZ
Phone: 020 8516 2977
Fax: 020 8516 2978
Email: tarryn@booktrust.org.uk
Web: www.booktrust.org.uk

This award is currently on hold.

(Annual award made to the author and illustrator of a children's book which combines excellence in both text and illustration.)

Somerset Maugham Awards

The Awards Secretary
The Society of Authors
84 Drayton Gardens
London SW10 9SB
Phone: 020 7373 6642
Fax: 020 7373 5768
Email: info@societyofauthors.org
Web: www.societyofauthors.org

Awarded each year to British authors under the age of 35 for a published work of fiction, non-fiction or poetry. The author must be a British by birth but not a national of "Eire or any of the British Dominions", and must be ordinarily resident in the UK. The work submitted must be a full-length book first published in Britain. It may be poetry, fiction, criticism, biography, history, philosophy, belles-lettres or a travel book. Dramatic works are not eligible.

Submision by publisher only.
Closing date: December.
Prize: £12,000 (shared).

The McKitterick Prize

Awards Secretary
The Society of Authors
84 Drayton Gardens
London SW10 9SB
Phone: 020 7373 6642
Fax: 020 7373 5768
Email: info@societyofauthors.org
Web: www.societyofauthors.org

Awarded for the best first novel by an author over the age of 40. Endowed by the late T.E.M. McKitterick.The author must not have had any other novel published (excluding works for children). The novel must be a full length work in the English language by one author (not a translation, and not a work for children). The work must be a work of 'fiction or imagination or substantially of fiction or imagination'. The work must either have been first published in the UK in the previous year (and not first published abroad), or be unpublished. If unpublished, it must not have been previously submitted for the McKitterick Prize.

Closing date: December.
Prize: £4,000.

Juliet McLauchlan Award

The Secretary
Joseph Conrad Society (U.K.)
c/o P.O.S.K.
238-246 King Street
London W6 ORF
Web: users.bathspa.ac.uk/conrad

An annual prize awarded by the Joseph Conrad Society (U.K.) for an essay on any aspect of the works and/or life of Joseph Conrad. The prize is dedicated to the memory of Juliet McLauchlan, a much loved Conradian and former Chair of the Society.

The essay competition is designed to foster work by new Conradians and emergent scholars, including undergraduates, postgraduates and independent scholars of any age, subject to the proviso that entrants should not have held a full-time academic appointment for more than three years. Essays must be original and not previously published, between 5,000 and 7,000 wordsand in English.

The essays will be judged by a panel of Joseph Conrad Society committee members. Winning and commended essays will be favourably considered for publication in *The Conradian*.

Closing date: April.
Prize: £200.

Enid McLeod Literary Prize

Franco-British Society
Room 623, Linen Hall
162–168 Regent Street
London W1R 5TB
Phone: 020 7734 0815
Fax: 020 7734 0815

This annual award is made to a book that contributes the most to Franco-British understanding, written in the English language and published in the UK during the calendar year preceding the year in which the award is presented.

Submission by author or publisher.
Closing date: December. Winner announced: Spring.

Mere Literary Festival

MLF Competition
Lawrences
Old Hollow
Mere
Warminster BA12 6EG
Web: www.merewilts.org.uk

Competition for a short story on any topic of not more than 2,500 words.
Entry fee: £4.00 per short story.

Closing date: July.
Prizes: 1st – £300; 2nd – £150; 3rd – £75.

MIND Book of the Year

MIND National Association for Mental Health
Granta House
15–19 Broadway
Stratford
London E15 4BQ
Phone: 020 8519 2122
Fax: 020 8522 1725
Web: www.mind.org.uk

An annual award for a work of fiction or non-fiction which deals with the experience of emotional distress in its widest interpretation, published in the year preceding the year in which the award is presented.

Submission by publisher only.
Closing date: December. Winner announced: May.
Prize: £1,000.

In 2004 the award was supported by the Independent on Sunday and Foyles Bookshops.

The Munster Literature Centre

26 Sullivan's Quay
Cork
Ireland
Email: munsterlit@eircom.net
Web: www.munsterlit.ie

The Sean O'Faolain Short Story Competition

An annual short story competition dedicated to one of Ireland's most accomplished story writers and theorists, sponsored by the Munster Literature Centre.

Open to original unpublished short stories in the English language of 3,000 words or less. The story can be on any subject, in any style by a writer of any nationality, living anywhere in the world who has not yet published a book-length work of adult fiction in the English language. You may make as many entries as you want.
Entry fee: 10, £10 stg, US$15, AU$18 or Can$16.

The winners will be announced at the International Frank O'Connor Festival of the Short Story in Cork in September 2005. The winners will be invited to read their prize winning stories at the festival.

Closing date: July 31st 2005.

1st Prize: 1,500 and publication in the literary biannual Southword.
2nd Prize: 500 and publication in Southword.
Four other shortlisted entries will be selected for publication in Southword and receive a fee of 50.

NASEN & TES Special Educational Needs Book Awards

The NASEN & TES Book Awards
Admiral House
66-68 East Smithfield
London E1W 1BX
Contact: Kerry Paige
Phone: 020 7782 3403
Email: kerry.paige@newsint.co.uk
Web: www.nasen.org.uk

The Awards have been created to recognise the authors and publishers of high quality books that inspire both children with special educational needs and their teachers. Awards are presented in three categories

The Special Educational Needs Children's Book Award
The Special Educational Needs Academic Book Award
The Books for Teaching and Learning Award

All books submitted for entry in any category must have been published in the UK in the 12 months prior to June. A maximum of three books per publisher.

Prize: £500 to the winning author of each category and to the publisher, a 1/4 page advertisement within The TES worth £1,200.

Bill Naughton Short Story Competition

Box No 2005
Aghamore
Ballyhaunis
County Mayo
Ireland
Web: www.aghamoregaa.com/society/shortstory.htm

Bill Naughton's success as a writer stems from his ability to appeal to a very broad spectrum of readers in a manner and style that can be easily understood. Priority is given to stories, which display qualities similar to those found in Bill Naughton's work. However, this rule is by no means exclusive.

Story can be on any topic chosen by the entrant. Maximum length of story is 2,500 words. All work must be unpublished

Entry Fee: £5.00, 7.00 or $8.00 per story . Three stories may be submitted for the price of two.
Closing date: 2nd September 2005.
Prizes: 1st – 200.00; 2nd – 130.00, 3rd – 65.00

NAWG Creative Writing Competition

The National Association of Writers' Groups
Head Office: The Arts Centre
Biddick Lane
Washington NE38 2AB
Web: www.nawg.co.uk

Categories for 2005

Free Verse Poem. Any subject. Maximum 40 lines.

Children's Poem. Any subject. Maximum 40 lines.

Poem using Rhyme. Any subject. Maximum 40 lines.

Open Short Story. Any subject. Maximum 1,500 words.

Fantasy/Sci-Fi Short Story. Maximum 1,500 words.

Children's Short Story. Any subject. Maximum 1,000 words.

One-Act Play. Any subject. Maximum ten minutes duration.

Article (not a personal reminiscence). Any subject. Maximum 1,500 words.

A Collection of Five Poems. Any subject. Maximum 40 lines per poem.

Denise Robertson Silver Trophy for the Best Group Anthology.

One entry only from each writers' group. Anthologies must not have been entered in this category before. This year entrants may also submit anthologies as a manuscript.

See website for submission details.
Closing date: 16th April. Shortlist: late July.

First prize in each category is an elegant engraved glass book in presentation box. Winners and runners-up receive a Certificate. Highly Commended and Commended also receive a Certificate.

Nestlé Smarties Book Prize

Book Trust
Book House
45 East Hill
London SW18 2QZ
Phone: 020 8516 2977
Fax: 020 8516 2978
Email: tarryn@booktrust.org.uk
Web: www.booktrust.org.uk

The Nestlé Smarties Book Prize was established in 1985 by Booktrust and is sponsored by Nestlé. It seeks to find the nation's best children's books to inspire and develop literacy skills for children under eleven in a fun and educational context. The awards are made to works of fiction or poetry for children written in English by a UK citizen, or an author resident in the UK. Books must have been published between October and the following September. A panel of adult judges chooses a shortlist of books in three age categories (under 5, 6-8 and 9-11), submitted by publishers. In September, school children across the UK are invited to enter a competition to become Young Judges, who will decide which books will receive the Gold, Silver and Bronze awards in each age category.

Submission by publisher only.
Closing date: July.
Prize: £2,500 (Gold), £1,000 (Silver) and £500 (Bronze).
All shortlisted books (chosen by adults) win prizes – Gold, Silver or Bronze – in their age category.

The New Writer

The Prose and Poetry Prizes
PO Box 60
Cranbrook TN17 2ZR.
Phone: 01580 212626
Fax: 01580 212041
Email: editor@thenewwriter.com
Web: www.thenewwriter.com

Short Stories – Up to 4,000 words and serials/novellas up to 20,000 words on any subject or theme, in any genre (not children's). Previously published material is not eligible for entry. Entry fees: £4 per short story or £10 per serial/novella.

Prizes: 1st – £300; 2nd – £200; 3rd – £100; Novella: 1st prize £300.

Essays, articles and interviews – Up to 2,000 words covering any writing-related or literary theme in its widest sense. Previously published material is not eligible. Single entry £4 (TNW subscribers two entries at same fee).

Prizes: 1st – £150; 2nd – £100; 3rd – £50.
Closing date: October.

Nobel Prize for Literature

The Swedish Academy
Box 2118
S-10313 Stockholm
Sweden
Phone: +46 8 10 65 24
Fax: +46 8 24 42 25
Email: sekretariat@SvenskaAkademien.se
Web: www.nobel.se

The nobel laureate in literature is chosen annually each Autumn by The Swedish Academy.

NOMA Award for Publishing in Africa

Mary Jay
Secretary to the Noma Award Managing Committee
The Noma Award
PO Box 128
Witney OX8 5XU
Tel: 01993 775 235
Fax: 01993 709 265
Email: maryljay@aol.com
Web: www.nomaaward.org

The Pan-African annual $10,000 prize for an outstanding book published in Africa. Established in 1979, the Noma Award is open to African writers and scholars whose work is published in Africa. The prize is given annually for an outstanding new book in any of these three categories: scholarly or academic; books for children; literature and creative writing (including fiction, drama,

poetry, and essays on African literature). Books are admissable in any of the languages of Africa, both local and European.

The annual $10,000 Noma Award is open to African writers and scholars whose work is published in Africa, rather than outside. The spirit within which the Award is given is to encourage and reward genuinely autonomous African publishers, and African writers.

Works submitted must have been published (regardless of its place of manufacture) by a publisher domiciled on the African continent or its offshore islands.

Closing date: Usually February.
Sponsor: The Award is sponsored by Kodansha Ltd, Japan.

Northern Rock Foundation Writer's Award

New Writing North
2 School Lane
Whickham
Newcastle upon Tyne NE16 4SL
Phone: 0191 488 8580
Fax: 0191 488 8576
Email: mail@newwritingnorth.com
Web: www.nr-foundationwriters.com

New Writing North, in partnership with The Northern Rock Foundation, launched the Northern Rock Foundation Writer's Award in 2002.

The Northern Rock Foundation Writer's Award is unlike most other awards and prizes in that it supports the creative work of an individual writer over a substantial length of time rather than giving recognition to just one book retrospectively.

The organisations created an award which offers unparalleled 'life support' for writers at the level of £20,000 a year for a three-year period, making the award worth a total of £60,000. The award is currently the largest literary award in the UK and the only one which is dedicated to supporting regional achievement.

The award was created with the recognition that many published writers have to undertake a variety of other work to support their creative writing. This award offers the chance for writers to be liberated from other work commitments that may limit their writing time. The award honours literary achievement and supports writers to maximise their creativity.

The award will be made to the most outstanding application from a writer based on the literary merit of the work that is submitted and on the quality of the writer's previous published work. The Northern Rock Foundation Writer's Award is worth £60,000. This amount is payable over three years at a rate of £20,000 a year.

The following criteria apply:

You must live and work in Tyne and Wear, the Tees Valley, County Durham, Northumberland or Cumbria and have done so for at least three years.

You must be a writer of poetry, prose, children's fiction or biography and have a track record of publication with a recognised publisher. (Work published by independent presses which is available nationally qualifies.)

You must have published at least two novels, collections of poetry, short stories or biography. (Please note that previous published work that is not literary in nature does not count.)

See website for how to apply.
Deadline for receipt of applications: end of January.

Northern Writers' Awards

New Writing North
2 School Lane
Whickham
Newcastle upon Tyne NE16 4SL
Phone: 0191 488 8580
Fax: 0191 488 8576
Email: mail@newwritingnorth.com
Web: www.newwritingnorth.com

These awards support writers of poetry, prose and non-fiction who live and work in the north east of England (Tees Valley, Tyneside, County Durham and Northumberland). The awards are made by an independent panel of judges which is chaired by Claire Malcolm, director of New Writing North.

Writers can apply for support in one of the two categories:

Time to Write Awards (awards up to £5,000)

These awards are aimed at supporting established writers to complete work in progress on new books or to spend time developing a direction for their writing work (ie, moving from poetry to prose). The awards 'buy time' for writers to write away from other distractions. To enter, writers must have published at least one book with a national publisher.

Northern Promise Awards (awards packages up to £2,000)

These awards are aimed at identifying and supporting writers whose work is not yet fully published but who the panel thinks are deserving of support. To enter writers must be able to demonstrate that they are serious about developing a career as a writer, either by having had work published in magazines or via other project work. Selected writers are offered a package of a cash award plus support to develop their work towards publication via mentoring, contact with professionals or other editorial support.

See website for how to apply.
Closing date: end January.

New Writing North awards two further prizes:

The Andrea Badenoch Fiction Prize

Andrea Badenoch was a gifted novelist who lived in Newcastle, and who produced four novels in the last few years of her life. Andrea was at the peak of her literary career when she died of breast cancer in 2004, and this prize seeks to commemorate her literary ability and her achievement as a writer.

You may enter for the award if you meet the following criteria: You live and work in Tyne and Wear, the Tees Valley, County Durham or Northumberland and have done so for at least one year. You are a writer of prose or children's fiction. You are 42 years old or older and a woman.

See website for application details.

The Waterhouse Award

The poet Andrew Waterhouse died in October 2001. He was a poet of enormous promise whose work had just started to garner great acclaim following the success of his first collection In (Rialto), which won the Waterstones/Forward First Collection prize. He also received a Northern Writers' Award in 2000. In 2002 New Writing North created a special award in Andrew's memory.

The Waterhouse Award will be given as a special title to a winning writer from each year of the Northern Writers' Awards.

Nuclear Age Peace Foundation

PMB 121
1187 Coast Village Road, Suite 1
Santa Barbara, CA 93108-2794
United States
Phone: +1 805-965-3443
Fax: +1 805-568-0466
Web: www.wagingpeace.org

The Swackhamer Peace Essay Contest

This is an annual international high school essay contest answering topical questions related to global peace and security.

Eligibility: Open to all high school students throughout the world. Applicants must be enrolled in the Autmn to Spring of the academic year.

Topic: Our vision is a world at peace, free from the threat of war and free of weapons of mass destruction. Translate this vision into an action plan that you can implement in your community or on your campus. Write a proposal for a youth-led event, campaign, or project that educates members of your community and/or other students concerning the continuing threat of nuclear weapons and the need for nuclear disarmament.

Awards: The top three winners will each receive a $1,000 award to implement their proposal. In total, $3,000 in prizes will be awarded.
Closing date: 1st June 2005.

Orange Prize for Fiction

Book Trust
Book House, 45 East Hill
London SW18 2QZ
Phone: 020 8516 2977
Fax: 020 8516 2978
Contact: Tarryn McKay
Email: tarryn@booktrust.org.uk
Web: www.orangeprize.com.

The Orange Prize for Fiction celebrates excellence, innovation and accessibility in women's writing. The Prize was set up in 1996 to celebrate and promote fiction by women throughout the world to the widest range of readers possible and is awarded for the best novel of the year written by a woman. Any

woman writing in English – whatever her nationality, country of residence, age or subject matter – is eligible. Translations of books originally written in other languages are not eligible.

Final date for entries: contact administrator
Longlist: March. Shortlist: May. Winner announced: June
Prize: £30,000 and a bronze figurine.

Orwell Prize

8a Bellevue Terrace
Edinburgh EH7 4DT
Phone: 0131 557 2517

The George Orwell Memorial Fund and the editors of *The Political Quarterly* will award £1,000 to each of two writers who are judged to have best achieved George Orwell's aim.

The prizes are to encourage good writing about politics, whether in non-fiction or fiction, about or associated with political and moral dilemmas, problems and ideas which raise issues of public policy or political concern construed in the broadest sense (including social and cultural concerns). Writing must be of a kind that is aimed at or accessible to the reading public rather than for specialist or academic audiences, and submissions should be of equal excellence in style and content.

No restriction on age or nationality, but the author must normally be resident in Great Britain or Ireland.

The two categories are:

- *A book or pamphlet*
- *Newspaper and/or periodical articles, features or columns, or sustained reportage on a theme.*

Closing date: January.
Prize: £1,000 (for each category winner).

Pencil Short Story Competition

Pencil
Beach
Bantry, West Cork
Ireland
Email: info@pencilshortstory.com
Web: www.pencilshortstory.com

Stories may be based on any subject but must not exceed 2,500 words. Entrants may submit an unlimited number of stories provided they are accompanied by the appropriate fee. Entries must by typewritten and can be submitted via email. All stories must be the original work of the author and must not be previously published. Stories must be in the English language. Entry fee: 10 per story .

Closing date: 31st of October. Winners notified: December.
Prizes: 1st – 300; 2nd – 150; 3rd – 50.

Samuel Pepys Award

Email: robingain@yahoo.co.uk
Web: www.pepys-club.org.uk

A biennial award (2005/07) given to the book which, in the opinion of the judges, makes the greatest contribution to the understanding of Pepys, his times or his contemporaries in the interest of encouraging scholarship in this area.

Prize: £2,000 plus a specially cast silver medal.
Sponsor: The Samuel Pepys Award Trust.

The Ben Pimlott Prize for Political Writing

Ben Pimlott Essay Prize
The Fabian Society
11 Dartmouth Street
London SW1H 9BN.
Web: www.fabian-society.org.uk

The Fabian Society and *The Guardian* have launched a political writing prize in memory of Ben Pimlott, leading Fabian thinker and political historian. The prize is for a biographical sketch of any figure, past or present, which best illustrates the political challenges of our age.

The theme for 2005 was political biography. Maximum of 3,000 words.

Closing date: March.
Prize: £3,000.
The winning essay is published in *Guardian Review*.

Portico Prize

The Portico Library
57 Mosley Street
Manchester M2 3HY
Phone: 0161 236 6785
Fax: 0161 236 6803
Web: www.theportico.org.uk

This biennial award is made to a book of general interest and literary merit set wholly or partly in the North West of England. Entries must have been published in the two years prior to April of the year in which the award is presented. The next award will be made in 2006.

Submission by publisher only.
Prize: £3,000.

Mathew Prichard Award for Short Story Writing

The Competition Secretary
The Mathew Prichard Award
2 Rhododendron Close
Cyncoed
Cardiff CF23 7HS
Web site: www.samwaw.org.uk

Entries must be in English. Maximum 2,500 words. Submissions must be the entrant's own work, not have won any prize nor be entered for any other competition or submitted for publication prior to the adjudication date.

Entry Fee: £5.00 per Script (£4.00 for SAMWAW Members). Competitors may submit any number of entries, but no competitor may win more than one prize.

Prizes: 1st – £1,000; 2nd – £600; 3rd – £300; 4th – £100.
Closing date: 28th February.

The V.S. Pritchett Memorial Prize

Royal Society of Literature
Somerset House
Strand
London WC2R 1LA
Phone: 020 7845 4676
Fax: 020 7845 4679
Email: info@rslit.org
Web: www.rslit.org

Established in 1999, this annual prize is awarded for an unpublished short story of between 2,000 and 5,000 words. It is supported by Chatto & Windus, V.S. Pritchett's publishers. Open to residents and citizens of Great Britain and the Republic of Ireland.

Closing date: April.
Prize: £1,000.

Pulitzer Prizes

The Pulitzer Prize Board
709 Journalism, Columbia University
New York NY 10027
United States
Phone: +1 212 854 3841
Web: www.pulitzer.org

Awarded for journalism in US newspapers, and for published literature, drama and music by American nationals. (21 categories)

The Michaelis-Jena Ratcliff Prize

Mrs Tabitha Bell
Drummond Miller, W.S.
31/32 Moray Place
Edinburgh EH3 6BZ
Phone: 0131 226 5151
Fax: 0131 225 2608
Email: tbell3@drummond-miller.co.uk

Established through an endowment by the late Ruth Michaelis-Jena (Mrs. Ratcliff) and awarded annually for an important contribution by an individual to the study of Folklore or Folklife. The ambit of Folklore and Folklife will be interpreted broadly. It may include aspects of oral history and community studies, for example, and relate to urban, industrial and technological as well as to rural and maritime material. Tradition and change should be taken into account. The prize is open to all individuals making a substantial contribution to research into the subject. Entries should be of about 80,000 words upwards.

The present prize is £3,000, which will be increased as the fund grows. Contact the prize administrators for application forms and detailed guidelines.

Closing date: 31 December.
Prize: £3,000.

Real Writers Short Story Awards

Real Writers
PO Box 170
Chesterfield S40 1FE
Phone: 01246 520834
Fax: 01246 520834
Email: info@real-writers.com
Email: RealWrtrs@aol.com
Web: www.real-writers.com

Full details appear on the website and paper entry forms are available in the early summer. On-line entry facility. No restrictions except that stories should be unpublished.

Closing date: 30 November.
Prize: £2,500 and 10 regional awards.
In 2004 the awards were sponsored by Time Warner Books

The Red House Children's Book Award

The Federation of Children's Book Groups
2 Bridge Wood View, Horsforth
Leeds LS18 5PE
Phone: 0113 2588910
Fax: 0113 2588920
Web: www.redhousechildrensbookaward.co.uk

Submissions of titles and enquiries:
Contact: Marianne Adey, National Co-ordinator

The Old Malt House
Aldbourne
Marlborough SN8 2DW
Phone: 01672 540629
Fax: 01672 541280
Email: marianneadey@aol.com

The Red House Children's Book Award, formally The Children's Book Award, established in 1980, is a project owned and co-ordinated by The Federation of Children's Book Groups, a registered charity. The FCBG acts as an umbrella organisation for the autonomous book groups in 32 regions across the UK. It is in these book groups that the initial reading and rating of books submitted for the award is done in order to create a shortlist of ten books that children can vote on.

The RHCBA is awarded in three categories – Books for Younger Children, Books for Younger Readers and Books for Older Readers.

Romantic Novelists' Association

c/o 38 Stanhope Road
Reading RG2 7HN
Email: enquiries@rna-ok.org
Web: www.rna-uk.org

Romantic Novel of the Year

This is the major award of the Association. Previously known as The Parker Romantic Novel of the Year it is now known as The Foster Grant Romantic Novel of the Year. Novels entered must have been first published in the UK. The winner, chosen from a shortlist of six, receives a £10,000 prize.

RNA Romance Prize

The First Award of £1,000 was made in April 2003. Category romances are short romances with a strong emphasis on the central relationship, usually published in a recognisable format, several books of similar type and length being published every month, or serials in magazines.

Eligibility: The Award is for a book, in English, or magazine serials. Books published electronically shall be eligible only if published in paper format during the appropriate year.

The minimum length is 30,000 words. The book must be submitted by the author, who must be a current member of the RNA. Only one title per author may be submitted in any one year. The same title may not be entered for the RNA Major Award or the New Writer's Award in any one year. Entry fee: £5.

New Writers' Award

The RNA have run their New Writers' Scheme to encourage fresh talent in the world of women's fiction since 1962. The purpose of the scheme is to encourage the writing of broadly romantic novels that reflect all aspects of love and life, contemporary or historical. Any unpublished author of adult fiction which reflects this remit may join the the RNA as a new writer and submit a manuscript to the Scheme.

The award is generously sponsored by Dr David Hessayon, in honour of his late wife Joan, a longstanding member of the RNA and a great supporter of the New Writers' Scheme.

Royal Literary Fund Fellowship Scheme

Royal Literary Fund
3 Johnson's Court,
London EC4A 3EA
Contact: Steve Cook, Fellowship and Education Officer
Phone: 020 7353 7160
Email: rlitfund@btconnect.com
Web: www.rlf.org.uk

The Royal Literary Fund's Fellowship scheme for writers was launched in autumn 1999 and is based mainly in UK universities and higher education colleges. RLF Fellows are established professional writers of literary merit, representing a wide range of genres, including biography, translation and scientific writing. In its first five years, the network of posts has reached every part of mainland Britain, involving old and new universities and departments in science and technology as well as in the humanities.

The scheme is intended to place professional writers in higher education institutions to offer writing support to all students. The principal aim of the Fellow's work is to foster good writing practice across all disciplines and media. Each post is hosted by a particular department. This may be an academic department/faculty (either in the Arts or in the Sciences) or a central 'service' department (such as the learning support centre or careers office).

Enquiries are welcomed at any time during the year. If your enquiry coincides with a recruitment round, you will be sent an application pack immediately and advised of relevant deadlines. Otherwise, your name and address will be held on file until recruitment re-opens. Application packs are not usually available between late April and late November.

In most years there are two recruitment rounds which open in late November. Deadline for the first round is usually mid January for posts beginning in the autumn of the same year. The second round usually closes late April for posts beginning in the autumn of the following year (ie: 18 months later).

To obtain an application pack, write to the Fellowship Officer. Eligibility and terms and conditions are detailed on the website.

The Royal Society of Literature / Jerwood Awards for Non-Fiction

The Royal Society of Literature
Somerset House
London WC2R 1LA
Contact: Paula Johnson
Phone: 020 7845 4676
Email: paulaj@rslit.org
Web: www.rslit.org

The Royal Society of Literature and the Jerwood Charitable Foundation present three awards for authors engaged on their first major commissioned works of non-fiction.

For the next three years, they will be making three annual awards, one of £10,000 and two of £5,000, to writers working on substantial projects. The awards are open to all areas of non-fiction.

Writers who are UK or Irish citizens, or who have been resident in the UK for

at least three years, are invited to send in applications. See website for further details.

The Royal Society of Literature Ondaatje Prize

The Royal Society of Literature
Somerset House
Strand
London WC2R 1L.
Contact: Paula Johnson
Phone: 020 7845 4676
Fax: 020 7845 4679
Email: paula@rslit.org
Web: www.rslit.org

The prize replaces the Royal Society of Literature's Winifred Holtby Prize for fiction of a regional character. It aims to carry on the Holtby tradition of choosing outstanding winners, often early in their careers, such as Kazuo Ishiguro and Hilary Mantel, both previous Holtby winners.

The Royal Society of Literature Ondaatje Prize is an annual award of £10,000 for a distinguished work of fiction, non-fiction or poetry, evoking the spirit of a place.

Any full-length work of fiction or non-fiction, or volume of poetry, which evokes the spirit of a place, and which is written by a citizen of the Commonwealth or the Republic of Ireland, is eligible. Such a book must be a unified and substantial work. Collections of short stories, novellas or children's books are ineligible. Books originally written in another language, and translated into English, are not eligible.

Each publisher, or imprint of a publisher, may enter one book published, or due to be published, within the calendar year. A short-list will be announced in May.

Submissions from October 18th 2005.

Runciman Award

The Anglo-Hellenic Society
16-18 Paddington Street
London W1M 4AS
Phone: 020 7486 9410

Awarded annually, in honour of the late Sir Steven Runciman, to a book about Greece or the Hellenic scene, published in the UK during the year preceding the year in which the award is presented. The award may be given for a work of fiction, drama or non-fiction; concerned academically or non-academically with the history of any period, biography or autobiography, the arts, archaeology; a guide book; or a translation from the Greek of any period.

Submission by publisher only.
Shortlist announced: February. Winner announced: Summer.
Award: £5,000.

Saga Award for Wit

Administration contact:
Victoria Tunberg
Belinda Harley Associates
22 South Audley Street
London W1K 2NY
Phone: 020 7499 4979
fax: 020 7499 4068
Email: info@belindaharley.com

Sponsored by *Saga Magazine* the award is for wit and humour in contemporary British writing. The prize aims to recognise the work of older writers in the tradition of Waugh, Wodehouse, Alan Bennett and Keith Waterhouse.

Fiction and non-fiction are eligible, but the author must have been aged over 50 when the book was published. Non-fiction can include travel writing, biography, memoirs and autobiography, and collected essays and journalism. Not eligible: on-line books, translations and self-published books.

Publishers may submit up to four titles.
Closing date: July. Shortlist announced: August. Winner announced: September.
Prize: £20,000. Authors of shortlisted titles receive £1,000.

Sagittarius Prize

The Awards Secretary
The Society of Authors
84 Drayton Gardens
London SW10 9SB
Phone: 020 7373 6642
Fax: 020 7373 5768
Email: info@societyofauthors.org
Web: www.societyofauthors.org

Awarded for the best first published novel by an author over the age of 60. The author must not have had any other novel published. The work must be a full length adult novel in English by one author (not a translation). The work must have been first published in the UK.

Submission by publisher only.
Closing date: December. Winner announced: Spring.
Prize: £4,000.

Saltire Society Literary Awards

The Saltire Society
9 Fountain Close
22 High Street
Edinburgh EH1 1TF
Email: saltire@saltiresociety.org.uk
Web:www.saltiresociety.org.uk
Phone: 0131 556 1836
Fax: 0131 557 1675

The Saltire Society has two literary awards: Scottish Book of the Year and Scottish First Book of the Year (by an author who has not previously published a book). They may be given for any book by an author or authors of Scottish descent or living in Scotland, or for any book which deals with the work or life of a Scot or with a Scottish question, event or situation. The book might be poetry, a novel, a play or other work of imaginative literature, or biography, literary criticism or a study of any Scottish issue. Books of multiple authorship would not normally qualify.

The selection procedure: The Literary Editors of leading Scottish newspapers and the editors of magazines and reviews in Scotland concerned with literature, are invited to nominate titles for the Award which, in their view, merit consideration for the Award from among the books reviewed in their pages during the preceding twelve months.

The Mona Schreiber Prize for Humorous Fiction and Non-Fiction

11362 Homedale Street
Los Angeles, CA 90049
United States
Web: www.brashcyber.com

Annual prize. Humour is subjective. Uniqueness is suggested. Weirdness is encouraged. Writers of comedic essays, articles, short stories, poetry, shopping lists and other forms are invited to submit.

Works up to 750 words in length. Entry fee: $5. No limit to entries but each must have a separate fee.

Closing date: 1st December for a December 24th announcement.
Prizes: 1st – $500; 2nd – $250; 3rd – $100.

The Scotsman & Orange Short Story Award

PO Box 105
Edinburgh EH8
Web: thescotsman.scotsman.com

2005 is the second year of the prize.

A short story up to 3,000 words long. The theme for 2005 is *Secrets* and stories should be loosely based around the word.

Only one entry per person. Stories should be a maximum of 3,000 words. Entries will be accepted from those born in Scotland, Scottish residents and Scots living abroad. Stories submitted must not have been previously submitted to any other competition. Scotsman Publications reserves the right to publish articles or extracts written by competition entrants in The Scotsman, and entrants must be willing to have their story printed in the short collection.

Closing date: January. Winners will be announced in *The Scotsman* in April.

Prizes: The overall winner will receive £7,500 and a trip to the Orange Prize for Fiction Awards ceremony.

Five runners-up will each receive £500.

Further payments will be made to the writers of the best 20 stories which will be published in a collection, *North*. The book is supported by the Scottish Arts Council and will be promoted in Ottakar's book stores throughout Scotland.

The winners and runners-up will be presented with prizes at an awards ceremony in Edinburgh.

Scottish Arts Council Children's Book Awards

Scottish Arts Council
12 Manor Place
Edinburgh EH3 7DD
Contact: Jenny Brown, Literature Department
Phone: 0131 226 6051
Fax: 0131 476 7050
Email: jenny.brown@scottisharts.org.uk
Web: www.sac.org.uk

Awarded to work by a Scottish writer or illustrator, or to a book with a strong Scottish interest. Books published between January and December in the previous year are eligible for an award.

Submission by publisher only.
Closing date: End of January. Winners announced: April.
Prize: £1,000 to each winner (up to three awards are made).

Sheffield Children's Book Award

Book Award Project Team
c/o Schools Library Service
The Bannerdale Centre
125 Carter Knowle Road
Sheffield S7 2EX
Phone: 0114 2506843
Fax: 0114: 2506841
Email: jennifer.wilson@sheffield.gov.uk
Web: www.sheffieldchildrensbookaward.org.uk/

The Sheffield Children's Book Award began in 1988, and was initiated to increase children's knowledge and access to the very best children's literature.

There are three categories: picture book, shorter novels, longer novels.

Each school selects the most appropriate Book Category for the class and receive a start up pack of ideas along with a collection of books to read and review. Each child is asked to vote for their favourite title and these votes are then collated over the summer. All children involved in the project are invited to the Award Ceremony along with all Shortlisted Authors, Illustrators and representatives from the Publishing Houses.

WH Smith Literary Award

Web: www.whsmith.co.uk

The WHSmith Literary Award has been awarded since 1959 – it celebrates good books from all genres of literature, and is given to the book that, in the opinion of the panel of judges, has made the most outstanding contribution to literature in the year under review.

Nominations are made by the judges.
Prize: £10,000.

Soho Theatre and Writers' Centre

21 Dean Street
London W1D 3NE
Administration: 020 7287 5060
Fax: 020 7287 5061
Email: mail@sohotheatre.com
Web: www.sohotheatre.com

The Verity Bargate Award

National playwriting competition for new writers. The Verity Bargate Award was established by Soho Theatre Company in 1982 to honour the memory of the company's co-founder. The Award is presented biennially to identify and celebrate the most outstanding new play by an emerging playwright.

The Award is open to any writer resident in the British Isles and Republic of Ireland and writers may submit one unproduced, unpublished full-length play.

The next Verity Bargate Award will be in 2006.

Prize: £3,500, a residency at the Soho Theatre and the opportunity to have your play staged in the heart of London's West End.

The Westminster Prize

In 2005 the Westminister prize was for a ten minute play based on a supplied photograph.

It is open to people of any age who live, work or study in the borough of Westminster being supported by the City of Westminster and Getty Images.

Prizes: 1st – £150 in theatre tokens; 2nd – £100 in theatre tokens; 3rd – £50 in theatre tokens.

See website for next round.

The Sunday Times National Student Drama Festival

NSDF
D14, Foxhole Centre
Dartington
Totnes TQ9 6EB
Phone: 01803 864836
Fax: 01803 847711
Email: admin@nsdf.org.uk
Web: www.nsdf.org.uk

PMA Writer's Award

The Personal Management Association, supported in alternate years by The Peggy Ramsay Foundation (subject to renewal in 2005) offers the PMA Writer's Award of £2,000 for a promising, non-established writer of a new play entered for, but not necessarily performed at, the annual NSDF.

The Sunday Times Playwriting Award

Awarded by Festival judges to the best new script performed at the annual NSDF.

International Student Playscript Competition

This goes to the best new script entered for the International Student Playscript Competition

Details and entry form can be downloaded from the NSDF website in the Awards section.

The Sunday Times Small Publisher Award

Independent Publishers Guild
PO Box 93
Royston SG8 5GH
Phone: 01763 247014
Fax: 01763 246293
Email: info@ipg.uk.com
Web: www.ipg.uk.com

This Award is no longer run, but the Independent Publishers Guild has announced that for 2006 they will be running a new Awards scheme which will be open to all independent publishers. There will be six categories; trade, academic, children's, education, innovation of the year, and multicultural.

For further information contact the IPG at the address above.

The Sunday Times Young Writer of the Year

Awards Secretary
The Society of Authors
84 Drayton Gardens
London SW10 9SB
Phone: 020 7373 6642
Fax: 020 7373 5768
Email: info@societyofauthors.org
Web: www.societyofauthors.org

Awarded for a full-length published work of fiction, non-fiction or poetry by an author under the age of 35, who must be a British citizen and ordinarily resident in Britain. The work must be by one author in the English language, and must have been first published in Britain in the year of the prize.

Closing date: 31st October.
Prize: £5,000.

Swanwick Competition

Writers' News Ltd
First Floor, Victoria House
143-145 The Headrow
Leeds LS1 5RL
Web: www.wss.org.uk

A free place at the 2005 Swanwick Writers' Summer School (worth £340) is the first prize in each of three writing competitions, organised by the School, in association with Writers' News.

Short story competition – for stories up to 1,000 words on any subject or theme. This competition is open to any previously unpublished writer. First prize is a free place at Swanwick (provided by the Writers' Summer School) plus a Writers' News trophy.

Children's writing competition – entrants submit the first 1,000 words of a novel aimed at a readership in the age range of 7 to 12 years. Open to anyone who has earned less than £5,000 from children's writing in the last two years. First prize is a free place at Swanwick (provided by The Hayes Conference Centre – venue for the Summer School) plus a special Writers' News trophy.

Non-fiction writing competition – entrants submit an 800 word synopsis for a non-fiction book on any subject. Open to any writer who has not had a non-fiction book published. First prize is a free place at Swanwick (provided by Writers' News) plus a special Writers' News trophy.

In each competition, the second prize is writing books to the value of £100 and third prize a £25 book voucher. The first-prize winners of the first two competitions will also be considered for publication in *Writing Magazine*.

Closing date: 9th May.

Theakston's Old Peculier Crime Novel of the Year

Festival Office
1 Victoria Avenue
Harrogate HG1 1EQ
Administration: 01423 562303
Fax: 01423 521264
Email: crime@harrogate-festival.org.uk
Web: www.harrogate-festival.org.uk/crime

2005 is the inaugural year of the award. The Theakston's Old Peculier Prize will celebrate the broad spectrum of crime fiction and is the only crime fiction award voted for by readers. It is awarded to the best crime or mystery novel of the year. A longlist of titles will be drawn up by the staff of Ottakar's Bookshops in April; a public vote will whittle this down to a shortlist of six in June and the winner will be announced at the opening night of the Festival in July.

Prize: £3,000.
Sponsor: Theakston's Old Peculier.

Theatre Book Prize

Society for Theatre Research
c/o The Theatre Museum
1E Tavistock Street
London WC2E 7PA
Email: e.cottis@btinternet.com
Web: www.str.org.uk

To mark the occasion of its Golden Jubilee in 1998 the Society decided to sponsor an annual Theatre Book Prize, with the first award being made in 1998. The award is made to books of original research into any aspect of the history and technique of the British theatre. Eligibility is confined to books in English but not restricted to authors of British nationality nor to books solely from British publishers. Contact administrator for further information.

Short list announced: February. Winner announced: April.
Prize: £400.

The David St John Thomas Charitable Trust Awards

David St John Thomas Charitable Trust
PO Box 6055
Nairn IV12 4YB
Phone: 01667 453351
Email: dsjtcharitynairn@fsmail.net
Web: www.writersnews.co.uk

The David St John Thomas Charitable Trust in association with *Writers' News* runs a number of competitions. The Trust's aim is to give pleasure and to stretch the ability of writers early in their careers. The competitions offer guaranteed publication of winning entries with a critique.

See Writers' News website for further details.

The Dylan Thomas Prize

Dylan Thomas Centre
Ty Llen
Somerset Place
Swansea SA1 1RR
Phone: 01792 474051
Email: info@thedylanthomasprize.com
Web: www.dylanthomas.org

The Dylan Thomas Literary Prize, a major new international award, rewards writing in English by authors under 30 from anywhere in the world. The inaugural Prize was simultaneously launched in Swansea, the birthplace and inspiration of Dylan, and New York in 2004. The first prize will be awarded at the Dylan Thomas Literary Festival in Swansea in September 2006.

This biennial literary prize of £60,000 will be awarded to the most outstanding literary talent, age under 30 at the launch date, writing a published work in the English language. The prize is funded through a rare combination of public, corporate and private sponsorships.

The prize will be awarded to the single author, who in the opinion of the judges, has written either the best eligible commercially published original volume of English language poetry, prose, fictional drama, collection of short fictional stories, fictional novel or novella ('a Literary Work').

Entries are to be submitted by international and UK publishers on behalf of eligible authors using the prescribed entry form and are to be accompanied by an entry fee of £100.

Closing date: 1st March 2006.
Winner announced in Swansea on 27th October 2006.
Prize: £60,000.

Hessell Tiltman Prize

English Centre of International PEN
6-8 Amwell Street
London EC1R 1UQ
Phone: 020 7713 0023
Fax: 020 7837 7838
Email: enquiries@englishpen.org
Web: www.englishpen.org

A prize created in 2002, made possible by a bequest to the PEN Literary Foundation of £100,000 from PEN member Marjorie Hessell-Tiltman. This prize of £3,000 is awarded annually for a non-fiction book of specifically historical content. Entrants, which may include first British translations, are to be books of high literary merit – that is, not primarily written for the academic market – and can cover all historical periods up to and including the Second World War.

Publishers are invited to draw attention to a maximum of two books on their lists, but neither authors nor publishers can make submissions to the Judges.

Tir na n-og Awards

Welsh Books Council
Castell Brychan
Aberystwyth SY23 2JB
Phone: 01970 624 151
Fax: 01970 625 385
Email: castellbrychan@wbc.org.ukk
Web: www.cllc.org.uk

Established in 1976 to raise the standard of children's and young people's books and to encourage the reading and buying of good books.

Three prizes are awarded annually:

Best English-language book with an authentic Welsh background.
Best Welsh-language Fiction.
Best Welsh-language Non-Fiction.

Qualifying period: preceeding calendar year.
Prize: £1,000 for each category.

Betty Trask Prize and Awards

The Society of Authors
84 Drayton Gardens
London SW10 9SB
Phone: 020 7373 6642
Fax: 020 7373 5768
Email: info@societyofauthors.org
Web: www.societyofauthors.org

Awarded for first novels by authors under the age of 35.

The author must be a Commonwealth citizen and must not have had any novel published. The work submitted must be in the English language and by one author (not a translation).

The work submitted must be a novel of 'a romantic or traditional nature' (i.e. not experimental). The work submitted may be published or unpublished.

Submission by publisher only.
Closing date: January.
Prize: £25,000 (shared).

The UK Film Council – 25 Words or Less

10 Little Portland Street
London W1W 7JG
Phone: 020 7861 7861
Fax: 020 7861 7862
Email: development@ukfilmcouncil.org.uk
Web: www.ukfilmcouncil.org.uk

The UK Film Council's Development Fund aims to broaden the quality, range and ambition of UK film projects and talent being developed. It is building creatively focused relationships with a breadth of talent, from first timers to experienced practitioners. As part of a wider initiative to help writers find the route to a successful career in film, and in order to broaden the range of spec scripts available to the industry, the Development Fund wants to fast track writers with the ambition to write high concept screenplays which are aimed at the international market and have commercial appeal.

25 Words or Less

The Development Fund will offer up to twelve successful writers per year a fixed sum of £10,000 to develop a first draft script in a specified genre. The Development Fund will assign a script editor to the project – the cost of which will be attributed to the project but will be met by the UK Film Council.

25 Words or Less will be run three times a year and each time different genres will be selected. See website for details.

The Development Fund will fund up to four applicants in each round.

Eligibility: This scheme is open to individuals 18 years and over and nationals and residents of the UK or another state of the European Union/European Economic Area. Companies are not eligible to apply.

Applicants must have: secured the services of a literary agent and/or have Full Membership status of the Writers'Guild of Great Britain (as such term is

defined by Writers' Guild of Great Britain) before applying for this scheme.

Story ideas must be original to the applicant and cannot be based on pre-existing works such as novels, comics or theatre plays. The project must fall within one of the genres specified in order to be eligible for consideration.

Projects should be capable of being developed as feature length theatrical films for commercial exploitation in the UK and the rest of the world and be intended for production in the English language unless there are mitigating factors to the contrary. Projects should also be wholly or substantially capable of qualification as a British film.

Projects that have previously been submitted to the Development Fund will not be eligible for consideration.

The investment is for developing high concept ideas to a first draft script. If the project is already developed to script stage this scheme is not applicable and so the project is ineligible.

Application: see website for further details.

George Viner Memorial Fund Trust

Headland House
308-312 Gray's Inn Road
London WC1X 8DP
Phone: 020 7843 3723
Fax: 020 7278 6617
Email: georgeviner@nuj.org.uk
Web: www.georgeviner.org.uk

Established in 1986 to help increase the number of Black and Asian journalists working in the UK. One of the biggest barriers to entering the media is the cost of gaining the high level of qualifications needed. This fund was established to provide funding to Black and Asian students taking a journalism course. Since its inception the Trust has supported over 100 students through college and into work.

The George Viner Memorial Fund is open to Black and Asian students who meet the following criteria:

Are in receipt of a formal offer of a place on a course within the fields of print, broadcasting, photographic or online journalism.

The course is an industry-recognised media course. All courses must be recognised by the NCTJ or the NUJ. A list of approved courses can be obtained by contacting the Fund Administrator or on the website.

Be a resident of the UK or Ireland.

Be planning to continue in education or start a professional career within the UK or Ireland, within the media industry.

Not be receiving a student loan or other sponsorship to cover the costs of the course applied for.

For further condition see website.

Welsh Books Council Publishing Grant

Welsh Books Council
The Publishing Grant Department
Castell Brychan
Aberystwyth SY23 2JB
Phone: 01970 624151
Fax: 01970 625385
Web: wbc.grants@wbc.org.uk

Details were not available at time of publication. Check website for details.

Whitbread Book Awards

Whitbread Book Awards Administration
The Booksellers Association
Minister House
272 Vauxhall Bridge Road
London SW1 1BA
Phone: 020 7802 0802
Fax: 020 7834 8812
Email: gill.cronin@booksellers.org.uk
Web: www.whitbread-bookawards.co.uk

The Awards:

Whitbread Biography/Autobiography Award

First Novel Award

Novel Award

Poetry Award

Whitbread Book of the Year

Whitbread Children's Book of the Year.

Each author's primary residence (i.e. for over six months of the year) must have been in the UK or the Republic of Ireland for the previous three years. UK or Irish nationality is not essential. Entries must have been first published between November and the following October of the prize year.

Closing date: end of June. Shortlist: November. Winners announced: January. Submission by publisher only.

Prizes: Whitbread Novel Award – £5,000; Whitbread First Novel Award – £5,000; Whitbread Biography/Autobiography Award – £5,000; Whitbread Poetry Award – £5,000; Whitbread Children's Book of the Year – £5,000; Whitbread Book of the Year – £25,000.

Whitfield Prize

Royal Historical Society
University College London
Gower Street
London WC1E 7HU
Phone: 020 7387 7532

Fax: 020 7387 7532
Email: rhsinfo@rhs.ac.uk
Web: www.rhs.ac.uk

For an original work on any historical subject in a field of British history. It must be its author's first solely written history book and published in English, during the calendar year, by a scholar normally resident in the UK.

Submission by publisher.
Closing date: December. Winner announced: July.
Prize: £1,000.

Raymond Williams Community Publishing Prize

Arts Council England
14 Great Peter Street
London SW1P 3NQ
Phone: 0845 300 6200
Fax: 020 7973 6590
Email: enquiries@artscouncil.org.uk
Web: www.artscouncil.org.uk

The Raymond Williams Community Publishing Prize is awarded annually for work of outstanding creative quality, which reflects the voices and experiences of the people of communities in this country. Non-profit making publishers producing books in mutual and co-operative ways are invited to submit one entry per year.

Prize: £5,000.

Wingate Jewish Quarterly Literary Prizes

Jewish Quarterly
PO Box 37645
London NW7 1WB
Phone: 020 8343 4675
Contact: Pam Lewis
Email: admin@jewishquarterly.org
Web: www.jewishquarterly.org/wingateprize.shtml

The Wingate Jewish Quarterly Prizes for fiction and non-fiction are awarded annually. Books must be published in English or translated into English in the previous 12 months and be considered by the judges to stimulate an interest in and awareness of themes of Jewish concern amongst a wider reading public.

Short-list announced in March.
Prize: £4,000 for winners in each category. 3 runners up awarded £300 each.
Supported by *The Jewish Quarterly* and H H Wingate Foundation.

Wolfson History Prize

The Wolfson Foundation
8 Queen Anne Street
London W1G 9LD
Phone: 020 7323 5730
Fax: 020 7323 3241

The prize is awarded to a book on a historical subject that is scholarly, readable and accessible to the general reader, published in the UK in the calendar year of the prize. Entries are not required.

Winner announced: June.
Prizes: one of £15,000 and one of £10,000.

David T. K. Wong Prize for Short Fiction

The English Centre of International PEN
6-8 Amwell Street
London EC1R 1UQ
Tel: 020 7713 0023
Fax: 020 7837 7838
Web: www.englishpen.org

Established in 2000, this international prize is presented every other year to promote literary excellence in the form of the short story written in English. Unpublished stories of between 2,500 words to 6,000 words are welcome from writers worldwide but entries must incorporate one or more of International PEN's ideals as set out in the PEN charter. Entries should not be sent direct to International PEN but should be submitted via the entrant's local PEN Centre. Administration fee: £25.

Closing date: 30th September.
Prize: £7,500.

The Keith Wright Literary Prize

The Secretary
Department of English Studies
University of Strathclyde
Glasgow G1 1XH
Phone: 0141 548 3711
Email: helen.m.millar@strath.ac.uk

This annual prize is in memory of the poet Keith Wright, who died at the age of 36. There are two awards, one for poetry and one for prose. The fund is designed to encourage those who have established their credentials as writers, but have not yet achieved full success. For this reason eligibility is limited to writers under 40 years of age, who have published prose and/or poetry in reputable UK periodicals or journals but have not yet had a complete volume published commercially. Entries must be in English, but beyond this there is no restriction on the kind of poetry or prose entered.

Closing date: November.
Prizes: Two prizes of £3,500.

Writers Bureau Poetry & Short Story Writing Competition

The Competition Secretary
The Writers Bureau
Sevendale House
7 Dale Street
Manchester M1 1JB
Web: www.writersbureau.com/competition/

Work may be on any subject or theme but should not have been previously published. No competitor may win more than one prize in each category. Poems must not exceed 40 lines. Short stories must not exceed 2,000 words.

Entry fee is £5.00/$8.00 per entry. There is no limit on the number of entries. Copyright remains with the author but winners must agree to assign first publication rights to The Writers Bureau on request, plus permission to include the work on the Writers Bureau website for up to 12 months.

Closing date: 31st July 2005.
All prize winners will be notified by 30th September 2005.

Prizes for both poetry and short story.
Prizes:1st – £1000; 2nd – £400; 3rd – £200; 4th – £100; 5th – £50 x 6.
The winning short story and poem will be published and on the Internet.

Writers inc

14 Somerset Gardens
London SE13 7SY
Contact: Morag McRae, Administrator
Phone: 0208 305 8844
Fax: 0208 469 2147
Email: via website
Web: www.writersinc-london.org.uk

Now in its 12th year, the competition welcomes prose and poetry entries in all styles, forms and subjects. Entries may be on any subject and take any form. Each poetry entry, whether a haiku, villanelle, short poem or extended sequence, will be judged in its own context, regardless of length or content. All entries are judged anonymously.

Poems: Short – single poem up to 60 lines. Long – single poem over 60 lines (maximum 600 lines). Poem sequence: a collection of poems linked by a unifying theme. A maximum of 600 lines and no more than 10 pages.

Short stories: 50 – 2,500 words.

Entries must be in English and be the original work of the entrant. Any number of entries is allowed by any one author. Entries (or parts of entries) may have been previously published in a magazine or journal but not in a collection or anthology. Copyright remains with the author but Writers inc.reserves the right to first publication after the closing date of the competition.

Entry fees: Poems: £3 per poem up to 60 lines, £6 per poem over 61 lines, £8 per set for a sequence. Short Stories: £5 per story, £12 per set of 3 stories.

Prizes: Up to £2,000 will be distributed at the discretion of the judges.

Winners are invited to read their work or extracts at a special event at The Barbican, London. Winning works or excerpts will be published in an

anthology. A portion of the prize fund may be allocated as bursaries, awarded to writers from London, to attend a writing weekend at the Abbey, Sutton Courtenay, Oxfordshire. One winning poem will be submitted to the Forward Poetry Prize for consideration in the Single Poem Category which carries a prize of £1,000.

Closing date: April.

Writer's Digest

74th Annual Writer's Digest Writing Competition
4700 E. Galbraith Road
Cincinnati, OH 45236
United States
Contact: Terri Boes
Phone: +1 513 531 2690 ext. 1328
Email: writing-competition@fwpubs.com.
Web: www.writersdigest.com

Compete and Win in 10 Categories

Inspirational Writing (Spiritual/Religious). 2,500 words max

Article: Memoirs/Personal Essay. 2,000 words max

Article: Magazine Feature Article

Short Story: Genre. 4,000 words max

Short Story: Mainstream/Literary. 4,000 words max

Poetry: Rhyming. 32 lines max

Poetry: Non-Rhyming. 32 lines max

Script: Stage Play (submission by mail only)

Script: Television/Movie Script (submission by mail only)

Children's Fiction. 2,000 words max

Entry Fee: Poems $10 for the first entry; $5 for each additional poem. All other entries $15 for the first manuscript; $10 for each additional manuscript .

Closing date: 16 May, 2005.
Prize: $2,500 cash and an all-expenses paid trip to New York City to meet with editors and agents. For full details see website.

Writers' Forum Short Story Competition

Writers International Ltd
PO Box 3229
Bournemouth BH1 1ZS
Phone: 01202 589828
Fax: 01202 587758
Email: editorial@writers-forum.com
Web: www.writers-forum.com

All types of story are required: humour, horror, erotica, crime, romance and science fiction. The preferred length is 1,500 to 3,000 words. Entrantss will

have been deemed to offer first publication rights and rights to appear in any future anthology of Writers' Forum. Reading fee: £10 (subscribers to Writers' Forum pay only £6).

Deadlines are 5th day of every month. Any entries missing a deadline will be automatically moved forward to the next competition.

Prizes range from £150 up to £250 in each issue with an annual trophy and a cheque for £1,000 for the best story of the year. Open to all nationalities but entries must be in English.

Writers' Week Literary Competitions

24 The Square
Listowel
Co Kerry
Ireland
Phone:+353 68 21074
Fax: +353 68 22893
Email: writersweek@eircom.net
Web: www.writersweek.ie

The Kerry Group Irish Fiction Award

Prize: 10,000 for a published work of fiction by an Irish author.

The Bryan MacMahon Short Story Award

Entry Fee: 8.00 each entry .
Prize: 2,500 (Not more than 3,000 words).

Duais Foras Na Gaeilge

Entry fee: 8.00 each entry .
Prize: 1,100.

Eamon Keane Full Length Play

One act plays are not eligible. Plays submitted should be for stage presentation only and should not have previously been staged. Plays can only be submitted once for this competition, re-submissions will automatically be disqualified.

Entry Fee: 20.00 each entry
Prize: 1,000

Writers' Week Originals Competition

Categories:
Short Story (maximum 1,500 words).
Humorous Essay (maximum 750 words).
Short Poem.

Entry Fee: 8.00 each entry .
Prize: 650 .

Writing in Prisons

Prize: 1,200.

Irish Post/Stena Line New Writing Competition

This competition is not open to Irish Residents. Details will be advertised in the 'Irish Post' UK.

Categories: Journalism and Short Story.

Kerry County Council Creative Writing Competitions for Youth

Categories: Creative Writing for 9 years and under (max 300 words), Creative Writing for 12 years and under (Max 500 words), Creative Writing for 14 years and under (max 500 words), Creative Writing for 16 years and under, (max 1,000 words), Creative Writing for 18 years and under (max 1,000 words), A Limerick for all age groups up to 18 years.

Prize Fund: 1,300. Submissions may be in the form of poems, short stories, essays, etc. Entry Fee: 1.00 with each entry submitted.
Sponsor: Kerry County Council.

Entries must not have been published previously. An entry form is not required for any competition. An unlimited number of entries may be submitted.
Closing date:1st March 2005.

There are no restrictions on any of the other competitions, all nationalities are welcome. Irish nationality applies only to the Kerry Group Irish Fiction Award. Entries may be in Irish or in English.

Yeovil Literary Prize

The Octagon Theatre
Hendford
Yeovil BA20 1UX
Web: www.yeovilprize.co.uk
Email: enquiries@yeovilprize.co.uk

The Categories

Novel – The Betty Bolingbroke-Kent Award
Requirement: Synopsis and 3 chapters to be judged by leading literary agent.
Entry Fee: £10.
Prizes:1st – £250, plus Microsoft Office 2003 (worth £300); 2nd – £100; 3rd – £30 (in Ottakar's book tokens).

Genre Short Story
Story must be aimed at *My Weekly* magazine and should not be more than 1,500 words. Entry Fee: £5.
Prizes: 1st – £100 & considered by *My Weekly* for publication; 2nd – £50; 3rd – £25 (in Ottakar's book tokens).

Non-Genre Short Story
There are no market restrictions for this short story, but it must not be more than 2,000 words. Entry Fee: £5.
Prizes: 1st – £100; 2nd – £50; 3rd – £25 (in Ottakar's book tokens).

Entries must be in English, the work of the entrant and must not have been accepted for publication, or published, in the category in which they are entered. No competitor may win more than one prize in each category.

Closing date: 31st March 2005.
Entry Forms from some Ottakar's bookshops, all Libraries, the Octagon Theatre or by downloading from the website.

Yorkshire Post Book of the Year Award

Margaret Brown
Literary Awards Coordinator
The Rectory
Ripley, Harrogate HG3 3AY
Phone: 01423 772217

Awarded to a work of fiction or non fiction, by a British or UK resident publshed in the UK in the preceeding year.

Submission by publisher only.
Closing date: December. Winner announced: May.
Prize: £1,200.

Young Minds Award

YoungMinds
102-108 Clerkenwell Road
London EC1M 5SA
Phone: 020 7336 8445
Fax: 020 7336 8446
Web:www.youngminds.org.uk

YoungMinds is the national charity committed to improving the mental health of all babies, children and young people.

Set up in 2003, this award is given to a work of literature (not academic or for children) which best portrays something of the unique subtlety of a child's experience and throws fresh light on the ways a child takes in and makes sense of the world he or she is growing into.

Award: £3,000.

special funds

BTBS, The Book Trade Charity

The Foyle Centre
The Retreat
Kings Langley WD4 8LT
Phone: 01923 263128
Fax: 01923 270732
Email: btbs@booktradecharity.demon.co.uk
Web: www.booktradecharity.demon.co.uk

BTBS is the book trade's own welfare charity. It is often the most appropriate channel through which assistance and support can be given to those members of the trade who find themselves in difficult circumstances.

BTBS expresses, in a range of practical ways, the responsibility that the community of the book trade - both individuals and companies - has towards its less fortunate colleagues. In return, the support of the trade is essential to BTBS, to enable it to continue offering assistance to those in need, and to develop its services to meet the changing needs of the trade.

The prime objective is to provide assistance for people in need throughout the UK who have worked in functions relating to the publishing and selling of books for a period of at least twelve months, and their immediate dependent relatives. It has a grants programme and offers advice and accommodation.

The European Jewish Publication Society

Dr Colin Shindler, Director
Phone: 020 8346 1668
Fax: 020 8346 1776
Email: cs@ejps.org.uk
Web: www.ejps.org.uk

Founded in 1995 the European Jewish Publication Society is a charity which assists in the publication of many books of Jewish interest. It provides grants to publishers up to £3,000 if a publisher believes that a manuscript deserves to see the light of day, but is ambivalent about the financial investment. The publisher submits the manuscript to the EJPS for appraisal. If the EJPS agrees to support the work, the publisher can apply for a grant of up to £3,000 for both fiction and non-fiction and up to £1,000 for poetry. The term 'Jewish interest' is interpreted liberally and widely with the general proviso that it should be of interest to as large an audience as possible – both Jewish and non-Jewish. Works that are narrowly specialised and/or academic are less likely to be awarded a grant.

Tony Godwin Award

c/o Laurence Pollinger Limited
9 Staple Inn
London WC1V 7QH
Email: info@tgmt.org.uk
Web: www.tgmt.org.uk

Tony Godwin was an outstanding publisher in the 1960s and 1970s. The memorial trust recognises his contribution to the publishing industry. The Award is open to all young people under the age of 35 who are UK nationals and working in the industry. It is made biennially and provides the opportunity for the recipient to spend at least one month in America as the guest of a publishing house so as to learn about international publishing. A full report is published following the recipient's return to the UK.

The Royal Literary Fund

3 Johnson's Court
off Fleet Street
London EC4A 3EA
Contact: Eileen Gunn, General Secretary
Phone: 020 7353 7150
Email: egunnrlf@globalnet.co.uk
Web: www.rlf.org.uk

The Royal Literary Fund is a British benevolent fund for professional published authors in financial difficulties. The RLF has been continuously helping authors since it was set up in 1790. It is funded by bequests and donations from writers who wish to help other writers. Its committee members come from all walks of literary life and include novelists, biographers, poets, publishers, lawyers and agents.

Help is given to writers in many different situations where personal or professional setbacks have resulted in loss of income. Pensions are considered for older writers who have seen their earnings decrease. The RLF helped over 200 authors last year.

To request an application form contact the General Secretary at the address above or by email providing a list of your publications including names of publishers, dates, and whether sole author.

Newspaper Press Fund

Dickens House
35 Wathen Road
Dorking RH4 1JY
Phone: 01306 887511

The Newspaper Press Fund is the fund for journalists. It is their oldest organisation and their principal charity. The fund was established in 1864 to assist journalists and their families; it was granted a Royal Charter in 1890, and continues to provide effective relief for those in need. If you are British or

Irish, under the age of 60, and have been earning your living on the editorial side of newspapers, television or radio for at least two years you are eligible to join. Foreign journalists working for British companies, and living in the UK, are also eligible to join.

The Society of Authors

84 Drayton Gardens
London SW10 9SB
Phone: 020 7373 6642
Fax: 020 7373 5768
Email: info@societyofauthors.org
Web: www.societyofauthors.org

The Society of Authors administers three charitable trusts which provide grants to authors in temporary financial difficulties. These trusts are only open to professional freelance writers for whom writing books or full length scripts has provided a principal source of income.

The Francis Head Bequest

Mrs Head, a well-known literary agent, generously established this trust in her will with the object of making grants to professional writers (writing in the English language) who were born in England, Scotland, Wales or Northern Ireland, and who are over the age of 35.

It is aimed at authors who by reason of illness or otherwise are in financial difficulty. She particularly wished to help authors who are temporarily unable to maintain themselves or their families owing to illness or an accident, but the terms of the trust are reasonably wide.

The Authors' Contingency Fund

A number of emergency grants are made each year to professional authors who are in immediate financial difficulties or for the financial relief of their dependants.

The John Masefield Memorial Trust

The Trust provides occasional grants to professional poets or their dependants who are faced with sudden financial problems.

Application is made by completing a form which can be downloaded from the website and returning it, with a covering letter, to Dorothy Sym at the Society of Authors. The same form applies to all three funds.

Academi Cardiff International Poetry Competition

3rd Floor
Mount Stuart House
Mount Stuart Square
Cardiff CF10 5FQ
Phone: 029 2047 2266
Fax: 029 2049 2930
Web: www.academi.org

Academi's Cardiff International Poetry Competition offers one of the largest money prizes for a poetry competition of its kind.

Each poem must be no more than 50 lines in length and must be typed or clearly written on one side of the paper only. Entrants may submit an unlimited number of poems, whichs may be in any style and on any subject. Entries should not be submitted for publication elsewhere while the competition is running. All entries will be judged anonymously. Entry fee: £5.

Eligibility: Entries accepted from writers of any nationality and from any country provided that: writer is English and is living, work has not previously been published, they are not translations of another author's work.

Prizes 1st – £5,000; 2nd – £1,000; 3rd – £750. Five honourable mentions will receive publication and free Academi membership. All the winning poems will be published in *The New Welsh Review*.

Closing date: end of January.

Amnesty International Poetry Competition

Amnesty International Reading
PO BOX 3461
Wokingham RG40 1WX
Web: www.amnestyreading.co.uk

Poems may be in any style or form and on any subject but must not exceed 40 lines (excluding title). All poems must have a title, and be in English. You may submit more than one. Each entry form covers multiple entries. Poems may not have been previously published or broadcast and must be the author's original work. All poems submitted are automatically considered for the Open and Human Rights prizes. The copyright of each poem remains with the author but the winning authors grant Amnesty International the right to publish (in print or on the internet) or broadcast the poems for one year from 31st July 2005.

Entry fee: £4 per poem for adults and £2 per poem for under-16s.
Closing date: April 30th 2005.

Prizes: 1st – £250; 2nd – £100; 3rd – £50.
Human Rights Prize: £100. (given to the poem which best promotes Amnesty International's campaign to Stop Violence Against Women).
Under 16s Prize: £100.

Aramby Publishing

1, Alanbrooke, Broadway
Knaphill, Surrey GU21 2RU
Competition updates are available by emailing – arambypublishing@getresponse.com
Web: www.webspawner.com/users/arambypublishing

The competition is aimed at promoting the work of new and lesser known writers and is open to anyone over the age of 16. Poems should be in English and must be your own work. They may be on any subject and in any form or style but should not exceed 40 lines. Entry fee is £5 for a manuscript of between 16 and 28 poems. There is no closing date as the competition is on-going.

Three times a year the best manuscripts are selected and permission from the winning authors is requested to publish. Small Press Publications are printed in a 32 page A5 booklet format and are published under the 'Aramby' imprint. Winning authors keep royalties from sales and will automatically receive a Poetry Book Society nomination for their title.

The Arvon Foundation (National Office)

42a Buckingham Palace Road
London SW1W 0RE
Phone: 020 7931 7611
Email london@arvonfoundation.org
Web: www.arvonfoundation.org

The next Arvon International Poetry Competition will be held in 2006.

Bursaries

Arvon runs residential creative writing courses at centres in four locations: Devon, Shropshire, Yorkshire and a centre near Inverness which is supported by Arvon but owned by the Moniack Trust. The courses, for people of all ages and backgrounds, provide an inspirational space and dedicated time to practise the art of writing.

Arvon fundraises to provide bursary support towards the course fee (currently £435) for those requiring financial assistance. It is a firmly held principle that courses should be accessible to anyone with a real commitment to writing, regardless of their circumstances.

There are four centres:
Lumb Bank (The Ted Hughes Arvon Centre), West Yorkshire, Moniack Mhor, Invernessshire; The Hurst (The John Osborne Arvon Centre), Shropshire, Totleigh Barton, Devon

Atlanta Review International Poetry Competition

Poetry 2005
PO Box 8248
Atlanta GA 31106
United States
Web: www.atlantareview.com

Poems must not have been published in a nationally-distributed print publication. No entry form or special format required.

Entry fee: $5 for the first poem, $3 for each additional poem.

Closing date: May 16, 2005.
Winners announced in August.

Prizes: 1st – $1,000; 2nd (2 prizes) – $100. Twenty International Publication Awards; Thirty International Merit Awards.

Ayr Writers Club

Web: www.ayrwritersclub.co.uk

See main entry in literature.

Bedford Open Poetry Competition

Contact: Gavin Stewart, stewartga@waitrose.com

Open to anyone of 16 years and over. Winners will be published in *The Interpreter's House magazine*.

Closing date: May 16, 2005. Winners announced in August.
Prize: £300, plus two x £100.

Boston Review

Annual Poetry Contest
E53-407 MIT
Cambridge MA 02139
United States
Phone: +1 617 258-0805
Email: review@mit.edu
Web: bostonreview.net

Winning poet receives $1,000 and publication in the *Boston Review*. Submit up to five unpublished poems, no more than 10 pages total. Only English-language poems. Simultaneous submissions are allowed if the Review is notified of acceptance elsewhere. Entry fee: $15 ($25 international). All entrants receive a one-year subscription to Boston Review.

Closing date: June 1.
Prize: $1,000.

Boulevard Poetry Contest For Emerging Poets

PMB 325
6614 Clayton Rd.
Richmond Heights MO 63117
United States
Web: www.boulevardmagazine.com

Awarded for the winning group of three poems by a poet who has not yet published a book of poetry with a nationally distributed press.

The poems may be a sequence or unrelated. Simultaneous submissions are allowed, but previously accepted or published work is ineligible. Entries will be judged by the editors of Boulevard magazine. Entry fee: $15 per group of three poems; $15 for each additional group of poems. Entry fee includes a one year subscription to *Boulevard*.

The winning poems will be published in the Fall 2005 or Spring 2006 issue of *Boulevard*. All entries will be considered for publication and for payment at our regular rates.

Closing date: 15th May 2005.
Prize: $1,000 and publication in *Boulevard Magazine* for the winning group of three poems.

The Bridport Prize

International Creative Writing Competition
Bridport Arts Centre
South Street
Bridport DT6 3NR
Phone: 01308 459444
Web: www.bridportprize.org.uk
Email: frances@poorton.demon.co.uk

Poems should be a maximum of 42 lines. The top 4 poems are then submitted to the Forward Prize. The top 26 stories and poems are published in the Bridport Prize anthology.

Closing date June
Prizes: 1st – £3000; 2nd – £1,000; 3rd – £500; 10 supplementary prizes.

British Haiku Society

38 Wayside Avenue
Hornchurch
Essex RM12 4LL
Web: www.britishhaikusociety.org

The James W Hackett Annual International Award for Haiku

This annual contest was instituted in 1990, using an initial donation from James W Hackett, a well-known pioneer in the field of haiku writing. Haiku must be original, in English, not previously published nor under consideration for publication or entered in any other competition. Each competitor may enter up to 5 haiku. Entry fee: £2.50 or $4.00.

Closing date: November.

Prize: One £70 prize. (If appropriate: up to two further prizes of £70 for poems of equal merit). One year's free subscription to The British Haiku Society (and up to two more, as above). Winning (and Commended) haiku will be published in Volume 15 No. 2 of *Blithe Spirit*.

The Nobuyuki Yuasa International English Haibun Contest

For work of literary merit in which the fusion of haiku verse and haiku prose is distinctive and convincing. A maximum of three submissions per entrant. Open to the public worldwide, for haibun in the English language only, of a length between 200 and 1,500 words, including one or more haiku. Work may be published or unpublished at the time of submission, but entry implies readiness for it to be published, if selected, in the contest anthology. Each haibun should be given a title. Entry fee: £10 or $15 for each haibun entered.

Prize: One overall winner will receive (1) an original framed Japanese painting donated by Professor Yuasa, (2) a signed original print created by artist David Walker to illustrate the winning haibun, (3) ten copies of an anthology containing the winning entry and a selection of commended haibun by other entrants. All other entrants will receive one complimentary copy of the anthology.

Closing date: 30 September.

Cholmondeley Awards for Poets

Awards Secretary
The Society of Authors
84 Drayton Gardens
London SW10 9SB
Phone: 020 7373 6642
Fax: 020 7373 5768
Email: info@societyofauthors.org
Web: www.societyofauthors.org

Founded by the late Dowager Marchioness of Cholmondeley in 1966 to recognise the achievement and distinction of individual poets. The annual awards are honorary and submissions are not accepted. The recipients are chosen by the Awards Committee for their general body of work and contribution to poetry.

Winner announced: Spring.
Prize: £8,000 (shared).

CLPE Poetry Award

Centre for Literacy in Primary Education
Webber Street
London SE1 8QW
Phone: 020 7401 3382/3
Fax: 020 79284624
Email: info@clpe.co.uk
Web: www.clpe.co.uk

In establishing the award, CLPE wanted to highlight an important branch of

children's literature and ensure that it receives proper recognition. It is presented annually for a book of poetry published in the preceding year.

Cotswold Writers' Circle Open Writing Competition.

Cotswold Writers' Open Competition
Anne Brookes
Vestry Cottage
Bell Lane
Minchinhampton GL6 9BP
Email: granne@waitrose.com

Poems 30 lines max; prose 1,250 words max. The winner is published in the anthology *Pen Ultimate*. Send SAE for entry form and conditions, or email.

Closing date: 31 January.
Prizes: £500; £250; £100.

The Geoffrey Dearmer Prize

The Poetry Society
22 Betterton Street
London WC2H 9BX
Phone: 020 7420 9880
Fax: 020 7240 4818
Email: competition@poetrysociety.org.uk
Web: www.poetrysociety.org.uk

The Geoffrey Dearmer endowment fund was established in 1997 in memory of the eponymous poet. By establishing an endowment fund the Dearmer family have enabled the Poetry Society to award an annual prize to the Poetry Review "new poet of the year" who has not yet published a book.

TS Eliot Prize

The Poetry Book Society
Book House, 45 East Hill
London SW18 2QZ
Phone: 020 8870 8403
Fax: 020 8877 1615
Email: info@poetrybooks.co.uk
Web: www.poetrybooks.co.uk

The PBS awards the annual T S Eliot Prize for Poetry. The Prize – described by Poet Laureate Andrew Motion as 'the Prize most poets want to win' – was launched in 1993 to celebrate the Poetry Book Society's 40th birthday and to honour its founding poet.

Submission by publisher only.
Closing date: August. Shortlist: November. Winner announced: January.
Prize: £10,000 which is kindly donated by Eliot's widow, Mrs Valerie Eliot.

firstwriter.com's International Poetry Competition

Web: www.firstwriter.com

Entries must be entirely the work of the entrant and must never have been published in a book or anthology, though they may have been previously published in a magazine/journal/periodical. Poems can be on any subject and in any style, but must be no more than 30 lines in length.

Poems may be simultaneously submitted to this and other competitions, or for consideration in a magazine, but not for a book or anthology. Poems submitted may be considered for publication online in firstwriter.magazine. Entry fee: $4.50/£3.00 per poem; three poems $3.75/£2.50 each; five poems $3.00/£2.00 each; ten poems for $2.25/£1.50 per poem.

Closing date: October.
Prizes: 1st – £500; $150 for the best runner-up from the United States and £100 for the best runner-up from the UK. Ten special commendations will also be awarded and all the winners will be published in firstwriter.magazine and receive a free year's subscription to the site.

Forward Poetry Prize

Forward Arts Foundation
84-86 Regent Street
London W1B 5DD
Phone: 020 7734 2303
Fax: 020 7494 2570
Email: info@forwardartsfoundation.org
Web: www.forwardartsfoundation.org

There are three categories for these awards:

The Forward Prize for Best Collection, £10,000
The Felix Dennis Prize for Best First Collection, £5,000
The Forward Prize for Best Single Poem, £1,000

The prize is administered by Colman Getty PR. For an entry form please contact: Kate Wright-Morris on 020 7631 2666 or kate@colmangettypr.co.uk

Foyle Young Poets of the Year Award

The Poetry Society
22 Betterton Street
London WC2H 9BX
Phone: 020 7420 9880
Fax: 020 7240 4818
Email: competition@poetrysociety.org.uk
Web: www.poetrysociety.org.uk

The Poetry Society, with support from the Foyle Foundation, offer young poets an opportunity to study alongside leading contemporary poets on a prize-winner's course at the The Arvon Foundation.

The competition is free to enter, and attracts entries not just from Britain but from around the world. Any writer between the ages of 11 and 18 can enter the

Award by sending their poem or poems. Poets can enter as many poems as they choose, of any length and on any theme.

All winners and runners-up will receive book prizes, plus free youth membership of the Poetry Society for one year, and will be invited to an awards party on National Poetry Day. The 15 overall winners will be invited to attend the prize-winners' writing course at the Arvon Centre, Lumb Bank.

Closing date: 31 July.

The Frogmore Poetry Prize

The Frogmore Press
42 Morehall Avenue
Folkestone CT19 4EF.
Web: www.frogmorepress.co.uk

The Frogmore Poetry Prize (sponsored by the Frogmore Foundation) was founded in 1987 and has been awarded annually since then.

Poems must be in English, unpublished, and not accepted for future publication. Poems should be no longer than forty lines, and any number may be entered. Entry fee: £2 per poem.

All shortlisted poems will appear in *The Frogmore Papers* (no. 66 Sept. 2005). Closing date: 30 June 2005.

Prize: 1st – 200 guineas and life subscription to *The Frogmore Papers*; 2nd – 75 guinea; 3rd – 50 guinea (both 2nd & 3rd receive a year's subscription to *The Frogmore Papers*).

Eric Gregory Trust Fund Awards

The Awards Secretary
The Society of Authors
84 Drayton Gardens
London SW10 9SB
Phone: 020 7373 6642
Fax: 020 7373 5768
Email: info@societyofauthors.org
Web: www.societyofauthors.org

The Eric Gregory Awards totalling £24,000 each year are awarded to British poets under the age of 30 on the basis of a submitted collection. Published and unpublished collections may be entered.

The author must be a British subject by birth but not a national of "Eire or any of the British Dominions or Colonies". The author must ordinarily be resident in the United Kingdom or Northern Ireland. The work submitted may be a published or unpublished volume of poetry, drama-poems or belles-lettres. No more than 30 poems should be submitted.

Winners will be invited to give a reading at the prestigious Ledbury Poetry Festival at the discretion of the Trustees, and may also be invited to take part in an event hosted and promoted by the Poetry Society.

Closing date: 31 October.

The Griffin Poetry Prize

The Griffin Trust For Excellence In Poetry
6610 Edwards Boulevard
Mississauga, Ontario L5T 2V6
Canada
Contact: Mrs. Ruth Smith, Manager
Telephone: +1 905 565 5993
Fax: +1 905 564 3645
Email: info@griffinpoetryprize.com
Web: www.griffinpoetryprize.com

The Griffin Poetry Prize is awarded annually in two categories – International and Canadian. In each category, the prize is for the best collection of poetry in English published during the preceding year. One prize goes to a living Canadian poet or translator, the other to a living poet or translator from any country, which may include Canada.

Translations are assessed for their quality as poetry in English; the focus is on the achievement of the translator. Submissions must come from publishers, who may enter an unlimited number of titles.

To be eligible for the International prize, a book of poetry must be a first-edition collection (i.e. not previously published in any country), written in English, or translated into English, by a poet/translator from any part of the world, including Canada.

To be eligible for the Canadian prize, a book of poetry must be a first-edition collection (i.e. not previously published in any country), written in English or translated into English by a Canadian citizen or a permanent resident in Canada.

Books must have been published in English during the calendar year preceding the year of the award. Winning the Griffin Poetry Prize (or any other prize) in previous years does not render a poet ineligible for the current year's prize. Only books of poetry written by authors or translators alive at the date of publication will be considered. Books must be the work of one poet. Selected and collected works are eligible. A book of translations by two translators is eligible if they have collaborated throughout. A collection of translations by various hands is not eligible. A book is defined as having at least forty-eight pages.

Prize: International and Canadian. Each prize is worth C$40,000.

Iota Poetry Competition

1 Lodge Farm
Snitterfield
Stratford-on-Avon CV37 0LR
Phone: 01789 730358
Email: iotapoetry@aol.com
Web: www.iotapoetry.co.uk

The competition is open to anyone aged 18 and over. Non-UK entries are welcome but all entries must be in the English language. Poems may be of any length and on any subject. Poems must be the original work of the author and must not have been previously published or be accepted for future publication elsewhere. Copyright of each poem remains with the author. Authors of

winning poems will grant iota permission to publish the poems in the May edition of iota and will receive one free copy. Authors of winning poems will also grant permission for publication on the iota website. Entry fee: Subscribers: free for up to two poems, subsequent poems £2 each. Non-subscribers: £2 per poem

Closing date: April 15th 2005.
Prizes: 1st – £100; 2nd – £50; and two prizes of £25.

Jerwood Aldeburgh First Collection Prize

Aldeburgh Festival
Goldings
Goldings Lane
Leiston, Suffolk IP16 4EB
Phone: 01728 830631
Web: www.thepoetrytrust.org

The award is made to the best first full collection of poetry as judged by a panel of readers. Qualifying period is work published in the UK in the twelve months preceding the closing date.

Submission from both publishers and poets.
Closing date: September. Winner announced: November.
Prize: £2,000 and a further £2,000 annually towards the promotion of emerging voices at the Aldeburgh Poetry Festival.

Supported by The Jerwood Foundation.

The Children's Competition was sponsored in 2004 for the 16th successive year by the East Anglian Daily Times. The successful writers received their prizes and performed their winning poems alongside Michael Rosen at the 16th Aldeburgh Poetry Festival. Book tokens are awarded as prizes.

The Keats-Shelley Prize

Hon. Secretary KSMA
1 Satchwell Walk
Leamington Spa CV32 4QE
Fax: 01926 335133
Email: contact@keats-shelley.co.uk
Web: www.keats-shelley.co.uk

Inaugurated in 1998 to reward excellence in writing on Romantic themes. The underlying purpose of the Prize is to encourage people of all ages, but particularly the young, to respond personally to the emotions aroused in them by the work of the Romantics through rising to the challenge of writing their own poem or essay. Entries are invited annually in two categories: poems, on a theme chosen by the judges, and essays on any aspect of the work or life of Keats or Shelley. Although open to all, it is promoted strongly to the universities and is launched at the beginning of each academic year.

There are £3,000 of prizes, awarded in each category to a winner and a runner-up. The winners have the additional bonus of being published in the Keats-Shelley Review.

Barbara Mandigo Kelly Peace Poetry Awards

Nuclear Age Peace Foundation
PMB 121
1187 Coast Village Road, Suite 1
Santa Barbara
CA 93108-2794
United States
Phone: +1 805 965 3443
Fax: +1 805 568 0466
Web: www.wagingpeace.org/awards

Annual series of Awards to encourage poets to explore and illuminate positive visions of peace and the human spirit. Open worldwide. All poems must be the original work of the poet, unpublished, and in English. Maximum 40 lines per poem. Send 2 copies of up to 3 typed unpublished poems. Entry fee: $5 for one poem; $10 for two or three poems. No fee for youth entries.

Application: Check website.
Closing date: July.

Winners Announced: October.
Prize: $1,000 Adult; $200 Youth (13 to 18); $200 Youth (12 and under).

The Petra Kenney Poetry Competition

PO Box 32
Filey YO14 9YG
Email: morgan@kenney.uk.net
Web: www.petrapoetrycompetition.co.uk

Annual competition. Poems must be original and unpublished and no more than 80 lines. Entry fee £3.00 per poem.

General category: 1st Prize – £1,000 (also published in *Writers Magazine*); 2nd Prize – £500; 3rd Prize – £250. There are also three Highly Commended, with each winning £125.
Comic Verse Category: One prize of £250.
Young Poets (aged 14-18): 1st Prize – £250; 2nd Prize – £125.

Kent & Sussex Poetry Society

Kent and Sussex Poetry Society
The Competition Organiser
Nash House, 25 Mount Sion
Tunbridge Wells TN1 1TZ

Open to anyone aged 16 and over. Poems should be in English, unpublished, not accepted for publication, and your original work. Poems may be on any subject and in any form or style. Must be typed and not longer than 40 lines. Entry fee: £3 per poem

Closing date: 31st January
Prizes: 1st. – £500; 2nd – £200; 3rd – £100; 4th – four of £50.
The prize winning poems will be published in the Society's Poetry Folio in July.

Kick Start Poets

Kick Start Poets Open Poetry Competition
C/O 'Corydon'
Pennings Drove
Coombe Bissett
Salisbury SP5 4NA
Contact: Ruth Marden, Secretary
Phone: 01722 329687
Web: www.kickstartpoets.freeuk.com

Kick Start Poets of Salisbury is an independent group supported by South West Arts and Salisbury District Council.

Poems must be original work in English, not previously published or accepted for publication in any medium, or awarded a place in any other competition. Poems of not more than 60 lines. You may submit as many poems as you like. Entry fee: £4 each for up to two poems; £10 for three poems; £3 each for four or more poems. No competitor may win more than one prize.

Winners and runners-up will invited to read their work at a public adjudication and reading during the period of the Salisbury Festival in May-June.

Agnes Lynch Starrett Poetry Prize

University of Pittsburgh Press
Eureka Building, Fifth Floor
3400 Forbes Avenue
Pittsburgh PA 15260
United States
Web: www.pitt.edu/~press/BIP/starrett.html

The University of Pittsburgh Press announces the Agnes Lynch Starrett Poetry Prize for a first full-length book of poems. Named after the first director of the Press, the prize carries a cash award of $5,000 and publication by the press in the Pitt Poetry Series under its standard royalty contract.

Eligibility: The award is open to any poet writing in English who has not had a full-length book published previously. We define "full-length book" as a volume of 48 or more pages published in an edition of 750 or more copies.

Submission fee: $20.00

Multiple Submissions: Manuscripts being considered by other publishers are allowed, but if accepted for publication elsewhere, please notify the Press.

Closing date: Manuscripts must be received during March and April.

Mslexia Women's Poetry Competition

Mslexia
PO Box 656
Newcastle upon Tyne NE99 1PZ
Phone: 0191 261 6656
Fax: 0191 261 6636
Email: postbag@mslexia.demon.co.uk
Web: www.mslexia.co.uk

Entry fee: £5 per person for up to five poems (no more than 800 words per poem), on any subject.

Closing date: 29 April 2005
1st Prize – £1,000; 2nd – £ 500; 3rd – £ 250. Ten runners-up will be published in the summer issue of *Mslexia*.

The New Writing section of *Mslexia* publishes poems and short stories. They request submissions (free) on a particular theme and pay £25 a poem and £15 per 1,000 words of prose. Contributors' guidelines are available on the website.

The Munster Literature Centre

The Southword Editions Poetry Chapbook Competition
Frank O'Connor House
84 Douglas Street
Cork
Ireland
Email: munsterlit@eircom.net
Web: www.munsterlit.ie

The first competition is being held in 2005. Competitors were invited to submit 5 poems. A shortlist of six poets is selected who are then invited to submit a manuscript of sixteen pages of poems. The winning work is reproduced in a numbered limited edition chapbook published in June. The winner receives 1,000 and twenty copies of the chapbook. The five runners-up receive payment of 100 each and have one or more poems published in *Southword*.

The competition is open to original poems in the English language . The five poems may not have been previously published in book or chapbook form. Poems which have appeared in periodicals or anthologies are acceptable.

Entry fee: 10, or £10. You may make as many entries as you want.

Closing date: February. Shortlist announced March. Winner by April 30th.

Prize: 1st – 1,000 and publication of a limited edition chapbook; 5 runners-up prizes of 100 and publication in Southword.

NAWG Creative Writing Competition

See main entry in literature

The New Writer

The Prose and Poetry Prizes
PO Box 60
Cranbrook TN17 2ZR.
Phone: 01580 212626
Fax: 01580 212041
Email: editor@thenewwriter.com
Web: www.thenewwriter.com

Single Poem

Entries in the single poem section must be previously unpublished with a limit of 40 lines. Entry fee: £4 per poem. Prizes: 1st – £100; 2nd – £75; 3rd – £50.

Collection of poems

Entries in this section (6-10 poems) can be previously published. No line limit. Entry fee: £10 per collection. Prizes: 1st – £300; 2nd – £200; 3rd – £100.

Closing date: October.

Norwich Writers' Circle Open Poetry Competition

Competition Secretary
NWC Open Poetry
25 Wensum Valley Close
Norwich NR6 5DJ
Web: www.norwichwriters.org.uk

For poems of up to 40 lines. Entry Fee: £2 per poem

Open Poetry Prize: £120; £70; £40.
Mary Ingate Prize: £20 for a poem on a rural theme by a resident of Norfolk.
John Coleridge Prize: £15 for a humorous poem.

Peterloo Poets Annual Open Poetry Competition

The Administrator
Peterloo Poetry Competition
The Old Chapel
Sand Lane
Calstock PL18 9QX
Phone: 01822 833473
Fax : 01822 833989
Email: poets@peterloo.fsnet.co.uk
Web: www.peterloo.fsnet.co.uk

Poems may be on any subject or theme and in any style or form but must not have been previously published. All poems must be typewritten in the English language, be the unaided work of the competitor, and must not exceed 40 lines. Entrance Fee: Adult section: £5 per poem entered to a maximum of 10 entries. 15-19 Age Group Section: £2 per poem entered to a maximum of 10 entries.

Closing date: 1st March.
Prizes: Adult section
1st – £1500; 2nd – £1000; 3rd – £500; 4th – £100; & Ten prizes of £50.
Prizes: 15-19 Age Group Section
Five prizes each of £100.

Pitshanger Poets National Poetry Competition

Pitshanger Poets
The Questors Theatre
Mattock Lane
London W5 5BQ
Email: pitshanger.poets@virgin.net
Web: www.pitshangerpoets.co.uk

Open to poets of any nationality over 18 years of age. Poems must be in English and not more than 40 lines. Poems must be the original work of the author and not have been previously published, broadcast or awarded a prize. Entry fee is £3.00 for the first poem and £2.00 for each subsequent poem.

Closing date: Usually end of February. Winners notified in April and invited to a prize giving and reading in London in the Spring.
Prizes: 1st – £250; 2nd – £100; 3rd – £50; plus 10 commendations.

The Plough Prize

The Plough Arts Centre
9-11 Fore Street
Torrington EX38 8HQ
Web: www.theploughprize.co.uk

Open Poem – Length up to 40 lines. Style unrestricted. Entry Fee: £3.50 per poem or £12 for four poems

Closing date: November 30th
Prizes: 1st £200; 2nd £100; 3rd £50.

Short Poem – Length: up to 10 lines. Style: Unrestricted
Prizes:1st – £200; 2nd – £100; 3rd – £50.

The Poetry Business – Book and Pamphlet Competition

The Studio
Byram Arcade
Westgate
Huddersfield HD1 1ND
Phone: 01484 434840
Fax: 01484 426566
Email: edit@poetrybusiness.co.uk
Web: www.poetrybusiness.co.uk

At the first stage, entrants are asked for small collections of 16 to 24 pages of poems. Poems may be of any length. A long poem may take several pages. You may submit as many collections as you wish. Entry fee: £18 per collection.

Closing date: 31 October.

First stage winners will have pamphlets published and receive an equal share of the cash prize, whether or not they choose to enter the second stage.

First stage winners may choose to enter the second stage by submitting an

extended manuscript (another 30-plus pages) at no extra charge, within one month of being asked. Poems may have been published elsewhere, but must not have previously appeared as a collection. The collection must be for adults, and in English; otherwise poems may be on any subject and in any style.

Copyright remains with the authors but The Poetry Business reserves the right to first UK publication of a winner's collection as a whole for 12 months from publication. (This doesn't prevent publication elsewhere of individual poems.)

The overall winner will have a book published, but not a pamphlet.
See website for full conditions. Entry forms available online from April.

Poetry London Competition

Poetry London
1a Jewel Road
London E17 4QU
Phone: 020 8521 0776.
Fax: 020 8521 0776
Web: www.poetrylondon.co.uk

Annual competition. Entries must be in English, original and unpublished. The maximum length is 80 lines. The number of entries allowed is unlimited. Entry fee: £3.00 for *Poetry London* subscribers, £4.00 for non-subscribers.

Closing date: February. Winners announced: April.
Prizes: 1st – £1,000; 2nd – £500; 3rd – £200; four commendations of £75.
Winners published in the Summer issue of *Poetry London*.

The Poetry Society National Poetry Competition

22 Betterton Street
London WC2H 9BX
Phone: 020 7420 9880
Fax: 020 7240 4818
Email: competition@poetrysociety.org.uk
Web: www.poetrysociety.org.uk

Established in 1978 by the Poetry Society. Entries are received from all over the world. The competition is open to over 18s. Poems must not exceed 40 lines (not including title) and each poem must be given a title. Poems must not have been previously published or broadcast, and must be the original work of the author. The cost for entry is £5.00 for the first poem and £3.00 for each one thereafter. If you join the Poetry Society (or are already a member) you get a second free entry, with subsequent poems at £3. Judges: Mark Ford, Alison Brackenbury and Bernadine Evaristo.

Closing date: 31 October.
Prizes: £5,000; £1,000; £500; 10 commendations of £50.

Pulsar Poetry Competition

Poetry Competition Administrator
Pulsar Poetry Magazine
34 Lineacre, Grange Park
Swindon SN5 6DA
Email: pulsar.ed@btopenworld.com
Web: www.pulsarpoetry.com

Poems of no more than 40 lines, on any subject. Open to everyone over 16 years of age. Entries must be the poet's own work, not previously published or currently submitted for another competition. Entry fee: £2.50 first poem; subsequent poems £1.00.

Closing date: Usually February.
Prizes: £100; £50; £25.

Winning and recommended poems are published in the June edition of *Pulsar*. A free copy of this edition is sent to every poet mentioned/published. Winners also receive a one year *Pulsar Poetry Magazine*, subscription.

Ragged Raven Press 8th Annual Poetry Competition and Anthology

1 Lodge Farm
Snitterfield
Stratford-on-Avon CV37 0LR
Phone: 01789 730358
Email: raggedravenpress@aol.com
Web: www.raggedraven.co.uk

Poems of any length and on any subject. Selected entries published in anthology. Entry fee: £3 per poem; £10 for 4 poems. Entry form/details from website or send sae to address above.
Closing date: 31 October.
Prizes: 1st – £250; four runners-up – £50.

Salmon Poetry Publication Prize

Salmon Publishing Ltd
Knockeven
Cliffs of Moher, Co. Clare
Ireland
Phone: +353 6570 81941
Fax: +353 6570 81621
Email: info@salmonpoetry.com.
Web: www.salmonpoetry.com

This biennial competition (next in 2006) is for a first collection of poetry from an Irish writer, or Irish resident. Manuscripts should contain at least 30 poems, but not more than 60. Each submission must be accompanied by a reading and processing fee of £10.00.

Closing date: July. Winners announced: September.
Prize: Publication of work.

Scottish International Open Poetry Competition

42 Tollerton Drive
lrvine
Ayrshire KA12 0ER
Web: www.irvineayrshire.org

The Scottish International Open Poetry Competition in association with Ayrshire Writers and Artists Society was founded in 1972 by Henry Mair and patron Hugh MacDiarmid.

The Competition is open to poets worldwide other than members of the aforementioned Society and Judges. Each poem must be the unaided work of the author; not previously published or broadcast. All entrants must be aged 16 years or over. Entries must be in English or Scots. Two entries only. There is no entry fee.

The competition is judged by members of the Society and by a national panel of judges. Winners will be announced at a prize-giving ceremony held in Irvine during the following March.

Closing date: 30 November.
First Prize – The MacDiarmid Trophy & £100.
International Section – The International Trophy.
Scottish Section – The Clement Wilson Trophy.

The Strokestown International Poetry Competition

Strokestown Poetry Festival
Strokestown
Co. Roscommon
Ireland
Phone: + 353 66 9474123, or + 353 71 9638540 (for information)
Email: pbushe@eircom.net or slawe@eircom.net
Website: strokestonpoetryprize.com

There are 3 categories

The Strokestown International Poetry Prize
– should be in English and not exceed 70 lines.

The Strokestown Prize for a poem in Irish, Scots Gaelic or Manx
– poems should not exceed 70 lines.

The Strokestown Prize for humorous political or topical satire in verse
– should be in English or Irish and not exceed 70 lines.

Entrants may submit an unlimited number of poems, in any of the categories. All poems must be the unpublished, original work of a living author. Entry fee: 5 (£4) per poem.

Shortlists will be announced in mid March, and prizes announced and awarded during the Strokestown International Poetry Festival, in April / May. Shortlisted competitors are expected to attend the prize-giving, and each will be invited to read a selection of his/her work at the festival for a fee of 300 plus 150 travelling expenses.

Copyright will remain with the competitor, but Strokestown Community Development Association reserves the right to arrange first publication or broadcast of selected poems as it sees fit.

Closing date: February.

Prizes:

The Strokestown International Poetry Competition
1st – 4,000; 2nd – 2000; 3rd – 1000.
In addition there will be up to seven commended poets who will be invited to read at the festival, for a reading fee and travelling expenses of 450.

The Strokestown Prize for a poem in Irish, Scots Gaelic or Manx
1st – 4,000; 2nd – 2,000; 3rd – 1,000; and 450 (reading fee of 300 and travel expenses of 150) for three other shortlisted poets.

The Strokestown Prize for humorous political or topical satire in verse
1st – 500; 2nd – 100; 3rd – 80.

Suffolk Poetry Society

2005 Crabbe Memorial Poetry Competition
Terence Butler, Competition Secretary
9 Gainsborough Road
Felixstowe IP11 7HT
Web: www.blythweb.co.uk/sps/spscomp.htm

Poets eligible are those who were born, educated or resident in Suffolk (for at least a twelve month period) or who are members of the Suffolk Poetry Society. Poems may be on any subject and in any form or style but must be in English and not exceed 50 lines. Poems must be the writer's own unpublished work (other than school or local publication) and must not have been broadcast or submitted previously to this competition or entered for any other current competition. Copyright of each poem entered remains with the author, who will grant Suffolk Poetry Society permission to publish any winning poem it may decide. An anthology of the winning and commended poems will be published in October 2005. Entry fee: £3 for the first poem; £1 for each additional poem.

Closing date: May 31st
Prizes: Winner will receive the Crabbe Memorial Silver Rose Bowl, engraved with the winner's name, to hold for one year, and £200; 2nd – £100; 3rd – £50.

Top 100 Poets of the Year

Forward Press Ltd
Remus House
Coltsfoot Drive
Peterborough PE2 9JX
Contact: Chiara Cervasio
Tel: 01733 898105
Fax: 01733 313524
Email (Enquiries): info@forwardpress.co.uk
Email (Submissions): inbox@forwardpress.co.uk
Web: www.forwardpress.co.uk

Forward Press Top 100 Poets of the Year first started in 1998. This poetry competition runs from November to October of the following year. A maximum of two poems of no more than 30 lines in length each, will be

considered. Entry is free. Every poem published by Forward imprints for that period is entered into the poetry competition.

100 poets share over £10,000 every year.

Prizes:
First Poetry Prize of £3,000.
2 x Second Poetry Prizes of £500.
4 x Third Poetry Prizes of £250.
10 x Fourth Poetry Prizes of £100.
83 x Top 100 Poetry Prizes of £50.
The top three winners have their own book published.

Christopher Tower Poetry Prizes

Christ Church
Oxford OX1 1DP
Phone: 01865 286591
Email: info@towerpoetry.org.uk
Web: www.towerpoetry.org.uk

An annual poetry competition open to 16-18 year olds in UK schools and colleges.

Poem no longer than 48 lines, on a different chosen theme each year. Entrants may submit only one poem. Entries must be written in English. Entrants must be in full or part-time education at a school, college or other educational institution in the United Kingdom.

Closing date: End of February.
Prizes: 1st – £1,500; 2nd – £750; 3rd – £500.
Each of the top prize-winners will also win a significant prize for their schools and colleges. Highly commended entries each receive £200.

John Tripp Award for Spoken Poetry

Academi
Mount Stuart House
Mount Stuart Square
Cardiff CF10 5FQ
Phone: 029 2047 2266
Email: post@academi.org
Web: www.academi.org

Academi has been holding events in tribute to John Tripp since 1990. The competition is open to all. Entrants have five minutes to impress the judges with their scintillating stanzas, vivacious verse and powerful performance. A series of regional heats throughout the country culminates in a Grand Final in Cardiff, with £500 in prizes on offer.

Judges will be looking for a combination of the quality of the performance and the quality of the poems read. Only poets reading their own work are eligible. Open to all those born in Wales or currently living in Wales. The poems performed are only eligible if they are: in English, have not been previously broadcast and are not translations of another author's work. Entry fee: £5.

The UKA Open Theme Poetry Competition

UK Authors
25 Quantock Close
Rubery, Rednal
Birmingham B4 0DT
Web: www.ukauthors.com

Entries must be made online. See website for details. Entry fee: £5 for the first entry, or £7 for three poems.

Prize: £50 and a poetry book of your choice from the UKA PRESS Bookshop

Closing date: 31st March.

Ver Poets Open Poetry Competition

181 Sandridge Road
St Albans AL1 4AH
Contact: Gillian Knibbs
Phone: 01727 762601
Email: gillknibbs@yahoo.co.uk

This annual competition is open to all. Entry forms available from above adress. Entry fee: £3.00 per poem; 4 poems £10.

Closing date: April 30th.
Prizes: 1st – £500; 2nd – £30; 3rd – £100.
Winning and selected poems are published in an anthology 'Vision On'.

Ware Poets Open Poetry Competition

The Competition Secretary
Clothall End House
California
Baldock SG7 6NU.

For poems of up to 50 lines.
Entry Fee: £3 for the first poem, £2 for additional poems.

Closing date: April 30th.
Prizes: 1st – £500; 2nd – £300; 3rd – £100.

Wells Festival of Literature

International Poetry Competition
The Competition Organiser
Creechbarn
Creech St Michael
Taunton TA3 5PP
Web: www.somersite.co.uk/wellsfest.htm

Poems should show imagination, skill and originality. The form need not be

traditional, but rhythm and scansion will be expected. Poems may be on any subject. They must not exceed 40 lines in length. A maximum of two poems may be entered by each poet. Entry Fee: £3.50 per poem.

Closing date: August.
Prize: 1st – £500; 2nd – £150; 3rd – £100.

Writers Bureau Poetry & Short Story Writing Competition

See main entry in literature.

Writer's Digest

See main entry in literature.

Writers' Forum Poetry Competition

Writers International Ltd
PO Box 3229
Bournemouth BH1 1ZS
Phone: 01202 589828
Fax: 01202 587758
Email: editorial@writers-forum.com
Web: www.writers-forum.com

Readers are invited to enter their poems for a competition to be held in each issue of *Writers' Forum*. Maximum length is 40 lines. No restriction on subject or theme. Poems must be unpublished

Entry fee: £5 for one poem or £7 for two.
Closing date:15th of every month.

Prize: 1st – £100; 2nd & 3rd – £25.

Writers inc

Web: www.writersinc-london.org.uk

See main entry in literature.

Writers' News

Web: www.writersnews.co.uk

Writers' News run monthly competitions – short story and poetry. See website for details

The British Comparative Literature Association and the British Centre for Literary Translation

(University of East Anglia)
Email: transcomp@uea.ac.uk
Web: www.bcla.org/trancall.htm

Awarded for the best unpublished literary translations from any language into English. Literary translation includes poetry, prose, or drama, from any period. Entry fee: £5.00 per entry. See website for detailed requirements.Winning entries will be published in the annual journal *Comparative Criticism* (C.U.P.).

Closing date: January. Winners announced: July on the BCLA website.

Prizes: 1st – £350; 2nd – £200; 3rd – £100.

John Dryden Translation Competition

Dr Jean Boase-Beier
John Dryden Translation Competition
School of Language, Linguistics and Translation Studies
University of East Anglia
Norwich NR4 7TJ
Email: transcomp@uea.ac.uk
Web: www.bcla.org

The British Comparative Literature Association and the British Centre for Literary Translation (University of East Anglia) jointly sponsor the translation competition for 2005. Prizes are awarded for the best unpublished literary translations from any language into English. Literary translation includes poetry, prose, or drama, from any period. Entry fee: £5 per entry.

Prize-winners will be announced on the BCLA website, and prizes presented later in the year. Winning entries are published in full on the website, and extracts from winning entries are eligible for publication in the BCLA's journal *Comparative Critical Studies*.

Prize: 1st prize: £350; 2nd prize – £200; 3rd prize – £100; other entries may receive commendations.

French Ministry of Culture – Grants to Literary translators

Cultural Department
French Embassy
23 Cromwell Road
London SW7 2EL

Contact: Yann Perreau, Book Attaché
Phone: 020 7838 2073
Fax: 020 7838 2088
Email: bdl@ambafrance.org.uk
Web: www.frenchbooknews.org.uk

The French Ministry of Culture provides funding for translators wishing to stay in France in order to translate French works in the fields of literature or the humanities. The translator must be working on a commissioned translation and have a contract with a publisher. Grants are awarded by the Directeur du Livre after consultation with a committee of translators, publishers and Ministry representatives. This committee meets during the last quarter of each calendar year. The grants awarded to each translator is for the sum of 10,000FF per month for one to three months, excluding travel expenses.

Independent Foreign Fiction Prize

Arts Council England
14 Great Peter Street
London SW1P 3NQ
Phone: 0845 300 6200
Fax: 020 7973 6590
Web: www.artscouncil.org.uk

The £10,000 prize honours a great work of fiction by a living author which has been translated into English from any other language, and published in the UK. The prize is shared equally between the author and the translator.

Publishers wishing to enter books should contact the Literature Department.

Shortlist announced: February. Winner announced: April.

Prize: £5,000 is awarded to the winning author and £5,000 to the winning translator at a ceremony each April.

Supported by the Arts Council and promoted by The Independent newspaper.

Marsh Award for Children's Literature in Translation

Gillian Lathey
The National Centre for Research into Children's Literature
Digby Stuart College, University of Surrey Roehampton
Roehampton Lane
London SW15 5PU
Phone: 020 8392 3008
Fax: 020 8392 3819
Email: G.Lathey@roehampton.ac.uk

Aims to encourage the translation of foreign children's books into English. It is a biennial award open to British translators of books for 4-16 year olds, published in the UK by a British publisher. Any category will be considered with the exception of encyclopaedias and reference books. No electronic books. The award is made to the translator. Most recent award 2003

Prize: £1,000.

Sponsor: The Marsh Christian Trust.

The Corneliu M Popescu Prize for European Poetry Translation

The Poetry Society
22 Betterton Street
London WC2H 9BX
Phone: 020 7420 9895
Email: competition@poetrysociety.org.uk

The Corneliu M Popescu Prize for European Poetry Translation is named after Corneliu M Popescu, translator of the work of one of Romania's leading poets, Mihai Eminescu, into English. Popescu was killed in the violent earthquake of March 1977, aged 19.

This biennial prize is open to collections of poetry published in the preceeding two years which feature poetry translated from a European language into English.

Closing date: end of May (2005/07)

Prize: £1,500.

Revelations – The Gate Translation Award

The Gate Theatre
11 Pembridge Rd
Notting Hill
London W11 3HQ
Phone: 020 7229 5387
Fax: 020 7221 6055
Contact: Penny Black, Literary Manager
Email: literary@gatetheatre.co.uk (but not scripts)
Web site: www.gatetheatre.co.uk

Biennial award for the translation of a dramatic work either by a translator or playwright working from a literal translation. The winning script will be produced at the Gate Theatre and published by Oberon Books, the short-listed plays will be given a staged reading. Next deadline February 2006.

Award: £2,000.

Translation at the Gate Theatre is supported by the Moose Foundation.

Stephen Spender Prize for Poetry Translation

Stephen Spender Memorial Trust
20 Kimbolton Road
Bedford MK40 2NR.
Phone: 01234 266392
Email: r.pelhamburn@abingdon.org.uk
Web: www.stephen-spender.org

2004 was the inaugural year of the prize, which is for poetry translation. Entrants may translate a poem from any language, classical or modern. Open to British residents. A primary aim of the Trust is to continue Stephen Spender's work in the field of literary translation by helping contemporary

writers of prose and poetry reach an English-language readership and by facilitating translation projects which otherwise would not be viable. The Trust gives up to £5,000 a year in grants for translation projects. Applicants for a translation grant should first read the criteria at www.stephen-spender.org

For details and entry forms visit the website or write enclosing a SAE to the address above.

Cash prizes in two categories – 18 and under, and Open (with first, second and third at each level). The best entries will be published in The Times and in a commemorative booklet.

Sponsored by *The Times*.

TLS-Porjes Prize for Hebrew Translation

The Jewish Book Council
POB 38247
London NW3 5YQ
Phone/Fax: 020 8343 4675
Email: info@jewishbookweek.com
Web: www.jewishbookcouncil.com

In 1998 the Jewish Book Council unveiled a new initiative, the TLS-Porjes Prize for Hebrew-English Translation, to promote recognition of the skills of Hebrew-English translators. The award is sponsored by the Porjes Trust and the Times Literary Supplement, and administered by the Jewish Book Council.

The prize of £2,000 is awarded to the winning translator of a full-length book of general interest and literary merit.

The awards are made every three years, the last being in 2004 for books published between 2001 and 2003. For details of next prize see website.

The Translators Association Prizes

Society of Authors
84 Drayton Gardens
London SW10 9SB
Phone: 020 7373 6642
Fax: 020 7373 5768
Email: info@societyofauthors.org
Web: www.societyofauthors.org

The Translators Association prizes are listed below. Entries should be submitted by the publisher. The closing date is December each year. There is no limit on the number of submissions that can be made by a publisher.

Dutch/Flemish Translation: The Vondel Translation Prize £2,000

A biennial prize for translations into English of Dutch and Flemish works of literary merit and general interest. The translation must have been first published in the UK or the USA during the two years up to and including the final year of entry. Next deadline: 2006.

French Translation: The Scott Moncrieff Prize £2,000

An annual prize for full length French works of literary merit and general interest. The original must have been first published in the last 150 years. The translation must have been first published in the UK in the year of entry.

German Translation: The Schlegel-Tieck Prize £2,000

An annual prize for translations of full length German works of literary merit and general interest. The original must have been first published in the last 100 years. The translation must have been first published in the UK in the year of entry.

Greek Translation: The Hellenic Foundation for Culture Translation Prize £1,000

A triennial prize for a translation from modern Greek into English of full-length works of imaginative literature (prose, poetry or drama). The translation must have been first published in the three years up to and including the final year of entry. The publisher may be based anywhere in the world but the translation must have been available for purchase within the United Kingdom. Next deadline: 2007.

Italian Translation: The John Florio Prize £2,000

A biennial prize for the translations of full length Italian works of literary merit and general interest. The original must have been first published in the last 100 years. The translation must have been first published in the UK in the two years up to and including the year of entry. Next deadline: 2006.

Portuguese Translation: The Calouste Gulbenkian Prize £1,000

A triennial prize for translations of full length Portuguese works of literary merit and general interest. The original must have been published in the last 100 years. The translation must have been first published in the UK in the three years up to and including the year of entry. Next deadline: 2007.

Spanish Translation: The Premio Valle Inclán £1,000

An annual prize for translations of full length Spanish works of literary merit and general interest. The original must have been written in Spanish but can be from any period and from anywhere in the world. The translation must have been first published in the UK in the year of entry.

Swedish Translation: The Bernard Shaw Prize £1,000

A triennial prize for translations of full length Swedish language works of literary merit and general interest. The original can be from any period. The translation must have been first published in the UK during the three years up to and including the year of entry. Next deadline: 2005.

Weidenfeld Translation Prize

Administered by:
Dr Karen Leeder
New College
Oxford OX1 3BN
Tel: 01865 279525
Fax: 01865 279590
Email: karen.leeder@new.ok.ac.uk

Annual prize. Awarded to the translator or translators of a work of fiction, poetry or drama written in any living European language by any author, living or dead. The translation must be into English and may be the work of up to three translators.

Submission by publisher only.
Prize: £1,000.

Welsh Literature Abroad

Canolfan Mercator Centre
Y Buarth
Aberystwyth SY23 1NN
Phone: 01970 622 241/544
Fax: 01970 621 524
Email: llcd-wla@llcd-wla.org
Web: www.welsh-lit-abroad.org

WLA's translation grants are open to foreign publishers for the translation of Wales' two literatures (Welsh and English language literature). In the case of translations of Welsh-language literature into English, publishers in the UK can also apply. Applications are assessed by Welsh Literature Abroad's grants panel. A sample of the translator's work is assessed by an external reader where necessary (e.g. if the translator's work is not previously known to WLA).

Up to 100% of the translator's fees is available. Grants for sample translations also available. The translation must be published within 30 months from the translation grant offer date.

Download application form from website.

Closing dates: 1st of March; 1st of June; 1st of September; 1st of December.

Writers in Translation

English PEN
6-8 Amwell Street
London EC1R 1UQ
Contact: Catherine Speller
Phone: 020 7713 0023, 07977 573 321
Fax: 020 7837 7838
Email: catherine@englishpen.org

This is a new programme for English PEN extending the organisation's work into literary translation.

Writers in Translation awards grants to UK publishers to assist with promoting and marketing works they have contracted to publish in English translation. In association with the publisher, Writers in Translation devises a promotional strategy designed to increase public awareness of the title, and of translated literature in general.

Publishers are asked to submit a sample translation of the work to the programme coordinator, as well as supporting information about the work. This material is assessed by the programme's Steering Committee, which consists of prominent translators, publishers, writers and other industry professionals. The committee meets twice-yearly to discuss material, and will choose one title for the programme to support at each meeting.

The programme will consider both fiction and non-fiction. All works submitted to the programme must adhere to PEN's aims, and should either:

- explore a freedom of expression or human rights issue
- contribute in some way towards inter-cultural understanding through illuminating an aspect of another country or culture

Up to £4,000 will be available to support a title. Funds will be allocated at the discretion of English PEN. The grants are open to all UK publishers for works that are under contract to be translated into and published in English.

There are two rounds of submissions per year.

funding agencies

England

The national office of Arts Council England is in London. In addition there are nine regional councils.

Arts Council England, National Office
14 Great Peter Street
London SW1P 3NQ
Phone: 0845 300 6200
Fax: 020 7973 6590
Textphone: 020 7973 6564
Web: www.artscouncil.org.uk

Arts Council England, East
Eden House
48-49 Bateman Street
Cambridge CB2 1LR
Phone: 0845 300 6200
Fax: 0870 242 1271
Textphone: 01223 306893

Arts Council England, East Midlands
St Nicholas Court
25-27 Castle Gate
Nottingham NG1 7AR
Phone: 0845 300 6200
Fax: 0115 950 2467

Arts Council England, London
2 Pear Tree Court
London EC1R 0DS
Phone: 0845 300 6200
Fax: 020 7608 4100
Textphone: 020 7973 6564

Arts Council England, North East
Central Square
Forth Street
Newcastle upon Tyne NE1 3PJ
Phone: 0845 300 6200
Fax: 0191 230 1020
Textphone: 0191 255 8500

Arts Council England, North West
Manchester House
22 Bridge Street
Manchester M3 3AB
Phone: 0845 300 6200
Fax: 0161 834 6969
Textphone: 0161 834 9131

Arts Council England, South East
Sovereign House
Church Street
Brighton BN1 1RA
Phone: 0845 300 6200
Fax: 0870 242 1257
Textphone: 01273 710659

Arts Council England, South West
Bradninch Place
Gandy Street
Exeter EX4 3LS
Phone: 0845 300 6200
Fax: 01392 229229
Textphone: 01392 433503

Arts Council England, West Midlands
82 Granville Street
Birmingham B1 2LH
Phone: 0845 300 6200
Fax: 0121 643 7239
Textphone: 0121 643 2815

Arts Council England, Yorkshire
21 Bond Street
Dewsbury
West Yorkshire WF13 1AX
Phone: 0845 300 6200
Fax: 01924 466522
Textphone 01924 438585

Northern Ireland

The Arts Council of Northern Ireland
MacNeice House
77 Malone Road
Belfast BT7 3AN
Phone: 028 90385200
Web: www.artscouncil-ni.org

Scotland

Scottish Arts Council
12 Manor Place
Edinburgh EH3 7DD
Phone: 0131 226 6051
Fax: 0131 225 9833
Help Desk on 0845 603 6000 (local rate within the UK).
Web: www.scottisharts.org.uk

Wales

The Arts Council Wales has its main office in Cardiff and two regional offices:

Arts Council Wales
Central Office
9 Museum Place
Cardiff CF10 3NX
Phone: 029 20 376500
Fax: 029 20 221447
Minicom: 029 20 390027
Web: www.artswales.org

Mid & West Wales Office
6 Gardd Llydaw
Jackson's Lane
Carmarthen SA31 1QD
Phone: 01267 234 248
Fax: 01267 233 084
Minicom: 01267 223 496

North Wales Office
36 Prince's Drive
Colwyn Bay LL29 8LA
Phone: 01492 533 440
Fax: 01492 533 677
Minicom: 01492 532 288

Arts Council England

Below is a summary of the main types of grant available through Arts Council England. Full details on their website.

Grants for the arts – individuals, organisations and national touring.

A three year plan was announced in 2003 describing how grant-in-aid (direct grant from the Government) and the National Lottery good causes fund would be invested for the period 2003/06. You can apply at any time until 31 August 2005. You will be able to apply to the new Grants for the arts programme from 1 October 2005, and application packs will be available in the late summer 2005. The new programme will broadly be the same as the existing one.

Grants for the arts are for individuals, arts organisations, national touring and other people who use the arts in their work. They are for activities that benefit people in England or that help artists and arts organisations from England to carry out their work.

All the documents you need to make an application are available to download from the website. These include guidance notes, the application form and information sheets.

Aims of Grants for the arts

ACE invests in the arts across England by making grants available under five aims:

- To change people's lives through the opportunity to take part in or experience high quality arts activities
- To increase opportunities for cultural diversity in the arts. By 'cultural diversity', we mean the full range and diversity of the culture of this country. In some cases our focus will be on race and ethnic background, and in others on disability, for example
- To support excellence, new ideas and activity to help build long-term stability in arts organisations
- To invest in the creative talent of artists and individuals
- To increase resources for the arts

Who can apply

- Artists, performers, writers, promoters, presenters, curators, producers and other individuals working in the arts
- arts organisations
- local authorities and other public organisations
- partnerships, collectives, and regional and national organisations
- organisations whose normal activity is not arts-related, including voluntary and community groups
- groups of organisations or individuals.

Your application must take place mainly in England. There are some exceptions to this, for example, when artists are involved in professional development activities in other countries.

Organisations receiving regular funding from ACE can only apply if their lead officer agrees in writing beforehand. Individuals working for organisations with regular funding from ACE may only apply for training, professional development and travel grants in certain circumstances and if the money is not available through their employer.

You are expected to find at least 10% of the cash you need for your activity from other sources.

In special circumstances ACE will provide a grant for the total cost of your activity. These circumstances could include bursaries for individuals or situations where there are few opportunities for raising money from other sources.

Grants for individuals

Individuals can apply for grants for arts-related activities which might include:

- projects and events
- commissions and productions
- research and development
- capital items (such as equipment)
- professional development and training, including travel grants
- bursaries
- fellowships
- residencies
- touring

Your application can cover more than one type of activity.

Grants normally range from £200 up to a total of £30,000, and can cover activities lasting up to three years. We can award larger grants for major projects and residencies. Most grants will be under £30,000.

Grants for organisations

Arts organisations and other people who use the arts as part of their work can apply for grants for arts-related activities. This might include:

- projects and events
- activities for people to take part in
- education activities
- research and development
- commissions and productions
- marketing activities
- 'audience development'
- capital items (such as equipment and improvements to facilities and buildings)
- professional development and training
- organisational development to improve the long-term stability of arts organisations
- touring

Your application can cover more than one type of activity.

Grants normally range from £200 up to a total of £100,000, and can cover activities lasting up to three years. Most grants will be under £30,000.

Grants for national touring

National touring means touring in two or more Arts Council England regions. ACE can support work of all kinds and scales to tour in England. They can also consider tours where up to 15% of the planned tour is in Northern Ireland, Scotland and Wales. Grants can help cover costs associated with time-limited, not-for-profit tours.

Grants for national touring are available for individuals and organisations, and normally range from £5,000 up to a total of £200,000. You can apply for a grant to cover activities lasting up to three years. Most grants will be under £100,000.

The Arts Council of Northern Ireland

Web: www.artscouncil-ni.org/

SIAP – Support for the Individual Artist Programme

Travel Awards Scheme

Travel Awards are offered to people working in the arts in Northern Ireland to travel outside Ireland in advancement of their skills and expertise, or the furtherance of their career. Website gives guidance on how much is available to specific destinations e.g. East Coast USA £500 (June-August) £300 (September-May). Priority will be given to practising individual artists.

Artists of all disciplines and in all types of working practice, as well as technical and administrative staff who:

- have made a contribution to artistic activities in Northern Ireland for a minimum period of one year; and
- are domiciled in Northern Ireland.

General Art Awards Scheme

General Art Awards are offered to artists in Northern Ireland, for specific projects, specialised research, personal artistic development and certain materials/equipment.

Awards of up to £5,000 in total inclusive of any materials, equipment, professional services are offered in this scheme.

Artists of all disciplines and in all types of working practice, as well as technical staff, who:

- have made a contribution to artistic activities in Northern Ireland for a minimum period of one year; and
- are domiciled in Northern Ireland.

Priority will be given to practising individual artists. Special priority will be given to artists whose work is challenging and innovative, especially in areas of new technology. Students applying for a General Arts Award are eligible subject to the domicile requirement and who can demonstrate their contribution to artistic activities in Northern Ireland.

Collaborative applications from individual artists working together in cross-discipline projects/activities are encouraged. One application form should be used for the complete collaborative project. Collaborative projects are not eligible for more than the standard £5,000 limit.

Closing date: 8 September.

Artists in the Community Scheme

Awards are offered under the Artists in the Community scheme to an artist or artists for a residency of up to 6 months with community groups or organisations. In this scheme the artist/artists would be expected to work for 3 days per week (or the equivalent), with a number of community groups in a workshop context, with a view to producing work from their groups for publication, performance or exhibition at the conclusion of the residency, possibly in conjunction with his/her/their own work.

Five awards of £10,000 each are available. These awards cover fees, travel and subsistence.

Artists of all disciplines and in all types of working practice who:

- have made a contribution to artistic activities in Northern Ireland for a

minimum period of one year; and
- are domiciled in Northern Ireland.

By arrangement with:

- Arts organisations.
- Arts Centres.
- Organisations without a primary purpose of arts promotion but which want to use the arts to promote their work.
- Community associations/consortia of community associations.

Major Individual Awards Scheme

Three Major Awards are offered to create the circumstances in which established artists can develop individually with a view to attempting extended or ambitious work. One of these awards each year will be discipline-specific. In 2005/06 the discipline will be Poetry.

3 awards of £15,000 each are offered in this scheme.

Artists of all disciplines and in all types of working practice who:

- have made a contribution to artistic activities in Northern Ireland for a minimum period of one year; and
- are domiciled in Northern Ireland.

Closing date: 9 June.

The Arts & Disability Award Scheme

The Arts & Disability Awards Ireland are an innovative partnership between the Arts Councils of Ireland and the Arts and Disability Forum. Awards of up to £5,000 are offered in the scheme. The Awards, now in their fourth year, are designed to celebrate work of quality and innovation by disabled artists throughout Ireland. This year there will be two opportunities during the year to apply for awards.

Details and Application forms from:
The Arts and Disability Forum
Cathedral Quarter
109-113 Royal Avenue
Belfast BT1 1FF

Arts and Artists Abroad

As part of its strategy to enhance the international profile and reputation of Northern Irish arts, awards are offered for individual artists and arts organisations/groups who have experience in or proven potential for exhibition, performance or other artistic presentation in the international arena, to present their work abroad. New work from Northern Ireland will be prioritised.

The Arts Council of Northern Ireland will also consider applications from individual artists and arts organisations/groups wishing to present their work in other regions of the UK (i.e. Scotland, Wales and England) and in the Republic of Ireland. However, priority will be given to applications dealing with presentations/performances/exhibitions etc. outside the UK and the Republic of Ireland.

The total annual budget available in this scheme will be £60,000. The Arts Council will normally fund up to fifty per cent (for organisations) or seventy-five per cent (for individuals) of travel, accommodation, visas, subsistence, carriage, insurance and approved exhibition/performance costs.

Who can apply?

- Individual artists and arts organisations/groups of all disciplines and in all types of working practice.

- Arts organisations/groups must be based in Northern Ireland, and show both a credible track record of contributing to artistic activities here and a commitment to a continued artistic programme in Northern Ireland in the future. Applications from arts organisations/groups with experience of international work and/or annually supported by the Arts Council of Northern Ireland (under ASOP) will be prioritised.

Closing date: 8 September.

Arts and Disability Networking Abroad

As part of its strategy to enhance the European and International profile and reputation of artists with a disability and Arts & Disability organisations/ groups, the Arts Council of Northern Ireland offers awards for individual artists and arts organisations/groups who have experience in or proven potential for exhibition, performance or other artistic presentation on an international basis, to present their work abroad. The Arts Council also wishes to encourage the development of European/international strategic networking potential within the Arts and Disability sector.

The Arts Council of Northern Ireland will consider applications from individual artists and arts organisations/groups working in the Arts and Disability sector who wish to present their work in other regions of the UK, or to develop new networks and partnerships in Scotland, Wales and England and in the Republic of Ireland.

The total budget available in this scheme will be £5,000. The Arts and Disability Networking Abroad Scheme will normally fund up to ninety per cent (for organisations/groups or individuals) of travel, disability support costs (e.g. carers), accommodation, visas, subsistence, carriage, insurance and approved exhibition/performance and/or networking costs.

Scottish Arts Council

Web: www.scottisharts.org.uk

The Scottish Arts Council is the principal channel of public funding for the arts in Scotland. As an 'arm's length' body they are independent from, but accountable to the Scottish Executive, from which most funding is received. They also distribute funds from the National Lottery to the arts in Scotland. The main aim of lottery funding is to support arts projects which make an important and lasting difference to the quality of life for the general public.

Applications are accepted from individuals and organisations.

Funds for individuals:

Crafts funding priorities

Start Up – To encourage new makers with a high level of creativity and skill, who have a viable development plan, to establish themselves as practitioners in Scotland. Funding is available to assist with maintenance and the cost of equipment for production.

Minimum £3,000 – maximum £8,000
Closing dates: 4 April, 10 October.

Creative Development – To encourage established makers to create new work. Funding is available to buy time and/or additional equipment to develop work in new directions and promote the results.

Minimum £5,000 – maximum £8,000
Closing date: 4 April, 10 October.

Literature funding priorities

Writers' Bursaries – Assistance to enable published writers of literary work and playwrights to devote more time to their writing.

Minimum £3,000 – maximum £15,000
Closing date: 4 July, 16 January 2006.

New Writers' Bursaries – Bursaries of £2,000 are available to assist writers of literary work and playwrights with little publishing or production track record to create new work.

Closing date: 4 April.

Storytellers' Bursaries – For research and development of creative work.

Minimum £1,500 – maximum £5,000
Closing date: 4 July, 16 January.

Visual Arts funding priorities

Creative and professional development – To assist individual artists with the immediate costs involved in producing and presenting work.

Minimum £1,000 – maximum £5,000
Closing date: 4 April, 10 October, 16 January 2006.

Creative and professional development bursaries – Bursaries of £15,000 are available to buy time for exploration of new ideas and/ or realisation of significant projects.

Closing date: 10 October.

Artist Film and Video – A fund run jointly by the Scottish Arts Council and Scottish Screen. Awards are available to support innovative and experimental

work by visual artists using film and video. A total budget of £50,000 is available.

Minimum £5,000 – maximum £15,000.
Closing date: 10 October.

Amsterdam Residency 2006 – Bursary of £16,000 to support an artist to live and work for 12 months (January 2006 to January 2007) in a furnished studio/ apartment in Amsterdam.

Closing date: 4 July.

New York Residency 2005 – Bursary of £12,000 to support an artist to live and work for nine months (October 2005 – June 2006) in a furnished apartment in New York.

Closing date: 4 July.

New Media Residency 2005 – Bursary of £10,000 to support an artist for nine months (October 2005 – June 2006) at the University of Abertay, Dundee.

Closing date: 4 July.

Funding for individuals across artforms

Creative Scotland Awards 2006 – The Scottish Arts Council Creative Scotland Awards of £30,000 to support Scotland's leading artists. The awards provide a unique opportunity for artists to experiment and realise imaginative ideas in a major project. Guidelines and application forms available late summer 2005.

Closing date: 28 October 2005. Shortlist decided: December 2005. Awards announced: mid-March 2006.

Professional development

This fund offers assistance for individual artists in most artforms working at a professional level in the arts in Scotland, and representatives of arts organisations, supporting their role in the development of the sector.

Funding is available for:

- short-term or one-off training courses
- conference fees
- masterclasses
- mentoring
- travel to see work
- undertaking research
- establishing contacts and partnerships
- exploring opportunities for future projects.

Applications are particularly welcome from disabled artists and artists from minority ethnic backgrounds.

Minimum £75 – maximum £2,000.
Applications are accepted throughout the year.

Funding for organisations

Crafts funding priorities

We will support organisations in:

- projects which ultimately improve the quality and quantity of crafts exhibitions
- related educational programmes, shown, initiated and circulated in Scotland

Minimum £250 – no maximum

Closing date for applications £5,000 and over: 4 April, 10 October, 16 January 2006. Applications under £5,000 see website.

Literature funding priorities

Writers Factory

ScottishArts are planning to launch a new Block Publishing Grants scheme in Spring 2005 which will enable established publishers to apply for funding for multiple titles in a single application.

Publications – To assist established Scottish-based publishers of books and magazines with the publication of works of literary/cultural merit that represent some financial risk.

Books: Minimum £500 – maximum £5,000.
Magazines: Not fixed, but likely to be in the range £2,000 - maximum £14,000.
Closing dates: Books: 4 April, 4 July, 10 October, 16 January 2006.
Magazines: 16 January 2006.

Writing Fellowships – Assistance for organisations to employ writers to develop their own work in the context of dynamic opportunities within specific communities.

Grants are available to cover the writer's fee, which would typically be a minimum of £18,000 per annum or pro rata. Up to 50% partnership funding required for most projects.

Closing date: 4 April, 4 July, 10 October, 16 January 2006.

Literature Development Workers – Support for appropriate host communities to create full-time posts to assist literature development with an emphasis on creative reading and writing.

Grants are available to cover postholder's salary, which would typically be a minimum of £18,000 per annum or pro rata. 50% partnership funding required.

Closing dates: 4 April, 4 July, 10 October, 16 January 2006.

Festivals and spoken word events – For live literature events of quality and strategic importance

Minimum £2,000 – maximum £20,000.
Closing date: 16 January 2006.

Translation – To assist publishers overseas with the cost of translating works of 20th century and contemporary Scottish literature.

Minimum £100 – maximum of up to 90% of translation fee, subject to a limit of £5,000.

Closing date: 4 April, 4 July, 10 October, 16 January 2006.

Storytelling live – Support for storytelling projects and festivals, including residencies.

Minimum £1,500 – maximum £10,000.
Closing date: 4 April, 16 January 2006.

Visual Arts Funding

See website for updates. Current funds exhausted.

Funding for organisations across art forms

Access and Participation – To support projects which increase access to the arts. We will prioritise projects which help overcome economic, social, cultural or geographical barriers to involvement in the arts.

Minimum £5,000 – maximum £50,000.
Closing date: 4 April, 10 October.

Arts in the Community (Festivals and Promoters) – For small-scale promoters and festivals for activity involving professional artists. Projects which involve professional artists working in a community setting are encouraged. Proposals must involve more than one artform. Priority will be given to proposals which take place in social inclusion areas of low arts provision.

Minimum £100 – maximum £5,000.
There are no deadlines. Applications are accepted throughout the year.

Audience development – To support projects designed to increase and broaden audiences through new marketing activity, innovative approaches or research.

Priority given to applications focusing on under-represented audience segments (e.g. disabled people, minority ethnic communities, new and lapsed attenders).

Minimum £5,000 – maximum £75,000.
Closing date: 4 April, 10 October.

Awards for All – This small lottery grants scheme is run jointly by all Scottish lottery distributors, including the Scottish Arts Council. Grants of between £500 and £5,000 are available to community groups with an annual income of less than £20,000. For an application pack contact the Awards for All hotline number: 0845 600 2040

Children and young people – To support projects which increase opportunities for children and young people (up to the age of 18) to enjoy the arts. This can include the production of new work.

Minimum £5,000 – maximum £50,000.
Closing date: 4 April, 10 October.

Creative industries – Ideasmart is an award scheme for people with ideas which require early-stage investment to bring them towards market readiness. The scheme is open to individuals or micro businesses in the areas of architecture, crafts, visual arts, design, fashion, film and video, computer games, music, the performing arts, publishing, television or radio. Ideasmart is looking for innovation and creativity in products, process and business models. See www.ideasmart.org for further information.

Cultural diversity – To support projects which encourage artistic and organisational development in organisations from a minority ethnic background and from other arts organisations which demonstrate a commitment to diverse arts activities.

Minimum £3,000 – maximum £20,000.
Closing date: 4 April, 10 October.

Partners: Scotland's Artist Residency Programme – To support artist residencies of three months to two years based in, and working in collaboration with, a local community. Priority given to proposals in social inclusion areas or which involve people who have few or no opportunities to participate in the arts. As part of the residency the artist will also have time to develop their own work.

Minimum £4,000 – maximum £40,000.
Closing date: 4 July.

Arts Council Wales

Below is a summary of the main types of grant available through Arts Council Wales. Full details on their website.

All applications must be for work that reflects ACW's funding priorities. You may only hold one Training grant and one other grant at any one time.

Project Grants, £250 – £5,000

This level of grant is to allow individuals to explore project ideas or to build their creative, artistic and professional capability over time. If your project includes an element of production, you must have a partner organisation who will present your work in Wales. Applicants will need to demonstrate their ability to manage public funds effectively. You may only have one of these grants per year, measured from the date the project starts.

Production Grants, £5,001 – £20,000

This level of grant is to support artists in the creation of a new artistic product in collaboration with a new partner organisation who will present their work in Wales. For new touring product, existing partnerships will be considered. Work must be innovative and artistically challenging. You may only have one of these grants per year, measured from the date the project starts.

Creative Wales Awards, £5,001 – £10,000

These enable artists to develop their creative practice. This might include the creation of new, experimental and innovative work that takes forward the art form and artistic practise. Artists may propose taking time away from their usual commitments in order to concentrate on developing their work. It enables practising artists working in any creative discipline, or across disciplines, to enhance and refresh their skills, creativity and creative partnerships. You must have an established track record in your art form. You may only have one of these grants every three years, measured from the date the project starts.

Creative Wales Awards, £20,000 or £25,000

In addition to the above, artists should demonstrate a consistent level of achievement and contribution within their area of professional practise in Wales. For applications of £25,000 the projects must include a strong element of production. You may only have one of these grants every three years, measured from the date the project starts.

Training, £250 – £2,000

This type of grant aims to support individuals wishing to undertake or purchase training within Wales, the UK or abroad. It also aims to support the provision of all artistic, creative, technical, business and marketing training in the arts in Wales. You may only have one of these grants per year, measured from the date the project starts. However training grants may also be held alongside the other types of grants described above.

Eligibility Criteria

You must:

- Be able to demonstrate originality and excellence in your work and seriousness of purpose (for grants above £5,000 applicants must have been in practise for at least two years),
- Be aged 18 or over and not in full-time education,

- Live in Wales and demonstrate a commitment to Wales.

For Training: in addition, those undertaking training must:

- Have an appropriate career development plan,
- Be aged 16 or over and not in full-time education.

To be eligible, your proposed project must:

- Take place in Wales, although up to 15% of touring costs may be for activity in other parts of the UK and training courses may take place outside Wales,
- Be new, time limited activity that is additional to your usual professional practise,
- Include an appropriate level of partnership funding, in cash or in kind as appropriate, with at least 10% from a non-lottery and non-ACW source,
- Allow enough time before the date you wish to start the project for the application process and for thorough planning.

Closing dates: 2005/2006

Project Grants, £250 – £5,000: 14 June, 14 October, 14 December.
You must allow a minimum of 3 months between the application deadline and the date you wish to start your project.
Production Grants, £5,001 – £20,000: 21 April, 21 July, 7 October, 27 January.
You must allow a minimum of 5 months between the application deadline and the date you wish to start your project.
Creative Wales Awards, £5,001 – £10,000 and £20,000 or £25,000 : 3 October.
Training, £250 – £2,000: 14 April, 16 May, 14 June,15 August, 14 September, 14 October, 14 December, 16 January, 14 February, 14 March.
You must allow a minimum of 3 months between the application deadline and the date you wish to start your project.

ACW can consider applications for up to 90% of the eligible costs of a project.

Other ACW Schemes for Individuals

International Opportunities Fund

Funding to encourage professional arts practitioners and presenters to explore established and potential partnerships with practitioners, presenters and producers in countries outside the UK. Support is available for overseas visits aimed at the development of international work in Wales, and the development and delivery of activity outside the UK. Proposals should have a collaborative focus.

For further information contact: Rhys Edwards, Wales Arts International, 28 Park Place, Cardiff CF10 3QE. Phone: 029 20383037, Fax: 029 20398778, Email: rhys.edwards@wai.org.uk. Web: www.wai.org.uk

Agency Aministered Schemes

Artists in Residence Programmes, Artworks Wales

Funded through the Arts Council of Wales, Artworks Wales runs a national Artist in Residence programme. The programme is designed to support organisations and community groups who wish to collaborate with an artist for a minimum period of six weeks and can offer up to 50% of project costs. Artworks Wales also offers full project management support from scoping and developing a project, including calculating the project budget, to assistance in recruiting, appointing and contracting artists, project monitoring and trouble-shooting.

Artworks Wales offers three residency-related schemes designed to enable individual artists to engage proactively with communities and businesses, and to train alongside more experienced artists. Details of all of these schemes are available from Artworks Wales. This grant scheme is designed to fulfil the needs of artists by providing funding for projects that develop their artistic practice and to help alleviate the associated administration. Grants of up to £6,000 are available to artists who have project initiatives that involve community collaboration and that demonstrate innovative thinking and artistic practice.

Details of the schemes for artists are advertised nationally through a-n, artists' newsletter, through Crefft/Artists' Notes (deadlines permitting), through the art website www.artx.co.uk and through the Artworks Wales website and database www.cywaithcymru.org

For further information contact: The AiR Administrator, Artworks Wales, 11-12 Mount Stuart Square, Cardiff CF10 5EE. Tel: 029 2048 9543. Email: info@cywaithcymru.org.

5 Counties Competition, 49
Aberdeen Art Gallery, 89
Academi Cardiff Int. Poetry Competition, 267
Academy of Children's Writers
 Write a Story for Children Competition, 185
Academy Schloss Solitude, 159
Ackerley, JR Ackerley Prize for Autobiography, 185
Adams, Ansel Adams Research Fellowship, 111
AgfaPhoto GmbH
 International Agfanet Photo Award, 111
Alexia Foundation
 Professional Alexia Grant, 112
 Alexia Annual Photo Contest – Students, 112
 Awards of Special Recognition, 113
Alt-w, 9
Amnesty International Poetry Competition, 267
Andersen, Hans Christian Andersen Awards, 185
Anglo-Brazilian Society
 BAT/Souza Cruz Scholarship, 9
Angus Book Award, 186
Aramby Publishing, 268
Arcimboldo Award for Digital Creation, 113
Arles Photography Book Prize, 114
Art Plus, 49
Artes Mundi Prize, 50
Arts and Crafts in Architecture Awards, 50
Arts and Science Research Fellowships, 10
Arts Grants Committee (Sweden), 51
Artworks: Young Artists of the Year Awards, 51
Arvon Foundation, 268
Asham Award, 186
Ashley, Laura Ashley Foundation, 10
Association of Mouth and Foot Painting Artists, 52
Association of Photographers
 AOP Bursary, 115
 AOP Open, 115
 AOP Photographers' Awards, 114
 AOP Student Photographer of the Year, 116
 Assistants Awards, 115
 Document, 115
 Zeitgeist, 115
Atlanta Review Int. Poetry Competition, 269
Authors' Club Best First Novel Award, 187
Ayr Writers Club, 187

BA/Nielsen Book Data Author of Year Award, 188
Bad Sex Prize, 188
Bailey, Chrisi Bailey Award, 116
Balmoral Scholarship for Fine Arts, 160
Barnack, Oskar Barnack Prize, 117
Bass Ireland Arts Award, 53
BBC Talent Awards, 188

Beck's Futures Exhibition and Award. 53
Bedford Open Poetry Competition, 269
Bellagio Study & Conference Centre, 160
Belluard Bollwerk International, 11
Beneath The Sea, 118
Berry, David Berry Prize, 188
BFWG Charitable Foundation
 Emergency Grants, 12
 Foundation Grants, 11
 Theodora Bosanquet Bursary, 12
Birmingham Short Story Competition, 189
Biscuit Publishing, Int. Short Story Prize, 189
Bisto Book Awards
 The Bisto Book of the Year Award, 190
 Bisto Merit Awards, 190
 The Eilís Dillon Award, 190
Black River Publishing, 118
Black, James Tait Black Memorial Prize, 190
BlindArt Competition, 12
Boardman Tasker Award, 191
BOC Emerging Artist Award, 53
Bolwick Arts, 161
Bombay Sapphire, 89
Booktrust Early Years Awards, 192
Booktrust Teenage Prize, 192
Boston Review Short Story Contest, 192
Boston Review, 269
Boulevard Poetry Contest For Emerging Poets, 270
Bowling, Harry Bowling Prize, 193
BP Portrait Award & Travel Award
 BP Portrait Award, 54
 BP Travel Award, 54
Branford Boase Award, 193
Branford, Henrietta Branford Writing Comp, 194
Bray, Archie Bray Foundation for Ceramic Arts, 90
Braziers International Artists' Workshop, 162
Bridport Prize
 Int. Creative Writing Competition, 194, 270
Briggs, Katharine Briggs Folklore Award, 194
British Academy Book Prize, 195
British Academy, 13
British Book Awards, 195
British Chamber of Commerce in Germany e.V., 13
British Comparative Literature Association, 289
British Council, 55
British Czech and Slovak Association, 195
British Deer Society, 119
British Fantasy Society Awards, 196
British Glass Biennale, 90
British Haiku Society, 270
British School at Rome
 Abbey Scholarship in Painting, 162
 Abbey Fellowship in Painting, 162

Arts Council of Northern Ireland Fellowship, 163
Derek Hill Foundation Scholarship, 164
E A Abbey Memorial Trust Fund for Mural
 Painting in Great Britain, E Vincent Harris Fund
 for Mural Decoration, 163
Sainsbury Scholarship, Painting & Sculpture, 164
Wingate Rome Scholarship in the Fine Arts, 164
British Science Fiction Association Awards, 196
BTBS, The Book Trade Charity, 264

Caerleon International Sculpture Symposium, 55
Caine Prize for African Writing, 197
Caldera Residencies, 165
Camargo Foundation, 165
Campbell, George Campbell Travel Grant, 56
Can Serrat International Art Centre, 166
Canter, David Canter Memorial Fund, 91
Carnegie, Carnegie Medal, CILIP, 197
Carr, Inches Carr Trust Dec. Arts Bursaries, 92
Center for Documentary Studies/Honickman First
 Book Prize in Photography, 119
Chadwick, Helen Chadwick Fellowship, 167
Chaplin, Sid Chaplin Short Story Competition, 197
Chapnick, Howard Chapnick Grant, 120
Cheongju International Craft Competition, Korea, 92
Children's Writers' & Artists' Story Comp, 198
Cholmondeley Awards for Poets, 271
Churchill, Winston Churchill Memorial Trust, 13
Clark Digital Bursary, 14
Clarke, Arthur C Clarke Award, 198
Clerkenwell Award, 93
CLPE Poetry Award, 271
Coburg Glass Prize, 93
Cockpit Arts Seedbed Award, 15
Cohen, David Cohen Prize for Literature, 199
Collide, 15
Commonwealth Arts and Crafts Award, 56
Commonwealth Arts and Crafts Awards, 94
Commonwealth Photographic Awards, 120
 Dan Eldon Prize, 121
Commonwealth Short Story Competition, 199
Commonwealth Writers' Prize, 200
Cook, Ernest Cook Trust, 94
Cook, Thomas Cook Travel Book Award, 200
Cooper, Duff Cooper Prize, 201
Cotswold Writers' Circle Open Writing Comp., 272
Coventry Arts and Heritage, 16
Craft Pottery Charitable Trust: Annual Awards, 95
Crafts Council Bursary 100% Design, 96
Crafts Council Development Award, 95
Crawshay, Rose Mary Crawshay Prize, 201
Crime Writers Association Awards, 201
Cultural Co-operation And Touring, 16

D&DA, 17
DAAD
 Scholarships for Artists, 17
 Study Scholarships for Graduates, 18
Daiwa Anglo-Japanese Foundation, 18
Danish Cultural Institute
 Artists in residence programme, 19

Coscan Travel Award Scheme, 19
Dark Tales Short Story Competition, 202
Davidson, Ruth Davidson Mem. Scholarship, 167
Davies, Rhys Davies Short Story Competition, 202
Dearmer, Geoffrey Dearmer Prize, 272
Deedes, Wyndham Deedes Travel Scholarship, 19
Design & Decoration Awards, 97
Deutsche Börse Photography Prize, 121
Deutsche Gesellschaft für Photographie e.V
 Cultural Award, 122
 Dr.-Erich-Salomon Award, 122
 Erich-Stenger-Prize, 122
 Herbert-Schober-Prize, 122
 Otto-Steinert-Prize, 122
 Robert-Luther-Prize, 122
Diagram Group Prize, 203
Discerning Eye, 56
Djerassi Resident Artists Program, 168
Doyle, Tony Doyle Bursary For New Writing, 203
Dryden, John Dryden Translation Competition, 289
Du Maurier, Daphne Du Maurier Festival Short
 Story Competitions, 203
Dundee Book Prize, 204
Dundee Visual Artists Awards Scheme, 57
Dupont, S.T. Dupont Golden Pen Award, 204

East International, 58
Eisenstaedt, Annual Alfred Eisenstaedt Awards, 122
Eliot, TS Eliot Prize, 272
Embroiderers' Guild art of the STITCH, 98
Embroiderers' Guild Scholarship, 97
Encore Award, 205
English-Speaking Union Scholarships
 Chatauqua Institution Scholarships, 20
 Chilton Art History Scholarship, 20
Entente Cordiale, 21
European Association for Jewish Culture, 21
European Biennial Competition for Graphic Art, 58
European Ceramic Work Centre, 99
European Cultural Foundation (ECF)
 Grants, 22
 S.T.E.P. beyond mobility scheme, 22
European Jewish Publication Society, 264
European Publishers Award for Photography, 122
Ewart-Biggs, Christopher Ewart-Biggs Prize, 205

Faber, Geoffrey Faber Memorial Prize, 205
Fairbairn, Esmée Fairbairn Foundation
 Serving Audiences, 59
 Supporting Artists, 59
Farjeon, Eleanor Farjeon Award, 206
Federation of British Artists
 New English Art Club, 65
 Royal Institute of Painters in Water Colours, 60
 Royal Society of British Artists, 64
 Royal Society of Marine Artists, 62
 Society of Wildlife Artists, 63
 The National Print Exhibition, 65
 The Pastel Society, 61
 The Royal Institute of Oil Painters, 61
 The Royal Society of Portrait Painters, 63

Fergusson, J D Fergusson Arts Awards Trust, 66
Fidler Award, 206
FiftyCrows, 123
Fine Arts Work Center, 168
firstwriter.com
 International Poetry Competition, 273
 Short Story Contest, 206
Fish Publishing
 One Page Story Prize, 207
 The Historical Short-fiction Prize, 207
 Fish International Short Story Prize, 207
 The Fish Unpublished Novel Award, 208
Fletcher, Sir Banister Fletcher Award, 208
Florence Trust Residencies, 169
Ford Foundation, 22
Forward Poetry Prize, 273
Foundation for Sport and the Arts, 23
Foyle, Charles Henry Foyle Trust Award for
 Stitched Textiles, 100
Foyle, Foyle Young Poets of the Year Award, 273
Franklin Furnace Fund for Performance Art, 66
French Ministry of Culture, 289
Frogmore Poetry Prize, 274
Fujifilm Distinction Awards, 124
Fujifilm Student Awards, 124
Fujifilm/PPLA Colour Printer Awards, 125

Gallon, Tom-Gallon Trust Award and the Olive
 Cook Prize, 208
Garrick/Milne Prize, 67
Gen Foundation, 24
Getty Foundation
 Internships, 25
 Research Grants for Institutions, 25
 Research Grants for Scholars, 24
Gladstone History Book Prize, 209
Glass Sellers' Prize & Student Award
 Glass Sellers' Prize, 100
 Glass Sellers' Student Award, 100
Glassell School Of Art
 The CORE Program: Visual Artist Residency /
 Critical Studies Residency, 170
Glenfiddich Food and Drink Awards, 209
Global Arts Village Residencies, 170
Godowsky, Leopold Godowsky, Jr. Color
Photography Awards, 125
Godwin, Tony Godwin Award, 265
Gollancz, Sir Israel Gollancz Prize, 209
Gomperts, Juliet Gomperts and Janet Konstam
 Memorial Scholarships, 171
Good, Phillip Good Memorial Prize, 210
Gooderson, Doris Gooderson Short Story Comp., 210
Gottlieb, Adolph & Esther Gottlieb Grants, 67
Graham Foundation, 68
Great Britain Sasakawa Foundation, 25
Greenaway, Kate Greenaway Medal, 211
Greenshields, Elizabeth Greenshields Foundation, 68
Gregory, Eric Gregory Trust Fund Awards, 274
Griffin Poetry Prize, 275
Groot, Virginia A. Groot Foundation, 69
Guardian Children's Fiction Award, 211
Guardian First Book Award, 211

Guardian Student Media Awards, 212
Guardian/Piccadilly Press Writing Competition for
 Teenagers, 214
Guild of Food Writers Awards, 214
Guildford Book Festival
 First Novel Award, 215
 Short Story Competition, 215
Gulbenkian, Calouste Gulbenkian Foundation
 Anglo-Portuguese Cultural Relations, 26
 Non-professional Arts Projects, 26
 Research and development, 26
Gunk Foundation, 26
Gunn, Neil M Gunn Writing Competition, 216
Guthrie, Tyrone Guthrie Center, 172

Hamlyn, Paul Hamlyn Foundation
 Awards for Artists, 27
 Increasing Access to the Arts, 27
Hasselblad Foundation
 San Michele Stipend, 127
 Grez-sur-Loing Stipend, 127
 Hasselblad Foundation International Award in
 Photography, 126
 Stipends and grants in Photography, 126
 Victor Fellowship, 126
Hawthornden Prize, 216
Heinemann, W.H. Heinemann Award, 217
Herbert Art Gallery and Museum, Coventry Open, 69
HI Arts Artists' Award Scheme, 69
HI Arts Makers Award Scheme, 101
Hill, Heywood Hill Literary Prize, 217
Hill, William Hill Sports Book of the Year Sports
 Book of the Year, 217
Hubbard's, L. Ron Hubbard's Illustrators of the
 Future Contest, 70
Hubbard's, L. Ron Hubbard's Writers of the Future
 Contest, 218
Humanity Photo Awards, 127
Hunting Art Prizes, 70

IASPIS, 173
IMPAC, International IMPAC Dublin Literary
 Award, 218
Independent Foreign Fiction Prize, 290
International Photography Awards, 128
Iota Poetry Competition, 275
ISG (CILIP)/Nielsen BookData Awards, 219
Isle of Man Tourism Photo Competition, 129

Japan Foundation
 Fellowship Programme, 29
 Local Project Support Programme, 28
Jerwood Aldeburgh First Collection Prize, 276
Jerwood Applied Arts Prize, 101
Jerwood Drawing Prize, 71
Jerwood Painting Prize, 72
Jerwood Photography Award, 129
Jerwood Sculpture Prize, 72
Johnson, BBC Four Samuel Johnson Prize, 219
Jones, Mary Vaughan Jones Award, 220

Kala Artist Fellowship Programme, 173
Keats-Shelley Prize, 276
Keller, Helen Keller International Award, 73
Kelly, Barbara Mandigo Kelly Poetry Awards, 277
Kelpies Prize, 220
Kenney, Petra Kenney Poetry Competition, 277
Kent & Sussex Poetry Society, 277
Kick Start Poets, 278
Kinross, RSA John Kinross Scholarship, 73
Kiriyama Prize, 220
Kirk Fund, 29
Knox, Frank Knox Memorial Fellowships, 29
Kobal, John Kobal Book Award, 130
Kodak Portrait & Wedding Awards, 130
Kohler, John Michael Kohler Arts Center
 Arts/Industry Artist-in-Residency, 174
Korea Foundation, 30
Koret Jewish Book Awards, 221
Koret Young Writer on Jewish Themes Award, 222
Kraszna-Krausz Book Awards, 222
Kraszna-Krausz Foundation Grants, 131
Kress Conservation Fellowship, 74
Künstlerinnenhof Die Höge, 174

Lady Short Story Competition, 222
Lakeland Book of the Year Awards, 223
Lancashire County Library and Information Service
 Children's Book of the Year Award, 223
Lange, Dorothea Lange-Paul Taylor Prize, 132
Langlois,The Daniel Langlois Foundation for Art,
 Science, and Technology, 30
Le Prince Maurice Award, 223
Legend Writing Award, 224
Leica Medal of Excellence, 133
Lettre Ulysses Award for the Art of Reportage, 224
Leverhulme Trust
 Academic Collaboration: Int.l Networks, 31
 Artists in Residence, 31
 Early Career Fellowship, 31
 Major Research Fellowships in the Humanities
 and Social Science, 31
 Research Fellowships, 31
 Study Abroad Fellowships, 32
 Study Abroad Studentships, 32
 Training and Professional Development, 32
 Visiting Fellowships, 32
 Visiting Professorships, 32
Libbon Premier Competition, 225
Lichfield & District Writers Short Story Comp, 225
Lichfield Prize, 225
Liguria Study Centre for the Arts & Humanities, 175
Llewellyn, John Llewellyn Rhys Prize, 226
London Photographic Awards
 Adsight, 134
 Let's Face It, 134
 Photoart Competition, 134
London Salon of Photography, 134
Longford, Elizabeth Longford Prize for Historical
 Biography, 226
Longman History Today Awards, 227
Lynch, Agnes Lynch Starrett Poetry Prize, 278

Macmillan Writer's Prize for Africa, 227
Maine Photographic Workshops
 Karen Van Allsburg Memorial Scholarship, 135
 3rd Annual Yarka Vendrinska Memorial
 Photojournalism Scholarship, 135
 R.I.P.E. Benefactor Scholarship Fund, 135
Maine Photographic Workshops – The Golden Light
Awards
 Photographic Book of the Year Awards, 137
 Photographic Print Competition, 136
 Photographic Project Award Program, 136
 Top 100 Photographers, 137
Man Booker Prize for Fiction, 228
Marsh Award for Children's Literature in
 Translation, 290
Marsh Biography Award, 229
Martindale, Hilda Martindale Awards, 33
Maschler, Kurt Maschler Award, 229
Masefield, Paddy Masefield Award, 33
Mathews, Francis Mathews Travel Scholarship, 33
Maugham, Somerset Maugham Awards, 230
McKitterick Prize, 230
McLauchlan, Juliet McLauchlan Award, 230
McLeod, Enid McLeod Literary Prize, 231
Mere Literary Festival, 231
MEXT (Japanese Government) Scholarships for
 Postgraduate Research Studies, 175
Milne, James Milne Memorial Trust, 34
MIND Book of the Year, 232
Montana Artists Refuge Residency Program, 176
Moore, Henry Moore Sculpture Fellowship, 177
Moores, John Moores Exhibition, 74
Moorman, Theo Moorman Charitable Trust, 102
Mslexia Women's Poetry Competition, 278
Multi Exposure Awards, 34
Munster Literature Centre
 Sean O'Faolain Short Story Competition, 232
 Southword Editions Poetry Chapbook Comp, 279

N.E.S.T.A.
 Creative Pioneer Programme, 36
 Dream Time Fellowships, 35
 Fellowship programme, 35
. Ignite!, 35
 Invention and Innovation Programme, 35
 Learning Programme, 35
NASEN & TES Special Educational Needs Book
 Awards, 233
National Museum of Women in the Arts, 75
Naughton, Bill Naughton Short Story Comp., 233
NAWG Creative Writing Competition, 233
Nestlé Smarties Book Prize, 234
New English Art Club Drawing Scholarship, 75
New Writer Prose & Poetry Prizes, 235 & 279
New York Public Library's Center for Scholars and
 Writers, 177
Newspaper Press Fund, 265
Nikon Photo Contest International, 137
Nobel Prize for Literature, 235
NOMA Award for Publishing in Africa, 235
Nordic Culture Fund, 36
Nordic Institute for Contemporary Art, 177

North Lands Creative Glass, 178
Northern Rock Foundation Writer's Award, 236
Northern Writers' Awards, 237
Norwich Writers' Circle Open Poetry Comp., 280
Nuclear Age Peace Foundation
 Swackhamer Peace Essay Contest, 238

Observer Hodge Photographic Award, 138
Onassis, Alexander S. Onassis Foundation, 37
Onassis, Alexander S. Onassis Public Benefit
 Foundation, 76
Orange Prize for Fiction, 238
Orwell Prize, 239

Parry, Ian Parry Award for Photographers, 139
PDN Contests
 PDN Photo Annual, 139
 PDN/Nikon Self-Promotion Awards, 140
 TOP KNOTS, 140
Pearl Awards, 37
Pencil Short Story Competition, 239
Pepinières Européennes Pour Jeunes Artistes, 178
Pepys, Samuel Pepys Award, 240
Peterloo Poets Annual Open Poetry Comp., 280
Phodar Biennial, 141
Photo Review Annual Int. Photography Comp., 142
Pick, Charles Pick Fellowship, 179
Picture Editors' Awards
 Newspaper Awards, 142
 Portfolio Awards, 142
 Single Image Awards, 143
Pictures of the Year International, 143
Pilar Juncosa & Sotheby's Awards
 Pilar Juncosa Grant for an educational project, 77
 Pilar Juncosa Grants for training, experimentation
 and creative work, 77
 Pilar Juncosa Research Grant on Miró, 77
 The Pilar Juncosa and Sotheby's Award, 77
Pimlott, Ben Pimlott Prize for Political Writing, 240
Pitshanger Poets National Poetry Competition, 281
Plough Prize, 281
Poetry Business, Book and Pamphlet Comp., 281
Poetry London Competition, 282
Poetry Society National Poetry Competition, 282
Polaroid Corporation
 Artist Support Program, 144
 The Polaroid International Photo Awards, 144
Pollock-Krasner Foundation, 78
Popescu, Corneliu M Popescu Prize for European
 Poetry Translation, 291
Portico Prize, 240
Prichard, Mathew Prichard Award, 241
Prince's Trust
 Grants for education, training or work, 38
 Business start up, 38
Pritchett, V.S. Pritchett Memorial Prize, 241
PSI Fellowship, 179
Pulitzer Prizes, 241
Pulsar Poetry Competition, 283

Queen Elizabeth Scholarship Trust, 102

Ragged Raven Annual Poetry Competition, 283
Ratcliff, Michaelis-Jena Ratcliff Prize, 242
Real Writers Short Story Awards, 242
Red House Children's Book Award, 242
Refocus Now Ltd, 79
Revelations - Gate Translation Award, 291
Rhubarb-Rhubarb Bursaries, 145
Romantic Novelists' Association, 243
Rootstein Hopkins Foundation Grants, 79
Royal Academy of Arts Summer Exhibition, 79
Royal Birmingham Society of Artists, 80
Royal Horticultural Society Photographic
 Competition, 145
Royal Literary Fund, 265
Royal Literary Fund, Fellowship Scheme, 244
Royal Netherlands Embassy – Postgraduate
 Scholarships, 39
Royal Overseas League Travel Scholarship, 39
Royal Scottish Academy – Friends Bursary, 80
Royal Scottish Society of Painters in Watercolour
 Alexander Graham Munro Travel Award, 81
 John Gray Award, 81
 May Marshall Brown Award, 81
 Residency for visual artists at Hospitalfield
 House, Arbroath, 180
 RSW Council Award, 81
 Sir William Gillies Award, 81
Royal Society
 Jerwood Awards for Non-Fiction, 244
Royal Society of British Sculptors
 Royal Academy Bronze Casting Award, 82
 Royal Society of British Sculptors Bursary, 82
Royal Society, Royal Society of Literature Ondaatje
 Prize, 245
Royal West of Engalnd Academy – Student
 Bursaries, 82
RSA Design Directions, 82
Runciman Award, 245

Saga Award for Wit, 24
Sagittarius Prize, 246
Salmon Poetry Publication Prize, 283
Saltire Society Literary Awards, 246
Salvesen, Alastair Salvesen Art Scholarship, 83
Samaritans
 Photographic & Digital Image Competition, 146
Santa Fe Center for Photography
 Excellence in Photographic Teaching Award, 148
 Project Competition, 147
 Santa Fe Prize for Photography, 148
 Singular Image, 147
Schreiber, Mona Schreiber Prize for Humorous
 Fiction and Non-Fiction, 247
Schweppes Photographic Portrait Prize, 148
Scotsman & Orange Short Story Award, 247
Scottish Arts Council Children's Book Awards, 248
Scottish Arts Council, 103
Scottish International Open Poetry Competition, 284
Scottish Sculpture Workshop, 180

Sefton Open, 83
Shapiro, Evelyn Shapiro Fellowship, 103
Sheffield Children's Book Award, 248
Shrewsbury Open Competition, 84
Singer & Friedlander /Sunday Times Watercolour
 Competition, 84
Siskind, Aaron Siskind Foundation, 149
Site Gallery, 149
Smith, W. Eugene Smith Memorial Fund, 150
Smith, WH Smith Literary Award, 249
Society of Authors
 Authors Contingency Fund, 266
 Francis Head Bequest, 266
 John Masefield Trust, 266
Society of Wildlife Artists
 SWLA Bursaries, 40
 Wetlands for Life, 40
Soho Theatre and Writers' Centre, 249
Spender, Stephen Spender Prize, 291
Spider Awards, 150
St Hugh's Foundation
 The Henrietta Bowder Memorial Bursary, 41
 The St. Hugh's Fellowship, 41
Stapley, Sir Richard Stapley Educational Trust, 41
Stationers And Newspaper Makers' Educational
 Charity, 42
Stiftung Kunstlerdorf, 41
Strokestown International Poetry Competition, 284
Suffolk Poetry Society, 285
Sunday Times National Student Drama Festival, 249
Sunday Times Small Publisher Award, 250
Sunday Times Young Writer of the Year, 250
Swanwick Competition, 251

Tanner, Mark Tanner Award, 85
Tasara, Centre for Creative Weaving, India, 104
TCB-Cafe Publishing, 151
Textile Industry Awards
 Young Designer of the Year, 105
 Young Manager of the Year, 105
 Young Weaver of the Year, 105
The Times / Tabasco® Young Photographer, 152
Theakston's Old Peculier Crime Novel, 251
Theatre Book Prize, 252
Thomas, David St John Thomas Charitable Trust, 252
Thomas, Dylan Thomas Prize, 252
Thouron Awards, 42
Tiltman, Hessell Tiltman Prize, 253
Tir na n-og Awards, 253
TLS-Porjes Prize for Hebrew Translation, 292
Top 100 Poets of the Year, Forward Press, 285
Tower, Christopher Tower Poetry Prizes, 286
Translators Association
 Dutch/Flemish Translation: Vondel Prize, 292
 French Translation: Scott Moncrieff Prize, 293
 German translation: Schlegel-Tieck Prize, 293
 Greek Translation: Hellenic Foundation Prize, 293
 Italian TranslationJohn Florio Prize, 293
 Portuguese Translation: Gulbenkian Prize, 293
 Spanish Translation: Premio Valle Inclán, 293
 Swedish Translation: Bernard Shaw Prize, 293
Trask, Betty Trask Prize and Awards, 254

Travel Photographer of the Year
 Travel Photographer of the Year, 152
 Young Travel Photographer of the Year, 153
Trierenberg Super Circuit, 153
Tripp, John Tripp Award for Spoken Poetry, 286

UEA Writing Fellowship, 181
UK FILM COUNCIL - 25 Words or Less, 25
UKA Open Theme Poetry Competition, 287
UNESCO-Aschberg Bursaries for Artists
 Programme, 43
United Nations Environment Programme -
 International Photography Competition, 153

V&A Illustration Awards, 85
Ver Poets Open Competition, 287
Vetrate Artistiche Toscane, 105
Viner, George Viner Memorial Fund Trust, 255
Voies Off, 154

Wales Arts International
 International Project Fund, 44
 International Project Research Fund, 44
Ware Poets Open Poetry Competition, 287
Warhol, Andy Warhol Foundation, 86
Webster, Tom Webster Photographic Award, 155
Weidenfeld Translation Prize, 294
Wellcome Trust
 People Awards, 46
 Production Awards, 45
 Pulse, 46
 Research and Development Awards, 45
Wells Festival of Literature, 287
Welsh Books Council Publishing Grant, 256
Welsh Literature Abroad, 294
Whitbread Book Awards, 256
Whitfield Prize, 256
Whitney Museum of American Art, 86
Wildlife Photographer of the Year
 Eric Hosking Award, 155
 Gerald Durrell Award, 156
 Innovation Award, 155
 Wildlife Photographer of the Year, 155
 Young Wildlife Photographer of the Year, 156
Williams, Raymond Williams Community
Publishing Prize, 257
Wingate Jewish Quarterly Literary Prizes, 257
Wingate Scholarships, 47
Wolfson History Prize, 258
Women's Studio Workshop
 Artists' Book Production Grants, 107
 Artists' Book Residency Grants, 107
 Independent Work, 106
 Special Ceramics Fellowships, 107
 Studio Residency, 106
 Fellowship Grants, 181
Wong, David T K Wong Prize for Short Fiction, 258
Wong, David T.K. Wong Fellowship, 182
Woo Charitable Foundation Arts Bursaries, 88
World Press Photo Contest, 157

Worshipful Company of Glaziers
 Neville Burston Memorial Award, 108
 The Arthur & Helen Davis Scholarship, 108
 The Ashton Hill Award, 108
 The Award for Excellence, 108
 The Stevens Competition, 107
Worshipful Company of Turners, 109
Wrexham Arts Centre - International Print Biennale
 Residency, 182
Wrexham County Borough Council, 48
Wright, Keith Wright Literary Prize, 258
Writers Bureau Poetry & Short Story Writing
 Competition, 259
Writers in Translation, 294
Writers inc., 259
Writers' Digest.com, 260
Writers' Forum Poetry Competition, 288
Writers' Forum Short Story Competition, 260
Writers' News, 288
Writers' Week Literary Competitions, 261

Yaddo, 183
Yeovil Literary Prize, 262
Yorkshire Post Book of the Year Award, 263
Young Minds Award, 263

Zelli Porcelain Award, 109

For further information on all our titles
please visit our web site

www.dewilewispublishing.com